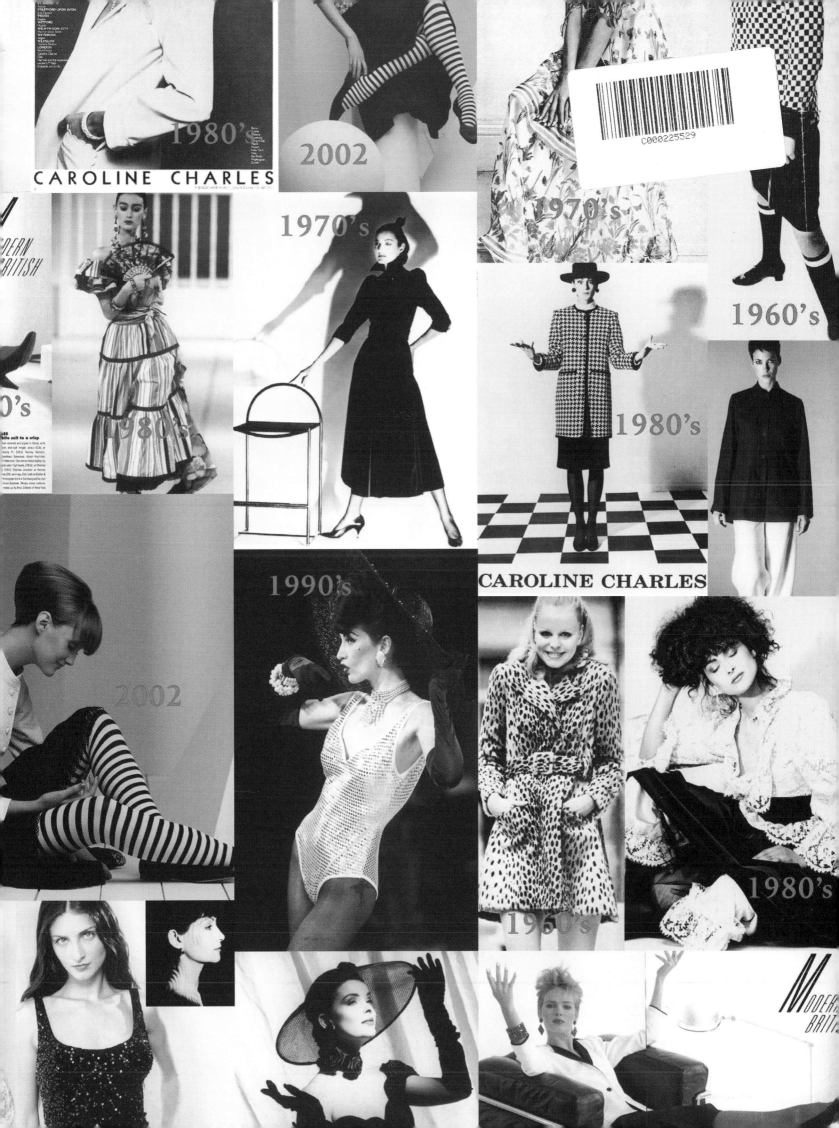

1980's

CAROLINE CHARLES

2002

1970's

1970's

1960's

1980's

1990's

CAROLINE CHARLES

2002

1960's

1980's

CAROLINE CHARLES

50 Years in Fashion

The diaries & scrapbooks
of a leading London designer

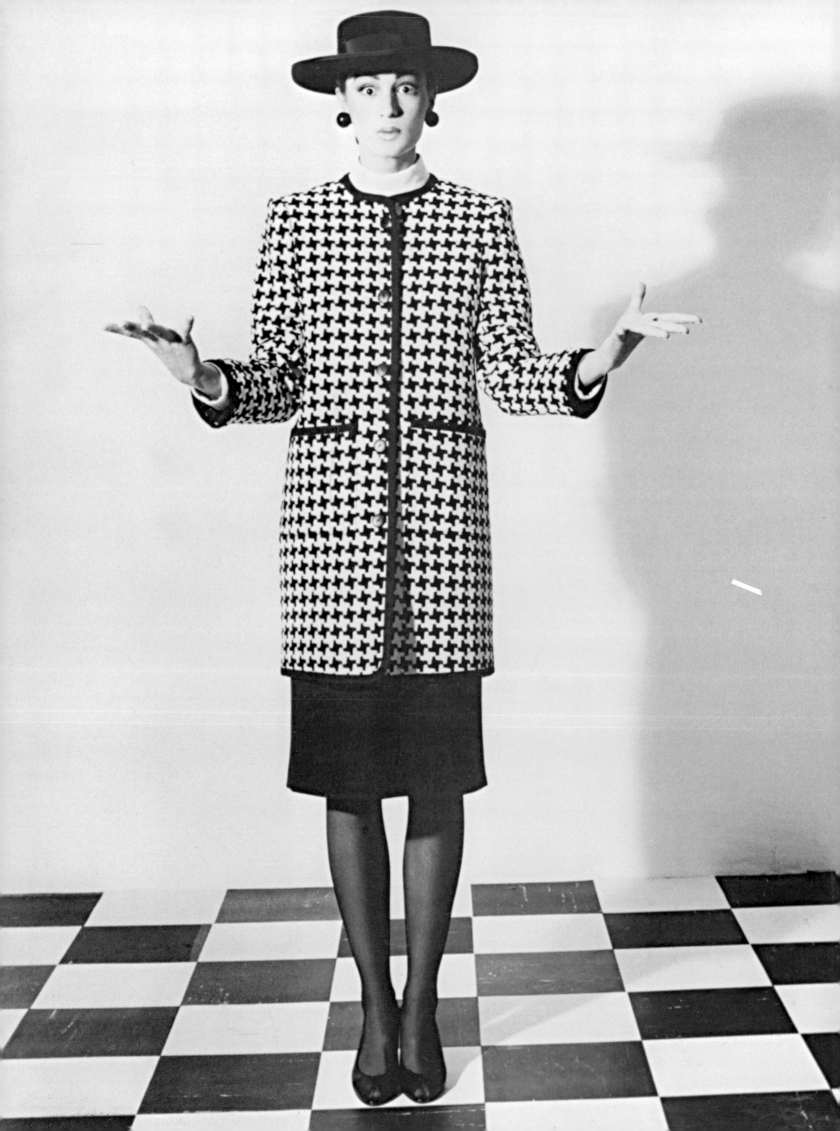

CAROLINE CHARLES

50 Years in Fashion

The diaries & scrapbooks
of a leading London designer

ACC Editions

CONTENTS

NICHOLAS COLERIDGE CBE – MANAGING DIRECTOR CONDÉ NAST BRITAIN

"I think of Caroline as the most English of all designers. Her work has always managed to personify a certain civilised and chic Englishness, but also always to be interesting. I have never seen a badly dressed woman wearing Caroline Charles – it is actually impossible."

ALEXANDRA SHULMAN – EDITOR BRITISH _VOGUE_

"Caroline has been one of the success stories of British fashion. Unafraid to stick to her original, clear vision, her tailored and feminine style has been an international export for several decades, popular for being elegant, wearable and flattering to most women."

SUZY MENKES – FASHION EDITOR _INTERNATIONAL HERALD TRIBUNE_

"Caroline Charles expresses a particularly English spirit of restraint and refinement that resonates with her loyal audience. For half a century she has put women first, thinking about their needs and desires, rather than her own self-promotion. Yet no one wears her own creations as stylishly as the designer who gave them life."

HAROLD TILLMAN CBE – CHAIRMAN OF THE BRITISH FASHION COUNCIL

"I have had the pleasure of knowing Caroline Charles over her extensive career. She is a great asset to British fashion. Her creations encapsulate true British elegance and enjoy popularity across the board for that winning combination of wearability and originality. She was never afraid to be a trailblazer in her early days and established herself early as a force to be reckoned with in the British fashion industry. Her formidable standing in the industry has led her to be a source of inspiration for many other designers. She now truly deserves to be acknowledged as a national treasure."

CAROLINE BAKER – FASHION DIRECTOR, _YOU_ MAGAZINE

"I became fashion editor of _Nova_ magazine in 1968 – Caroline Charles was already a famous designer! In the Swinging Sixties she herself was the total Sixties chic young designer who we saw on TV and read about in the newspapers, as she was dressing all the famous happening people at that time … and looking absolutely gorgeous herself – so inspiring at a time when us females were all beginning to enjoy careers away from the traditional role of the housewife!

Being a total 'planet fashion'-immersed designer, her designs changed from the cute shift architectural sixties to the flowing hippie romantic styles that then took over the way we dressed – in fact this has been one of Caroline's strengths – always in the fashion loop, her collections are always right there with the style mood of the moment. She has been a favourite designer to many of our most important in-the-limelight 'first' ladies, princesses and actresses throughout her career, which goes to show that her designs are not only beautiful but wearable. Her love of fabrics, textures and colours has always made her collections so special and her themes each season are always so beautiful and inspiring. Caroline has been a wonderful ambassadress for the British fashion industry and helped to put Brit fashion on the map of the international fashion circuit.

And Caroline herself is a charming, friendly, lovely person – visiting the beautiful super-chic head office in Beauchamp Place is always such a pleasure!"

VICKI WOODS – JOURNALIST

"She has said that her ideal customer is 'a Caroline Charles collector' and in my own collection of her woman-shaped tailoring is a black silk-velvet jacket from 1990 with a nipped waist and high closure. The sleeves and jacket hem are lavishly embroidered with bright silver leaves and flowers and this contrast of rich embellishment with covered-up, high-necked tailoring is quite Spanish. Or Tudor. Or both. Which is of course, very, very English. I always feel like _Maria Stuarda_ in that jacket."

STEPHEN BAYLEY – AUTHOR

"With sharp wit, even sharper charm, meticulous design and fastidious execution, Caroline Charles has effortlessly and elegantly survived fifty years in the sometimes turbulent and capricious world of fashion. This certainly shows astonishing resilience, but more importantly proves the enduring value of true style. And what is style? It's the 'dress of thought'. That's _never_ going out of fashion. Nor is Caroline."

CANDIDA LYCETT GREEN – AUTHOR

"Caroline's vision has remained as clear and fresh as the day she started out on Dover Street. Her tenacity is unparalleled; her quest for perfection unceasing and across the decades, her quiet brilliance has been unswervingly consistent. It goes without saying that her friendship is steadfast, but above all, it is her innate grace and elegance which pervades everything she creates and everything she does."

VALERIE GROVE – WRITER

"My Caroline Charles outfits share certain characteristics I feel everyone should know about. They are well-cut, therefore flattering. They are timeless and durable, as good as new after 25 years. I can show you a two-piece camel wool costume which survived, in rapid succession (a) a nocturnal transatlantic flight – economy (b) a vicious mud-splattering from a New York yellow cab, en route to see Tina Brown and (c) the spilling of Alan Coren's red wine over it; yet (with a few flicks of a brush) it still looked bandbox-pristine. And the silver sequinned mermaid-shaped ballgown (c.1988) hangs in my cupboard, borrowed again and again by daughters, actors, torch-singers, transvestites...

The other characteristic is that they all seemed expensive at the time, but *sub specie aeternitatis*, since they last for ever, they are practically free.

And Caroline herself – dressed with the utmost simplicity and understated chic, even on the tennis court – always looks poised and in quiet command, which is very inspiring, in a couturier, and also enviable."

BRUCE OLDFIELD – DESIGNER

"My Beauchamp Place neighbour for over quarter of a century, Caroline occupies a unique place in the fashion world. No one encapsulates the ladylike qualities of British style more so than her.

There are few designers who come to mind when asked who illustrates the essence of the English lady. Caroline Charles would be at the top of that list, occupying a very cherished place in the industry for over four decades."

DAVID SASSOON – DESIGNER

"Caroline's career and mine have run parallel together for over 50 years.

I well understand the loyalties that Caroline's clientele generate for her very British sense of style and her understanding of the requirements of the women that she dresses.

I admire her energy and professionalism. She always looks impeccable and stylish in everything she wears and is the best advertisement for her brand."

JOAN BAKEWELL – BROADCASTER

"Caroline Charles knows all about beauty. For decades she has shared her inspiration with us through the line, texture, colours and adornment of her wonderful clothes. We are all the happier for it."

SUE CREWE – EDITOR *HOUSE & GARDEN*

"After spending my teenage years dressing from Biba, Miss Selfridge and Kensington market, in my twenties I graduated to Ossie Clark, Bill Gibb and Caroline Charles. Nothing from Ossie or Bill survives in my cupboards, but I still have beautiful clothes from Caroline that span four decades; clothes that I wear with pride and panache to this day."

JESS CARTNER-MORLEY – FASHION EDITOR, THE *GUARDIAN*

"Few fashion designers have the talent or energy to make the grade at London Fashion Week, even for a year or two – Caroline Charles has been a key part of London fashion for nearly half a century. She has dressed true British style icons from Mick Jagger to Princess Diana, and her career spans the explosion in fashion and music in London in the 1960s to the current day resurgence of London as a fashion capital – a fantastic achievement."

JOHN MINSHAW – INTERIOR DESIGNER

"Caroline's clothes have remained timeless and classically chic."

RICHARD KNIGHT – CHRISTIE'S, LONDON

"Caroline's shop is truly one of the great landmarks in Knightsbridge. But Caroline has established a reputation far beyond the realms of Beauchamp Place. Her designs are a British Classic."

For my family, and for all who have worked with us over the years.

A special thanks to Hannah for her work on this book.

It was a stroke of luck to be starting a small dress design company at this moment. 1963 London was humming and just about to break into song with its own small group of creative people: new playwrights, artists, photographers, film makers, designers, actors, dancers and, most attention-grabbing, new pop musicians. I managed to be part of a group of young London designers who were coming up behind Mary Quant. Of course these talents had always existed, but the luck of it was that America was excited by the idea of 'Swinging London'; even Paris was interested. Young journalists were being given their break and writing about their own generation, they fanned the flames for all of us as we basked in our new-found fame.

I had been working for the fashion photographer Tony Rawlinson in his basement studio in Dover Street. On the ground floor was Blades, the trendiest and top quality men's tailor of the day. This was the domain of Rupert Lycett Green, the dandiest of dandies, who kindly lent me Eric, his pattern cutter, for my first collection.

1960s

C.C. on a submarine in Portsmouth Harbour, 1963

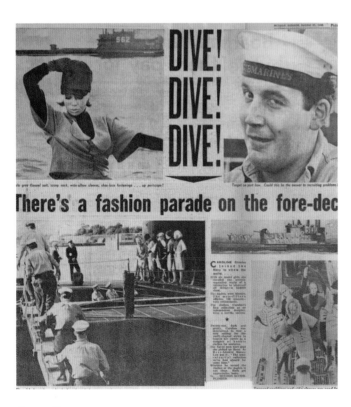

1963

We made the first Caroline Charles samples in a Chelsea attic. The collection was launched in September 1963 with a photo shoot of six model girls on a submarine in Portsmouth Harbour. The Navy was very welcoming and piped us aboard, though the photographer made us pose on an alarmingly slippery deck before we were all allowed to go below.

After the sophisticated, sexy and womanly clothes of the '50s, the inspiration for the '60s was Youthquake. An ingénue Lolita look was sexy, but in an apparently innocent and amusing way. It felt different, free and slightly dressing-up box. We were not dressing to be seen as future wives, but assumed this disguise of the dolly bird. It was tongue-in-cheek.

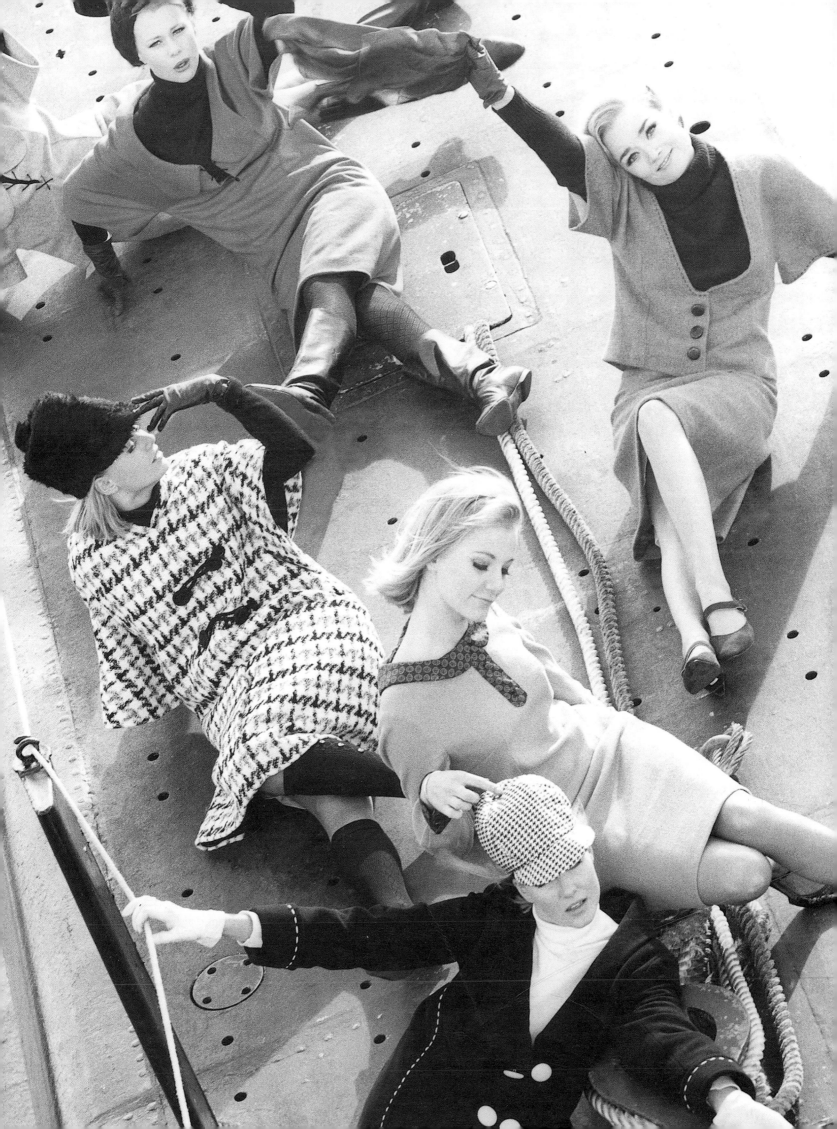

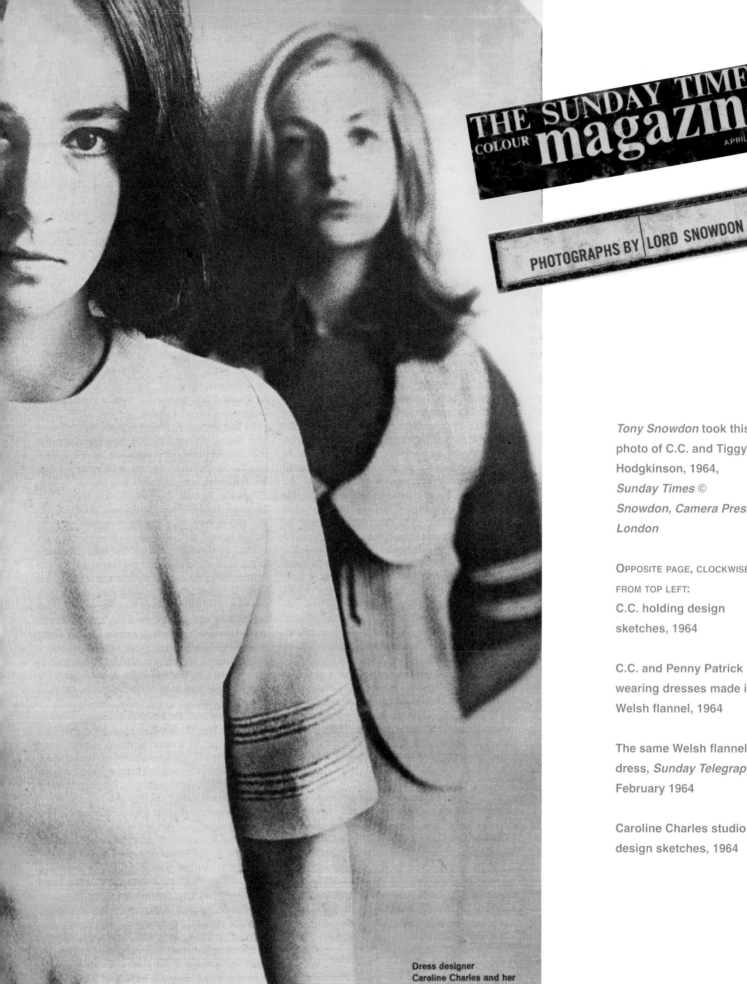

THE SUNDAY TIMES
COLOUR magazine
APRIL 5, 1964

PHOTOGRAPHS BY LORD SNOWDON

Tony Snowdon took this photo of C.C. and Tiggy Hodgkinson, 1964, *Sunday Times* © *Snowdon, Camera Press London*

OPPOSITE PAGE, CLOCKWISE FROM TOP LEFT:
C.C. holding design sketches, 1964

C.C. and Penny Patrick wearing dresses made in Welsh flannel, 1964

The same Welsh flannel dress, *Sunday Telegraph*, February 1964

Caroline Charles studio design sketches, 1964

Dress designer Caroline Charles and her associate Tiggie Hodgkinson. Their dresses are by Caroline

THE NEW RAG TRADERS

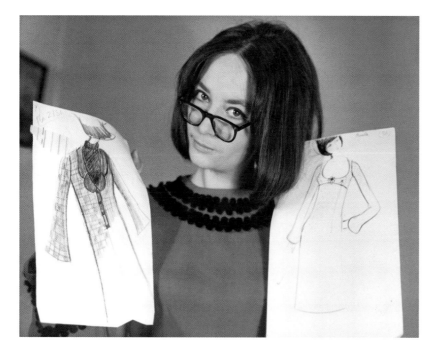
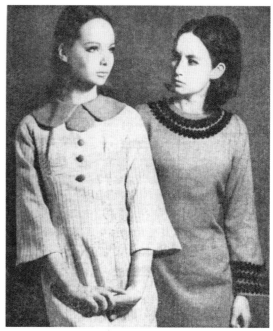

The Spring 1964 Collection designs were shown to the *Sunday Times* who sent Tony Snowdon to photograph Tiggy and me. Tiggy Hodgkinson was my assistant and is now an outstanding photographer. We were christened the new rag traders and more orders followed. We used cottons from Liberty and Welsh flannels, the latter inspired by swatches that Tony Snowdon had brought with him on the photographic shoot. As beginners, we made clothes for almost immediate wear, innocently not adhering to the trade habit of making six months in advance.

The clothes were very 'little girl' with droopy collars and bracelet-sleeve dresses worn over long-sleeve polo necks. I used the black and white houndstooth checks, which still feature in my work. The models wore bonnets or jockey caps and the flat boots that we were all wearing at the time. Back in

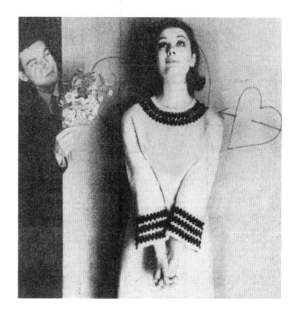

London there was a break-in and the whole collection was stolen. As these were the first samples, it really mattered. But a fan sent us twelve dozen red roses and I realised that the only thing to do was to carry on and remake them. So we did, and with great success: we took orders from Harrods, Woollands 21 and 31 shop and Countdown in the King's Road, a shop owned by Pat Booth and Jimmy Wedge, as well as the Dorothée Bis shop in Paris. With that many orders we didn't have time to stop and think about what a good start we'd made!

Caroline Charles

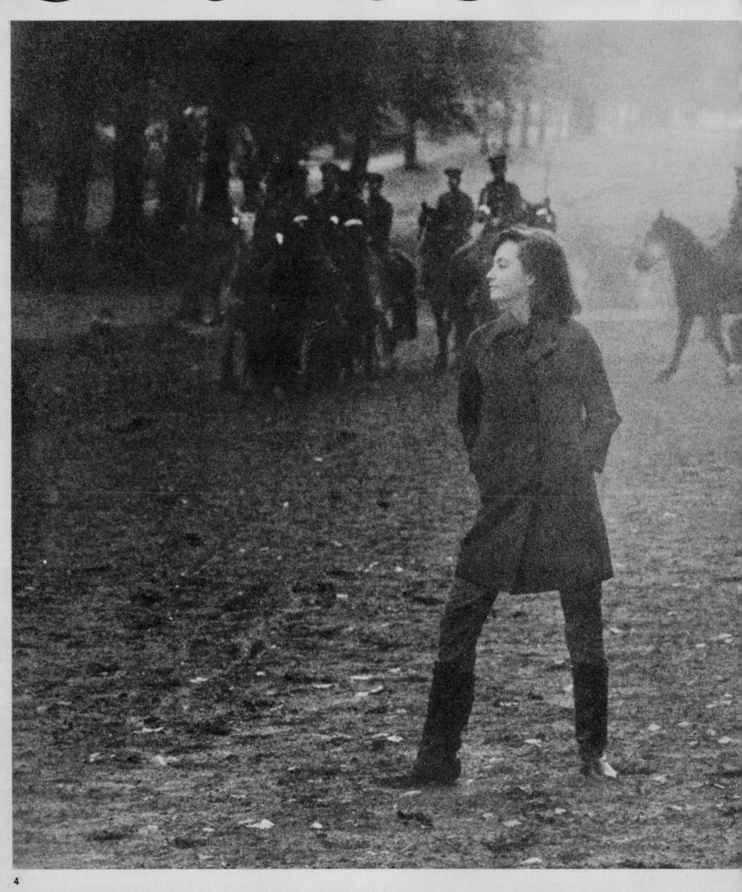

nvades the U.S.

Don McCullin

Britain's youngest, brightest, clothes designer tells – with some surprise – how she captured New York once and is about to do so again

Next Wednesday Miss Caroline Charles, aged 22—youngest of the English designers whose fashions have captured New York —returns there to show her spring collection. She is dark, beautiful and frail, with a small voice and a languid manner. But she is deceptive: she is made of iron; her energy is matched only by her persistence. Nothing will stop her. She is at the top now, and might stay there 50 years. How has it happened? She speculates herself in this talk to John Gale.

"I was born in Cairo", Miss Charles says, "and my father was an army officer. I was a terrible home-craft kind of child: I had a loom and wove tweed. I went from my convent school (I am a Catholic, a very passionate one) to Swindon Technical College, which had a particularly good art section. After the first year I definitely wanted to be a dress designer; I felt that art teaching

In Hyde Park in the early morning, Caroline Charles prepares for a job too big for the Horse Guards: conquering the U.S. again.

5

Don McCullin took this picture of C.C. early morning in Hyde Park, 25 October 1964,
The Observer © Contact Press Images

'I think, once the clothes are on, the person should shine through'

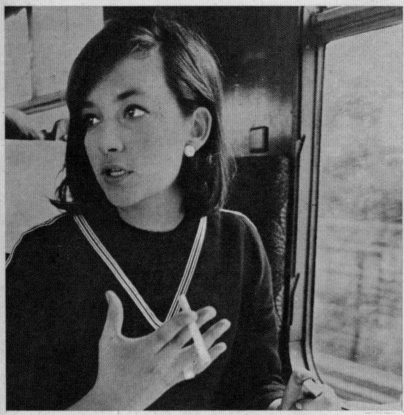

Dual-purpose dress loses undersweater for evening.

was not *for* anything, not practical, didn't come into everyday life. Dressmaking was my craft once a week.

"I left Swindon after two years instead of the full four, so I'm totally unqualified and without a national diploma in art. I went and worked for a couturier in London, the top end of the trade, hand done, beautifully done, wonderful cloth: I started in a basement workroom picking up pins and dressing the model girls. All this was terribly glamorous and totally unpaid.

"Then I went to Mary Quant as a salesgirl in her bazaar in Knightsbridge. I stayed there a year and was tremendously happy, selling amusing and well-designed clothes to amusing people. Next I worked for a year with a fashion photographer.

"All this time I had been designing in the evening and early hours of the morning. My first excitement, when I was with the couturier, was to make Susannah York's first film *première* dress.

"When I left the photographer's I had so many clients already that I converted my dining-room table into a cutting table and stitched away all day. This was surprisingly successful

and lucrative; so much so that I could afford to employ a girl to help me. This was in May last year. October came, and with no knowledge of the wholesale business, being always on the retail or couture side, I borrowed a few hundred pounds, employed a secretary, and—still in my flat—produced a tiny collection of rather seedy garments; people seemed to like them. We were doing mad things like buying material retail in the downstairs department of Harrods and selling it back as a dress to the dress department upstairs.

"Anyway, the whole lot was stolen. In December last year I borrowed a bit more money from different friends, produced a collection of about 12 dresses and a few suits, bought a dress rail, hung the clothes up on important hangers, and rang up the buyers of the stores, starting with the ones nearest my flat. They came and they ordered twos and threes, and the first two came back because they were badly made.

"But this gradually built up. It was terribly late in the season, so we were pretty lucky. Then I and my secretary packed suitcases and took plane, bus, or train to Liverpool, Birmingham, Manchester, and Plymouth, and we

opened more accounts that way.

"Mmm, in May this year I showed a second collection, of autumn and winter clothes, and at the same time as I was expanding accounts in this country, I was starting to export: Montreal, then Bermuda and New York. Then I took an aeroplane to Paris carrying a suitcase, which was really tough. They weren't pleased to see me, were terribly rude, and didn't like the idea of English people bringing interesting designs that were not Scottish tweed, cashmere, or wellington boots. Anyway, we did manage to open one big store account and three boutique accounts.

"After Paris I went on to Stockholm, where I knew there was a very good store, and to my horror the entire Swedish population were on their three weeks' legal holiday. The whole place was deserted. I rang the store and managed to find the merchandising director, who hadn't quite gone on holiday, and he said, you know, things really weren't worth doing: everyone was away. So I cried. And he said, 'I'll come and see your clothes'.

"He had the brain-wave that the buyer who'd be interested in these clothes had an allergy to trees. and grass and would not have left the city. He rang her up: round she came; and at the last minute everything was saved. So, mmm, one got an enormous order.

"The next sort of event was that buyers from Macy's in New York arrived in hordes one night —quite late—in the showroom I had then in Pont Street. They loved the clothes and immediately said: 'Can we have an exclusive? Will you come to New York in September at our expense?' They kept saying they were the biggest store in the world. And, mmm, that was that.

"So I went, and it went like a rocket. I was besieged by manufacturers in New York who all wanted to manufacture the clothes. Macy's took a whole page of the *New York Times* to bang Caroline Charles.

"The first thing Macy's did when I arrived was to give a Press breakfast, which was a bit alarming: it was at 8.45 in a palatial suite of offices, and I sat on a dais with all the presidents of the store under an enormous sign that said: THINK CORPORATE.

"The breakfast? Tea and kippers, which stank the whole place out. And English muffins. I didn't know what English muffins were: they're little squares of lead.

"Having your own company, Caroline Charles Ltd, stops you getting big-headed and starry-eyed, and you know what every day holds for every member of your staff. The eight or 10 of us all know what's going on. My

sister sews in the workroom during her holidays, and my sma[ll] brother is a delivery boy. Until re[-] cently I did everything: design[,] samples, invoicing, selling, book[-] ing orders, deliveries, letters[,] modelling, cutting cloth at 5[0] yards a time. I think we can now[w] produce enough. I am loath t[o] let the manufacture go out of thi[s] country: our standards are bette[r.]

"It's not my achievemen[t] that we've done things quickly[.] It's due to Mary Quant branchin[g] out five years ago and strugglin[g] with stuffy England and makin[g] buyers and the Press appreciat[e] and become aware that youn[g] people can produce saleable an[d] pretty clothes. I and the othe[r] young designers haven't had t[o] break down the walls that Mar[y] had to break down.

"I have no respect for th[e] conventional, but I don't aim t[o] produce way out *avant-gard[e]* dressing. I don't aim to produce [a] uniform way of dressing. I thin[k] once the clothes are on someon[e] the person should shine throug[h] and the clothes should be secon[-] dary. The dress should attract at[-] tention from way across the room[,] but then, having met the person[,] you shouldn't be distracted by th[e] dress from what the person i[s] saying. Mary Quant had to star[t] way out several years ago, sh[e] had to swing to get their attention[.] I'm lucky enough to come i[n] when the pendulum's swingin[g] back again.

"At the moment I'm wear[-] ing the sort of dress that if I tak[e] the black sweater off from under[-] neath I can go out to dinner in[.] My stuff can do for anything; it['s] not designed for a specific occa[-] sion. This dress has a lowish neck[.] It's made of black face-cloth—o[r] broad-cloth, as the American[s] call it—with a black-and-whit[e] braided V-neck. And braid run[-] ning down the shoulder sea[m] and arm to the wrist. And a braid[-] ed tie belt. It's called 'Hussar'. [I] name all the clothes. They're sor[t] of people to me, not just things[.]

"For me, dressing pop star[s] has set a trend: your ideas be[-] come acceptable to someon[e] else. When I was in America [I] rang up the White House an[d] spoke to Luci Baines Johnson—[] about something quite different—[] and she asked me to send he[r] sketches from which she coul[d] order. Which was exciting. I[n] Paris I met Mme Pompidou—wif[e] of the French Prime Minister—[] who is terribly attractive an[d] bronzed and *sportive*. She aske[d] me to send her some ideas an[d] sketches and things. I met hi[m] briefly, and went to their countr[y] house just outside Paris. Thing[s] have gone marvellously well.

"Am I ambitious? Only so [] far as I'd like to see as man[y] people as possible wearing m[y] clothes." ∞

Radio Caroline, the pirate radio station, suggested I did a talk show. By strange coincidence, their offices were at 17 Curzon Street, London, where I had once been an apprentice to couturier Michael Sherard. By this time, the new London clubs were in full swing, particularly the Ad Lib off Leicester Square and the Garrison and Helen Cordet's Saddle Room in Park Lane. The 'Twist' was superseded by the 'Madison' and then the 'Bossa Nova'. It was in the Ad Lib that I met Rudolf Nureyev, for whom I would one day design a fur coat; Nureyev was very moody and very beautiful and very Russian.

By April 1964 we had moved into a new space in a Chelsea basement and started to travel to the main English towns, where we showed the clothes to buyers in their shops (even modelling them if necessary) but generally being told "not our type, dear". However, a visit to Stockholm produced a good order from the Nordstrom store, and back in London there was a visit from a buyer for Macy's, the New York mega store. Macy's made orders on every piece of the collection and asked if they could organise a Caroline Charles appearance in store in the autumn!

CAROLINE CHARLES, 22, was trained at Swindon a r t school. Worked for couturier Michael Sherard, then as salesgirl for Mary Quant. Then as a secretary who couldn't type to a fashion photographer. Hit the London fashion scene in May, 1963. Recently returned after a ten-day visit to America, where she sold her entire autumn collection to the big New York store, Macy's. Sells in Bermuda, too. About American fashion, she comments "Their college campus look is much too cute for today's girls."

"CAVALIER." Black and white jacket and skirt. Selling here for 16 gns. Price in dollars not yet known.

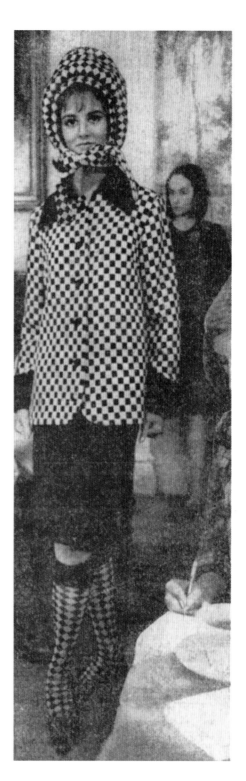

ABOVE:
C.C.'s favourite jacket, *Daily Mirror*, October 1964

LEFT:
C.C. head shot and sketch, *Daily Mirror*, October 1964

OPPOSITE PAGE:
Headshot of C.C. interview by John Gale, 25 October 1964, *The Observer*

My first trip to America was in the autumn of 1964 at the invitation of Macy's. I had grown up with stories of America because my aunt had been married to a Madison Avenue advertising man. So I had preconceived notions about '50s Americana. It was of course bigger, bolder, more exciting, more yellow cabs, more everything… I had a suite at the Plaza Hotel and just the closet was enormous – larger than the whole of my London flat! Eugenia Sheppard, the *New York Times* fashion editor, came to interview me. I had a swift tidy up and thought I'd done a good job. This *grande dame* of fashion publishing sat there and was charming and did a lovely piece on the 'visiting designer from swinging London'. It was only when she got up that I could see imprinted on the back of her skirt the outline of my suspender belt; the poor woman had been sitting on it without a murmur.

The Americans were quite intrigued by us, they couldn't believe we were so unpushy. They couldn't believe we said "gosh", "golly" and "super". They couldn't believe that we would be so obliging and not go "hello I'm the greatest". They thought we were 'kooky'. They still had hair-dos with flick-ups, while by this time we were sporting Vidal Sassoon sassy short hair cuts. They were much more 'done' than us and we felt very modern and free in comparison. There was a big breakfast show at Macy's in an auditorium with a large top table for the directors, the leading fashion journalists and me, and a huge audience. All the window displays were Caroline Charles, and the whole way through the store they were playing British pop music. British pop music and fashion were wedded and sold brilliantly for the next three years.

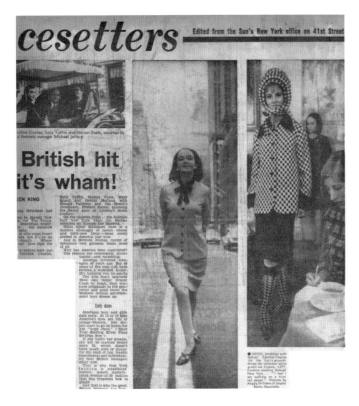

This was one of many articles written about British designers going to U.S.A., photo of C.C. and model on Park Avenue, New York, 1965, *Pacesetters*

ABOVE:

C.C. and American fashion designer Norman Norrell in New York, 1965

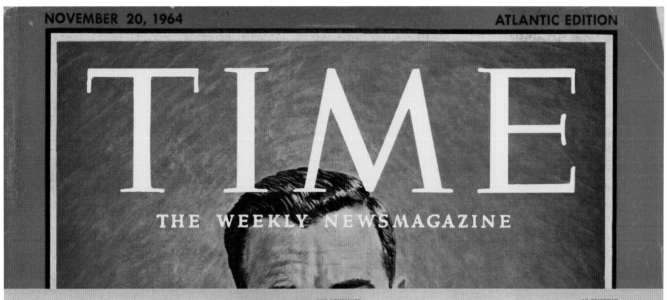

TIME
THE WEEKLY NEWSMAGAZINE

MODERN LIVING

CUSTOMS

The Godot Game

It figures in no labor statistics, is the object of no time-motion studies, the subject of no sociological thesis. Nonetheless, taken in bulk, it probably consumes more hours out of more days —and is far more essential to survival— than any national pursuit but television. The name of the game: waiting.

Sometimes the result is worth the tedium (the birth of a baby), sometimes not (the refusal of a loan). Either way, there is no alternative method for meeting a plane or departing on one, getting a tooth removed, a passport renewed, or voting. Like any routine, waiting takes its own time, has its own special locales, makes its own etiquette. The furniture, accordingly may be much the same, but the fellow who reclines expansively in a comfortable armchair while awaiting an expense-account lunch guest is apt to assume a straighter posture in an identical chair when protesting outrageous alimony demands. Waiting for the P.T.A. meeting to begin, he sprawls. Waiting for the loan officer to finish a phone call, he assumes the

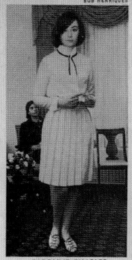

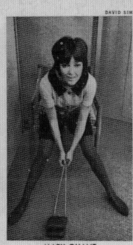
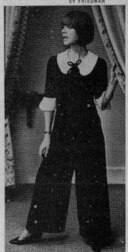

CAROLINE CHARLES MARY QUANT JEAN MUIR

Nostalgia, roses and trailing black velvet.

of being caught engrossed in the *Reader's Digest* and branded a condensed personality, bring along a newspaper instead). Opticians invest in anything, so long as the print is good and dark; while pediatricians can get away with paper towels, stapled together, since anything not bound in cast iron will be in shreds before lunch time.

Left to themselves, they relapsed into the national uniform of high-necked blouses, sensible shoes, tweeds, frowned on those who, like Lady Godiva, did not. There were local designers, but they tended to turn out clothes for the Queen, or for anyone interested in dressing like her. All this has been changed by something called "The Chelsea Revo-

We had great PR coming from New York and *Time* magazine printed: 'Caroline Charles most precisely defines the Chelsea look.' (*Time* magazine, 20, Nov. 1964)

ABOVE:

C.C., Mary Quant and Jean Muir, photographed for *Time* magazine, 20 November 1964

RIGHT:

C.C. and assistant in front of a promotional poster, 1965

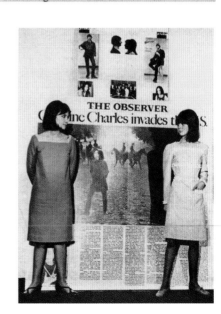

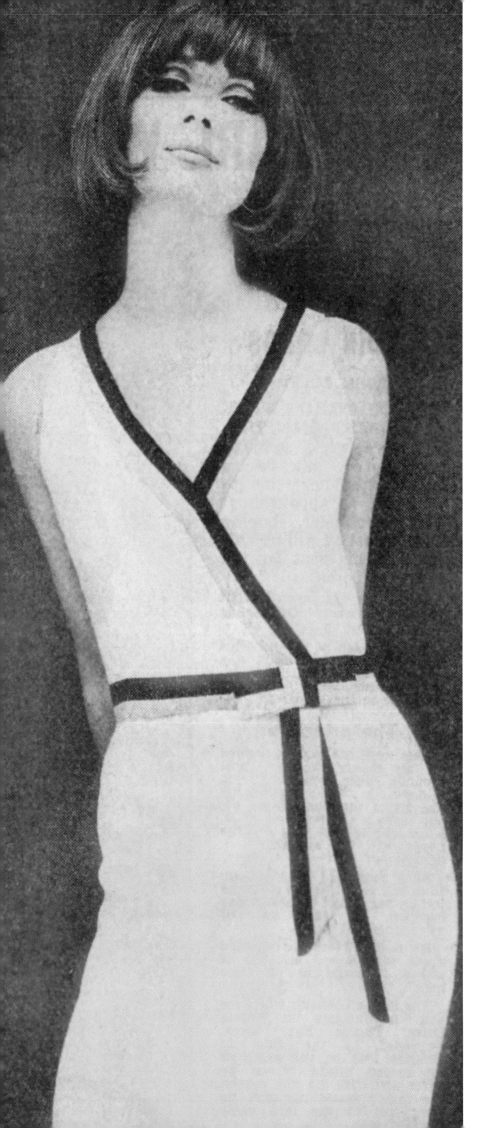

On another visit to New York I stayed at the Algonquin Hotel, famous for Dorothy Parker's round table dinners, now no longer. I met Wilfrid Brambell in the elevator – Steptoe on TV. He asked me for my toothpaste. It might have amused Dorothy Parker, who I love to read.

We had been commissioned to design under our own name for JC Penney. They were the largest mail-order company in the U.S. at the time and they put us on their front cover.

On a Sunday morning in Claridges, and not in Church, I received a £2000 cheque from a man for Puritan Inc as a possible advance from a signing for the US.

We had been a guest London designer for Macy's, the largest U.S. store and we had signed up and licensed to Jonathan Logan, the largest dress manufacturer. This is how the U.S. welcomed us in the early '60s and it was hard to believe.

Nicole models crepe wrap dress, 1965

C.C. at a party in New York, July 1965

Jill Kennington models wool and braid dress in
London, 1965

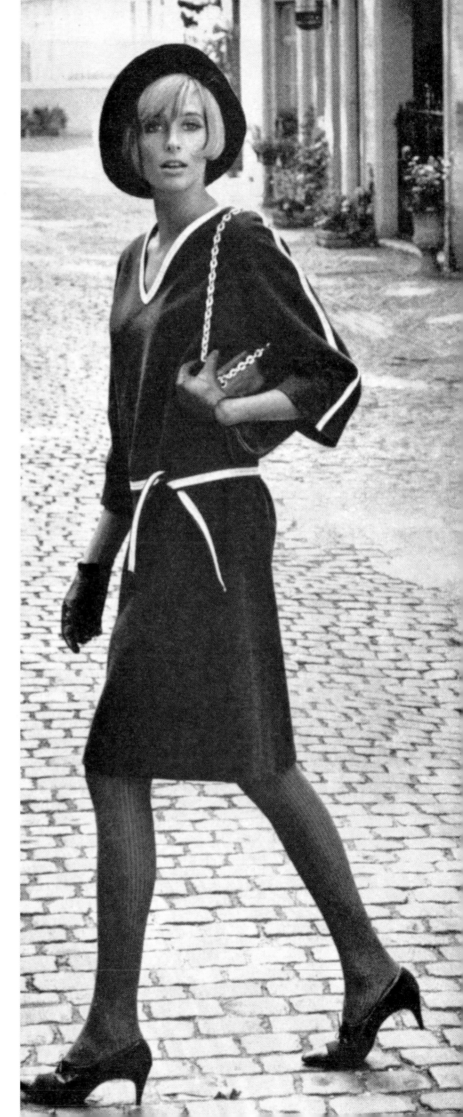

OPPOSITE PAGE:
C.C., Mick Jagger and Chrissie Shrimpton, Paris

BELOW:
Peter Finch, C.C. and Mick Jagger, London

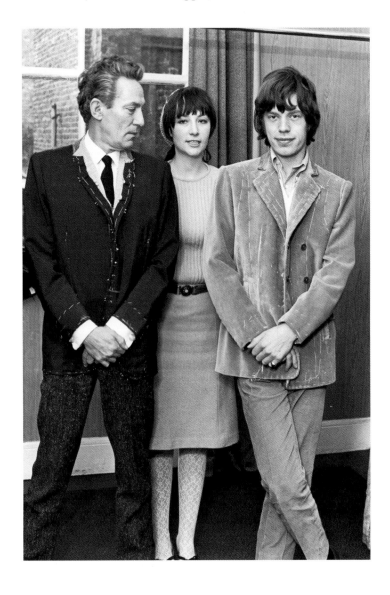

Back home, London was busy and buzzy and we moved into two floors of Maddox Street W1. This move was very important for us and generally a more serious workspace – Jean Shrimpton's sister, Chrissie joined us from school as our house model and general front person. She came to us through our really good PR assistant, Tricia Lock, who has now become a well-known film stylist. Chrissie's boyfriend Mick Jagger often collected her at 5.30. He wasn't that famous at this point, just a pop singer who was friendly and unpretentious with no affectations, from a nice family like Chrissie and Jean. He was – and is – very slim, with this brilliant face. I asked "Should I do you a suit?" and he said, "Oh yeah, go on." We got it made by a local tailor in corduroy, and it gave him a sort of arty look. You couldn't get suits like that in the '60s – this was before *Take 6*.

The work just kept coming: we made a suit for Peter Finch, who was gorgeous with a wonderful Edwardian curved chest which tapered in to the waist – I remember him being very naughty and always delighted to be offered a drink

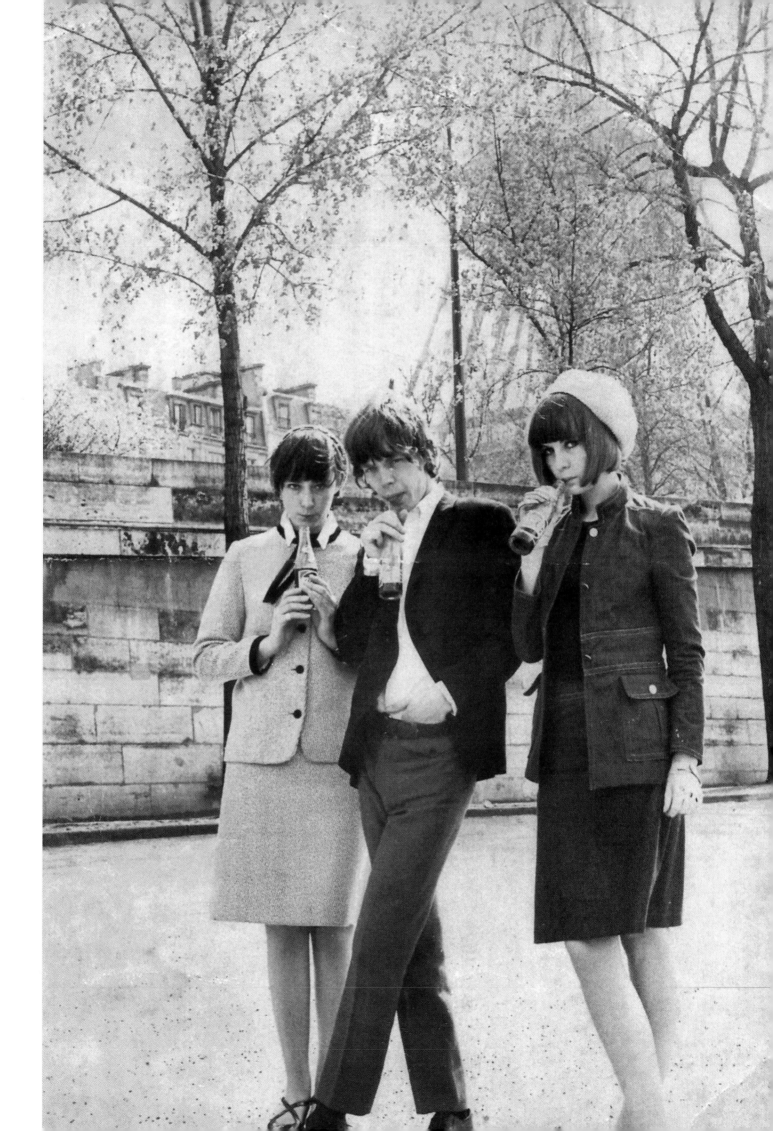

Cilla Black
Ready steady go!
T V.

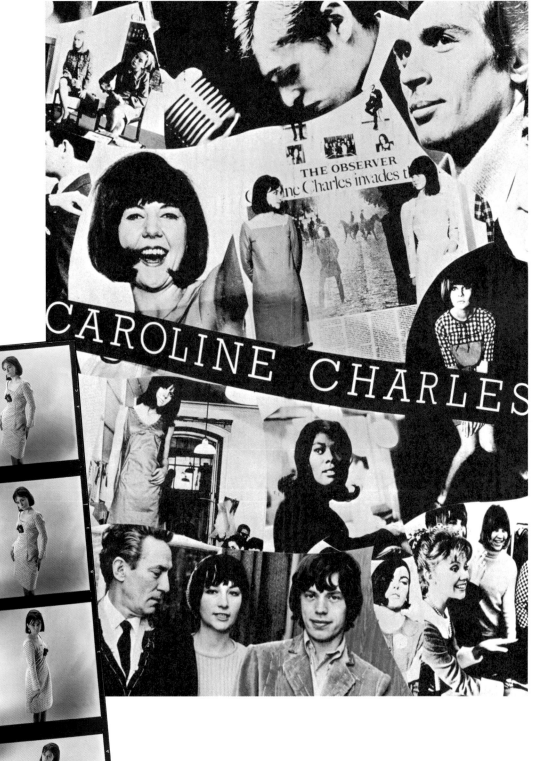

THE OBSERVER
Caroline Charles invades t

CAROLINE CHARLES

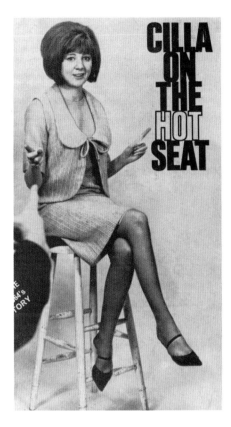

ABOVE:
Popstar Cilla Black models a Caroline
Charles dress and jacket

Top right:
Cilla Black wearing a Caroline Charles
dress on *Ready, Steady, Go!*

OPPOSITE PAGE, CLOCKWISE FROM TOP LEFT:
Caroline Charles dress; Caroline
Charles promotional postcard for the
USA, 1964; Contact sheet of C.C.
wearing the same design as seen on
Cilla Black on *Ready Steady Go!*,
1964; Caroline Charles studio sketch
of the same dress, 1964

The cross-over between celebrities and fashion
worked well. The trick is, as in any era, to put
together all the bits you want, like the new dresses
with the new star; both benefit from the association.
The pop star makes it on to the fashion pages as
well as the pop pages, while the designer breaks
into the pop world, and her clothes are seen by a
wider audience. So it was only natural that Cilla, who
was new at the time, became a customer. She was
exactly as she seemed on TV – cheerful, easy-
going, chirpy, wonderful legs, wonderful slim body.
She wore Caroline Charles on all the pop shows
singing 'Anyone who had a heart'. We made her
dresses in cotton lace and soft wool and silk crepe.
All good quality fabrics not associated with
showbusiness at the time and designed to appear
innocent but appealing.

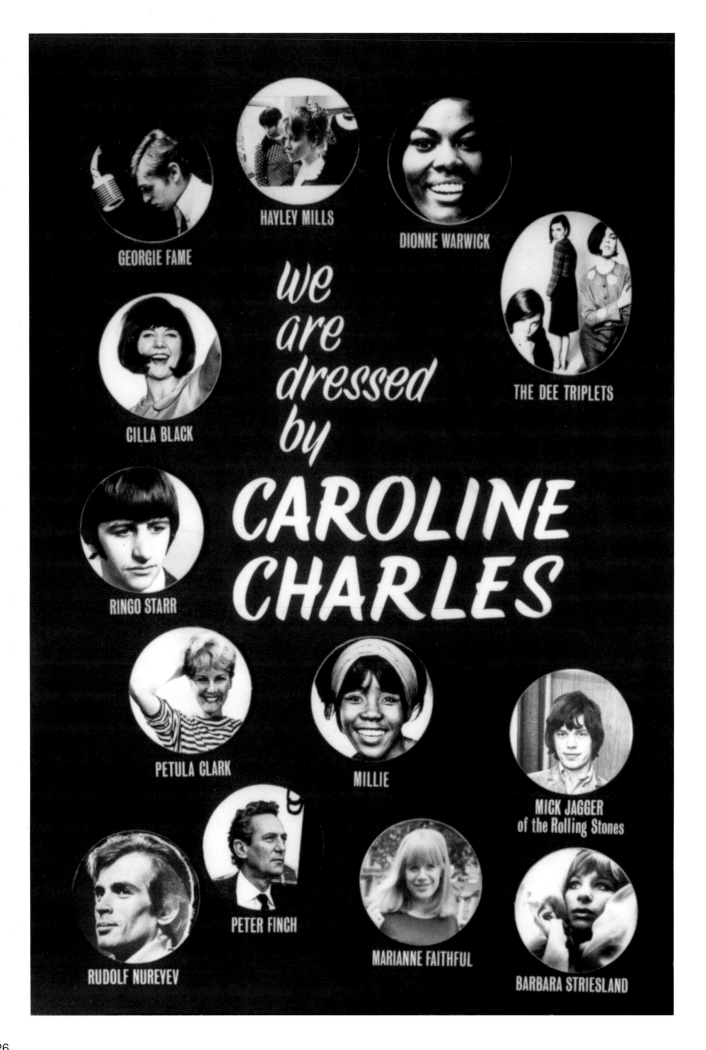

GEORGIE FAME

HAYLEY MILLS

DIONNE WARWICK

we are dressed by

THE DEE TRIPLETS

CILLA BLACK

CAROLINE CHARLES

RINGO STARR

PETULA CLARK

MILLIE

MICK JAGGER
of the Rolling Stones

RUDOLF NUREYEV

PETER FINCH

MARIANNE FAITHFUL

BARBARA STRIESLAND

OPPOSITE PAGE:
Caroline Charles promotional postcard, USA, 1960s

RIGHT:
Popstar Millie with C.C. for a dress fitting

BELOW LEFT:
Actress Jane Asher in pinstripe jacket

BELOW MIDDLE:
Actress Hayley Mills

BELOW RIGHT:
Singer Marianne Faithfull, Nov 1964

My clothes seemed to suit the new generation of rising stars. Marianne Faithfull, for one, had lots of the new collection. Marianne was really pretty and had a very sweet voice. I went on her first local English tour, briefly, to somewhere like Norwich, to hold her hand. Millie and Lulu were the latest pop singers and we dressed them in short A-line shift dresses; both Hayley Mills and Jane Asher, still young actresses at the time, had Caroline Charles clothes.

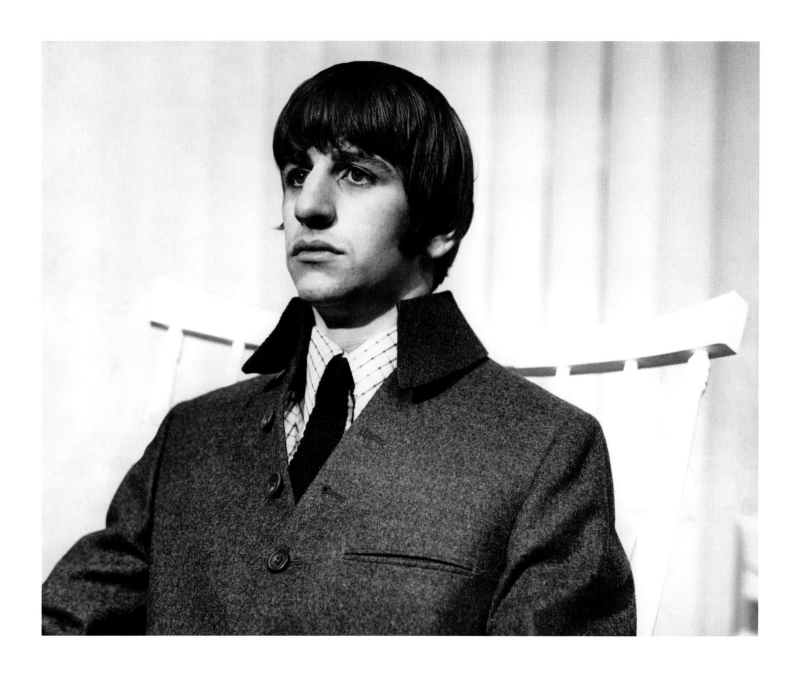

Ringo Starr wearing his Caroline Charles tailored
suit, London 1964

Ringo Starr had just announced his engagement to
Maureen Cox, so I was sent round to where he was
living in a flat on Cadogan Place (next to the Carlton
Towers Hotel), to find out if he'd like some suits. I
really wanted Ringo to look like a dandy, and he did:
using top-quality Saville Row men's fabrics and
tailoring techniques and changing the designs to a
Beau Brummell mood. He was extremely easy to
work with and Maureen was lovely. They seemed to
spend a lot of time watching television or drying their
hair with hand driers, which must have been new.
There wasn't any grandeur, at least in London, they
were just a normal couple.

It was great being backstage with the Beatles. I stood in the wings at Finsbury Park Astoria watching and listening to one of their concerts. The Fab Four all seemed to be having a good time and you could hear what they were really singing, as opposed to the screaming out front, which was ear-splitting and completely drowned out the songs. It was quieter with George Martin running a recording session in Abbey Road when I visited.

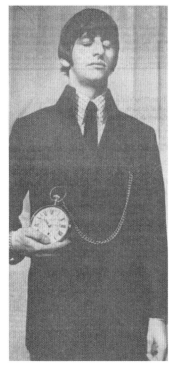

ABOVE:
C.C.'s sketch for Ringo's suit

MIDDLE, RIGHT & FAR RIGHT:
Ringo, London 1964

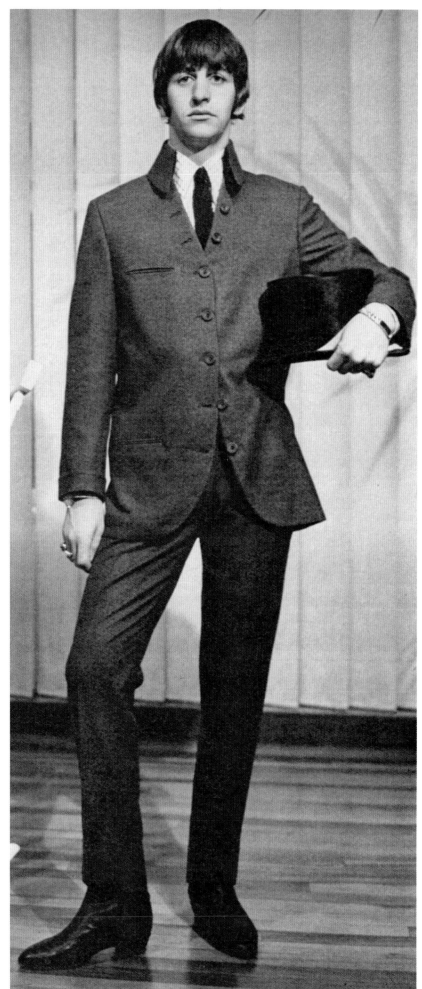

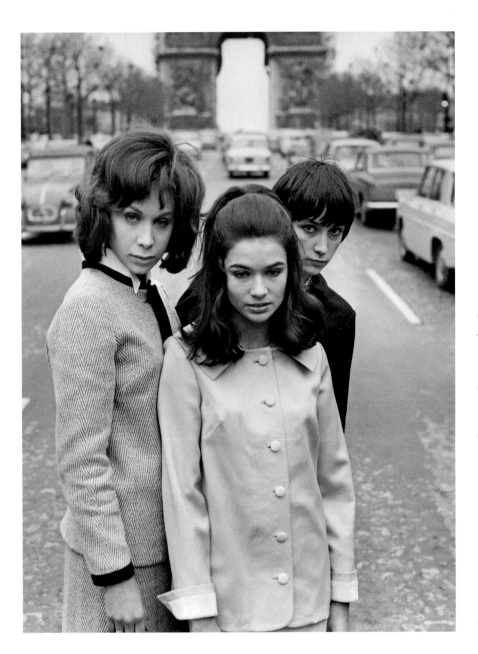

Actresses Tania Lopert and Christine de la Roche with C.C.,
all wearing Caroline Charles, Paris 1964

PARIS
Sunday Times:
Ernestine Carter

film:
Vittorio de Sica
A New World

Now things started to get glamorous,
and we were off to Paris with clothes
for a film called *A New World* directed
by Vittorio De Sica, which they were
shooting on the Metro at night. *The
Sunday Times* sent a photographer
and there are pictures of us jumping,
laughing, running up the middle of the
Champs Elysées. The producer Cubby
Broccoli put us up in the Georges V
Hotel and I had lunch with the hot
French young designer Emmanuelle
Khanh; I couldn't believe it, she was
wearing a fur coat even though the
temperature was over 70˚c!

THE SUNDAY TIMES

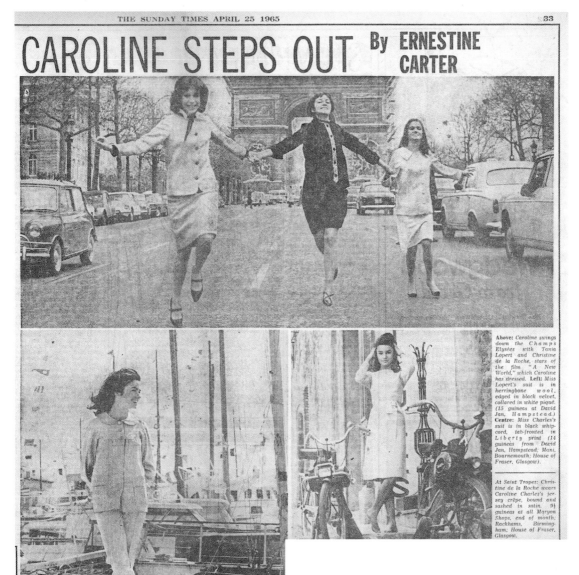

THE SUNDAY TIMES APRIL 25 1965 33

CAROLINE STEPS OUT By ERNESTINE CARTER

Above: *Caroline swings down the Champs Elysées with Tania Lopert and Christine de la Roche, stars of the film "A New World," which Caroline has dressed.* **Left:** *Miss Lopert's suit is in herringbone wool, edged in black velvet, collared in white piqué. (15 guineas at David Jan, Hampstead.)* **Centre:** *Miss Charles's suit is in black whipcord, tab-fronted in Liberty print (14 guineas from David Jan, Hampstead; Mani, Bournemouth; House of Fraser, Glasgow).*

At Saint Tropez: Christine de la Roche wears Caroline Charles's jersey crêpe, bound and sashed in satin. 9½ guineas at all Maryon Shops, end of month; Rackhams, Birmingham; House of Fraser, Glasgow.

Article in *The Sunday Times* illustrated with pictures of Tania Lopert, Christine de la Roche and C.C. taken on the film set of *A New World*, produced by Cubby Broccoli, Paris and Saint Tropez, 1964

RIGHT:
Press shot of C.C. used in a Beverly Nichols' *My World* article in *Woman's Own* magazine, London, 1964

LEFT:
SEATED, FROM LEFT TO RIGHT: 'Young London designers', Gerald McCann, Angela Cash, C.C., Tony Armstrong;
STANDING AT BACK: Mary Quant, 1965, *Seventeen* magazine

OPPOSITE RIGHT:
'The people who make London swing', article in London 1965, *Weekend Telegraph*

Number 30 April 16 1965

WEEKEND TELEGRAPH

LONDON: THE MOST EXCITING CITY

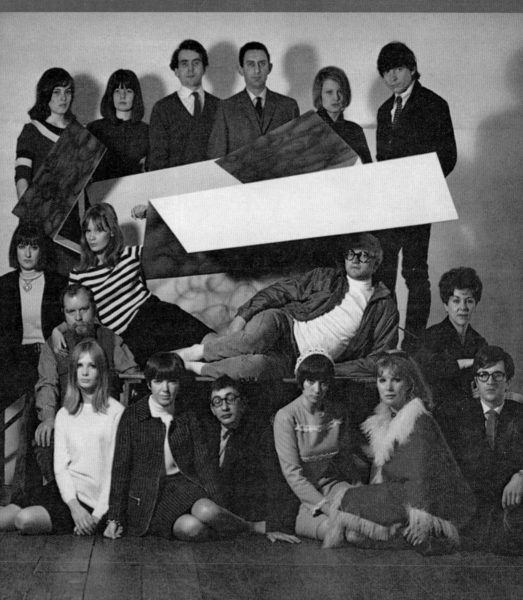

Some people who make London swing group around a modern piece of sculpture, 'Box' 1965 by David Hall at the Arts Council in St. James's Square. Top (l. to r.): Jan Blake–figure maker, Maureen Cleave–journalist, Gerald Scarfe–cartoonist, John Michael–men's wear designer, Barbara Hulanicki–dress designer–artist, David Bailey –photographer. Middle: Pauline Fordham–designer, Peter Blake–painter, Celia Hammond–model, David Hockney–painter, Rose Evansky–hair stylist. Bottom: Susan Murray–model, Mary Quant–dress designer, Kasmin–gallery owner, Caroline Charles–dress designer, Susan Hampshire–actress, Paul Clark–graphic designer

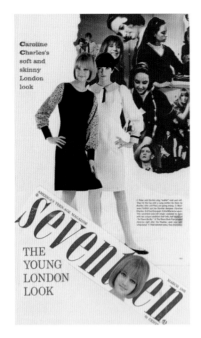

Seventeen magazine, 1965

C.C., *Daily Sketch* newspaper, 1964

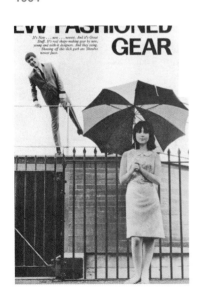

Pop magazine *Fabulous*, 1964

In August that year, I flew to New York to look at our showroom. Bob Dylan was seated close by and wrote in my sketchbook: 'May god bless you please. Bob Dylan'.

The trip was quite an event. NBC 6pm News showed 'Caroline Charles London designer to the Beatles' arriving. There were drinks at P.J Clarke's with the celebrity photographer Harry Benson who was a friend of our good promoter, Jeremy Banks. I met Richard Avedon at his studio and Jerry Schatzberg, pop photographer and film maker, gave a party for me after dinner at Elaine's. Jonathan Logan had several floors at 1407 Broadway, which looked like a whole town on its own – I didn't even know which elevators to take. They had made, sold and delivered our collection to department stores across the country, and now it was time to promote, promote, promote!

Andy Warhol fever was in full swing and we visited a wonderful roller-skate dance hall where the atmosphere was fantastic. Everyone was very dressed up, including boys in fabulous ballgowns – a memorable scene!

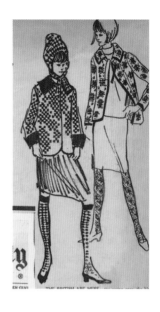

3 sketches of Caroline Charles clothes used by stores in the USA for advertising

TOP:
C.C. & models in USA advertising campaign

MIDDLE LEFT:
C.C in London, 1965

MIDDLE RIGHT:
C.C. shot by the *New York Herald Tribune*, USA, 1965

BELOW RIGHT:
Collage of C.C. and sketches, 1965

BELOW:
The note Bob Dylan hand wrote to C.C. on board a flight to New York.
Bob Dylan headshot © *Getty Images*

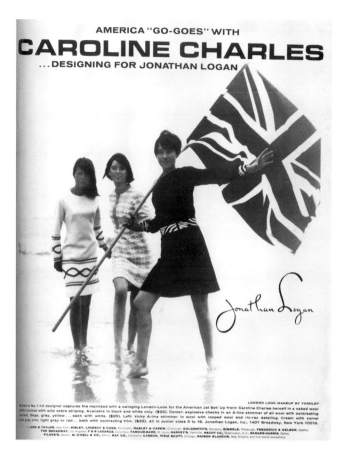

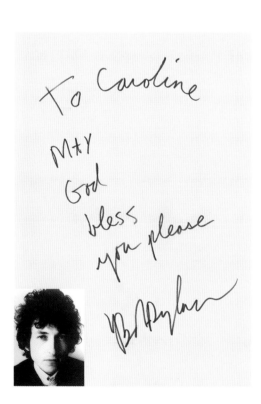

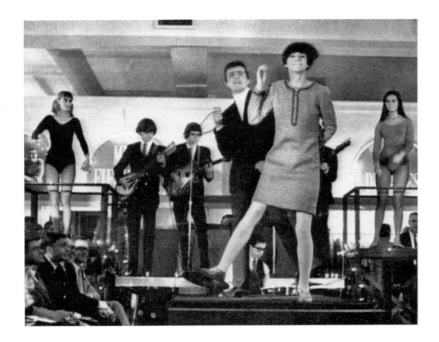

TOP: The USA fashion/pop tour, *New York Times* magazine, 10 September 1965

YOUTHQUAKE

So off we set for a pop/fashion whistlestop tour of 24 cities. I spent a lot of time in Dallas airport because it was the hub, (under a statue of a cowboy), waiting for the next plane and watching the people. I met lots of students and learnt a great deal about American Christian names through signing autographs. They loved the music and the clothes, which were by their standards short and unconventional – little shifts rather than the shirtwaisters they were used to, short hair rather than pony tails. "Lolita", the Nabokov character, the child seducer must have been a subliminal influence at the time. We looked to them like Mary Quant first looked to me – sharp, fun, free. They all had a little bit of money and we would sell quantities of clothes. I thought America was generous and fun and that just about everything was possible there. The stores were massive and the shows were exciting; there was a band, go-go dancers and a T-shaped catwalk. The models could dance and at the end the audience would get up on the catwalk and join the models, the band playing on, the go-go girls with fishnet tights in their cages and a man on a mike.

Washington – do two shows – packed audience of young girls who love the clothes, the band, the go-go girls on stage and the models who also dance – sign lots of autographs. Visit President Kennedy's grave.

Baltimore – chauffeur-driven Cadillac 40 miles to do a TV show – 1,000 people at the show, very good atmosphere, talked to kids and signed autographs. Did a second show, not so good!

New Orleans (via Dallas) – Had dinner at Brennan's restaurant. Real movie-type restaurant – terrace, fountains, palm trees, arcades and excellent food, all in the French quarter – Mississippi River very wide and slow with marvellous paddle steamers. Bourbon Street is full of fantastic Jazz clubs, night clubs, strip joints and galleries plus 1850s-type houses with balconies and hanging plants. The show is medium with no organisation. However get a good reaction.

Via Atlanta (to change for Nashville) – A very rough flight but great being met with dozens of girls and photographers – Country & Western singer Hank Williams Jr. gives me red roses and drives in an open white Hollywood-style Western car lined with white leather and silver dollars and a silver saddle in it – the car doors were silver pistols! Hank Williams sang 'Your Cheatin' Heart' – very famous. Nashville the big recording centre in U.S. – very good show, did C.B.S TV news interview, signed hundreds of autographs, and sold lots of clothes!

Via Dallas/ Memphis/ Denver – Outdoor show on terrace, huge crowd, great pop group "The Wild Ones", it was a good show, signed lots of autographs, sold lots of dresses… Car to airport to Chicago. Fab French hotel – Astor Towers, watched *Casablanca* on TV.

21/08/1965

Chicago continued – Usual store show then TV talk show, very dull except one guest is the actor Fess Parker who plays Davy Crockett on TV.

24/08/1965

Cleveland – 2 shows. Good crowd – driven to Aspen with Caroline Charles model. Poor show – no group – bad records – signed autographs.

25/08/1965

Boston – Ritz Carlton, super hotel – roses sent to room – no shows. Talked to College Board, kids, clients – many dresses sold out, "who's for croquet" an especially good white dress!

26/08/1965

New York – Interview with *New York Sunday Times*. Great show at the Arnold Constable Store – Trudie Heller's band and two girl dancers in fishnet tights…
12:30 Elaine's club **2:30am** Bed! (Elaine's was an Annabel's-type posh nightclub.)

27/08/1965

Louisville – 2 shows.

28/08/1965

St. Louis – 2 shows.

30/08/1965

Dallas – **9:30am** Radio Show. Caroline Charles live shows at **11:30, 12:30, 1:30.** Marvellous lunch at Chateaubriand Restaurant. Took afternoon plane to Kansas – terrible storm and people thrown out of seats, very frightening, food thrown everywhere. Man saying his prayers! Landed back in Tulsa (makes me think of Gene Pitney's current hit song "24 Hours from Tulsa") – take taxi out to dinner in strip club – 1 fat girl, 1 thin girl, horrible food, horrible dancers, rough clientele. **11pm** Took plane again – terrible storm – drinks flew down my front and back – more terrified passengers, flew back to Tulsa at 1,000 feet under storm(?) Could see what movies were playing at local cinemas!
1:30am Braniff Airways out to Kansas City again, terrible storms, electric lightning, flew the whole way at 1,000 feet. Caroline Charles

model took the bus! **3:00am** Hotel positively Dickensian… Red roses sent

31/08/1965

Kansas City – **9:00am** Radio show
12:00 Caroline Charles show – fantastic over 1,000 kids, well organised, great group.
1:00pm Interview and pictures for a local newspaper – TV film interview for newsreel. Went shopping with model and saw *The Collector* starring Terry Stamp and Samantha Eggar. Very good. **6:00pm** News ran Caroline Charles interview. **7:00pm** Caroline Charles show in shopping centre – over 1000 kids. Dinner with "Blue Things" and store people.

01/09/1965

Chicago/Philadelphia – **6:45am** Plane.
1:00pm Show at Gimbels. So bad – no music – no atmosphere. Took plane to Columbus and had dinner at the home of company agent – great to be with a family. They had put a sign on their garage saying 'Welcome Caroline Charles'.

02/09/1965

Columbus – **8:30am** Newspaper interview. **11:30am** Caroline Charles show. Good pop group. **2:00pm** Radio show. **3:00pm** Caroline Charles show. Group sent away. Poor show. **7:55pm** Took plane to Chicago to Los Angeles – arrived 2:50am – bed 4:00am.
San Diego – Luxury American resort hotel. Huge, expensive – pool – tennis – beach. Old-fashioned dancing under palm trees and tropical shrubs – American and Chinese food, Mexican waiters, 14 miles from the border – saw 2 movies *Yum Yum Tree* with Jack Lemmon – grim, and *Shenandoah* with Jimmy Stuart – very good.

06/09/1965

Drove to **Los Angeles** – Pulled over by police for crossing white line and frisked! We show them photos of the Beatles which save the day, the policemen melt! Beverly Hills Hotel. **4:30pm** TV news interview. **5:00pm** Yardley's gave a tea for Caroline Charles.

07/09/1965

Get a Limousine Cadillac to a downtown store. NBC TV News interview. **3:30pm** Show

– good. Drove to Anaheim store.
7:30pm Show – good.

08/09/1965

4:30pm Pasadena show – Yardley award. Very pretty gold medal.
Ambassador Hotel. Press and TV, British Consul. I made a speech…
7:30pm Caroline Charles show at West Cavena – very good.

09/09/1965

3:30pm Show at Valley store. **5:30pm** Recorded TV show *Shindig,* 4 min slot. **7:30pm** show at Del Amo store – record crowd. British consul Mr Waters attended again.

10/09/1965

12:00 noon 'Night Life' interview. **3:30pm** Caroline Charles show. **7:00pm** Caroline Charles show. **9:00pm** Phil Hawley family dinner – very nice.

11/09/1965

10:00am San Diego – Taking models – pop group etc. **12:00 noon** Press lunch (made speech). **3:00pm** Caroline Charles show – medium good. Televised. **5:00pm** Plane to **Los Angeles.**

12/09/1965

5:00pm TV talk show on raft in Beverly Wilshire Hotel pool. *Night Life* with Les Crane, Oleg Cassini and other guests.

13/09/1965

New York – 1407 Broadway showrooms.

17/09/1965

London – England looked so green and beautiful. It had been wonderful to meet so many people and to have been part of this 'youth quake' involving pop, music and fashion.

Portrait of C.C. used in the USA

Meanwhile, the BBC Radio show *Teen Scene* had a weekly fashion slot for Caroline Charles and every week there were great opportunities to talk to stars visiting London, like the Everly Brothers. *Juke Box Jury* was a very popular Saturday night pop show hosted by David Jacobs and I was the first dress designer on the panel of four who chose the records of the week. I wore a dress that I designed especially for the occasion in white cotton lace; as a reaction to American designer Rudi Gernreich's famous 'topless' dress, mine was cut to the waist on both sides. The high neck and simple shape made it look fresh and innocent.

Image of C.C. that was featured in an Ernestine Carter article, August 1964, *Sunday Times*

RIGHT AND OPPOSITE PAGE: Caroline Charles lace dresses were extremely popular with the press and featured on many editorial pages including in *U.S. Vogue* and *Vanity Fair*

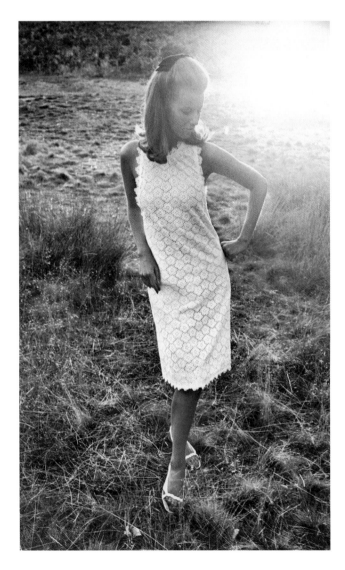

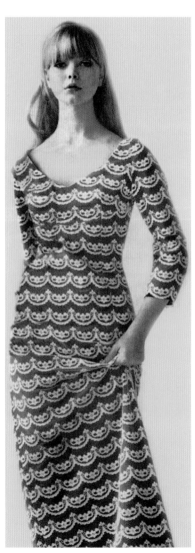

Fishnet
lace
thickly
covers
brown
taffeta,
adds
an
outsize
rose.
The
shape
is
slim,
Empire,
sleeveless.
The
neck
is
a
wide
horseshoe.
By
Caroline
Charles,
7 gns.

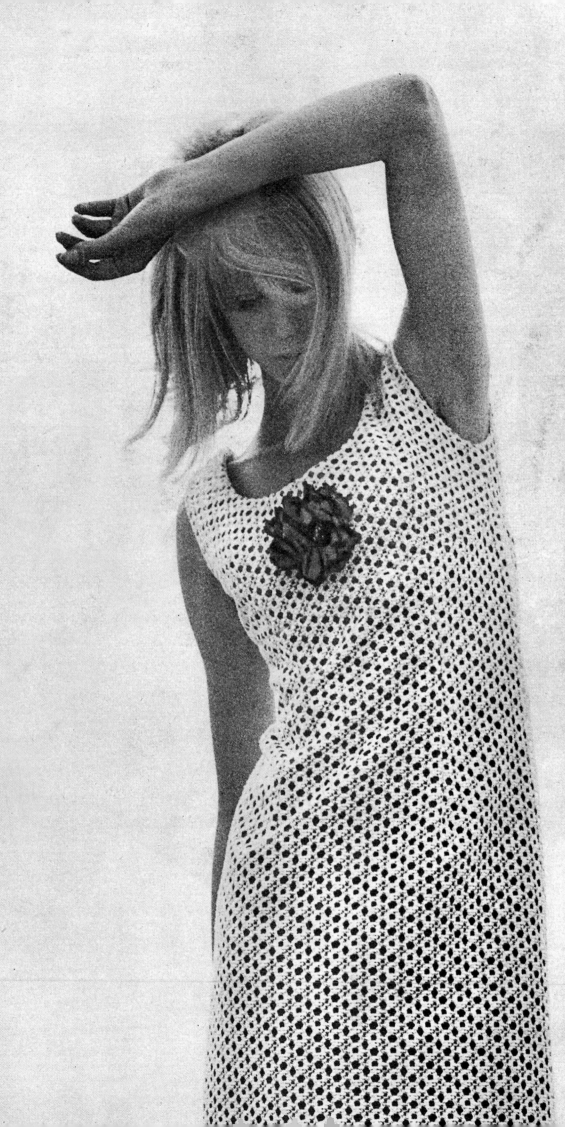

C.C among USA models including Peggy Moffitt in a photo shoot for Vidal Sassoon's book, *Sorry I kept you waiting, Madam*

·····••❀❀ Just in from England! ❀❀••·····

THE LONDON LOOK
YARDLEY OF LONDON, INC.

Yardley ran a successful advertisement campaign for make-up aimed at the new youth market, featuring Jean Shrimpton in a Caroline Charles dress

OPPOSITE PAGE:
C.C. photographed in her new showroom, 1964 © *Rex features*

Jean Shrimpton was doing a shoot with David Bailey for Yardley and we designed a cotton lace *My Fair Lady* style dress for the photograph. White cotton lace was a favourite fabric at the time in our collection, slightly like a bedcover but affordable and I put a colour like chocolate brown underneath as a lining to make it more chic. Barbra Streisand, who was starring in *Funny Girl* at the Prince of Wales Theatre, sent for some dresses which were to be delivered to the stage door…

Back to the U.S. and Sybil Burton (Richard Burton's ex) had opened a new club called 'Arthur' on 54th Street and it was much more our style than the New York famous 'Shepherds' and 'le Club'. Our dancing was different to theirs: the twist was new and seemed very sexy to the Americans. Vidal Sassoon had a great space on Madison Avenue and I was one of the people on the cover of his book, *Sorry I kept you waiting, Madam.*

We travelled back via Bermuda and did a store show at Triminghams, with whom Liberty's had a tie-up so we used Liberty fabric. The finely woven cotton lawn, printed with small flowers fitted the childlike Lolita mood. The split sleeves were a more adult look, but small flat Peter Pan collars prevailed on simple A-line dresses. Shorty Trimingham met us at the airport, he was wearing Bermuda shorts and was very welcoming. It was a really charming outpost of old England, like stepping back into the properness of the 1940s or '50s. My life-long habit of choosing good-quality fabrics and making easy-to-wear shapes with interesting details was beginning to establish a look that has lasted well.

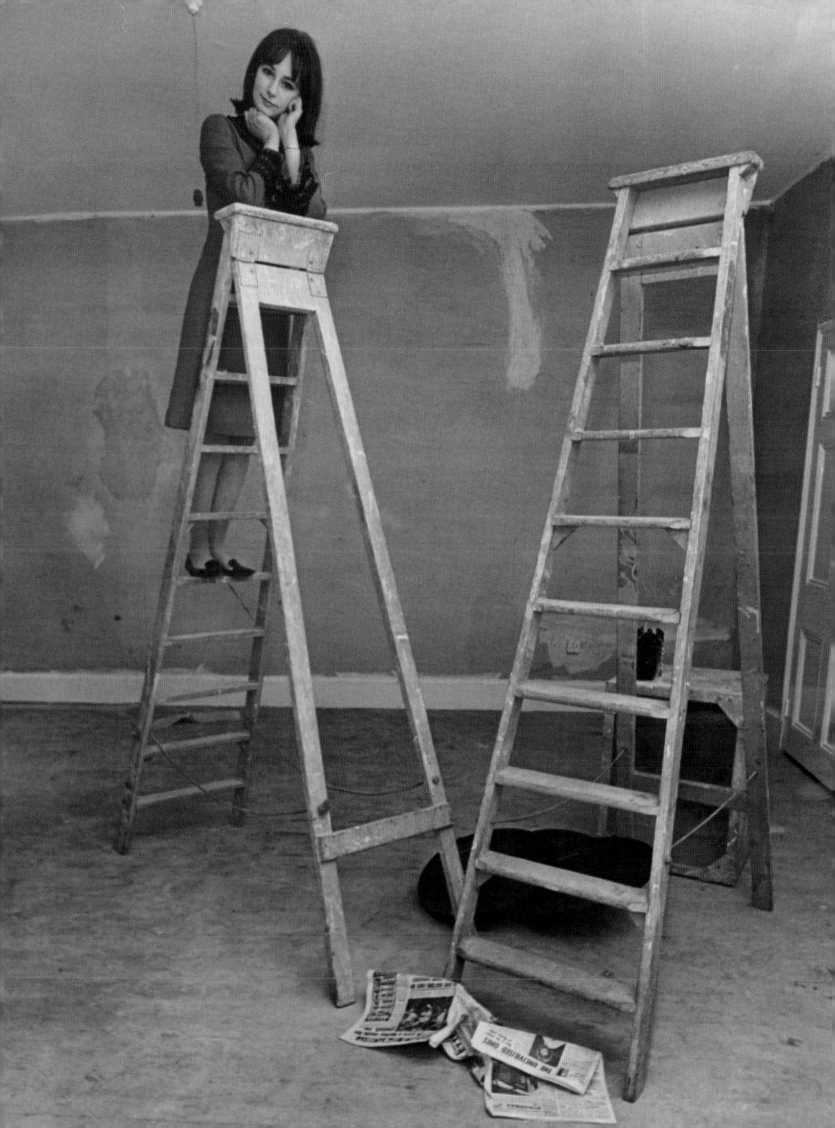

Despite the excitement of touring the US, signing autographs and doing TV shows, I found it very difficult to design clothes in America because I felt that they already had everything there was to have. It was very hard to find your own space, unlike in London. It's like a performer marking their bit of stage. I felt that America was fantastically good for business and for press and for the exuberance of itself, but I didn't ever feel I could sit and draw and turn these drawings into 'my take', because 'my take' was and is very London.

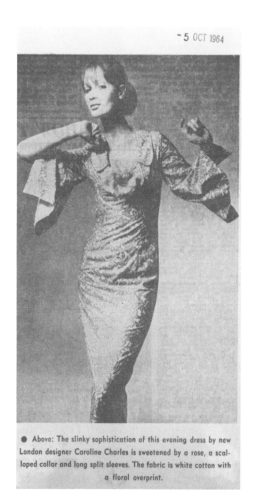

- 5 OCT 1964

● Above: The slinky sophistication of this evening dress by new London designer Caroline Charles is sweetened by a rose, a scalloped collar and long split sleeves. The fabric is white cotton with a floral overprint.

Celia Hammond in cotton print dress with open sleeves, 1964

OPPOSITE PAGE:
Celia Hammond models a floral top and soft jacket, 1965, *Tatler*

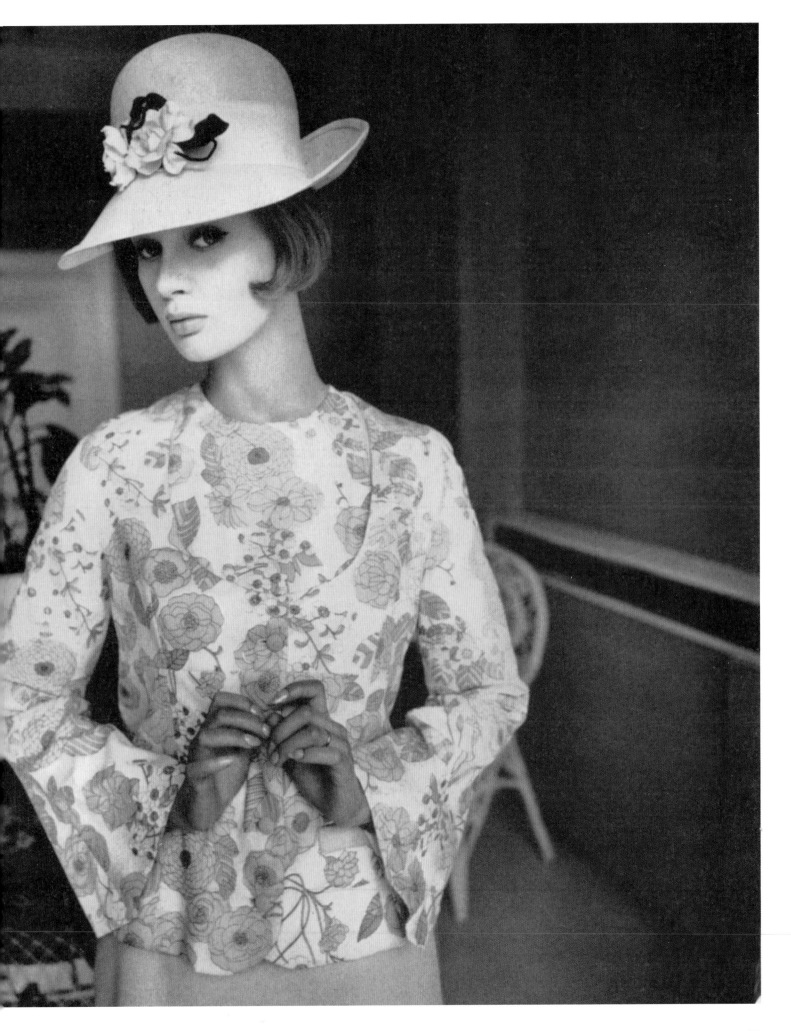

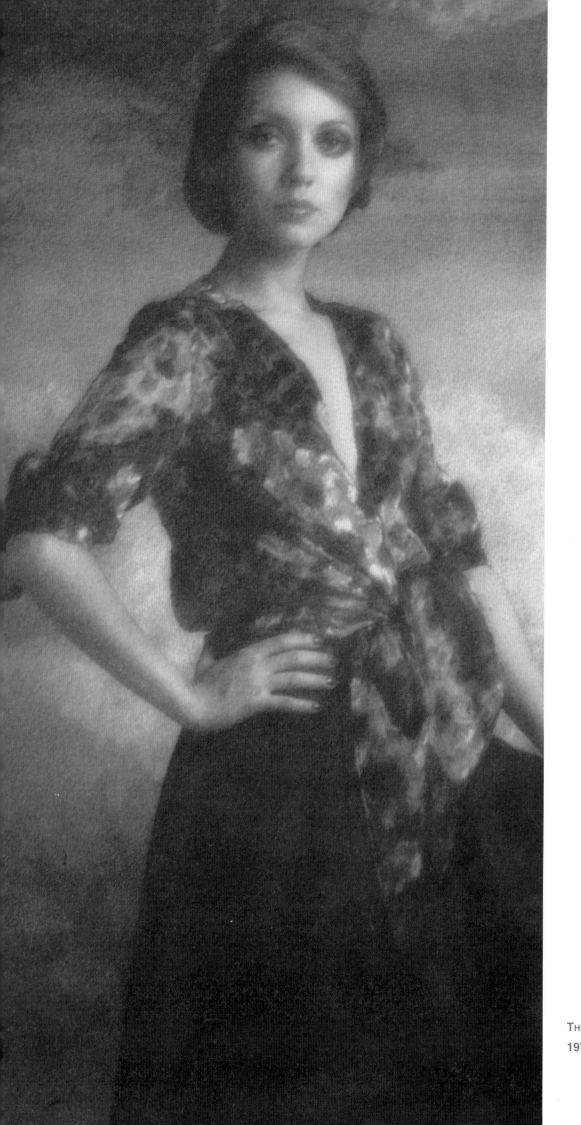

THIS PAGE AND OPPOSITE:
1975, *Woman's Journal*

1970s

Caroline Charles print long linen dress

OPPOSITE:
Caroline Charles cut-velvet wrap blouse and silk satin jacket over a lace dress, 1974
Catwalking

BELOW:
Illustrations by Sue Gregory, Caroline Charles designs in marbled leather and silk

1970

Times had changed and we moved back to Chelsea from our Mayfair showrooms and set up on the first floor of a house in Beauchamp Place. I felt happier with a collection that was less mass market, but rather designed for a 'made-to-measure' and wholesale business. This was the real beginning of my love affair with fabrics and I followed any leads that would produce special pieces.

The collections we made then were small, and the mood in general had begun to swing away from kooky short shapes towards gentle and ethnic hippy styles. In her Soho shop, Thea Porter had introduced Lebanese wedding robes, which had proved very popular; and influential. Of course these depended on old textiles with intricate weaving and embroidery, which were not easy to find. Zika Ascher produced marvellous gothic prints on crinkle silk georgette that he called 'Giselle', and that for us pushed the fashion mood towards the pre-Raphaelite mystics. Victorian folklore, ethereal fantasies and fairy illustrations, such as the 'water babies', were popular. We began to sell dresses made from these fabrics, to Liberty's, which was the perfect place as it fitted brilliantly into their ethos. The whole thing merged into a very romantic look, very curvy with really big sleeves and high waists with lots of ribbons used as decorations, with coloured boots and coloured tights. Zandra Rhodes' fabrics appeared as kaftans. Ossie Clark did a 1940s take on it, gathering Celia Birtwell fabrics at the shoulder but making longer skirts. Each good designer has his or her 'moment', a point in time when their style matches perfectly the mood and fashion of the time: Ossie left a serious footprint, as did Jean Muir subsequently, and, briefly, Bill Gibb with the knitter Kaffe Fassett.

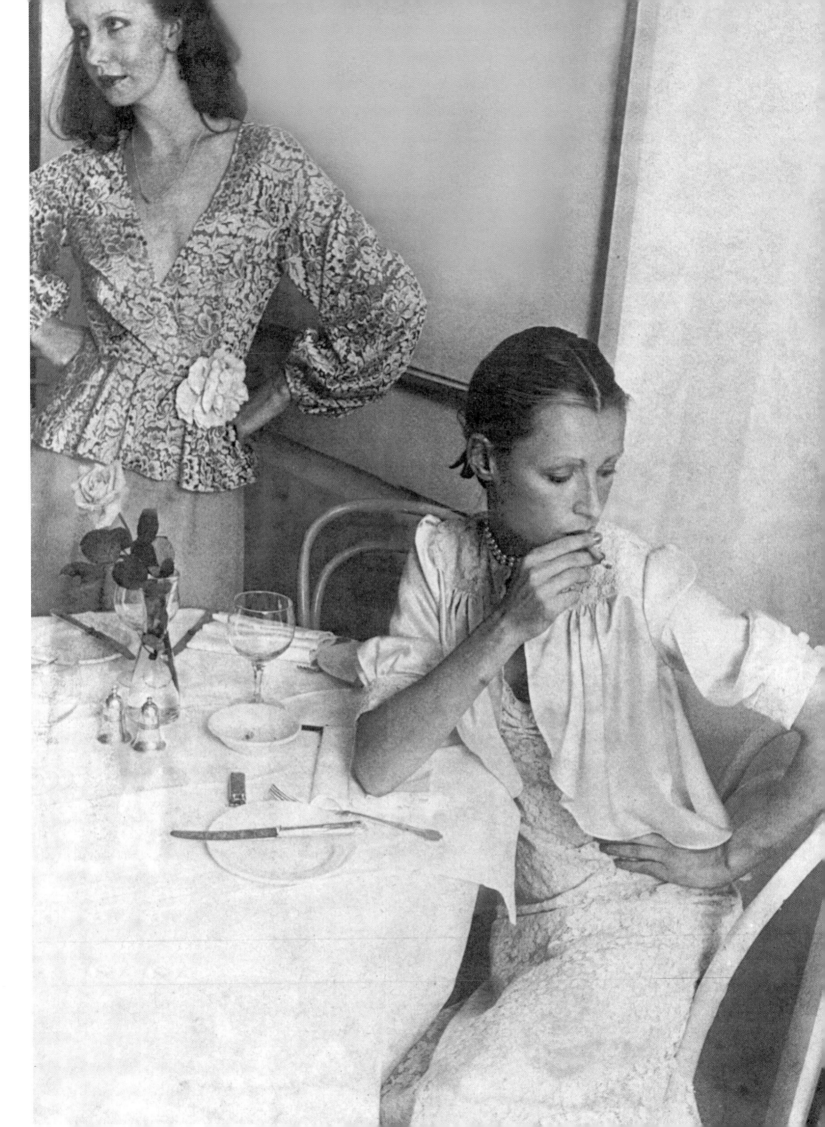

With the dawning of the seventies, 'peace and light' was the mood of the times: George Harrison going to India, Mick getting into a white dress for the concert in the park… Everything had changed from the exuberance of the '60s – when anything was possible and we were 'swinging London' – to this whole movement of 'We are going to change the world!' Hair got longer. There were a lot of biscuits made out of interesting things and sitting on the floor. All the clothes just drooped.

The 1960s London fashion scene had been a real roller coaster experience, but by the '70s things were a little calmer and we felt slightly more established. We moved into new spaces in Beauchamp Place, and squeezed a workroom and an accounts department onto the top floor, and a showroom and office on the first floor – we were above the Great American Disaster hamburger restaurant, so, a lot of the cooking smells wafted our way!

The collections were very New Romantic and the fabrics became more and more fabulous as European companies came visiting us with suitcases full of irresistible swatches. Gradually we did less and less made-to-measure clothing and concentrated on our collection for the wholesale market, which started to sell well in Harrods and Liberty's, and Fortnum & Mason as well as many special boutiques. The US buyers for Saks Fifth Avenue and Lord & Taylor still came from New York, and from Neiman Marcus, and I. Magnin from Dallas; and the orders flooded in.

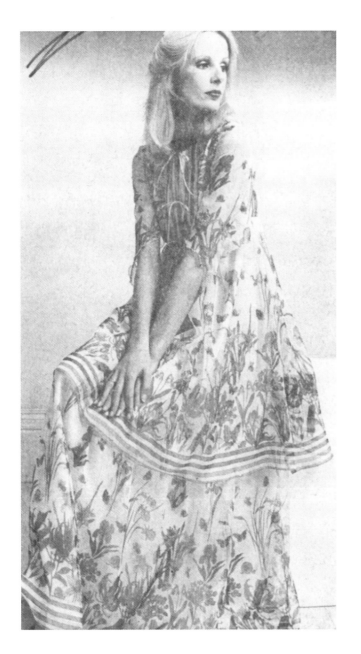

LEFT:
Evening dress in soft ivory chiffon, panels printed with flowers and butterflies, February 1974

OPPOSITE PAGE:
Caroline Charles for Ascher dresses made in silk crimp giselle, printed with gothic images
June 1971, *Woman's Journal*

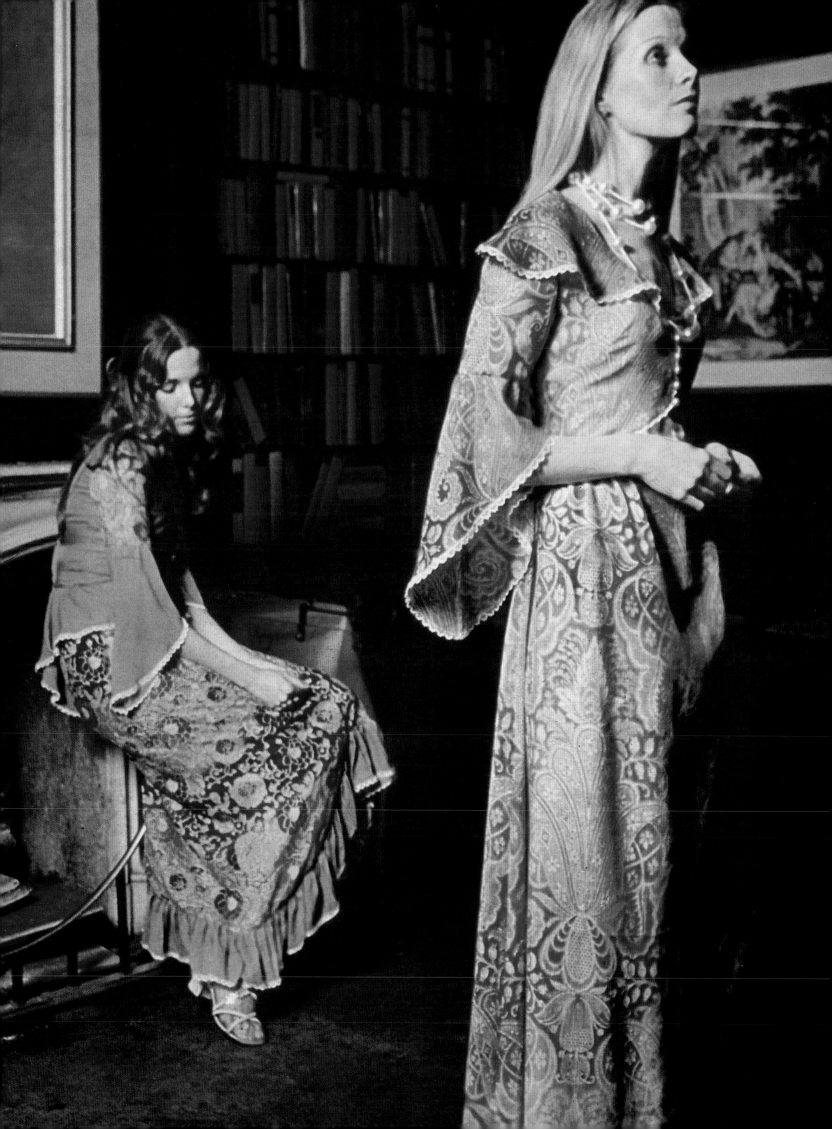

LEFT:
Sketch of Caroline Charles jacquard woven cardigan with
bound edges, worn with culottes, October 1970, *Country Life*

OPPOSITE PAGE:
Caroline Charles evening cardigans over soft long skirts,
October 1973, *Silano/Harpers & Queen*

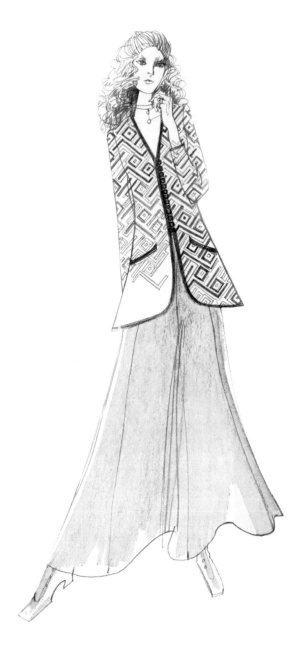

The design consultancy work also grew into fun furs
and maternity wear, plus leather and suede for a
public company called Barrow Hepburn. Our role was
to advise on colours and textures for clothing leathers
each season – they were a large group of tanneries
spread from Yorkshire to Calcutta to Nairobi, and
were really excellent people to work for – the Chief
Executive Dick Odey had a great talent for marketing
and fun. He encouraged us to visit the tanneries and
talk to the management and bring ideas that would
translate into sales to shoemakers and garment
makers – leather was very fashionable and we made
many samples, ranging from pale pearlised nappa to
pearl grey glove suede to marble prints, even to
tough but soft and supple motorbike jackets. The
marbling technique was new and we worked with
clever people in Kings Cross, who mixed lovely
colours together that looked like precious endpapers
in old books. The waistcoats and jackets looked good
worn with soft silk satin blouses and jeans.

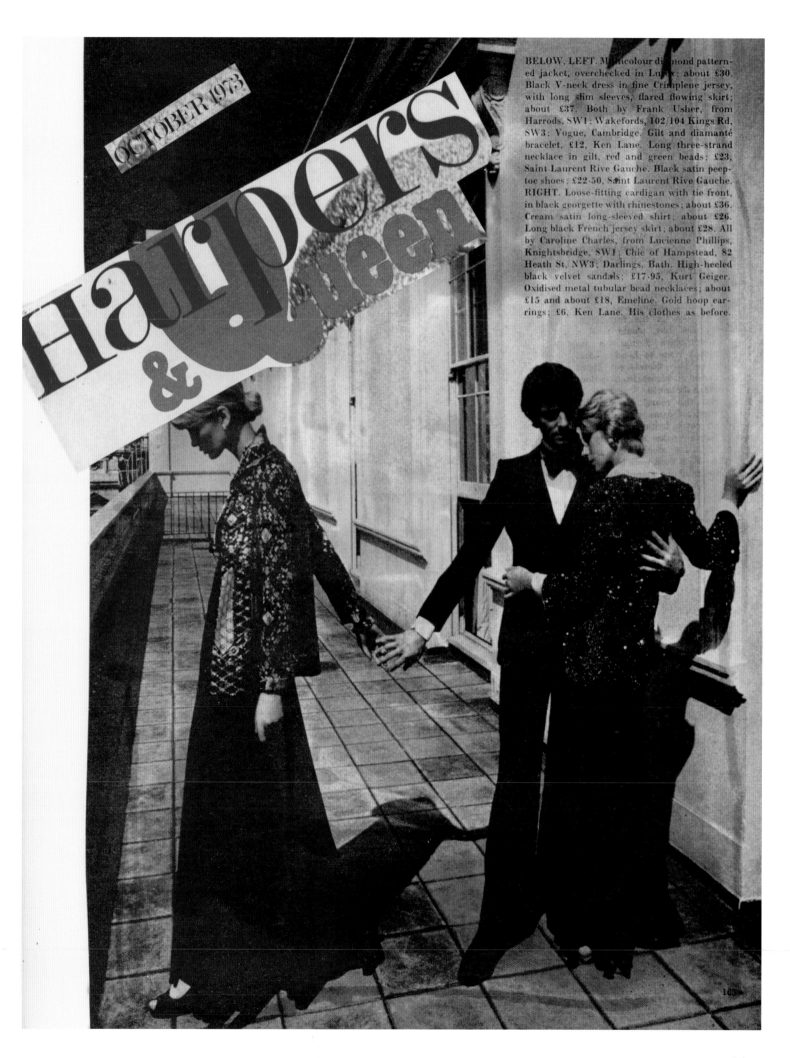

BELOW, LEFT. Multicolour diamond pattern-
ed jacket, overchecked in Lurex: about £30.
Black V-neck dress in fine Crimplene jersey,
with long slim sleeves, flared flowing skirt;
about £37. Both by Frank Usher, from
Harrods, SW1; Wakefords, 102/104 Kings Rd,
SW3; Vogue, Cambridge. Gilt and diamanté
bracelet, £12, Ken Lane. Long three-strand
necklace in gilt, red and green beads; £23,
Saint Laurent Rive Gauche. Black satin peep-
toe shoes; £22·50, Saint Laurent Rive Gauche.
RIGHT. Loose-fitting cardigan with tie front,
in black georgette with rhinestones; about £36.
Cream satin long-sleeved shirt; about £26.
Long black French jersey skirt; about £28. All
by Caroline Charles, from Lucienne Phillips,
Knightsbridge, SW1; Chic of Hampstead, 82
Heath St, NW3; Darlings, Bath. High-heeled
black velvet sandals; £17·95, Kurt Geiger.
Oxidised metal tubular bead necklaces; about
£15 and about £18, Emeline. Gold hoop ear-
rings; £6, Ken Lane. His clothes as before.

163

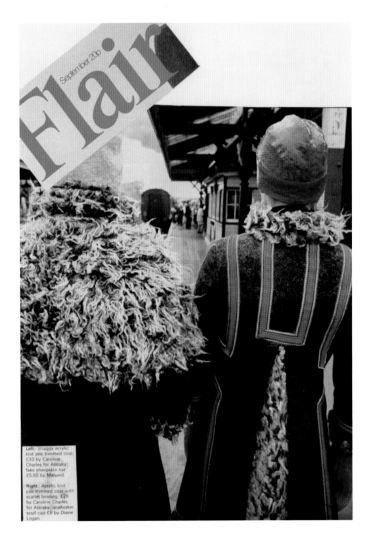

Left: Shaggy acrylic knit pile trimmed coat, £33 by Caroline Charles for Astraka; fake sheepskin hat £5.50 by Malyard.

Right: Acrylic knit pile trimmed coat with scarlet binding, £25 by Caroline Charles for Astraka; snakeskin scull cap £6 by Diane Logan.

TOP:
Caroline Charles award-winning faux fur designs for Astraka. Braided coats using the wrong side of the cloth. Advertisement, 1971, *Flair* magazine

CENTRE RIGHT:
Astraka promotional drawing, early '70s

CENTRE LEFT & BELOW:
Caroline Charles studio sketches for the Astraka faux fur designs, 1971

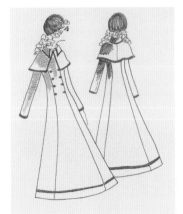

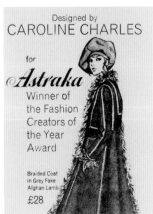

Designed by
CAROLINE CHARLES
for
Astraka
Winner of the Fashion Creators of the Year Award

Braided Coat in Grey Fake Afghan Lamb
£28

LICENSING

Small collections and particularly our rather special ones needed capital, and that, despite a generous bank manager, was difficult. So when a shoe company from Norwich called Norvic invited us to design children's shoes for them, and a fur fabric company called Astraka offered us a contract, we accepted. This way of working for many other companies became a good source of income and it was stimulating and interesting for a designer. Miss Selfridge was the hot young store of that year, and we designed a range for them for two seasons running under our label but made by them. Yardley, commissioned clothes for their US business promotions. Children's clothes were another part of our work and there was a particularly good fashion show on the *QE2*, sponsored by a man-made yarn producer. Another design project was for a jewellery company, which also included designing sunglass cases in jewelled fabrics. Then we designed a range of leather bags and belts for an export company, so generally life was busy!

Barrow Hepburn believed in showing at trade fairs in Paris and Bologna each year and would send a team of staff and consultants to join the marketing effort. These outings were very stimulating (and amusing), and led to many contacts with European businesses, not to mention many good dinners and parties. Hot pants – or winter shorts – were in fashion in London, and we wore them over thick tights and flat coloured boots, but in Florence the elderly Italian women disapproved and would hiss at us! European styles for the young were still very classic, where as London fashion was much taken with dressing up in a theatrical way, for day or night, in ruffle shirts, dandy coats, tight trousers or long skirts and big belts.

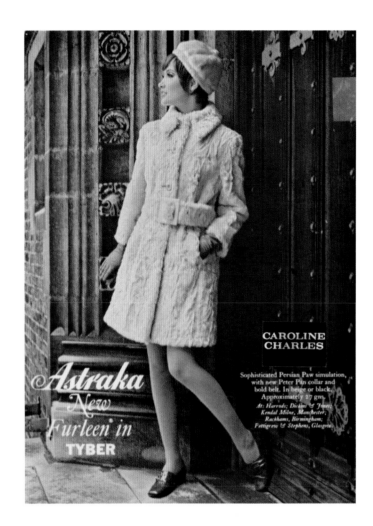

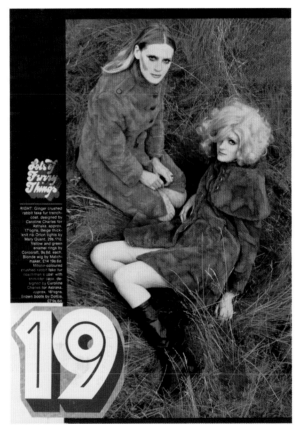

Caroline Charles faux fur for Astraka. The coats were made using a very soft fabric or a flat ponyskin with fox collar & cuffs – <u>all fake</u>, *19* magazine

THIS PAGE:
Adverts, Caroline Charles for Astraka, 1972

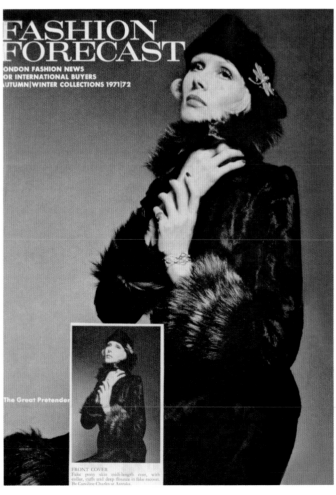

There was more wonderful travel when we visited tanneries in Calcutta and went down the Hooghly River in a boat belonging to the Chinese family who ran the tannery. In Mumbai (or Bombay as it was then) there were meetings with leaders in the leather industry and more hospitality from people who have become life-long friends.

India was an exciting source of new fabrics and embroideries and has remained a constant in our collections ever since. In the early days of importing from India there were many problems with quality and delivery dates and currency rates, but the struggle has always been worth the strain!

Corporate uniforms were becoming more design aware, and our next one was for the sales staff of Estée Lauder in Harrods. After this job I was summoned to Terence Conran's office at Habitat to discuss the uniform. Terence had his feet on the desk and enquired whether I'd like to sew a missing button on to his jacket! Deciding to pass on his invitation, we went on to suggest Chinese-red T-shirts, blue denim skirts and jeans teamed with Kickers boots and Mulberry belts, all of which were accepted and became the staff uniform for Habitat.

ABOVE:
Caroline Charles was licensed to design a children's clothing collection in man-made yarns that were comfortable and practical

BELOW, FROM LEFT TO RIGHT:
Staff uniforms for Habitat; Caroline Charles maternity wear included smocks in printed cottons; Caroline Charles maternity smock, 1971, *Mother & Baby*

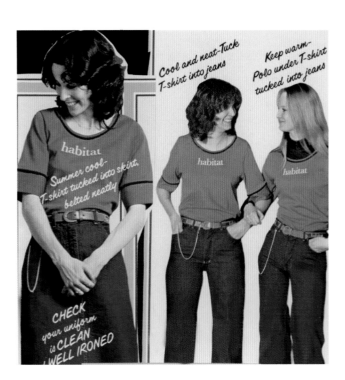

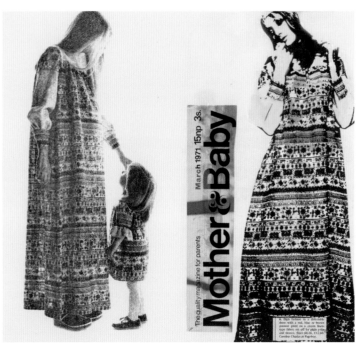

By contrast, that year we also designed speedway leathers for the world No 1 British driver. I stood in the centre of the race track ring and gave the prize to the winner, who was cheeky and fun. The combination of a highly lit arena at night time, the strong smell of bike fuel plus the roar of the crowd was intoxicating.

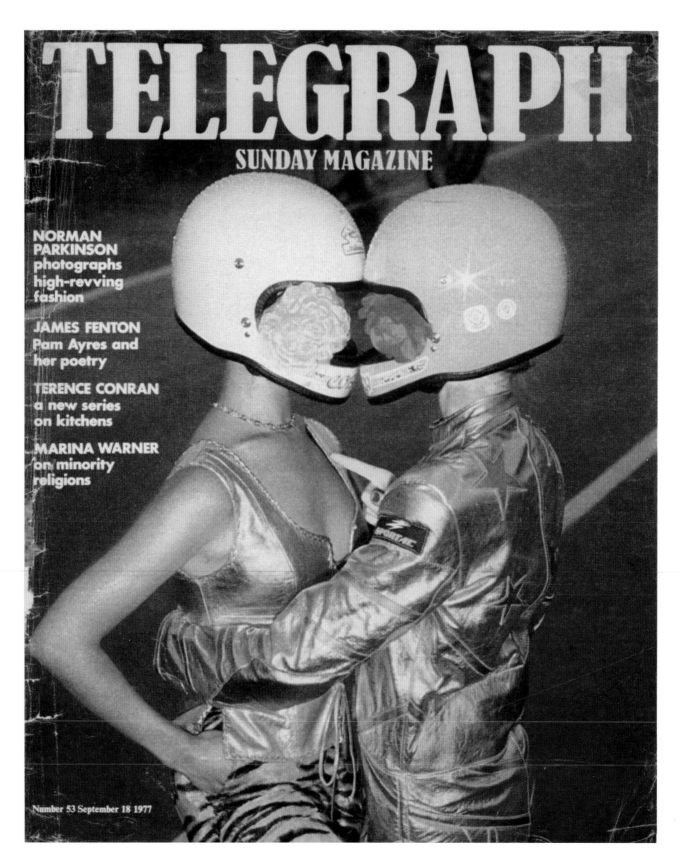

TELEGRAPH
SUNDAY MAGAZINE

NORMAN PARKINSON photographs high-revving fashion

JAMES FENTON Pam Ayres and her poetry

TERENCE CONRAN a new series on kitchens

MARINA WARNER on minority religions

Number 53 September 18 1977

55

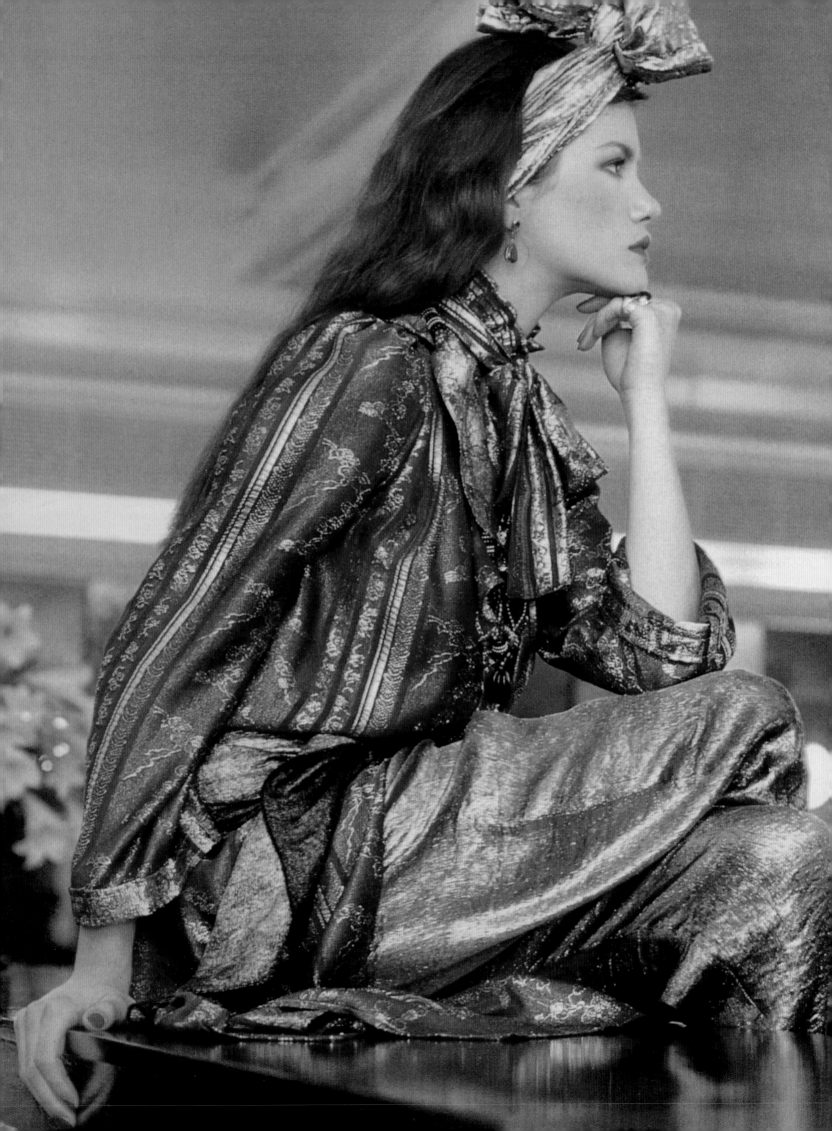

OPPOSITE PAGE:
Lightweight French woven silk and lurex blouse, worn
with gold lamé trousers, *Harpers & Queen*

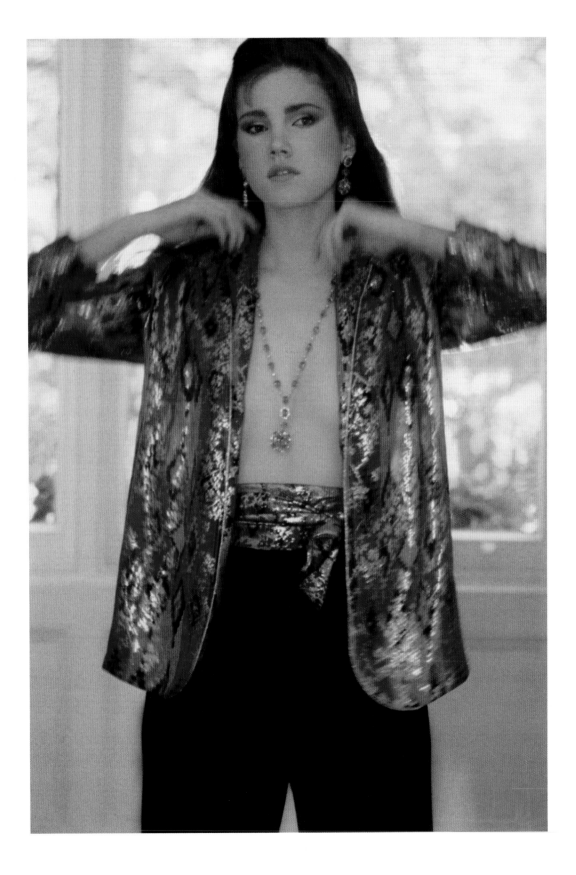

Dinner jacket in woven brocade and piped in gold, worn
with crepe trousers, late '70s

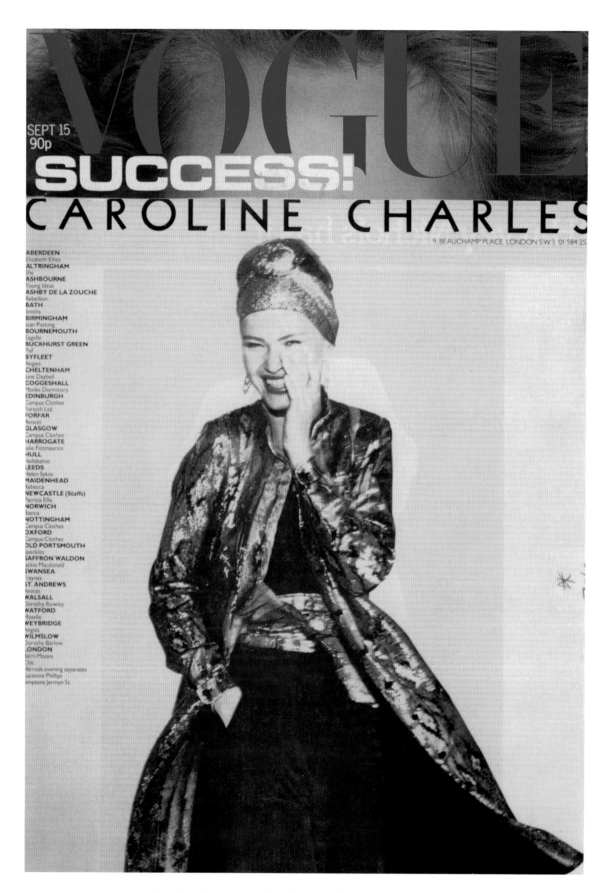

Caroline Charles Rahja silk brocade coat and cummerbund. The image ran as an advert in *Vogue*

OPPOSITE PAGE:
Caroline Charles stripe silk bodice and skirt. Also an advert in *Vogue*,
Robyn Beeche

58

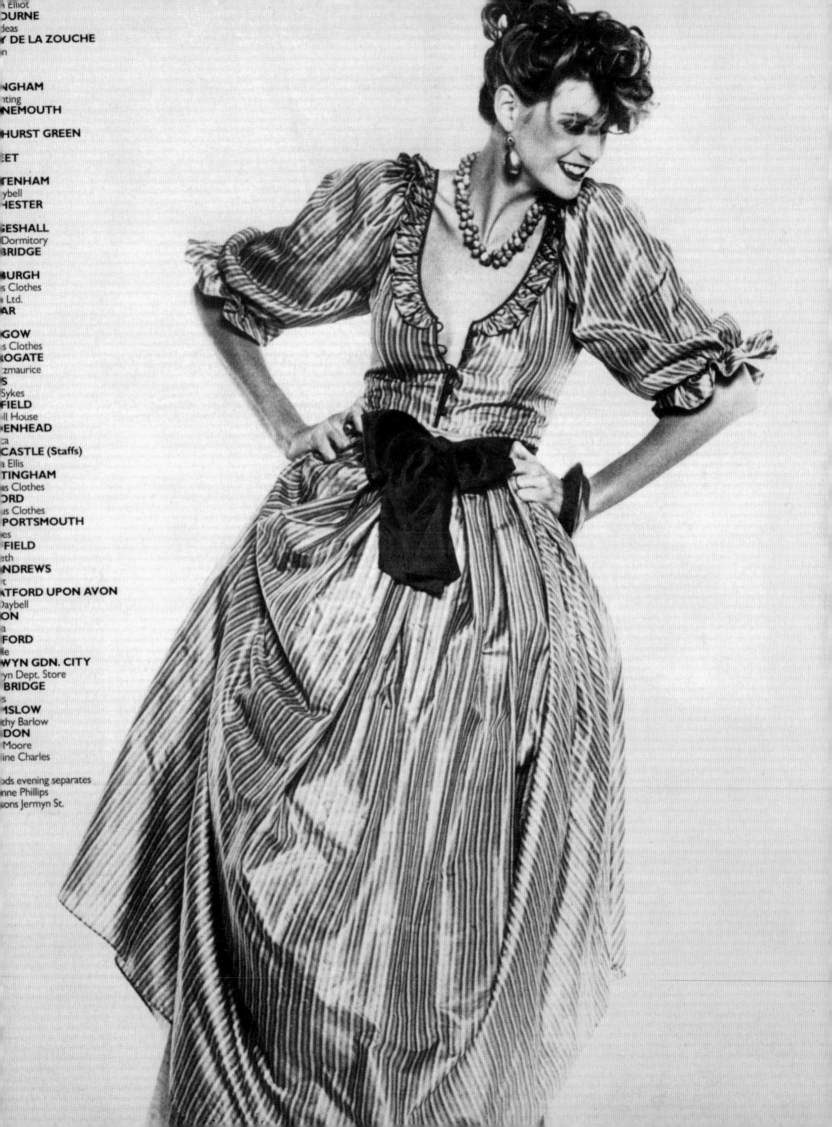

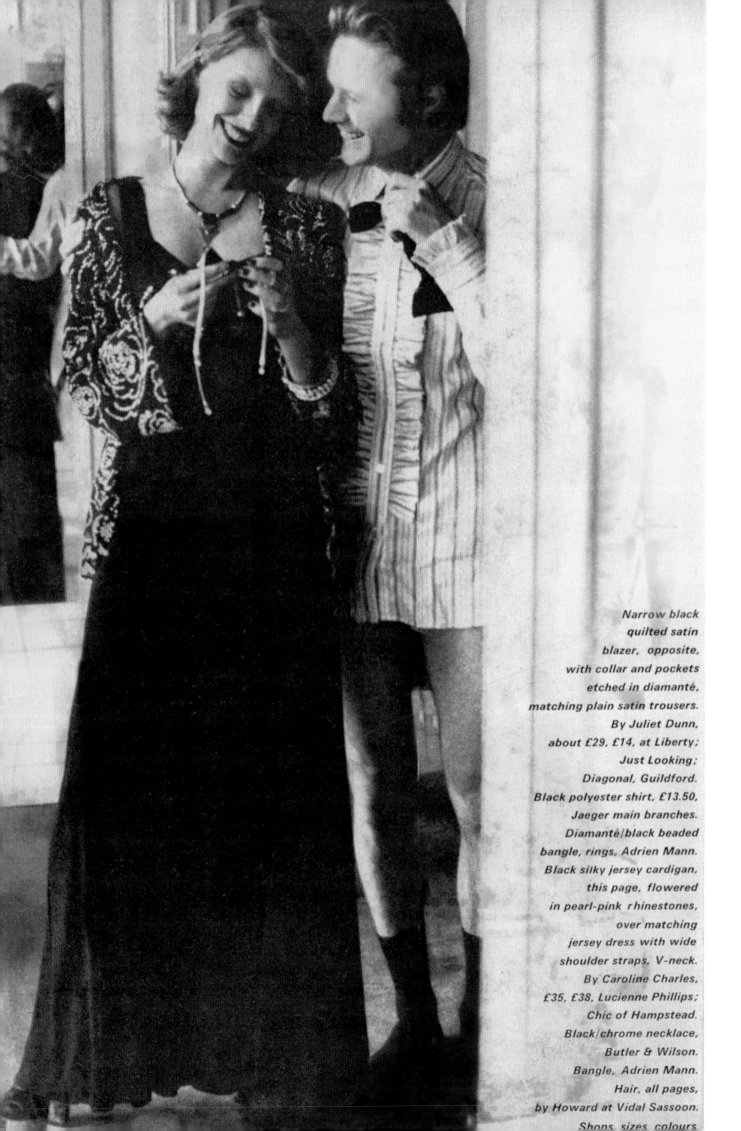

Narrow black
quilted satin
blazer, opposite,
with collar and pockets
etched in diamanté,
matching plain satin trousers.
By Juliet Dunn,
about £29, £14, at Liberty;
Just Looking;
Diagonal, Guildford.
Black polyester shirt, £13.50,
Jaeger main branches.
Diamanté/black beaded
bangle, rings, Adrien Mann.
Black silky jersey cardigan,
this page, flowered
in pearl-pink rhinestones,
over matching
jersey dress with wide
shoulder straps, V-neck.
By Caroline Charles,
£35, £38, Lucienne Phillips;
Chic of Hampstead.
Black/chrome necklace,
Butler & Wilson.
Bangle, Adrien Mann.
Hair, all pages,
by Howard at Vidal Sassoon.
Shops, sizes, colours

The making of our sample designs was another struggle that went on twice a year for spring and autumn. Drawing piles of sketches was the easy part! This was followed by visiting textile fairs in Frankfurt and Paris to choose fabrics. Then the European cloth companies made everything, and to persuade them to give you credit and send the sample lengths on time was a major feat. We ran our own workroom with a marvellous pattern cutter called George and two Spanish machinists. They spoke only in Spanish to each other, and insisted on going home for all of August, just when we needed them most! We also had South African girls as sample hands who were exceptional in every way and became like members of our family.

During the '70s we cut most of our production 'in-house' and bundled each garment including zip, thread, buttons, shoulder pads and sketch into individual bags and delivered these to a selection of small outworker factories all over North London. We were always asking favours because the quantities we were able to sell were so small. We were desperate to keep the quality high, but had no power to insist – this is why young designers in London then had a poor reputation for delivering clothes on time or to a high standard. The dream was that large factories would produce the small runs and help us to keep our delivery dates and our quality.

Of course, the UK was so focused on huge production runs for High Street chain stores, that this idea was impractical – instead we were often involved in design work and paid royalties, but never had the help needed to grow designer brands. We looked to France and Italy with green eyes, where we thought the culture was to support and produce the up-and-coming names, and where the fabric and factory people seemed to be working together.

Lace-trimmed velvet empire dress over a chiffon blouse, early '70s, *Woman's Journal*

OPPOSITE PAGE:
Rhinestone cardigan over a long black hurel jersey dress, October 1973, *Bruce Laurance/ Vogue © The Condé Nast Publications Ltd*

As the seventies marched on, the young designer companies gained respect and sales, and there were many people, particularly women, who helped expand our horizons. Lucienne Phillips was the doyenne of fashion buyers for young designers; her shop sold our clothes to the leading beauties of the day. Gerald, her husband, did the money and Lucienne did the choosing for their shop in Knightsbridge. Mrs Smudge Whiteman was the equally important buyer of fashion from London designers for her shop Chic of Hampstead helped by her mother. Vanessa Denza – who had been the buyer at Woollands 31 shop in Knightsbridge and helped to sell our clothes and promote London fashion – went on to run a successful recruitment agency for fashion designers, and to pull together the art school fashion shows in June each year. Anne Knight ran the designer rooms in Fortnum & Mason and they were the hot shopping spot in Piccadilly; Simpsons next door would have women's designer wear moments later in the '80s under Anne Price.

Ernestine Carter was another doyenne, but of fashion writers. *The Sunday Times* was her field, and her taste and good journalism made us respected by the world. Paris, of course, still thought it ruled, and at that time Milan and New York were considered outposts of manufactured mass-market designer clothes. Anna Wintour first appeared in our lives in spring 1970 and no-one guessed that she would go on to rule US *Vogue* in the noughties. Very pretty, with a precise eye for fashion, she worked on *Harpers & Queen* under Willie Landels' clever editorship and alongside the extra amusing journalist Vicki Woods. The excellent Liz Smith on the *Observer* and subsequently *The Times* ran well-informed and stylish fashion pages. Marit Allen was the sparky eye on *Vogue* under Beatrix Miller's editorship, while Anna Harvey was on *Brides* and went on to *Vogue* and was very supportive of young designer companies.

I am sure that the London designers of these years would agree that we all owe the growth of our businesses to these women. They encouraged us and were the focus of designer fashion shopping in London.

C.C. portrait, mid '70s, *Catwalking*

Opposite Page :
Embroidered floral shirt, a Caroline Charles design classic, 1975

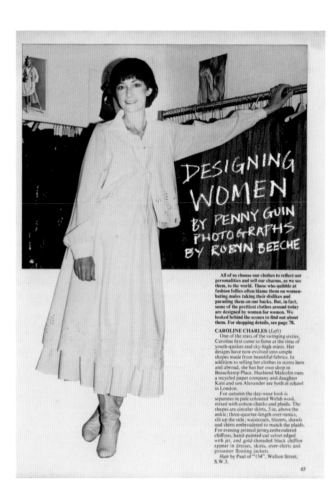

Inside the image (magazine page):

DESIGNING
WOMEN
BY PENNY GUIN
PHOTOGRAPHS
BY ROBYN BEECHE

All of us choose our clothes to reflect our personalities and sell our charms, as we see them, to the world. Those who quibble at fashion follies often blame them on women-hating males taking their dislikes and parading them on our backs. But, in fact, some of the prettiest clothes around today are designed by women for women. We looked behind the scenes to find out about them. For shopping details, see page 78.

CAROLINE CHARLES (*Left*)
One of the stars of the swinging sixties, Caroline first came to fame at the time of youth-quakes and sky-high minis. Her designs have now evolved into simple shapes made from beautiful fabrics. In addition to selling her clothes in stores here and abroad, she has her own shop in Beauchamp Place. Husband Malcolm runs a recycled paper company and daughter Kate and son Alexander are both at school in London.
For autumn the day-wear look is separates in pale coloured Welsh wool, mixed with cotton checks and plaids. The shapes are circular skirts, 3 in. above the ankle; three-quarter-length over-tunics, slit up the side; waistcoats, blazers, shawls and shirts embroidered to match the plaids. For evening printed jersey, embroidered chiffons, hand-painted cut velvet edged with jet, and gold-threaded black chiffon appear in dresses, skirts, over-shirts and gossamer floating jackets.
Hair by Paul of "154", Walton Street, S.W.3.

Robyn Beeche took this image of C.C. for an article on the success of women designing for women, 1976

OPPOSITE PAGE:
Ruffled shirt and matching trousers and spot ruffled dress, 1972

By this time, Leone Fielding was our house model and receptionist. She had soft curly hair and a Botticelli look that suited the new mood of soft clothes, chiffon and long crepe dresses worn with coloured boots. Beauchamp Place had become our headquarters, and originally we were opposite Deborah and Clare, who made the best shirts for men in high-quality fabrics. Their shop often had queues outside the door waiting to get in and they deserved their great success.

Further down Beauchamp Place was Gary Craze at Sweeney's, whose hairdressing basement for men and women was quite the trendiest, darkest and most frequented by the music and fashion stars. At another basement or three across the road at 5/6/7 was Parkes restaurant – now this was posh eating at its smartest, with plates of delicious food decorated with flowers, wonderful art on the walls, courtyard gardens; and even more dark and discreet. It needed to be, as the world of Liberace sat next to Princess Margaret, who sat next to Frank Sinatra etc., and if anybody knew, certainly nobody said. Celebrity life then was not the open book it has now become. The real star of this restaurant, after the death of Ray Parkes, was the cook and partner Tom Benson, who was loved by all. He pulled together the good traders of Beauchamp Place into putting on two street parties. Street parties had just started to become popular and the police were helpful in stopping the traffic at both ends of Beauchamp Place. We all had stalls on the pavements selling whatever we made, and as there were eighteen restaurants, there was certainly plenty of food. We had two rock bands, one each end and there was dancing and generally hanging out in Fiesta mode!

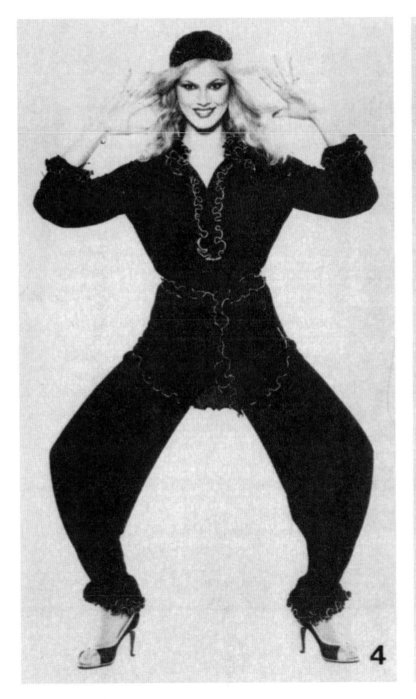

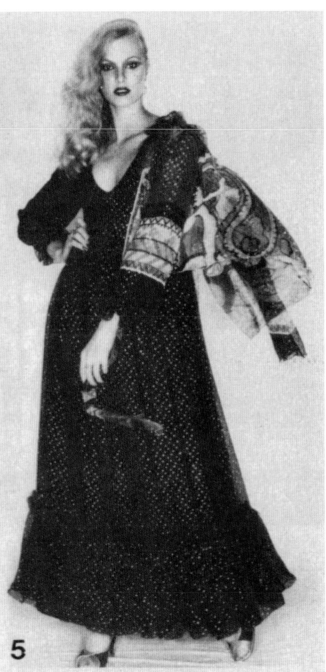

At this time our collection had been selling well in a Beauchamp Place shop called Janet Wilson. It was a season of full just-above-the-ankle flannel skirts with pockets, worn with peasant blouses and wide stretch belts and, of course, boots. It was time to have our own shop and, by a stroke of luck, the Polish antique dealer next door was ready to retire, and so we became retailers. We decided to give our first shop the feel of a feminine dressing room with very pale pink walls and a frieze of roses and lilies below the architrave. This was designed and sprayed by Natalie Gibson, who is an inspired textile designer, and now long established as the head of textiles at Central Saint Martin's College of Art and Design. John Minshaw designed and made a set of mirrored-edged cupboards to hang the clothes in, and a very modern but 1930s-inspired cabinet with thin panels of glass along the front. Later, John was named the 2007 Interior Designer of the Year; he is fabulously successful and deservedly so. Both these artists could draw and engineer their drawings into reality; and in my view that really counts.

We could not afford air conditioning for our first shop, so a large fan was fixed to the ceiling, which in my worst nightmares would have been the beheading of an innocent customer. My nightmare never came true, thankfully, and our first customer tried on clothes without a mirror, none having arrived yet. She bought a skirt with three tiers of black crepe each trimmed with different coloured fringe and a purple satin Russian shirt, and I could have kissed her when she said she felt good and would take it. At that moment I knew this was the way to sell clothes, in your own atmosphere and to lovely people. This has remained my belief, although, of course, I am very grateful to other retailers who sell our clothes!

The Maclaine twins wearing Caroline Charles for our first *Vogue* advert. The twins are wearing brown and black cotton dresses and are seen here with the photographer's dog, March 1974, *Sandra Lousada*

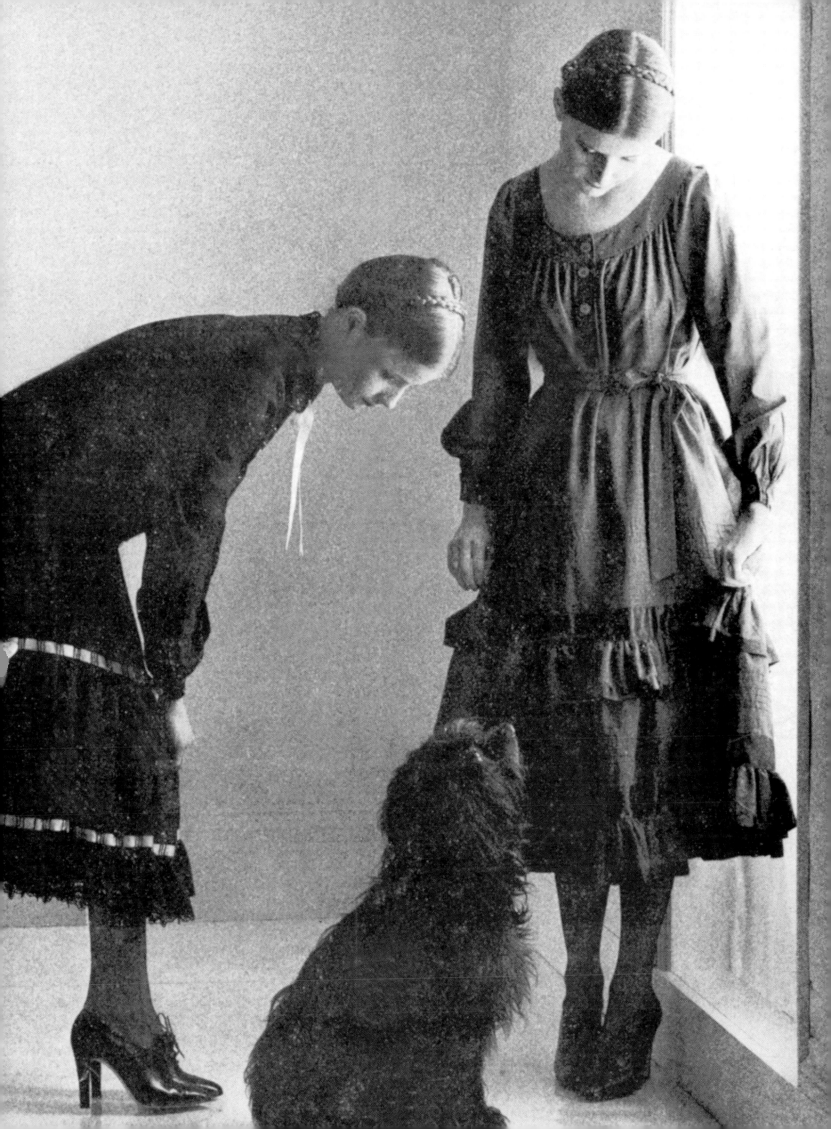

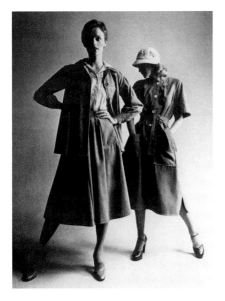
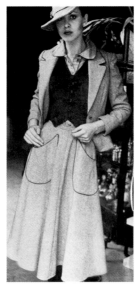
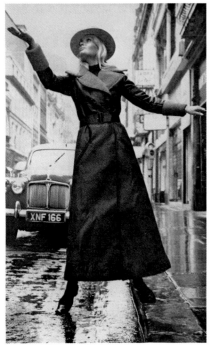
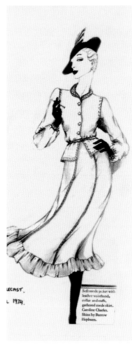

In the early '70s the silhouette was maxi skirts & coats with soft tailored jackets and lots of wool

ABOVE, CLOCKWISE FROM TOP LEFT:
Part of an Anne Price piece for *Country Life*, February 1975; Image from a promotional shoot; Illustration from a fashion forecasting piece, showing a Caroline Charles wool two-piece suit; Caroline Charles advert

OPPOSITE PAGE:
Advert commissioned by Simpsons of Piccadilly, wool shirt and skirt in a Collier Campbell print

At the sharper, business end of life, help from the export council was very welcome and they planned a four-day exhibition at the Piccadilly Hotel for a group of designers that included us, plus Gina Fratini, Mary Quant, Thea Porter, Hilary Floyd, Ossie Clark and Alice Pollock, Christopher MacDonald and John Bates. It was to cost £150 and we hoped to sell thirty dresses to cover the costs… The buyers were Lord & Taylor, Bloomingdale's, and Gimbel Bros., all from the U.S., as well as many UK stores and shops.

In **1973** the Heath government was struggling and the power was going off and strikes were happening, but in the fashion bubble we seemed to be unaware… Our Spring collection started to sell in Milan, and Italian *Vogue* used our hat on the cover. In the mid-sixties we had sold our clothes to shops in Paris, now Italy presented a new horizon. We worked with a glamorous woman who lived in a great apartment in Milan and carried a pearl-handled pistol in her bag! This was the time of kidnapping in Italy, and the era of peace and light and general hippy goodwill was fast coming to an end.

We returned to New York that year under our own steam, and set up camp in a hotel on Fifth Avenue, to try and expand our market in the US. Jackie MacIntosh, a great house model and sales person, helped us and the collection proved popular. Radical chic was the mood in New York, with Black Panthers in berets and Tom Wolfe being a popular read. In contrast, our clothes were very soft and non aggressive with pale panne velvets and Schlaepfer's Swiss sequins. Anyway, we came home reasonably pleased and London work went on. Having our feet firmly on the ground was essential to survival and the consultancies had us travelling to Leicester, Derby, Manchester and Walthamstow.

Simpson

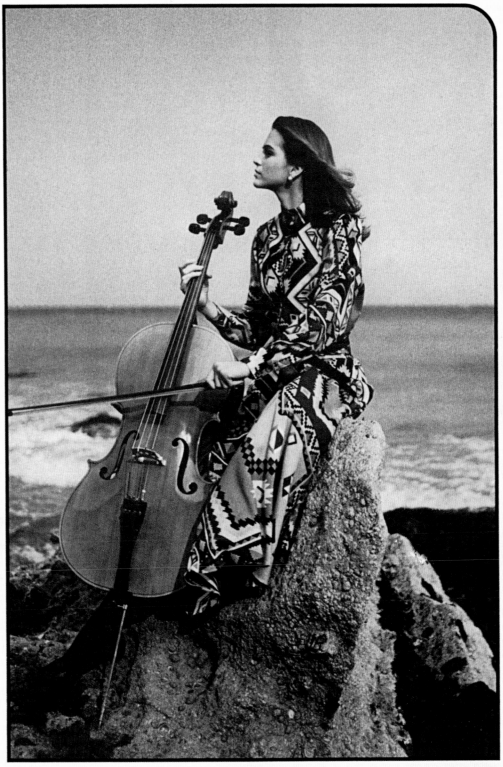

Caroline Charles in Pure New Wool at Simpson Piccadilly

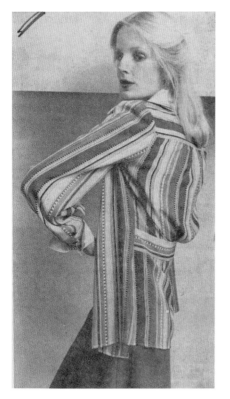

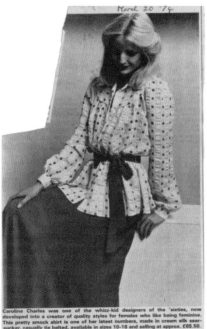

Caroline Charles was one of the whizz-kid designers of the 'sixties, now developed into a creator of quality styles for females who like being feminine. This pretty smock shirt is one of her latest numbers, made in cream silk seer-sucker, casually tie belted, available in sizes 10-16 and selling at approx. £65.50.

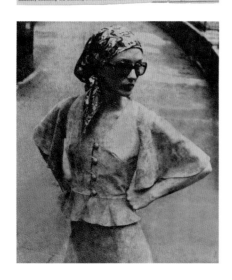

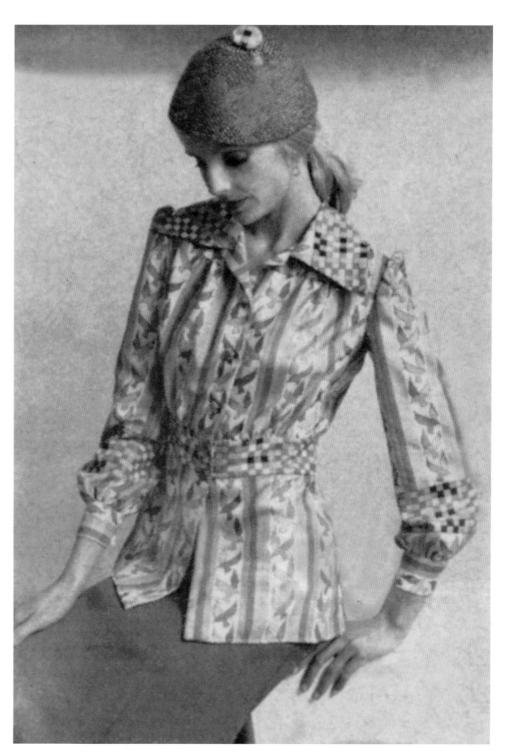

Bird-printed soft shirt jacket, March 1974, *Catwalking*

TOP LEFT:
Striped long shirt, 1974

CENTRE LEFT:
Soft printed shirt jacket, 1974

BELOW:
Suede and silk blouse, 1974

Photographs by John Swannell Hair by Paul at Mignon and Michael Make-up by Joan Price's Face Place

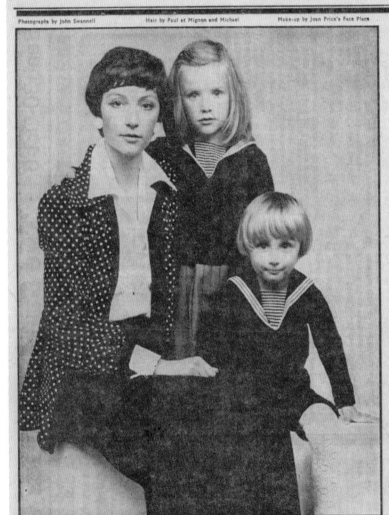

£OOK!

Fashion by Leslie Field

It's special offer time

CAREER girl, wife, mother — Caroline Charles is all of these and the outfit she models here is the look she designed as suitable for all these lives.

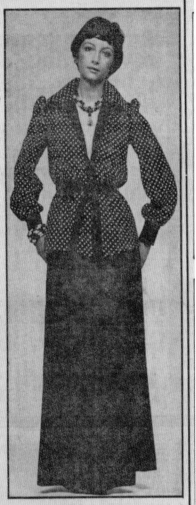

★ On the left Caroline with her children, Kate and Alexander, wears all three pieces and flat ivory earrings, £14 from Emeline

★ Above, Caroline wears the special offer shirt which costs £4.95

★ On the right, with the special offer suit, £14.95 Caroline wears a jet and rhinestone necklace £12, jet earrings £4.50 from The Ken Lane Shop, 50 Beauchamp Place, SW3, and 30 Burlington Arcade, W1. And jet and mother of pearl bangle bracelets, £8 each from Emeline, 45 Beauchamp Place, SW3

● CAROLINE CHARLES is one of the most talented designers on the English fashion scene, known for the elegant simplicity of her clothes that combine style with comfort and wearability. So when we first decided to press forward with the idea of a Look! Fashion Special Offer I went to her and asked if she would be interested in designing an outfit especially for us. With very little arm twisting she said yes, and so began endless discussions on every quality this miraculous garment had to have.

High quality

First, it had to be a really "special" look, with high quality workmanship and a price that could not be had elsewhere. Second, I wanted it to be not only "good fashion" but also an up-to-the-minute look which was at the same time flattering and practical for the broadest possible spectrum of readers. We talked, we argued, we compromised, but nearly five months later, the outfit photographed

Front and back view of the jacket. The

mothers everywhere, we love it a lot, then we offer no apologies for our prejudice.

The two-piece outfit features the new long line silhouette so prevalent in the autumn 1973 couture collections . . . broader shoulders, narrow hips and a soft waistline. It is sophisticated and tailored without being hard. The skirt is made from four panels of fabric so as to fall perfectly straight and flatter and shape any type of figure. The skirt is really long, reaching to where the foot breaks to go forward, not stopping short at the ankle.

It is, I think, the perfect length for late afternoon on into the evening, but if you prefer, take the hem up—which is a lot easier than having to let it down. The skirt has a narrow set-in waistband, a back zipper, and it comes in a solid colour so that you can wear it with dozens of different tops, dressing it up or down.

The polka dot jacket is trimmed with a solid front and back shoulder yoke,

belt. It is long, to the top of the thighs, and looks as smashing over trousers or a knee-length straight or pleated skirt, as it does here. Wear it buttoned and tied, or open with the belt tied in the back. It falls beautifully, just skimming the body, and can also be worn as a straight tunic top. Wear it naked at night with beads filling in the neckline, with shirts, polo neck jumpers, or as a jacket over a little black dress.

Economy

The suit is sold as a complete outfit and comes in black, milk chocolate brown, and a deep burgundy red, all with white polka dots, in 100 per cent Sarille crepe.

The price — £14.95 — includes VAT, postage and packing.

As an optional extra Caroline has designed a white shirt that will prove a useful asset to any wardrobe. It has a large well-defined collar, a very deep rever and the wide shoulders which are such an important fashion look this year,

It is also made of the same Sarille crepe, and costs £4.95.

A very important point is that all three pieces are meant to be hand or machine washed, and not dry cleaned, which is a great economy. Also, reports from all our testing indicates that the material is remarkably free from wrinkling. The workmanship is first rate and Caroline has kept as careful an eye on all the finishing details as she does on her own expensive collections.

Not only does the outfit have high fashion appeal, practical wearability, and an unlimited future year round, it comes at a price that cannot be matched by any department store.

● Sizes are always a problem, particularly when it comes to ordering by post. But we have done our best to get you as accurate a fit as possible by working out this bust/waist/hips guide.

Sizes:	10	12	14	16
To fit bust	32/33	34/35	36/37	38/39
waist	23/24	25/26	27/28	29/30
hips	34/35	36/37	38/39	40/41

John Swannell photo of C.C. with her children, Kate and Alex. C.C. wears pieces designed for a *Sunday Times* special offer. Readers could order the pieces directly from the newspaper, 30 September 1973

There was a great variety in theatre during the 1970s. The theatre half way down the King's Road had a musical play called *The Rocky Horror Show* and this set a new mood of black humour and fishnet tights in Chelsea. By contrast, we also saw Ella Fitzgerald at Ronnie Scott's club in Soho, of course she was as marvellous as her records and somehow very sweet and vulnerable and, of course, hugely famous.

The Martha Graham Dance Company were performing at Covent Garden and were really inspiring; and, by contrast, Tom Conti was at the Savoy in the new play *Whose Life is it Anyway?* on the theme of euthanasia.

Chris Moore was a photographer friend who took many of our pictures either in his studio or in our showroom. Today he is the world's number one catwalk photographer, and his work appears in the international fashion media every day. I find a glimpse of Chris at London Fashion Week the most comforting sight during the tension of pre-show nerves.

In Thurloe Square we often worked in the studio of the photographer Robyn Beeche, whose creative pictures line the stairs and corridors of our buildings today. Our model was often Catherine Dyer, who later married David Bailey, or Gail Elliott, both classic beauties who always understood the mood of the season and never took a bad picture. Emboldened with these good images we started to send out postcards and invitations to clients and press, and even arranged to advertise in *Vogue.* Today the big brands have enriched the magazines and elbowed the small designers off the front pages, but in the 1970s there was a more liberal mood to promoting young British designers with advertising spaces made more available. Charity fashion shows were a good way of showing new clothes to new people, and doing a little fundraising.

Ika models soft velvet jacket, August 1975, *Country Life*, *Catwalking*

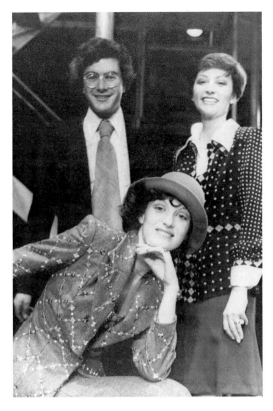

Theatre impresario Michael White invited us to do a photoshoot on stage in the West End

ABOVE:
Michael White, C.C. and model, August 1975, *Country Life* magazine, *Catwalking*

BELOW:
Model on stage in the West End, *Catwalking*

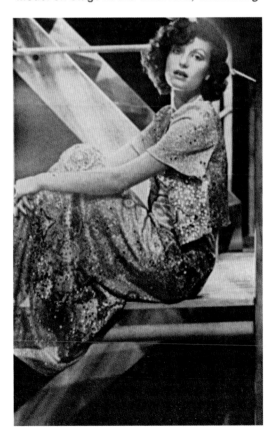

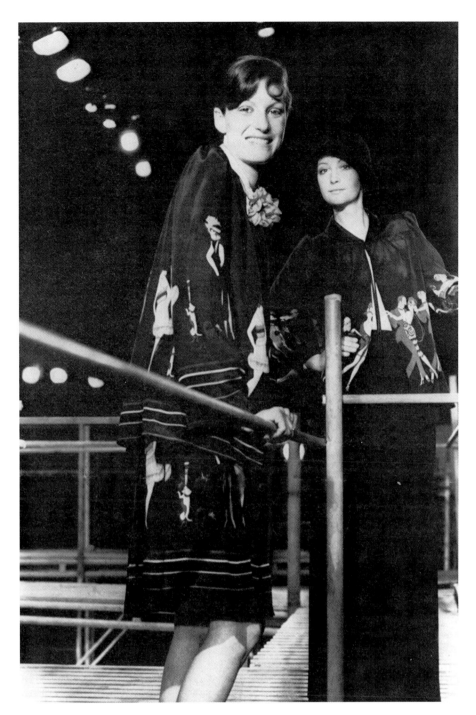

Model and C.C. on stage wearing printed silk kimonos, August 1975, *Catwalking*

A show we did at Sotheby's Belgravia was a big affair in the Pantheon building and we were able to have top models, including Marie Helvin, among others. Joanna Lumley was one of our girls that day and fabulous as always, she wore the backless dress on front ways, just adding double-sided tape to hold it in place! A particular memory is of the girls backstage in various stages of undress, who were smoking while sitting directly under a notice warning of the sprinkler system set to go off at the slightest whiff... we all remained dry.

To my utmost joy, during couture week in Paris in January **1974**, I was invited to go with Leslie Field of the *Sunday Times* and Michael Heath the cartoonist. We were to be the 'fresh eyes', and among others we saw the Balmain, Lanvin and Cerruti shows, which were very serious, but to me, at least, fascinating. Other London press were not amused to see a designer and a cartoonist reporting and tutted – in fact Prudence Glynn on her fashion page for *The Times* mentioned she had seen a designer…etc more tutting…

How things have changed. Then the big newspapers fashion pages counted for much and not to be in their columns was unthinkable. The trade and customers read every word and so it really mattered. Happily, our press books were good and full of pictures and I always took them to show the bank manager on my very frequent visits to discuss cash flow. He loved them and we got on famously in the bank's offices in Piccadilly Circus.

Michael Heath cartoon after H.M. Bateman, depicting C.C. amid disapproving journalists at the 1974 Paris couture shows

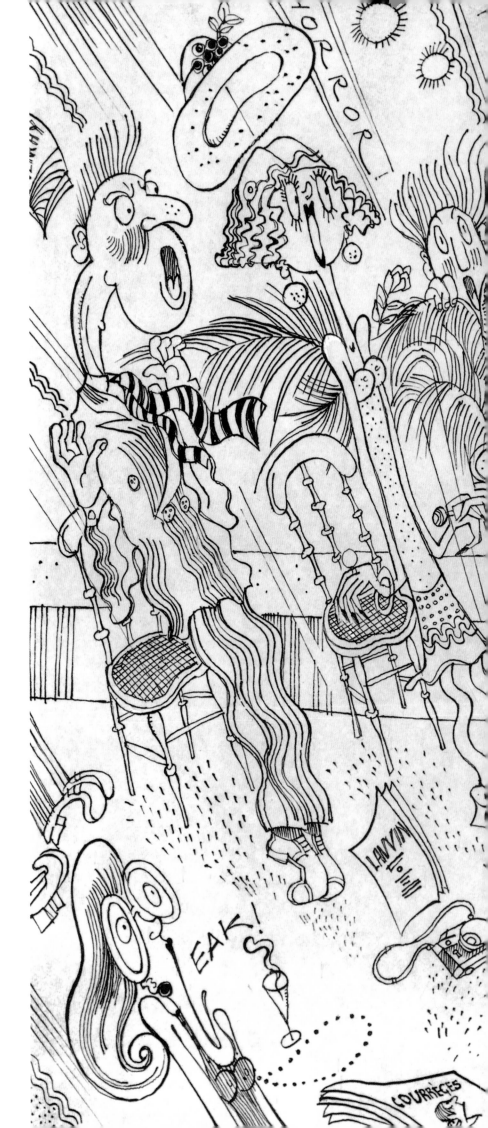

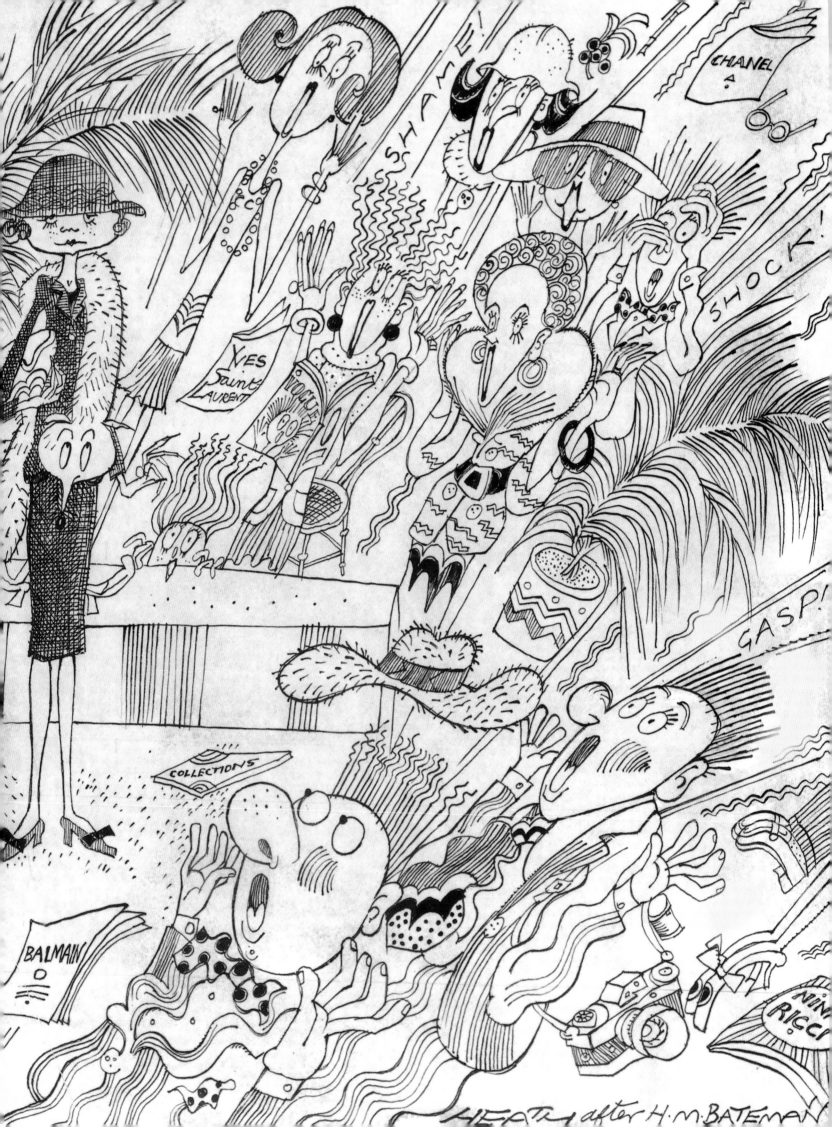

Below and Opposite Page:
Black and white portraits of C.C., late '70s,
Robyn Beeche

One glamorous moment was when *Vogue* invited us to bring clothes into their studio in Hanover Square for a special shoot. Norman Eales was the photographer and the model was the writer Jean Rhys, famous for *The Wide Sargasso Sea* and many sad Paris stories. She had disappeared and had just been re-discovered. Her wonderful gentle ways were of a woman who had lived through the early part of the 20th Century. We drank champagne and the hairdresser curled her blonde hair and the make-up artist did her face and she wore pale pink marbled satin Caroline Charles clothes and enjoyed her re-emergence as if she were just a girl.

The Derek Healey studio hosted a group of textile experts who met regularly to create colour cards and advise forward trends for the two years ahead. This group was unpaid, yet cared enough to give their time and expertise, so as to improve the use of colour and fabrics available to the High Street. Solveig Hill was one of these textile experts, and through her I became the only dress designer in this group. Somehow this led to me being sent to Dubrovnik to the European colour meeting. I sat beside the Union Jack at the big conference table, and gave the UK presentation. The many countries represented would debate the European colour card for the mood of the season and conclude groups of forward trends. The Nordic countries always chose cool grey-blue tones and the Germans always had a yellow ochre in their offering.

It was a good feeling to be working among European continentals in my field and I felt a little less offshore coming from the UK. To people not in the fashion world the idea of immersing oneself in colours and moods two years in advance must surely seem peculiar, but to us it was a creative base. At that time I learnt how to make colour

boards and since then have torn out pictures whenever they matter to me. Of course not out of books, but all magazines, brochures, postcards, wrapping papers etc. are fair game. This activity makes people very nervous sitting near me on aeroplanes and at the hairdressers!

It was important for the bank balance of the company to keep up the outside consultancy work, and so when invited to pitch for staff uniforms for Boots the Chemist, I accepted happily. In fact it was a very happy job to work on as the top people at Boots were charming and we had won the job over Hardy Amies and another designer. We worked with the fabric company Tootals on making a blended cotton print and a bright plain blue gabardine for overalls and pinafore dresses, as well as white with blue collars for pharmacists.

The Caroline Charles collection for 1975 was a really rich mix of colours including wine, ink, bottle, petrol and toffee; it was made in wool jersey, Angora flannel and crepe. There were stripes and plaids and patchworks and it all had a very exotic peasant flavour! The Middle Eastern market particularly bought in to Caroline Charles at that time, especially the sequin soft twinsets and long skirts.

In the mid-seventies we started to work with Peter Blond who was a leading supplier of clothes to Marks & Spencer – we had originally met on a trade outing to New York and South Carolina, where we were being shown the joys of Monsanto's man-made fabrics. Five years later we designed a group of tunics and shirts that were accepted by M&S and started to sell very well. My mother and staff would go into the Marble Arch branch and tidy up our designs and even buy them if things looked a bit slow! Peter Blond was marvellous to work with, being amusing and really interested in design. He

would pick me up in a Ferrari and drive to Skelmersdale in Lancashire to his state-of-the-art factory where we would make the original samples. In the M&S offices in Baker Street the presentations would be very serious, no joking and no smoking anywhere. The corridors all looked the same and I always had to allow an extra 20 minutes before a meeting because I would get lost... The success of the shirts allowed us to go on working together. doing a children's wear collection, which was a new

and welcome departure from women's wear. Years later Peter Blond arranged for Royal College of Art students to design for M&S, which introduced the High-Street giant to another fresh pot of talent.

English Fashion Designer
Caroline Charles and Her
New Boutique Welcomed to
Beverly Hills by Rubin Paris

Emboldened by the success of our first shop in Beauchamp Place we set in motion plans for a shop in Beverly Hills and together we chose a small store on the corner of Brighton way and Rodeo Drive. This opened in June 1979 and Anne and Tommy Yeardye gave us a party to celebrate – Tamara Mellon, their daughter recently developed the designer Jimmy Choo into a worldwide shoe business. *WWD*, US *Vogue* and the *LA Times* ran pictures and interviews, getting us off to a good start. The shop was like the Beauchamp Place shop, painted a very pale pink and had a frieze of roses and lilies and a mirrored desk, so the impression was pretty precious. In retrospect, it should probably have been bolder in its colours, which might have suited the sun and the clients better…

Rodeo Drive was a destination for shoppers who liked the famous designers, but the fashion store Georgio's, was really a star turn. He had built up wonderful collections and made his building into a glamorous place to be, with an Espresso bar as you came in – this was new!

By 1979 I was starting to really get a sense of what we had achieved. In the August we travelled back to Los Angeles to visit out shop and do an ABC TV programme and my husband and children were able to see the shop. In October I had lunch with Mary Quant, who I had not seen since 1963; I suddenly felt very grown up, instead of being her most junior member of staff... Sadly that November my Grandmother died, and I realised how much she had been my muse, with her elegant couture clothes and her amusing take on life in England and in France. The seventies had been a hugely exciting and busy decade with our two children growing up and a business that had really gained ground and recognition.

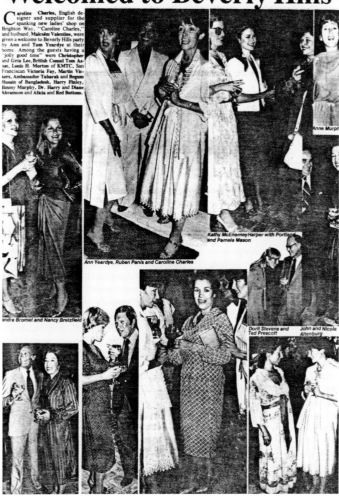

Caroline Charles Welcomed to Beverly Hills

Caroline Charles, English designer and supplier for the spanking new ladies' shop on Brighton Way, "Caroline Charles," and husband, Malcolm Valentine, were given a welcome to Beverly Hills party by Ann and Tom Yeardye at their home. Among the guests having a "jolly good time" were Christopher and Geta Lee, British Consul Ton Asion, Louis H. Morton of KMTC, San Franciscan Victoria Fay, Martin Vickers, Ambassador Tabarak and Begum Husain of Bangladesh, Harry Finley, Jimmy Murphy, Dr. Harry and Diane Abramson and Alicia and Red Buttons.

ABOVE:
C.C. and guests at the Beverly Hills opening party. Social page from *Fashion Wire*, 1979

OPPOSITE PAGE:
Rubin Paris and C.C. at the opening party for the new Caroline Charles shop, Beverly Hills, 1979

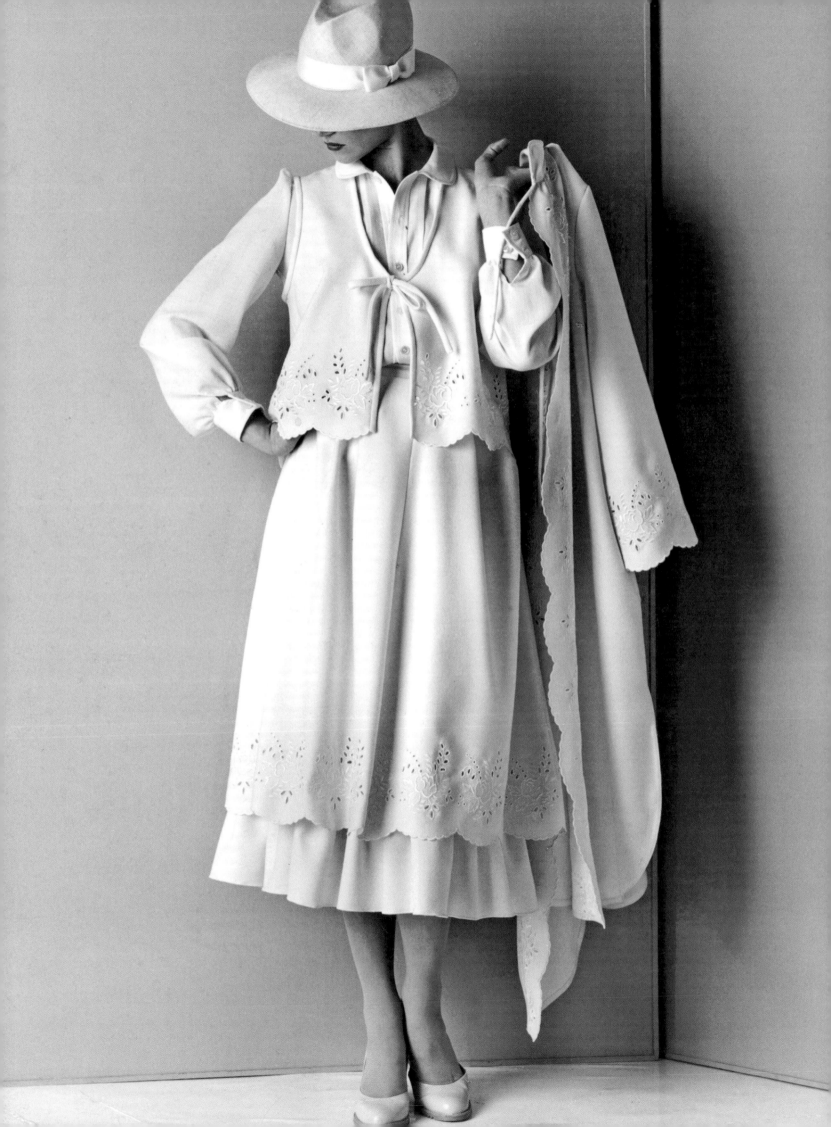

1980s

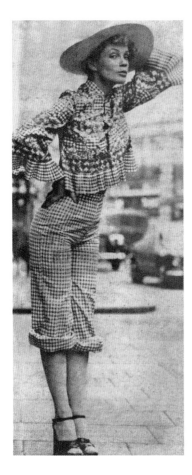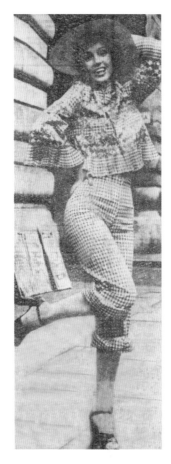

ABOVE:
Gingham cropped
jacket and
matching trousers
– gingham has
always been a
favourite fabric

Opposite Page:
Shirts and skirts
in Swiss cotton,
worn with long
lace up boots,
Caroline Charles
advert, 1981

PREVIOUS PAGE:
LEFT:
Caroline Charles
promotional
image, 1981

RIGHT:
Caroline Charles
advert, 1981,
Robyn Beeche

Tight leather waistcoats with ruffled
cotton dresses and long skirts, 1981

The British Embassy in Washington was an exciting place to stay in **1980**. Mary and Nico Henderson were the stars of this diplomatic top spot, and they made the house very attractive and welcoming. Mary had lured the best British interior designers to bring their fabrics and ideas, and together they made the embassy echo their talents.

From here I went on to Miami to work with a fashion group called the 24 Collection and they arranged for me to stay at the Palm Bay Club. The heavy security here was very surprising after the easy-going London that I knew, where there were no guards and certainly no need to lock your doors whilst driving round! The Palm Bay Club had tennis coaching on offer, so I brought a white tennis dress (obligatory) and had a lesson, which resulted in a cricked back… hours later an Oriental acupuncturist gave me a treatment and I was standing up straight again. There was a Caroline Charles fashion show in Palm Beach and in Bal Harbour and then a dinner given for us. At this I was sitting next to a well-known 'body enhancer', who explained to me why and how these slow-moving beauties surrounding us had their bodies lifted and moulded.

We had brought very young clothes from London; top-quality Swiss cotton lace trimmed and worn with boots to give a bit of edge, or wedge shoes. Also another favourite fabric, gingham, and embroidery was part of the collection; it was all young, high summer and high fashion. The Florida ladies loved it – eternal youth in paradise! Billy McCarthy the well-known New York decorator took me to lunch at a marvellous palazzo set on the water, called Sarasota. He was very much in the know of what went on in this fashionable part of the coast and made me laugh with all his stories. The following day I was a guest at a charity lunch and sat among more 'modified' women in pale pink dresses with blonde hair, who made me feel very welcome and were totally charming.

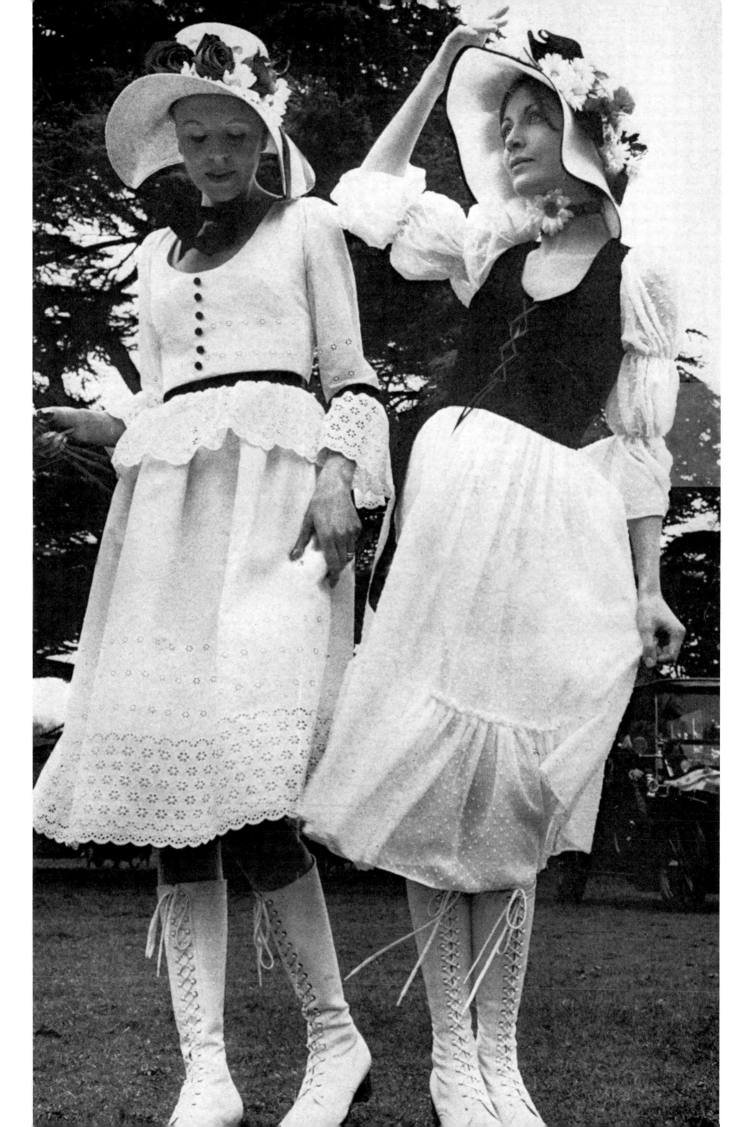

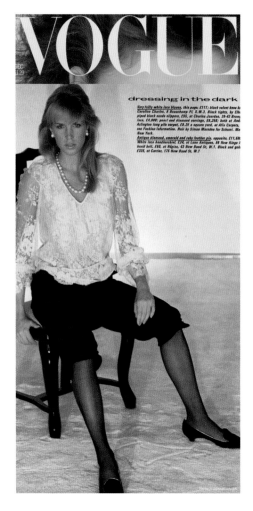

VOGUE

dressing in the dark

LEFT, TOP AND BELOW:
Albert Watson photographed
actress Andie MacDowell in a
Caroline Charles silk & lace blouse,
1988

ABOVE:
Lace blouse & knickerbockers,
*Demarchelier/Vogue © The Condé
Nast Publications Ltd*

RIGHT:
Caroline Charles studio sketch,
ruffled blouse and long skirt, 1988

OPPOSITE PAGE:
Ruffled lace blouse, velvet skirt and
lace bloomers, 1988, *Robyn Beeche*

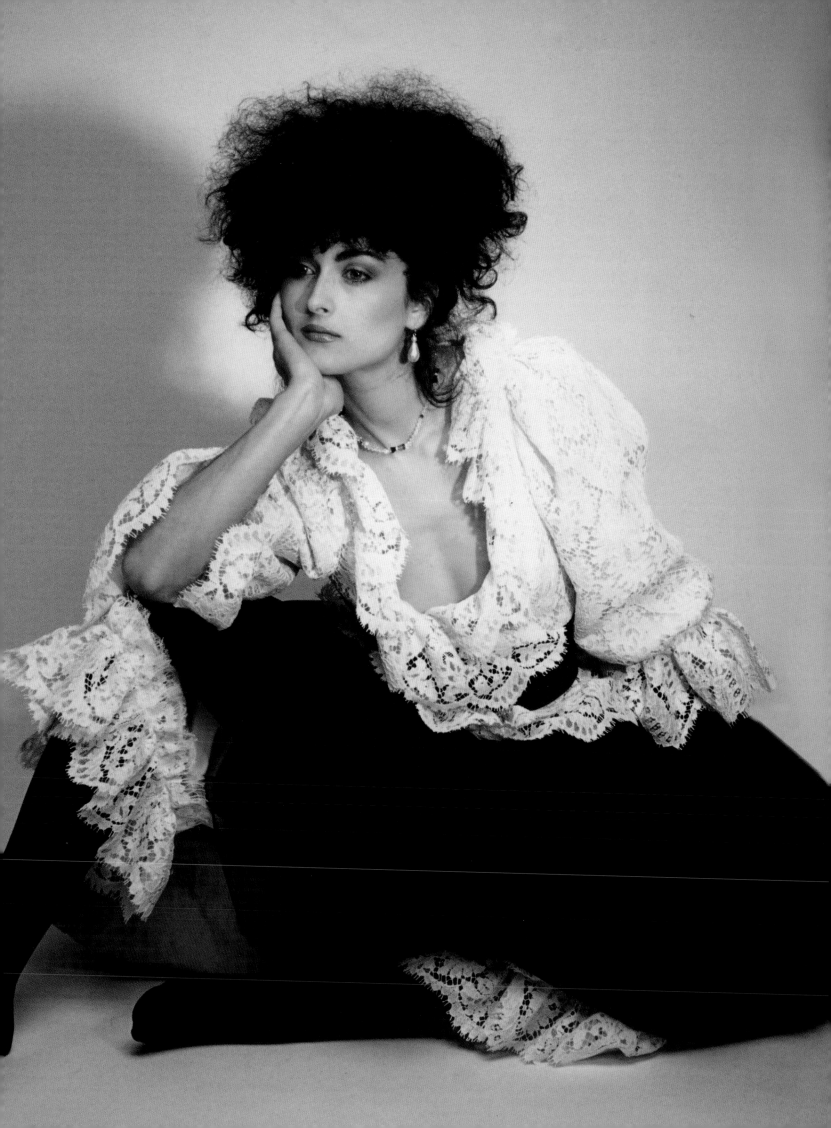

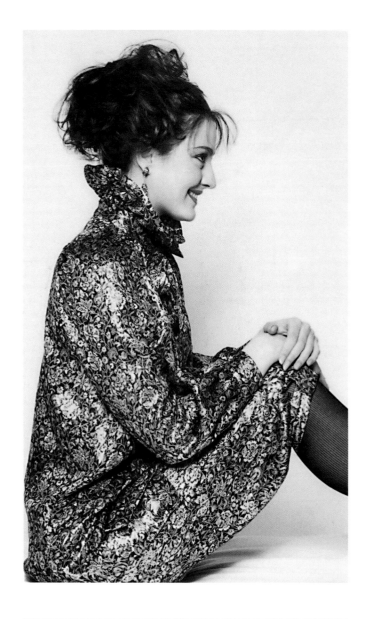

Back home the BBC approached us in December to design the clothes for a new programme to be called *Weekend Wardrobe*. It was a small collection of pieces to be cut out and sewn and finished in one series. I did the introduction and the final programmes, the middle parts were done by the presenter Ann Ladbury. She was an excellent sewing teacher and the whole series was a success, being repeated three times and going out at peak viewing times. BBC publications put out a book with patterns in the back and the sales were considerable. Sewing at home was still fashionable and new Italian sewing machines were on the market, which could be set to do embroidery stitches and fancy edges!

Another interesting project came up when we were introduced to the Playboy Club by the elegant David Russell of advertising fame who invited us to review the croupier bunny's costumes. The Playboy Club was then a casino in Park Lane that ran a scene of permanent night-time – no natural light crept in and the bunny 'mother' was definitely in charge of her girls. Eventually I was allowed to talk to these girls and discuss with them the uncomfortable black satin bathing suits with white fluffy tails attached to them. While studying the mood and atmosphere of the club, I learnt that the heavy hitters of the gambling world would send in their younger players, early in the evening, to warm up the tables for them!

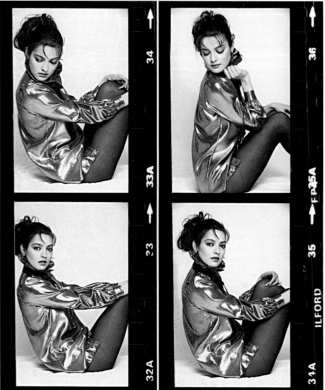

THIS PAGE:
Catherine Bailey wears silk and lamé tunics and knickerbockers, 1981, *Robyn Beeche*

OPPOSITE PAGE:
Naomi Campbell models silk brocade jacket, September 1988, *ELLE UK, Donovan*

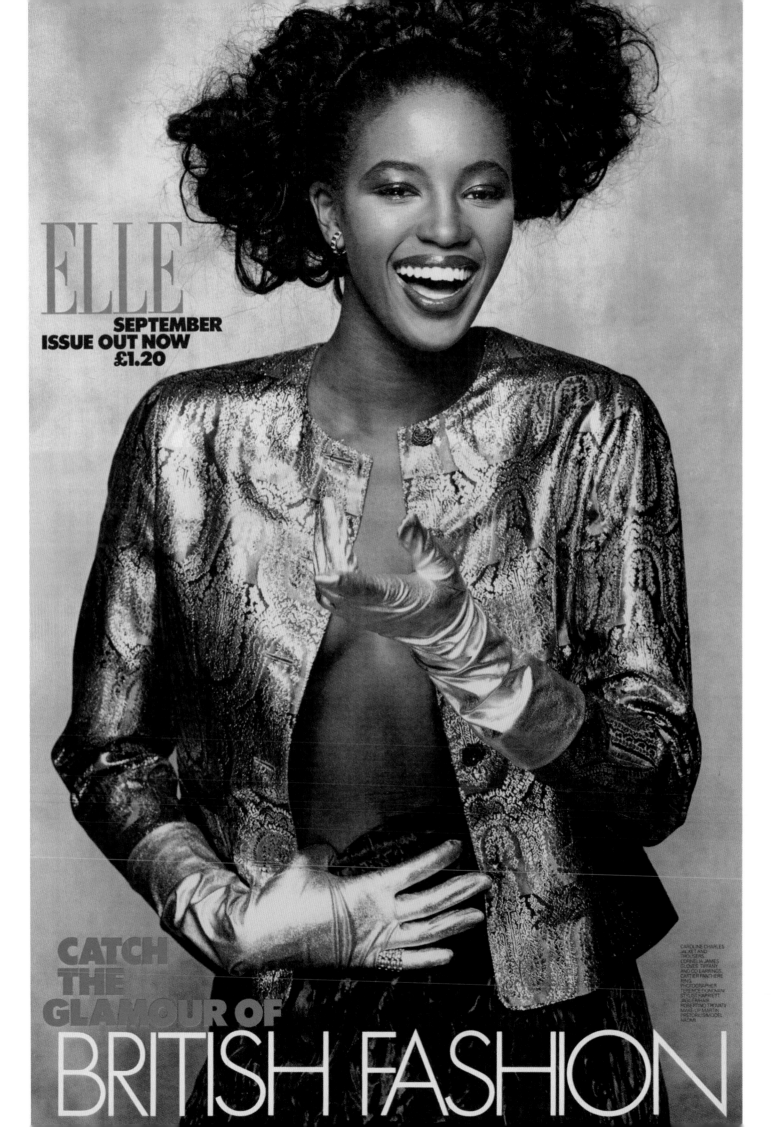

ELLE

SEPTEMBER
ISSUE OUT NOW
£1.20

CATCH
THE
GLAMOUR OF
BRITISH FASHION

CAROLINE CHARLES
JACKET AND
TROUSERS.
CORNELIA JAMES
GLOVES. TIFFANY
AND CO EARRINGS.
CARTIER PANTHERE
RING.
PHOTOGRAPHER
TERENCE DONOVAN.
STYLIST HARRIETT
JAGGER HAIR
ROBERTO TROVATI.
MAKE UP MARTIN
FREDRIKSSON.MODEL
NAOMI.

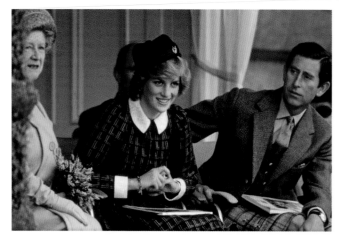

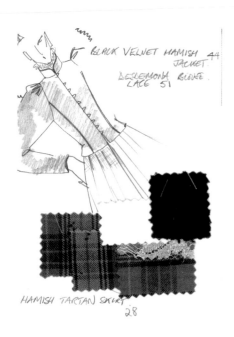

The original sketch and swatches for the plaid jacket and pleated skirt chosen by Diana, Princess of Wales

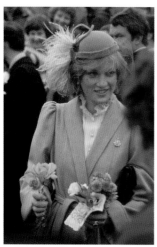

Diana, Princess of Wales chose these Caroline Charles pieces for a variety of public engagements:

Queen Elizabeth, The Queen Mother watching the Braemar Games with Diana, Princess of Wales and Prince Charles; the Princess wears a Caroline Charles plaid coat dress

Navy blue velvet suit and cream silk blouse, 2nd December 1983

Oatmeal wool coat and cream silk blouse, November 1981

Blue suit and cream silk blouse, 2nd December 1983

Green velvet suit and cream ruffle blouse, November 1983

Red suit, 6th December 1982

All photographs this page © *Getty Images*

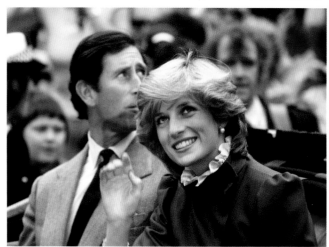

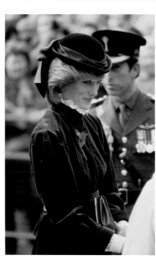

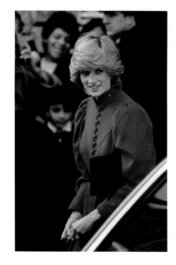

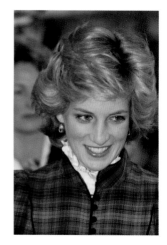

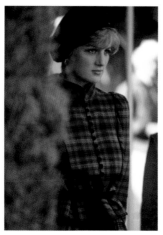

The Princess often returned to her favourite Caroline Charles pieces, this plaid coat dress, seen here in September 1981 and January 1985.

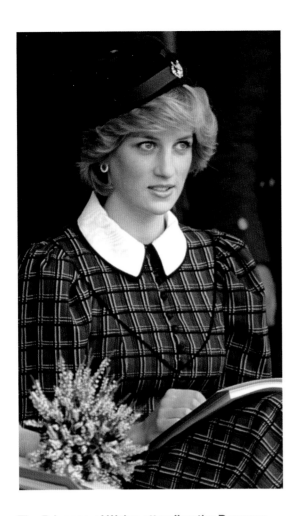

The Princess of Wales attending the Braemer Games in Scotland, wearing a plaid dress, 4th September 1982 © *Getty Images*

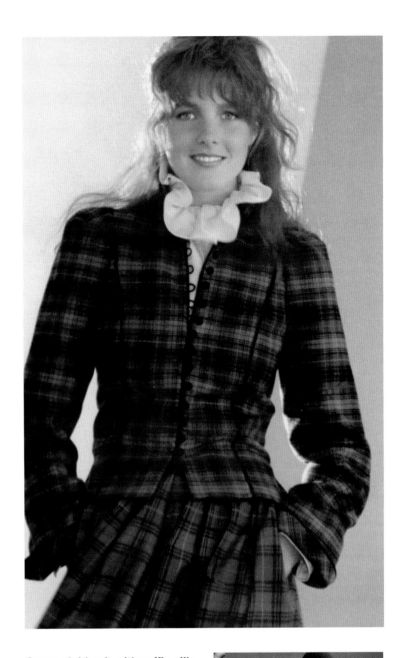

In the Spring of **1981** the beautiful Lady Diana Spencer and her mother came to visit us in our Beauchamp Place showrooms and chose clothes from the collection. It was a very happy meeting with lots of jokes and easy confidences and was the first of many visits. Later on, as The Princess of Wales, she would bring her friend and lady-in-waiting Anne Beckwith-Smith on shopping outings, and the two of them would choose her clothes and giggle a lot! A particular tartan suit was made for her to wear at the Braemar Games in the summer after her wedding. This suit had also been pictured in *Vogue* and so the press picked up on our name and we were known from then on as one of her designers.

Green plaid suit with ruffle silk blouse (the same outfit chosen by The Princess of Wales), August 1981, *Mike Reinhardt/ Vogue* © *The Condé Nast Publications Ltd*

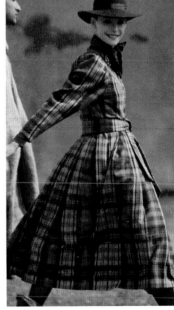

Checked coat dress in wool, 1981

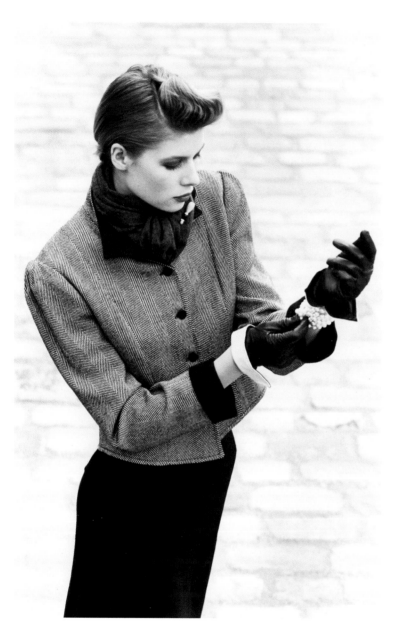

Herringbone jacket, trimmed with black wool collar and cuffs to match the pencil skirt

<small>OPPOSITE PAGE:</small>
Checked suit, renamed the 'Prince of Wales suit' for this editorial piece, February 1987, *Donovan/Vogue* © *The Condé Nast Publications Ltd*

In **1983** I received my first invitation to the Woman of The Year lunch at the Savoy, and it was a great honour to be included amongst the great and the good. Lady Lothian ran this fundraising event for the blind with energy and charm, and every year she would select three leading women to give a speech.

February in London was time for the London Young Designers' Fashion Show. Held at the Park Lane Hotel in Piccadilly, it was always well supported by press and buyers. We took good orders from New York, and started to sell to shops in Hong Kong owned by an attractive Australian called Margot Lee. By April of 1982 we were in Dubai, (where we were already selling our collection) for fashion shows at a huge and glittering hotel. The producers, models and Caroline Charles team were all flown in from London, and we shared the show with the Bulgari brothers, who had brought their fabulous jewellery from Italy. There were three shows: one for the Royal family, one for the dignitaries and business community, and one for the local expats; and all on separate evenings. Being backstage in the dressing rooms was an interesting experience. The jewellery was being shown on girls in black leotards – very James Bond. Of course, being so fantastically expensive, the jewellery had to have hunky Italian bodyguards at all times, so privacy was hard to come by.

Despite the stresses of putting on these shows we all remained on good terms, and ended up being given a party in the hotel – men one end of the room and women the other!

Later in the year we were commissioned to design the uniforms for the air hostesses on Gulf Air, and so the journey to Dubai had been doubly useful.

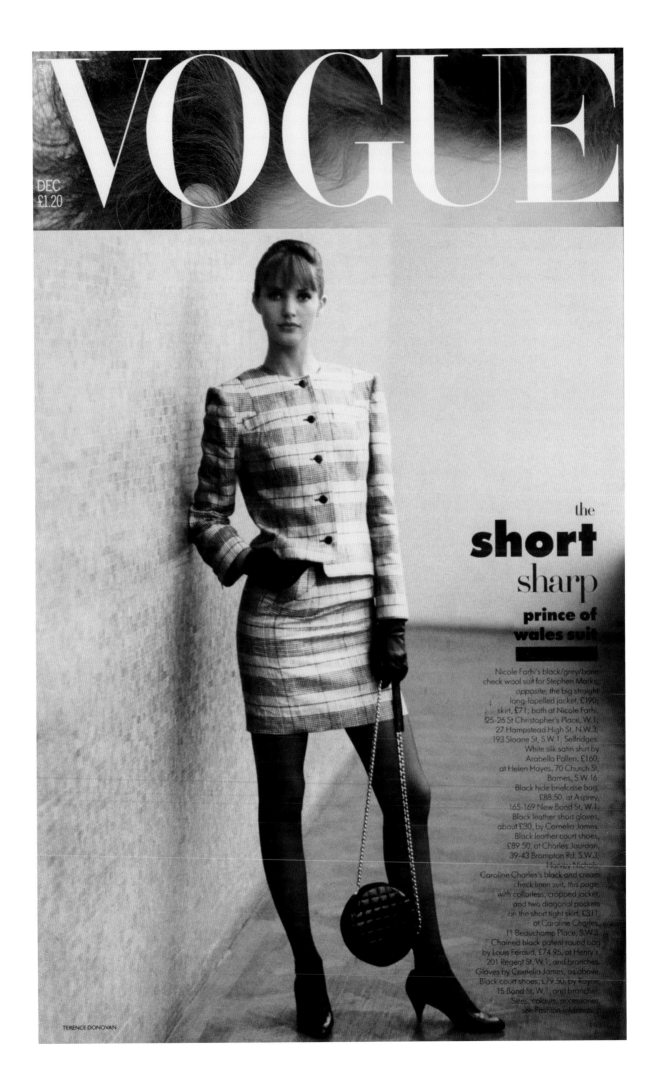

VOGUE

DEC
£1.20

the
short
sharp
prince of
wales suit

Nicole Farhi's black/grey/bone
check wool suit for Stephen Marks,
opposite; the big straight
long-lapelled jacket, £190;
skirt, £71; both at Nicole Farhi,
25-26 St Christopher's Place, W.1;
27 Hampstead High St, N.W.3;
193 Sloane St, S.W.1; Selfridges.
White silk satin shirt by
Arabella Pollen, £160,
at Helen Hayes, 70 Church St,
Barnes, S.W.16
Black hide briefcase bag,
£88.50, at Asprey,
165-169 New Bond St, W.1.
Black leather short gloves,
about £30, by Cornelia James.
Black leather court shoes,
£89.50, at Charles Jourdan,
39-43 Brompton Rd, S.W.3;
Harvey Nichols.
Caroline Charles's black and cream
check linen suit, *this page,*
with collarless, cropped jacket,
and two diagonal pockets
on the short tight skirt, £311,
at Caroline Charles,
11 Beauchamp Place, S.W.3.
Chained black patent round bag
by Louis Feraud, £74.95, at Henry's,
201 Regent St, W.1, and branches.
Gloves by Cornelia James, as above.
Black court shoes, £79.50, by Rayne,
15 Bond St, W.1, and branches.
Sizes, colours, accessories,
see Fashion Information

TERENCE DONOVAN

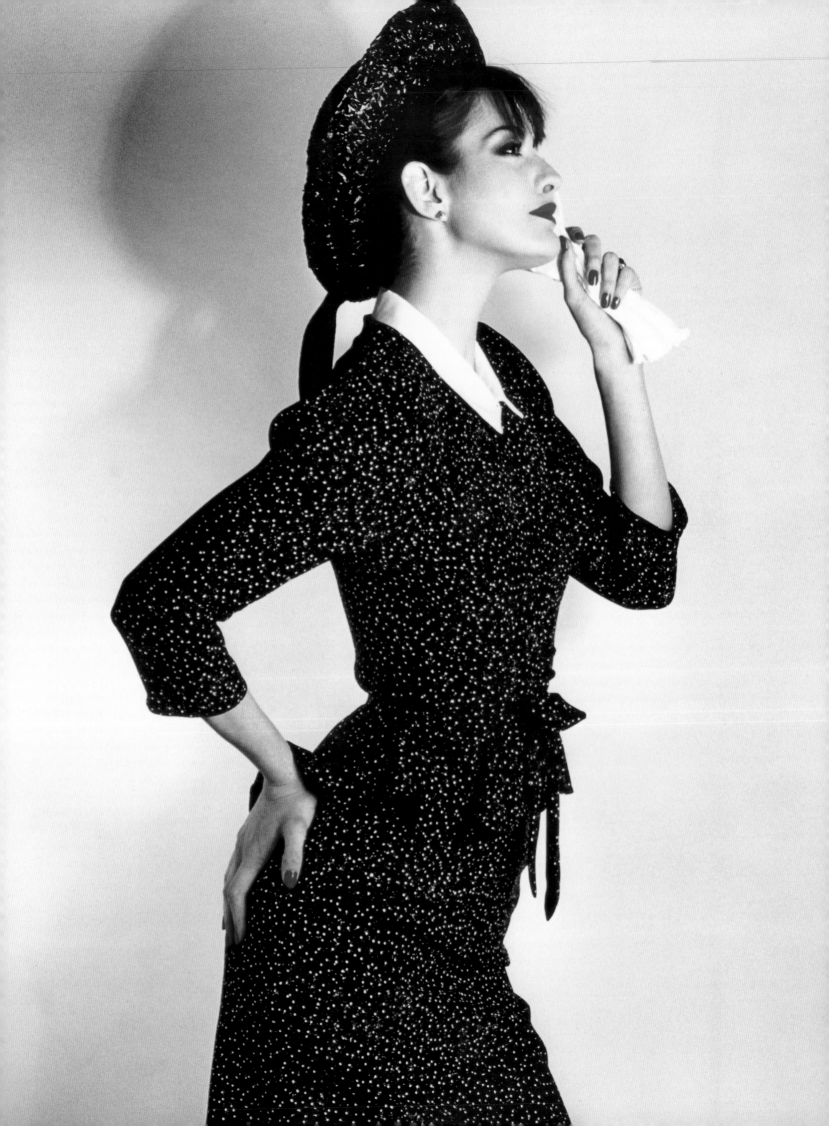

London Fashion Week took place in different places all over town, and it was particularly exciting to put on a show in the Erté ballroom at the Dorchester, with its fabulous blue glass panels. The whole ambience was thrilling and Asprey lent us some serious jewellery, including royal tiaras to put on with our silver lace dance frocks. Another interesting place we showed in for the next season was Hamilton's Gallery near Grosvenor Square and next to the Connaught Hotel. I remember the models having to change in a very narrow corridor, and the show running really fast. It came to a spectacular end with Gail Elliott, a new model and a great beauty, as the bride. The collection sold well in Neiman Marcus and other US stores and our business was going along very happily in our own shop and in the London emporia of Harrods and Harvey Nichols and Selfridges.

Then in **1983** a marvellous man called John Packer came into our lives. His job was to promote the top-quality men's fabrics from Reid & Taylor of Yorkshire, and he invited various designers to the Ritz Hotel to discuss his big show ideas. The Ritz was his centre while in London and he was as charming and clever as a man can be at harnessing the talent of young designers to traditional fabrics.

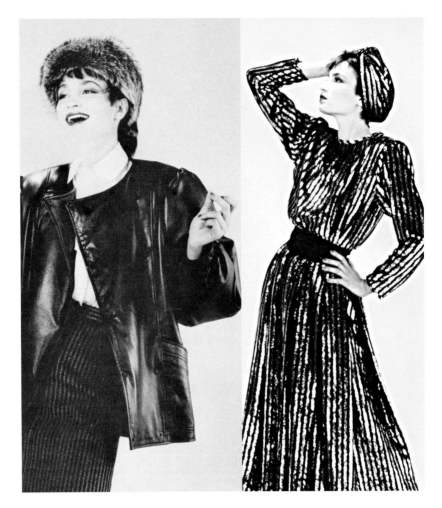

OPPOSITE PAGE:
Catherine Bailey models silk spot suit, 1983,
Robyn Beeche

THIS PAGE
LEFT:
Oversized leather jacket, 1984,
Liz McAulay

RIGHT:
Silk lamé and velvet black stripe sweater and skirt, 1984, *Liz McAulay*

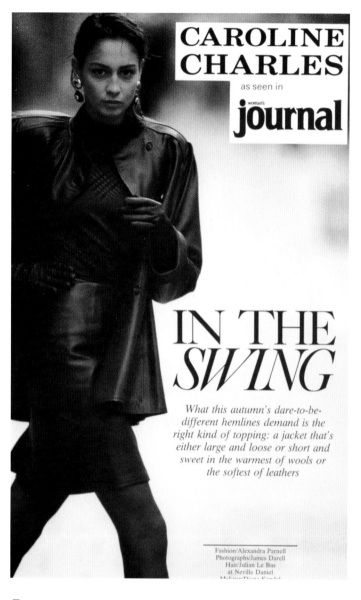

We were in New York again, working the usual round of showing our collections to store buyers and press. A treat outing was to the Carlyle Hotel to hear Bobby Short in cabaret. He played the piano and sang the classics in a really mellow 1950s way and we even got to meet him. By contrast, in London we had been to see David Bowie in concert. The new age man, he had fabulous clothes and make-up, and the performance was less pop and more Berlin cabaret, but with more theatre, more lighting and more sound.

Princess Margaret had become a client when the writer Angie Huth brought her to Beauchamp Place to choose some clothes for her visit to Los Angeles. I visited her in Kensington Palace to check that everything fitted and we chatted about the ballet, the steel workers' strike and her mother.

THIS PAGE
ABOVE:
Leather swing jacket, as seen in *Woman's Journal*, 1986, *James Darell*

RIGHT:
Caroline Charles studio sketches of swing jacket with matching skirts, 1986

OPPOSITE PAGE:
Swing leather jacket, 1986

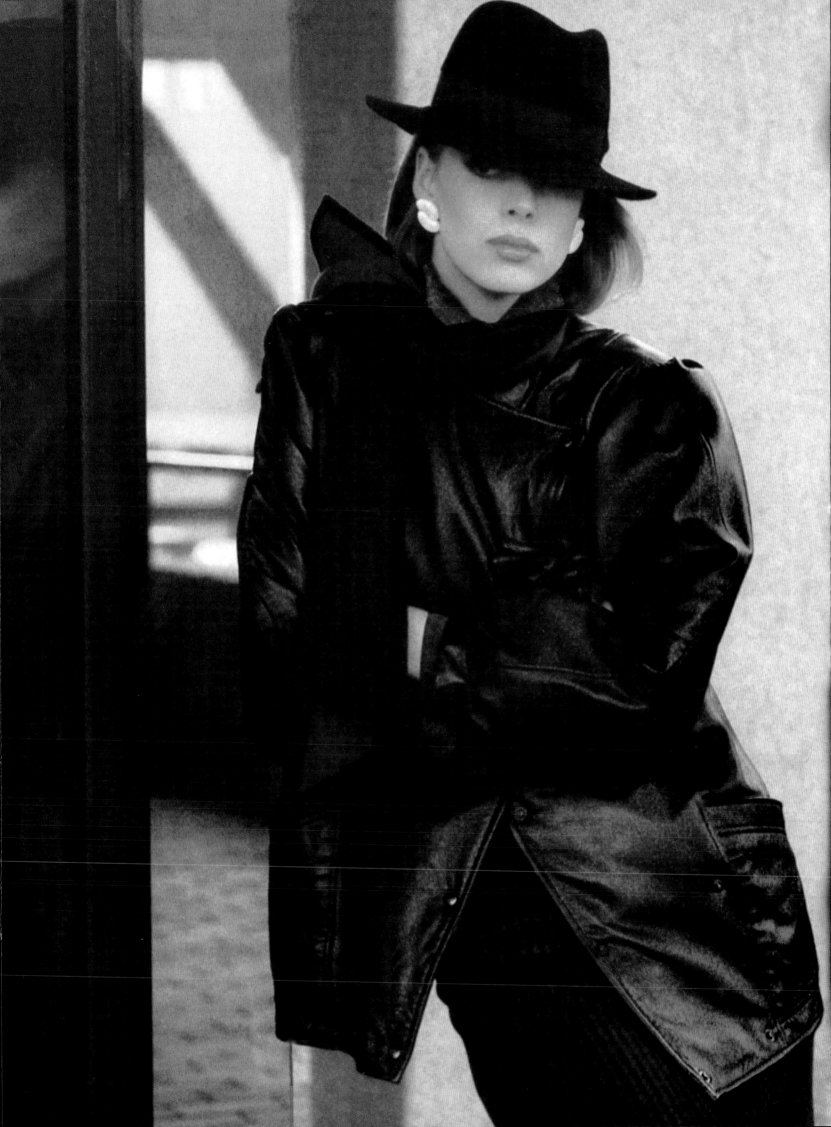

From New York we went south to Virginia to visit a shop in Charlottesville. They sold our clothes really well and we met the customers, and stayed in a lovely house with friends in Richmond. The American Civil War felt very recent with old boys sitting out under huge trees in the old town square and reminiscing, and we made a special visit to Williamsburg.

My inability to grasp the 24-hour clock nearly missed us the flight home. I am ashamed to say that we were so late that the airport staff had to arrange a car to take us out to the waiting area near the runway. It was very dramatic being on an airfield in the dark, and being driven through the runway lights in the rain. Finally, somehow we ran up the steps and banged on the door of the plane and were let in with our luggage.

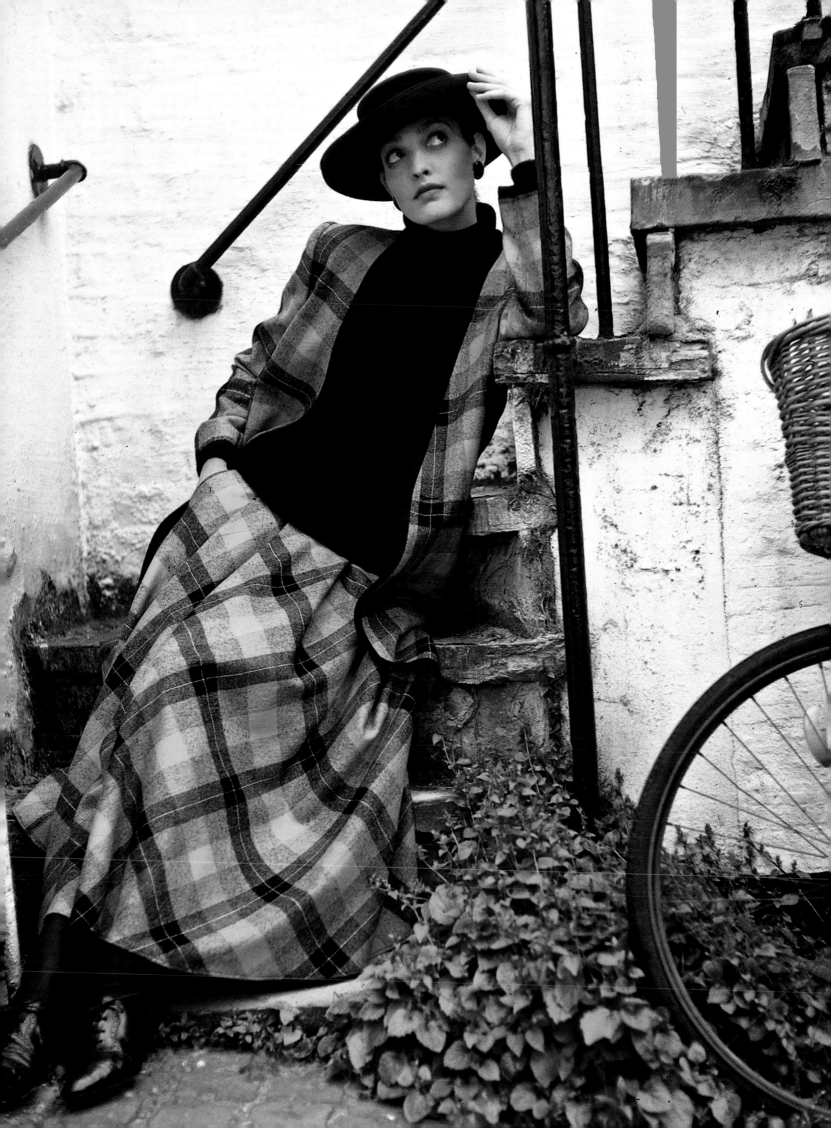

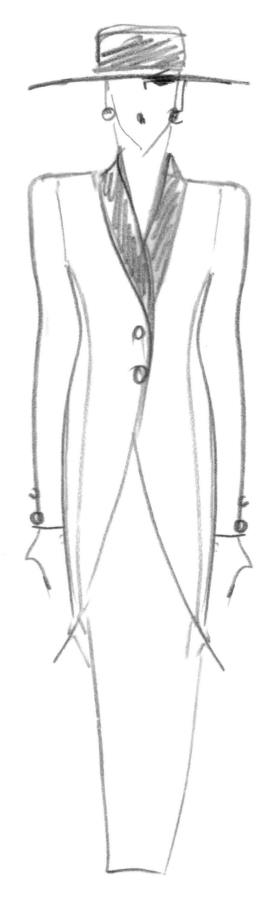

In January **1984** there was a charity fundraiser at the Theatre Royal, Drury Lane on a Sunday evening. A group of six dress designers had been persuaded to sing two songs on stage and a choreographer was appointed. Among this group were Janice Wainwright, myself and Ossie Clark. Rehearsals took place in our flat amid much merriment. The songs we had to perform were 'The Sewing Machine', a 1940s musical number and the Broadway classic 'The Show Must Go On'. On the day we were given a dressing room and at the rehearsal we duly sat at our sewing machines on stage and just got through the first numbers: "A sewing machine, a sewing machine, a girl's best friend. If I didn't have my sewing machine, I'd come to no good end…" Ossie Clark chose to bring his King Charles spaniel on stage and to sit aside observing the rest of us. There was a serious cast involved in this venture, including Judi Dench and Simon Callow amongst other theatre luminaries; so, although we dress designers were definitely not star performers, the show did go out to a full house and was filmed by TV cameras!

THIS PAGE:
Caroline Charles studio sketches, mid '80s

OPPOSITE PAGE:
Checked jacket and trousers, February 1988,
Eamonn J.McCabe/ Vogue © The Condé Nast Publications Ltd

black & white

Opposite, Caroline Charles' black and white checked wool short jacket, £208, and short black fitted rayon skirt with kick pleats, £112, at Caroline Charles, 11 Beauchamp Pl, SW3; Selfridges; Caroline's Collection, Guernsey; Monks Dormitory, Colchester. Leopard print chiffon scarf, £35, at Kenzo, 27-29 Brook St, W1; 17 Sloane St, SW1. Black leather gloves, by Dents, £23.95, at Selfridges; major stores. Sheer black tights, by Dior, £3.99, at major stores. Silver hoop earrings, from a selection, from £28, at Butler & Wilson, 20 South Molton St, W1; 189 Fulham Rd, SW3; Harrods.
This page, Caroline Charles' long wool double-breasted black and white checked jacket, £238, black and white houndstooth tapered trousers, £140, cream cashmere long-sleeved sweater (part of a twinset), £205. All at Caroline Charles. Black suede belt, by Osprey, £55, at Harvey Nichols; Selfridges; Julie Fitzmaurice, Harrogate. Triangular silver clip earrings, £65, and chunky silver bracelet, £280. Both by Malcolm Morris, at Janet Fitch, 2 Percy St, W1; David Joseph, 33 Clerkenwell Rd, EC1; The Scottish Gallery, Edinburgh.

February was the run up to our show at the Ritz. TV-am and other media did interviews and we eventually gave a breakfast show in the Ritz dining room. Mrs Thatcher threw a good party at No. 10 Downing Street and I was among the leading designers and buyers who were invited. Margaret Thatcher was an excellent host, and very good at giving one individual attention and remembering her Caroline Charles clothes. Her energy and stamina were obvious and incredible, later in the year we were all given a reception at Lancaster House to celebrate the new season.

OPPOSITE PAGE:
Velvet short evening dress with scalloped neckline. Hat made in Krin bound in velvet, 1985

THIS PAGE
LEFT:
Claudia Schiffer models a velvet corset jacket

RIGHT:
Embroidered spot velvet dress with bubble skirt, 1988, *Marie Claire*

BELOW:
Velvet and embroidered taffeta evening dress sketches, 1985

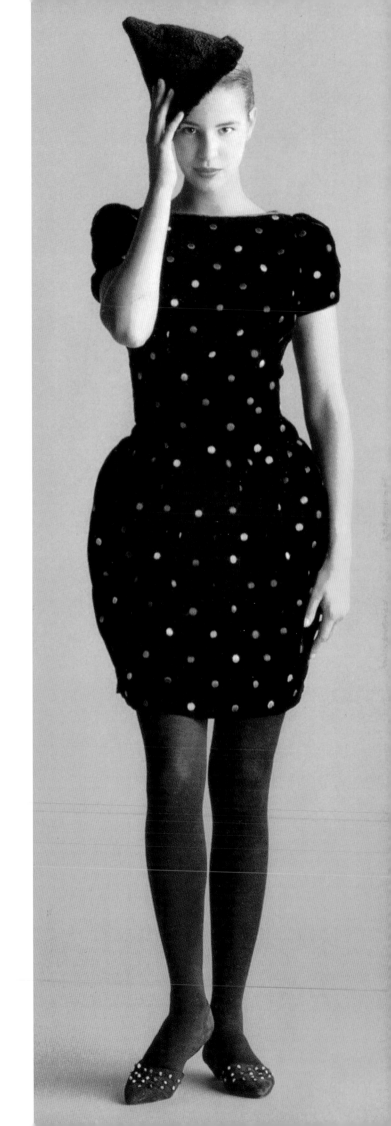

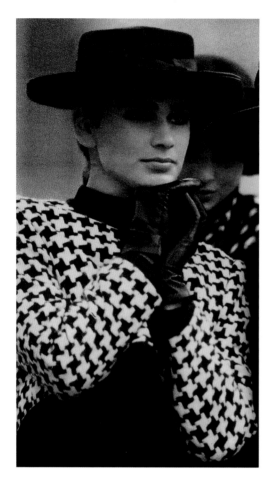

A favourite black-and-white dog tooth jacket, worn with a priest's hat in felt trimmed with ribbon, 1986

OPPOSITE: On 3 March 1987 a group of British designers put on a fashion show in the English Embassy in Paris, showcasing British design talent abroad. The designers are seen here with their models, from left to right: Ally Capellino, Murray Arbeid, Stevie Stewart, Bruce Oldfield and Caroline Charles. © *Rex Features*

BELOW:
Lisa Voyle ran the Caroline Charles studio at this time and drew very good sketches to illustrate the collections

Grey and black jersey suits and dresses, sketches by Lisa Voyle, 1986

Our Japanese agent Mr Uchinuma was in London in May and we began to lay plans for our future in the Far East. John Packer was the broker of all our good connections in that market and we owe our success there to him. In November I made my first independent visit to Tokyo travelling with my friend Solveig Hill. She had established a successful consultancy business advising many Japanese textile companies, and knew her way around.

We stayed at the New Otani Hotel, which was enormous and had the oldest garden in Tokyo with ponds full of golden carp. Yoyogi Park was one of the memorable places to visit on a Sunday, where groups of young men dressed as Elvis Presley gathered and sang to his recordings. Shibuya district contained more shops and more people than possibly imaginable; and dining in Ropongi was full of gangsters in waiting cars, engines purring and, yet, not threatening. One evening we travelled out to a residential area to spend an evening with an architect and his wife. Shoes off, of course, and the welcome was charming, the house tiny and neat and there was no fear of crime as we walked in the streets late at night. There were two other evenings of contrasting outings: one with a friend in the drink trade, who took me to many bars and a cabaret club with an all-boy cast dressed as girls – very 'La Cage aux Folles'; the other, dinner at the Brazilian Embassy in Tokyo where another friend was married to the Ambassador. The house and embassy were in an excellent modern building and, of course, my friend had learnt good Japanese.

The first meetings with Fujii Keori took place and we worked together from then on for many years. They were a family business with men's and women's clothing, a driving school and various other unrelated companies, which was typical of Japanese business then. The Japanese *WWD* and other newspapers ran interviews about a London designer visiting Tokyo and of course had heard of the 'Lady Di' connection. However, they didn't want to know that I had played tennis with the Japanese Emperor's son, then a student at Oxford. Apparently that was not allowed to be mentioned!

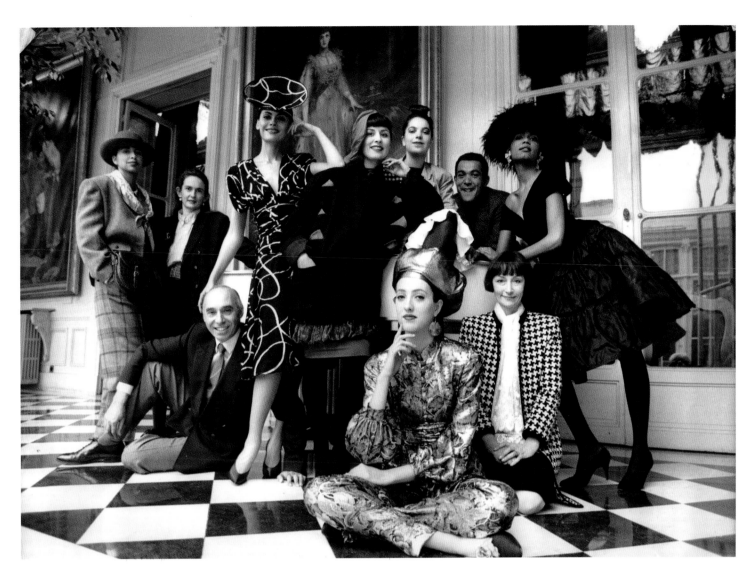

The V&A had a gallery known as the 'Boilerhouse', curated and run by the multi-talented Stephen Bayley, and they had put on the first really modern Japanese designer show for Issey Miyake. We had dinner in the Bayleys' house and it was interesting to meet him. His English was perfect and he was a very open spirited man. In May we were in Oporto in Portugal as the British judge at the Portuguese fashion 'Oscars'. These were held at Palácio de Cristal, and the Spanish star designer Adolfo Domínguez was a co-judge. In June we worked in Paris, and in October in Como doing fabric research before jetting off to Tokyo in the November. This was a very different journey as by now we had signed our contract with Fujii Keori, and Malcolm and I were travelling as their honoured guests: this was first-class tickets, the 5-star Okura Hotel, tickets to a Kabuki theatre performance and chauffeur-driven

luxury! It was also clear to me that our Japanese hosts were very happy not to have to deal with a woman on her own.

February is the month that Japanese fashion business people like to travel and so it became our turn to entertain a large group in London. We gave a show in our Beauchamp Place shop and a supper party on a river boat on the Thames. The supper provided on board was very 'picnic', including scotch eggs, our singer-songwriter son, Alex, gave a performance, and then we all danced to tapes of Elvis Presley. Friends who lived on the Thames on the Isle of Dogs put out a banner welcoming the company. Unfortunately the boat windows steamed up so our guests didn't get much of a view, but we had been told that the Japanese like private spaces when abroad!

Liza Minnelli, Lorna Luft and Eddie Rayne in the front row of a Caroline Charles fashion show, 1986

BELOW:
Black cut-velvet slim evening dress, 1986

OPPOSITE PAGE:
Catherine Bailey models black cut velvet evening dress, 1986, *Jonathan Postal*

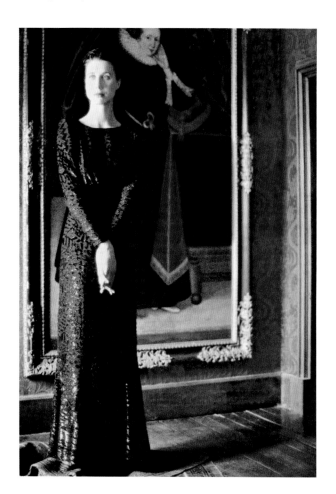

March **1984** brought round London Fashion Week and more parties were held at Lancaster House and the Hyde Park Hotel. Our newest celebrity clients were Liza Minnelli and her sister Lorna Luft, who were both charming and both top singers. Judy Garland had lived close to Beauchamp Place so they felt quite relaxed with us. Liza kept choosing clothes from the collection for her friend Meryl Streep, who is one of my favourite actors, so I was delighted. We also had more visitors from Japan who were leading wedding dress makers and we agreed to design for them and to license the Caroline Charles brand name.

By May we were on the plane to Tokyo stopping to re-fuel in Moscow. There we found our friend Nolan Hemmings, who was travelling with and part of the Peter Brook touring production of the *Mahabarata*. So there we all sat, drinking sweet dark wine in the airport bar lit by one 40-watt bulb. Later, in Tokyo we sat in on a part of a rehearsal for this monumental performance, which lasted a full 10 hours.

The Hotel Plaza, Osaka was our next stop and there were many press interviews and even a press conference with 14 journalists present. Of course this was all conducted through an interpreter and at one point I realised they were being told I was older than I was. This was because age was much revered in Japanese culture – hurray!

Kenroku Fujii and his wife hosted a nine-course French dinner for us and his honoured guests; definitely one up on our river boat outing.

Back to Tokyo on the bullet train, which was the fastest and most fun train imaginable: step on at your allocated number on the platform and leave within a minute. Girls brought food on trolleys calling out the "konnichiwa" greeting and bowing as they enter and leave the carriage.

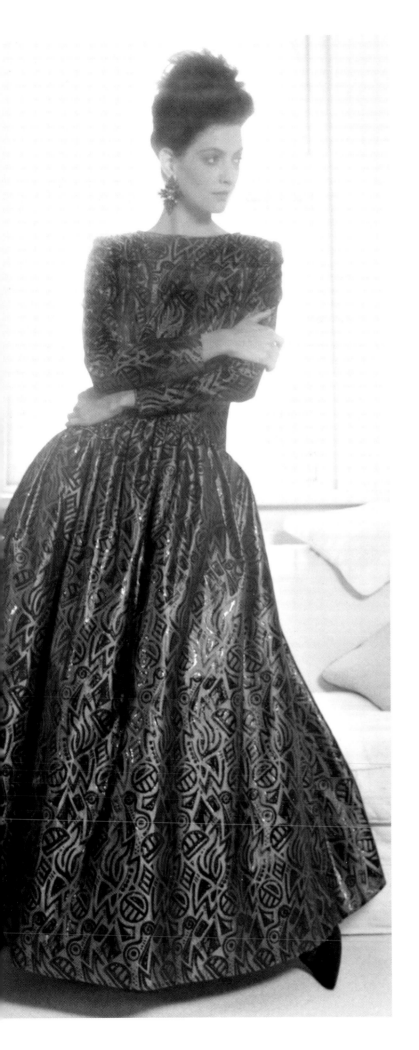

There were at least three immaculate restaurant cars serving food from different countries, meanwhile the scenery was flying by of villages, orange groves and hills… Malcolm had cricked his back and was bent in a perfect Japanese bowing position, which caused everyone to bow to him at least three times. The bowing protocol is complicated by concepts of seniority.

We were very spoilt on this trip and taken to a high-season Sumo wrestling match. We entered a large stadium going past a bamboo tower where a drummer was perched high up, summoning people by drum! There were many stalls selling delicious food in the entrance and a rather handy tray for food and drink built in to the seat. Like in Kabuki theatre, or at the Italian Opera, the audience called out to cheer on their favourites, and there was a very intense, festive atmosphere. The wrestlers were young boys from the country who had been well fed and grown tall and heavy. Like geisha girls, they belong to a stable or group and when not in the ring, you see them walking around in blue kimonos looking very gentle. Apparently the successful sumo fighters retire young and run their own bars.

We put on a fashion show at the British Embassy, which was very well organised; not to have to be backstage was quite a relief. The Japanese like Caroline Charles clothes to be elegant and simple. Tailored jackets in high tweeds, flannel trousers and embroidered coats were in the collection and, of course, the signature black-and-white pieces that the Japanese like, as I do. The beautiful model girls wore each piece perfectly. English tea was served and there were lots of people to talk to, from a Princess to actors and business people. The show was then put on again, this time in Kyoto; at the press conference, I made my speech via the interpreter again, to the 30 attentive journalists.

In April **1984**, Malcolm and I were back on the plane to Tokyo. This time we took our daughter Kate with us. Being in the theatre, she was a great communicator and soon had many of our non-English speaking Japanese colleagues understanding what we were designing and for whom. The treat outing on this trip was a visit to Mount Fuji, where we had the extraordinary opportunity to walk just above the snow line, and go boating on a nearby lake. This was the first time in all of the journeys to Japan that we had been to any of the real tourist spots, and we enjoyed making friends with other tourists, mainly from South Korea, and taking holiday snaps.

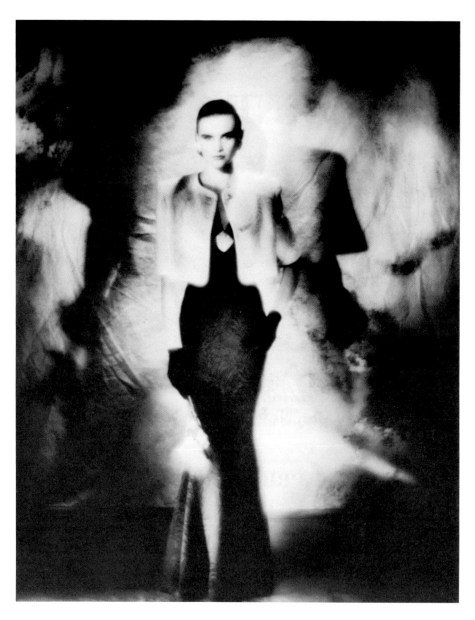

Caroline Charles advert inspired by Hitchcock's *The Birds*, featuring a white jacket over a long slim ball dress

OPPOSITE PAGE:
Catherine Bailey models velvet dinner dress, 1985, *Robyn Beeche*

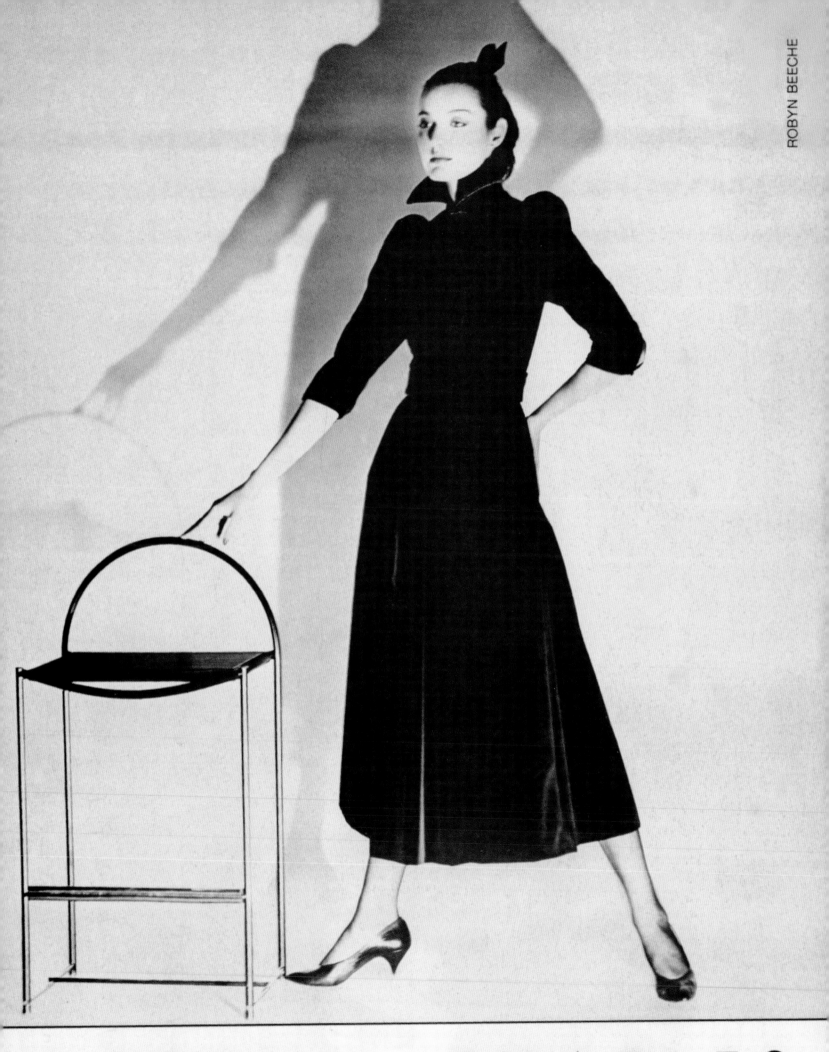

ROBYN BEECHE

AROLINE CHARLES

9, BEAUCHAMP PLACE, LONDON S.W.3 01-584 2521

Pale grey silk lamé dinner jacket and trousers
Caroline Charles advert, 1985, *Robyn Beeche*

Opposite page
Left:
Soft silk satin dress in pearl colours
Caroline Charles advert, 1985, *Neil Kirk*

Right:
Caroline Charles studio sketches of silk dresses, 1985

Black heavy jersey cape; velvet ball dress; grey flannel day dress, 1987/88, *Martin Brading*

BELOW:
These Caroline Charles studio sketches ran in a *Vogue* advertising campaign, 1988

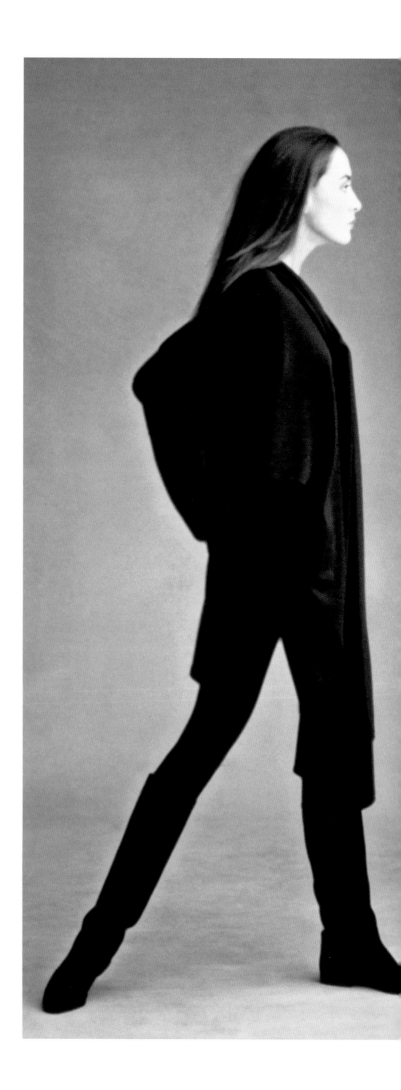

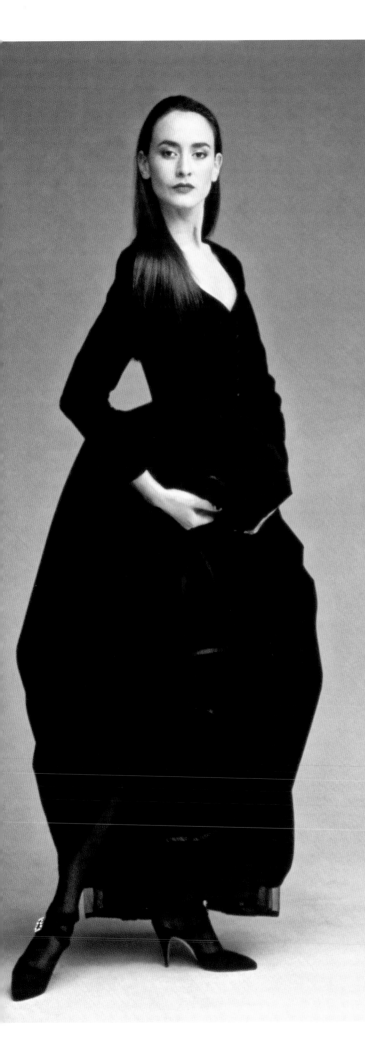
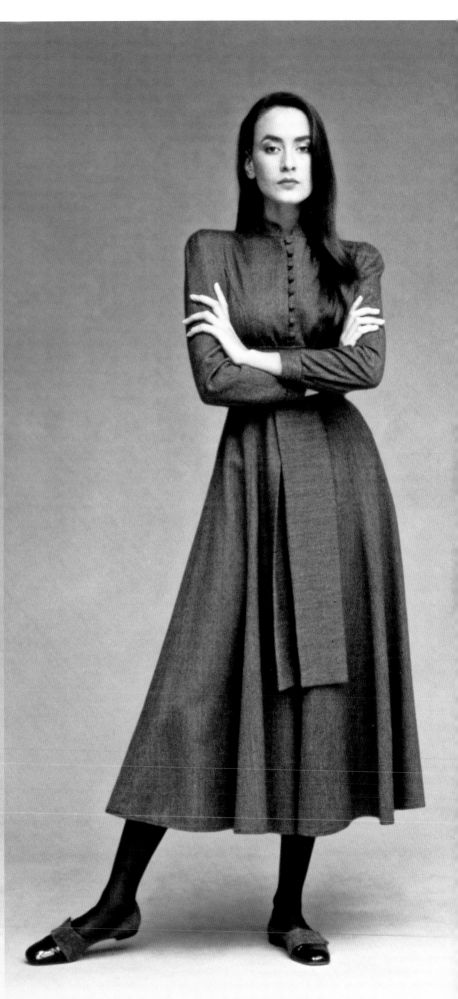

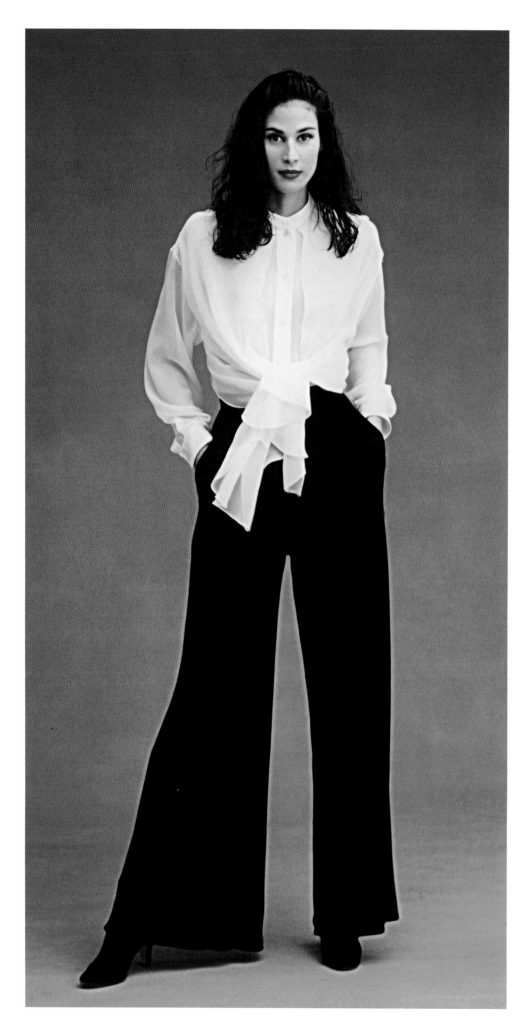

Caroline Charles advertising images, which ran in *Vogue*, 1988

LEFT:
White double silk georgette blouse and jersey trousers, 1988, *Martin Brading*

OPPOSITE PAGE:
Halter neck tomato-red silk georgette short dance dress, 1988, *Martin Brading*

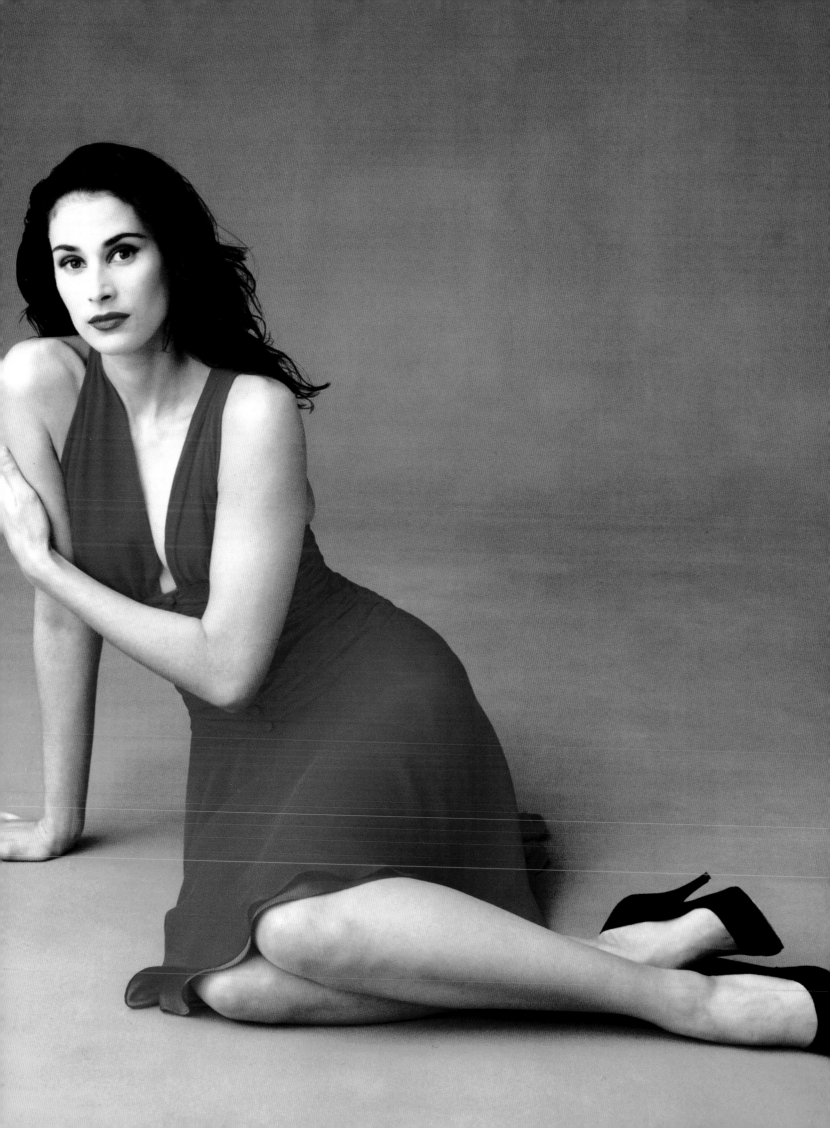

1987

At the same time, Caroline Charles collections were being prepared for another show at the Ritz and many new shops were buying our clothes, while celebrity actors like Diana Rigg and Julia McKenzie became clients. The Princess of Wales came to visit again, this time with Anna Harvey from *Vogue*, and it was obvious the Princess had become the prettiest flag waver for British fashion on the international scene.

Our Autumn journey started in Mumbai looking at fabrics and being given a party by Chandu Moraji, a wonderful friend. Next we went to the Mandarin Oriental Hotel in Hong Kong to have meetings with Haruna Adolph a woman who looked as if she'd walked straight out of a James Bond movie in her Alaïa dress and extremely high-heeled shoes.

Next stop was Kyoto, where we were part of a big bridal fashion show. Our licensee had put together Halston from New York, Valentino from Rome, Kenzo from Paris and Caroline Charles from London; the show was fabulous and the press loved it!

We had a good time going to lots of small bars in high-rise buildings, playing different rock and jazz, as well as another visit to a Kabuki theatre. There was also a special highlight of an hour spent with a geisha girl! This was a meeting arranged in one of the many small lanes in Kyoto close to the river. We sat in a bar with an interpreter, and discussed her clothes and make-up. There was something thrilling about seeing these girls in full make-up and costume at night by lantern light. From Japan we flew to San Francisco. The Christmas spirit was on in full US style, and we talked about opening a new shop there before getting home to London and lots more Christmas parties.

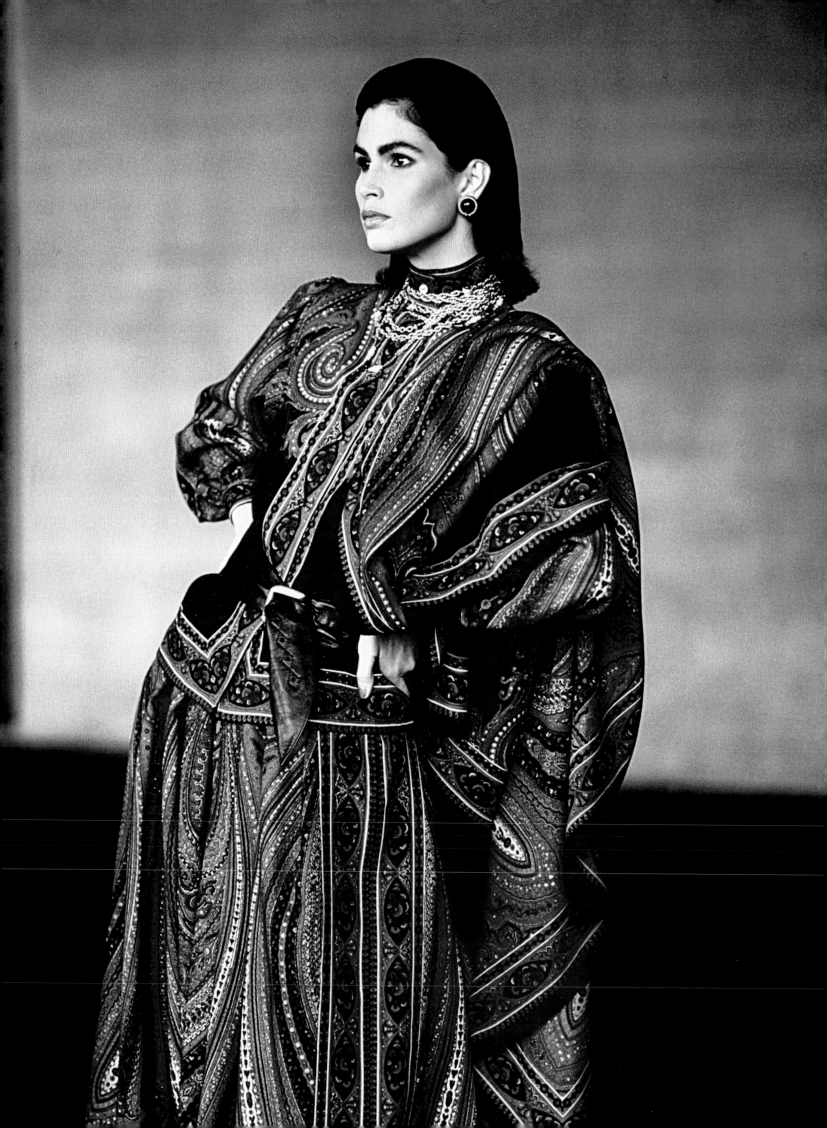

Another excitement later that year was making a dress for the Pirelli calendar shoot. This, of course, entailed running a Pirelli tyre track over our silver sequinned dress. The shoot was at the Ritz Hotel, and the photographer was Norman Parkinson, no less.

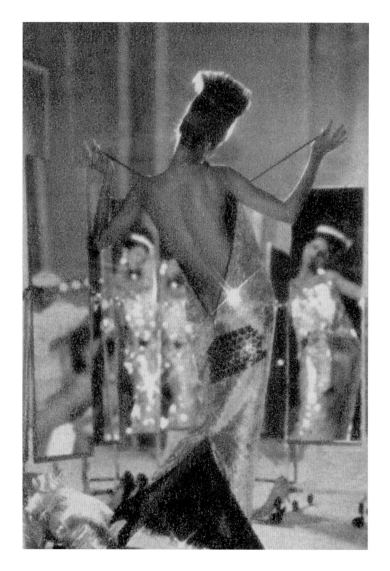

ABOVE AND OPPOSITE PAGE:
Parkinson photographed the silver sequin halterneck dress (above) and sequin long-sleeve dress (opposite) for the infamous Pirelli calendar, 1985. *The Sunday Times* **magazine ran these images from the shoot, 1985 ©** *Norman Parkinson Limited/ Courtesy Norman Parkinson Archive*

THE SUNDAY TIMES magazine

OCTOBER 28, 1984

PARKINSON RESTYLES THE CALENDAR GIRLS

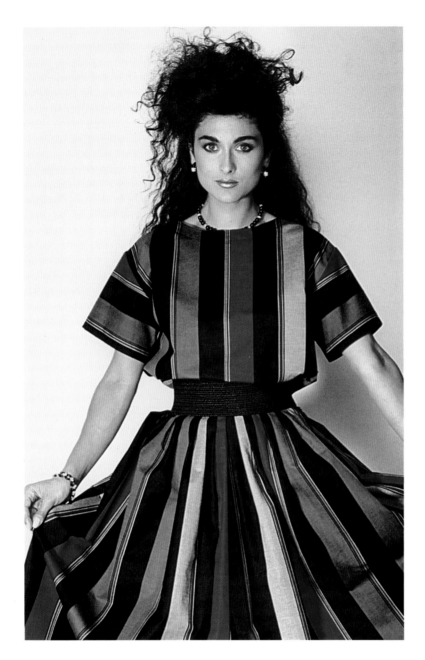

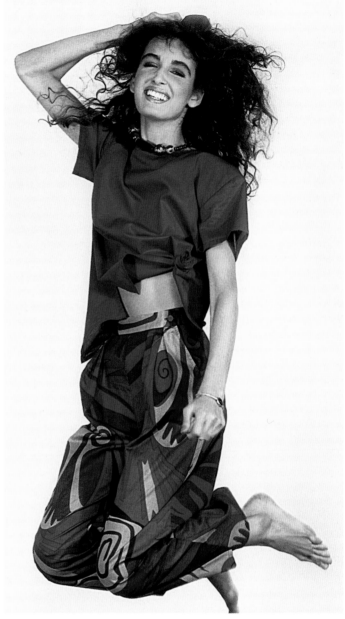

Mid 1980s, *Robyn Beeche*

By now we had started to develop more knitwear and jeans and weekend clothes and so we considered taking a small shop in Brompton Cross for this collection. The Michelin building boasted Conran, as well Issey Miyake and Joseph. It felt like the new retail hot spot, and we were happy to be part of this trend.

The next idea was to expand with a home and bed linen collection, for which we teamed up with Dorma. They were largely a Manchester-based business with a very extensive manufacturing and printing works and were part of the Coats Vyella Group. The first designs were printed on finest thread count Egyptian cotton and sold in limited quantities, being rather expensive.

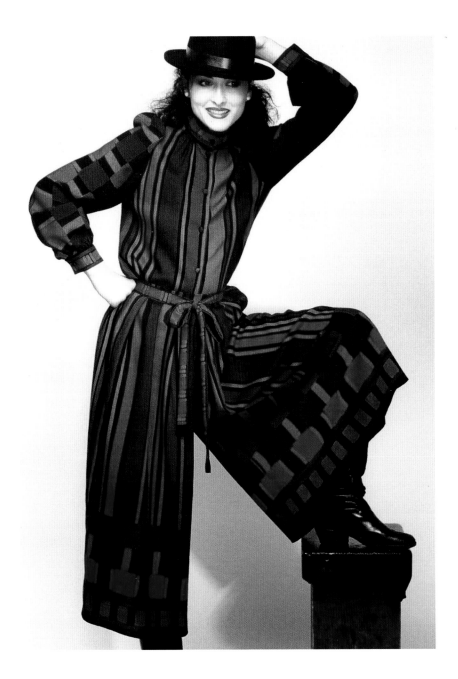

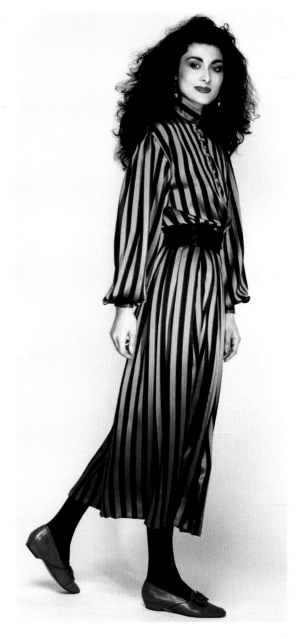

Things were hectic, to say the least: we were working on our new bedlinens, as well as our stockings and tights range, dress-making patterns for Style, plus the jewellery, and the work for collections to be made in Japan… However, our core was always the Caroline Charles collection and in October that season we showed in the London Fashion Week tent followed by a party at 10 Downing Street and a designers' dinner at San Lorenzo.

Amongst the various invitations was an irresistible one from Veuve Clicquot to join a group to fly in their private jet from Luton to Rheims. We toured the vineyards and were told the story of the widow running the champagne business and selling to the St. Petersburg élite. In Paris there was a luxe dinner and a night at the glamorous Lancaster Hotel just off the Champs Elysées.

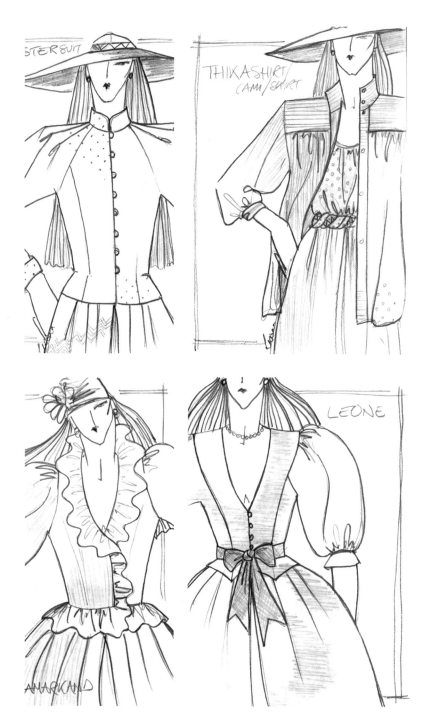

Caroline Charles studio sketches: spot-printed linen, cotton stripes and silk taffetas, 1987

Seersucker cotton separates in gentle colours for summer, 1987, *Robyn Beeche*

The following day we went to Longchamp for the big Arc de Triomphe race meeting; it was interesting to be part of Monsieur Arnault's LVMH group. The French dressed up in big hats and Chanel suits and we all drank lots of delicious champagne. The clever David Smith and David Russell did the advertising for Veuve Clicquot in London and they included us and Patricia Hodge, one of my favourite actresses, in this good outing.

In December *The Clothes Show Live* invited us to be in Leeds with Jeff Banks and his team. This was a very popular fashion event hosted and promoted by Jeff who really brought fashion on to the TV screens of the nation. We were quite regular guests on this show, which went out weekly, covering the whole gamut of fashion, from home dressmaking to haute couture and everything in between.

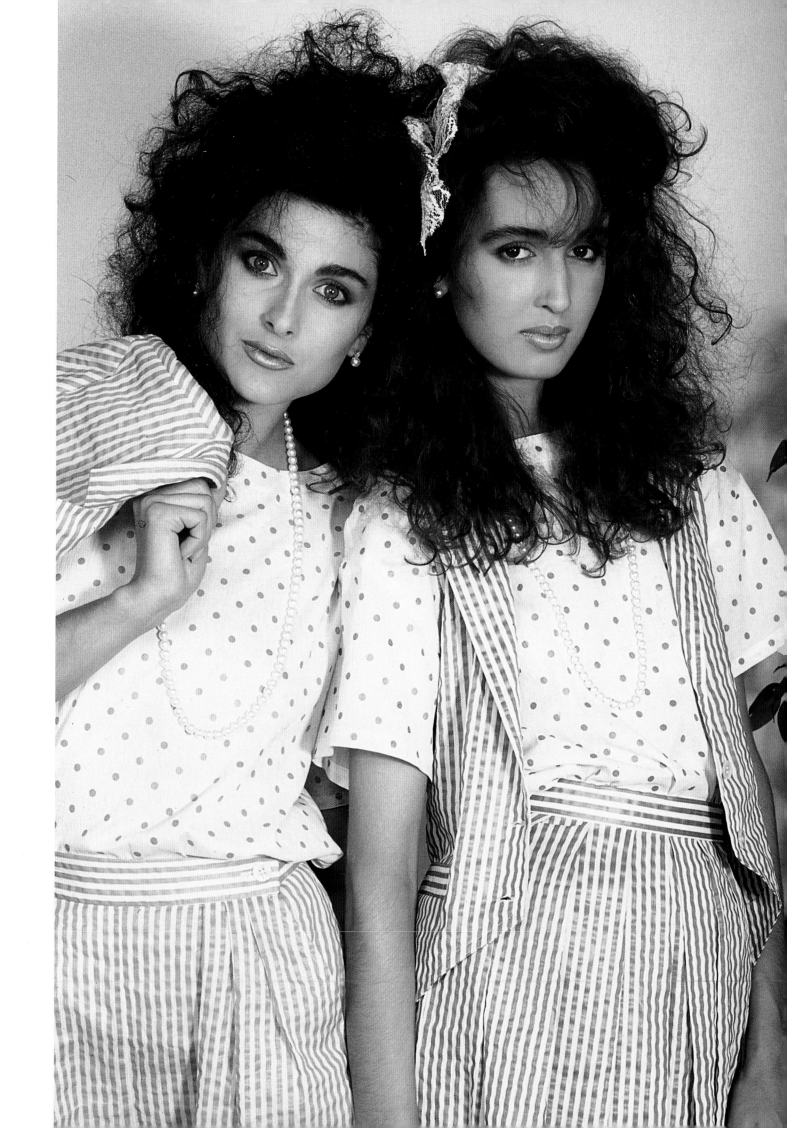

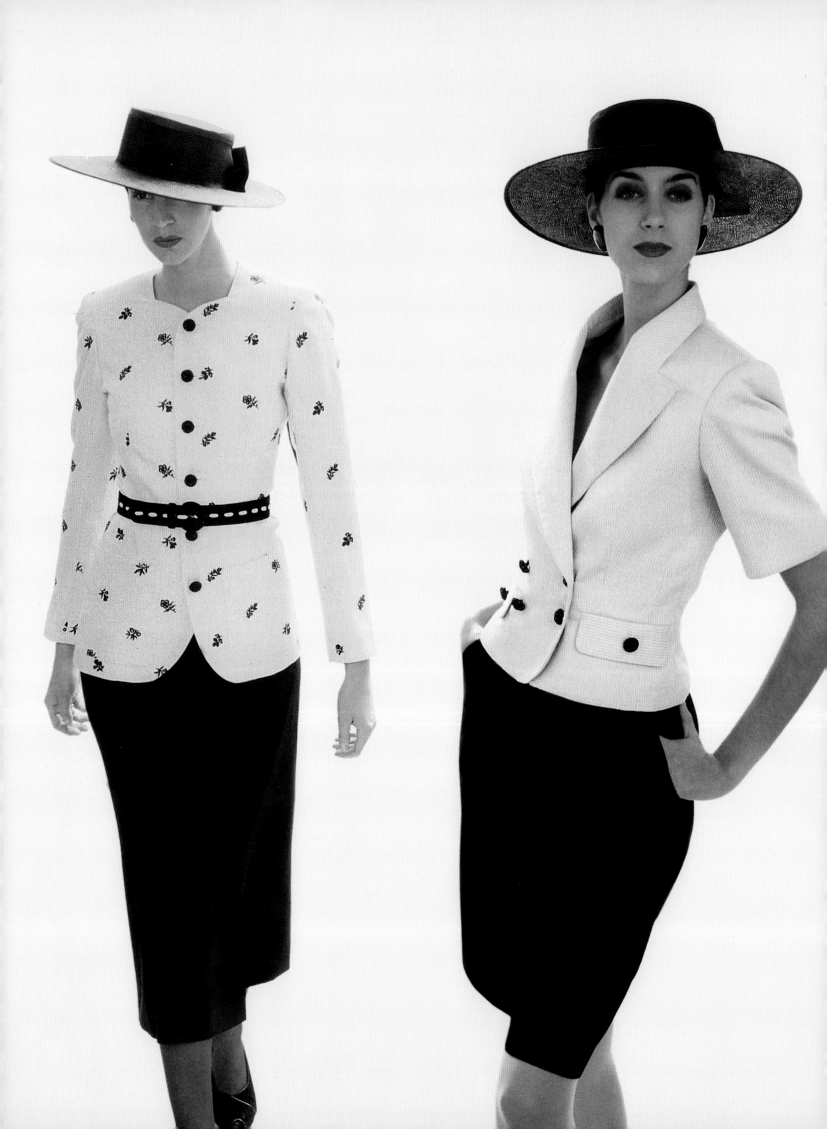

In early spring of **1988** we signed two new design jobs, which were as diverse as they were interesting. The first, in London's glamorous West End, was with Garrard to make a collection of semi-precious fashion jewellery; this was run by Edward Green, who introduced us to the intricacies of the jewellery world. The second was a contract with Aristoc, based in Nottingham, to make Caroline Charles tights, stockings and socks, and to help them with colour and pattern advice. Aristoc was run by Sue Clague and we enjoyed many years of working together to produce the successful Caroline Charles tights and stockings range. It was always thrilling to see our cream-coloured packaging in the stores, and the sales were strong. London designers licensing their names to manufacturing companies was a new thing following on from many successful tie-ups in France with Dior and the US with Calvin Klein.

In March we put on the Caroline Charles show in the theatre in Olympia. For the finale, the ball dresses were inspired by Marie Antoinette with tiny bodices and big netted skirts made in French brocades, beads and sequins and we used real 18th-century wigs on all the girls. The only problem was that the modern girls' heads were not the same size as the wigs, which made for a very mixed effect! The London Fashion Week whirled on with Murray Arbeid's glamorous party at the Royal Opera House, the Designers' Party at the Science Museum, and the Harvey Nichols party.

The same month there was another fitting to do at Kensington Palace, and another meeting at the Ritz with John Packer who was planning yet more fabulous and exotic fashion shows.

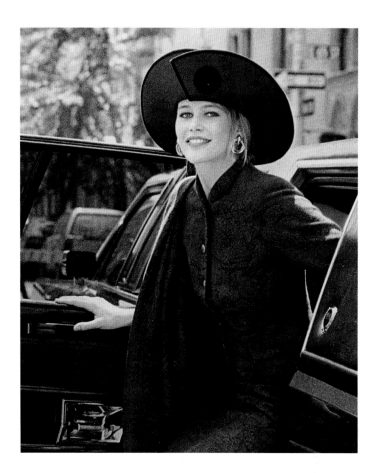

OPPOSITE PAGE:
Summer linen jackets, worn with straight black skirts, 1989, *Catwalking*

ABOVE:
Claudia Schiffer models a Caroline Charles wool suit for a *Dickins & Jones* advert, 1990

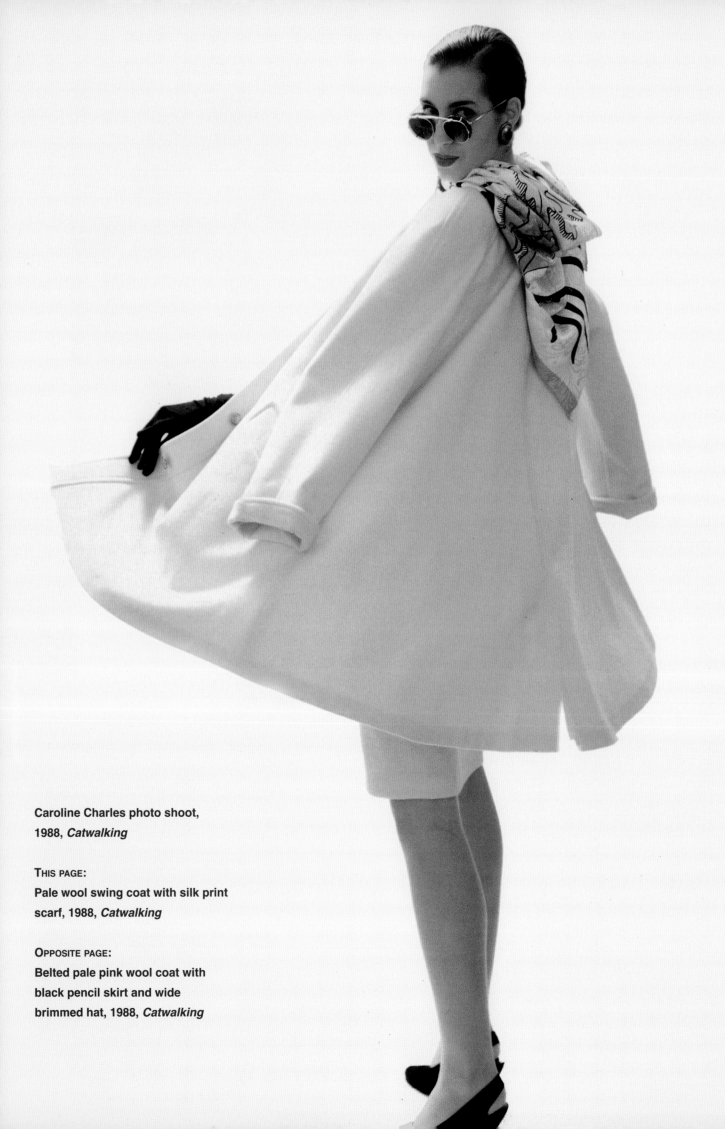

Caroline Charles photo shoot,
1988, *Catwalking*

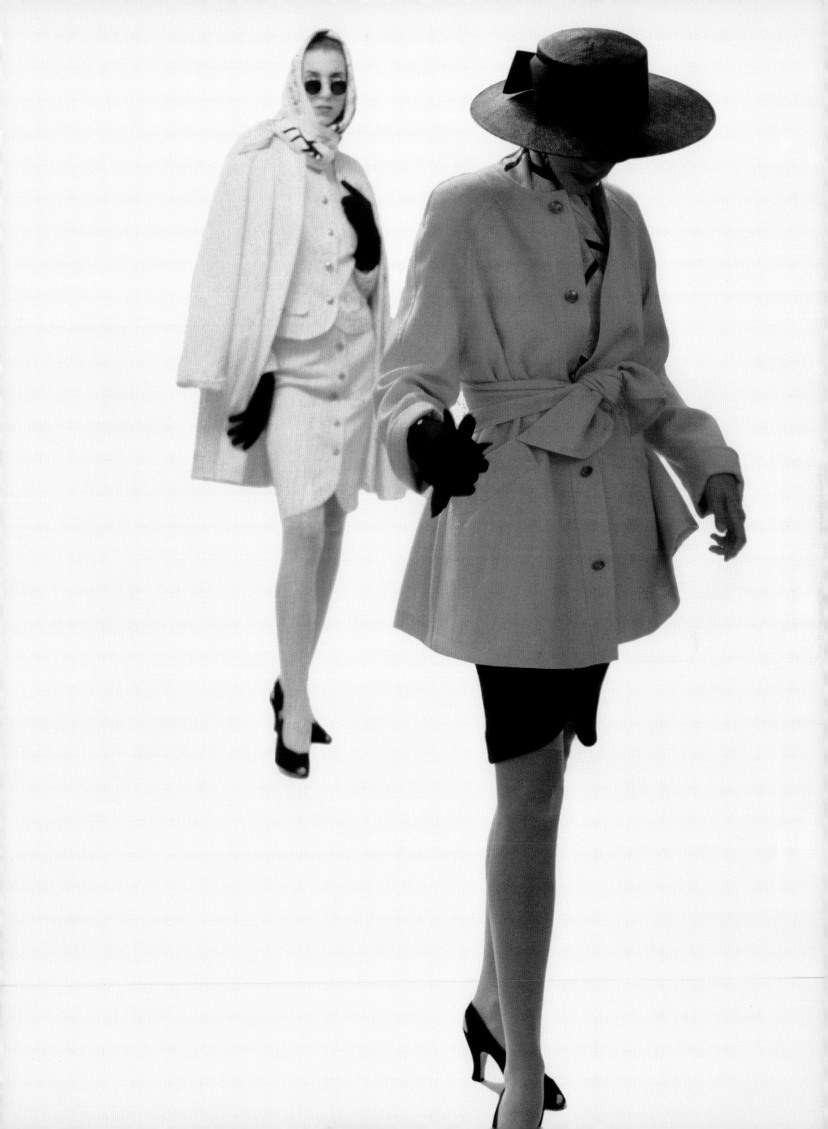

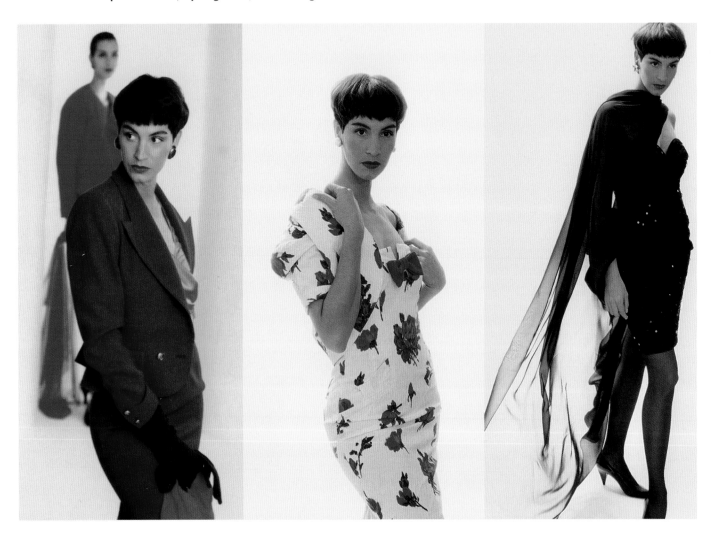

We flew from Tokyo to Taipai in Taiwan at the request of a textile company, who were interested in licensing the Caroline Charles name to put down the selvedge of their fabrics. We travelled there and back to Tokyo in the same day, but it was exciting to meet Taiwanese people, who were so completely determined to build their country up to rival Japan. Back to London in mid-December and one more trip, this time a little closer to home: to Manchester to work with the bedlinen people who made the Caroline Charles collection.

In the January of **1989** we started the New Year off with another new product – men's ties. The fashion for brightly printed ties in soft silks suited us ideally, having a workroom full of short lengths and leftovers. We found an excellent tie maker who made up our selection and they started to sell well in our Beauchamp Place shop. Interestingly, they were not, in the main, bought by women as presents, but by men who shopped happily amongst the frocks. The V&A asked us for some of our ties for their collection, and these were shown in their costume department at the time.

February brought our Japanese partners back to London, and another River Boat party and a special fashion show just for the seventy people who had come, these were a mixture of small fashion shops and larger store buyers plus the hosting company who we worked with. Our London Fashion Week show followed in March, and a glamorous London designer party in Claridge's welcomed the foreign journalists and buyers for the opening of the season. Annette Worsley-Taylor, who had for many years organised fashion week, and was also a great party giver, chose the French Revolution's 200th anniversary as this party's theme.

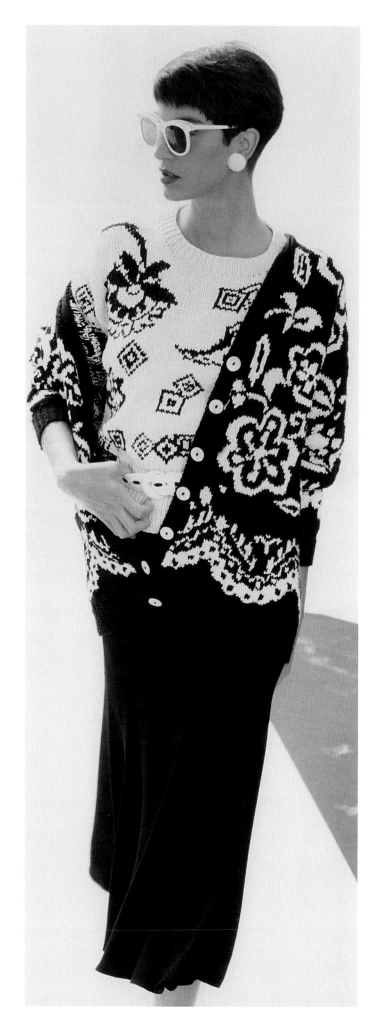

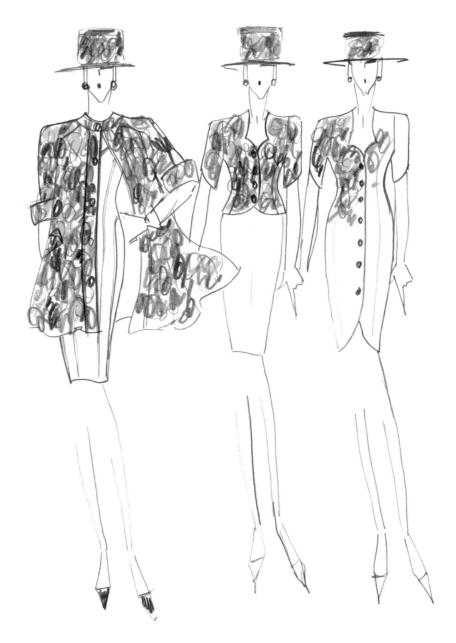

Floral printed linen garments,
Summer 1988

OPPOSITE PAGE:
Floral-print linen samples for the
Caroline Charles catwalk show,
1988, *Catwalking*

The Caroline Charles wedding dress licensees from
Kyoto came over for meetings and a proposal for
another design project. This time, to make a dress
collection for Burberry, who were keen to develop
their womenswear business, particularly in Spain. The
manufacturer was Gordon Morgan and we went out to
discuss the plan in San Lorenzo. It just so happened
that the Princess of Wales was lunching in a secluded
corner of the same restaurant and waved to say hello
… and like magic, the Burberry deal was done!

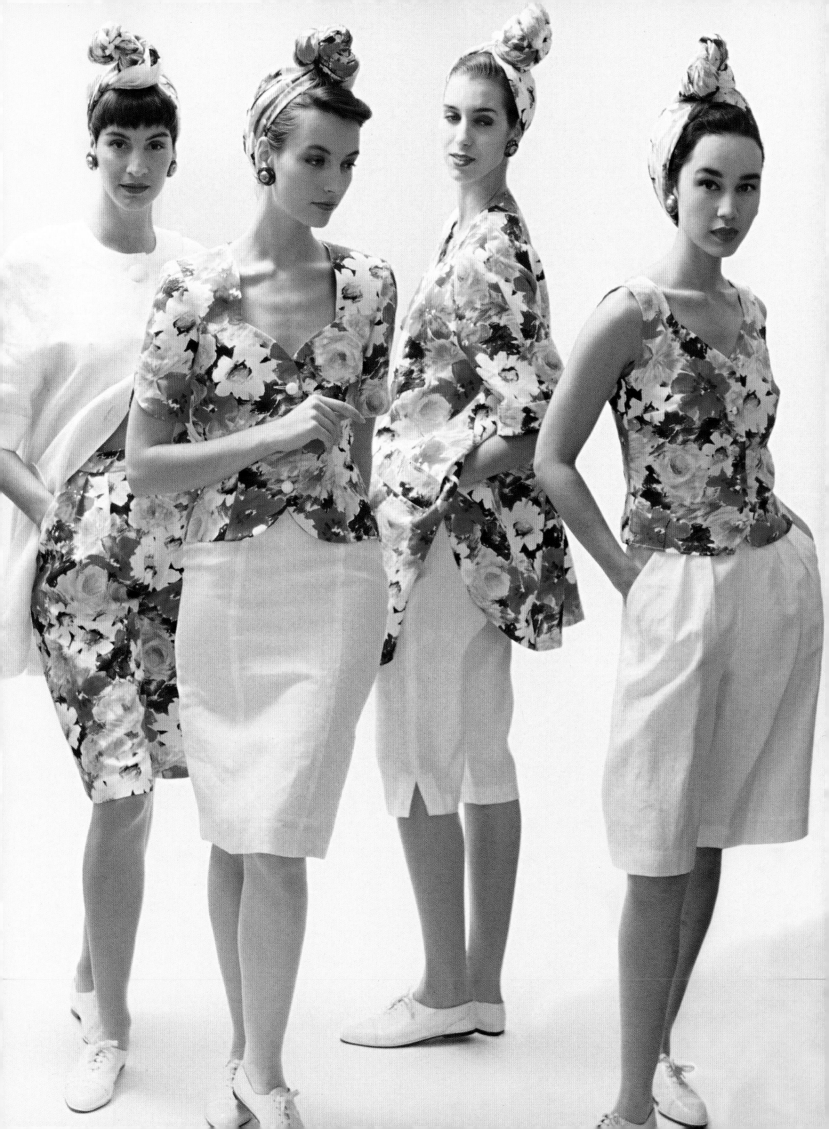

Vogue hosted a party at the Royal Academy of Arts, Piccadilly, in June for Hardy Amies' 80th birthday; as always he was debonair and amusing. The David Mlinaric party at the Royal College of Art was another memorable evening, as he had actors dressed as statues and white overalled mime artists up ladders pretending to be painting the ceiling, while we all had dinner. David Mlinaric was a very important part of our lives that autumn because he was designing and overseeing the renovation our 1830s flagship building. We had at last achieved a double-fronted building of two whole houses in Beauchamp Place! As well as complete renovation, it needed to be made ready for our shop, showrooms and offices. Finally, after several nail-biting delays, the opening party took place, with a big crowd, champagne and a jazz band. What the happy guests couldn't have guessed was that in a final drama that very morning the black-painted floor boards had still been wet! Every local hairdresser lent us their hairdryers and we ran hot air up and down the boards until, just in time, they were dry…

Text and sketches by Colin McDowell

96

Printed summer dress, 1988, *Colin McDowell*

OPPOSITE PAGE:
Shift dress and linen floral jacket, Summer, 1988

As we now had the space, we were able to commission wonderful new hats for a millinery section and new silk underwear for our lingerie department, and even set up a small bedroom area with our bedlinen alongside our pyjamas and dressing gowns. It was the designer doll's house dream, and we did lots of press photography and TV filming, which, happily, resulted in plenty of customers coming to visit.

ABOVE:
Painterly print silk dress 1985

OPPOSITE PAGE:
**Floral halterneck top and flared
skirt, June 1988, *Harper's Bazaar*
© *ICP, David Seidner Archive***

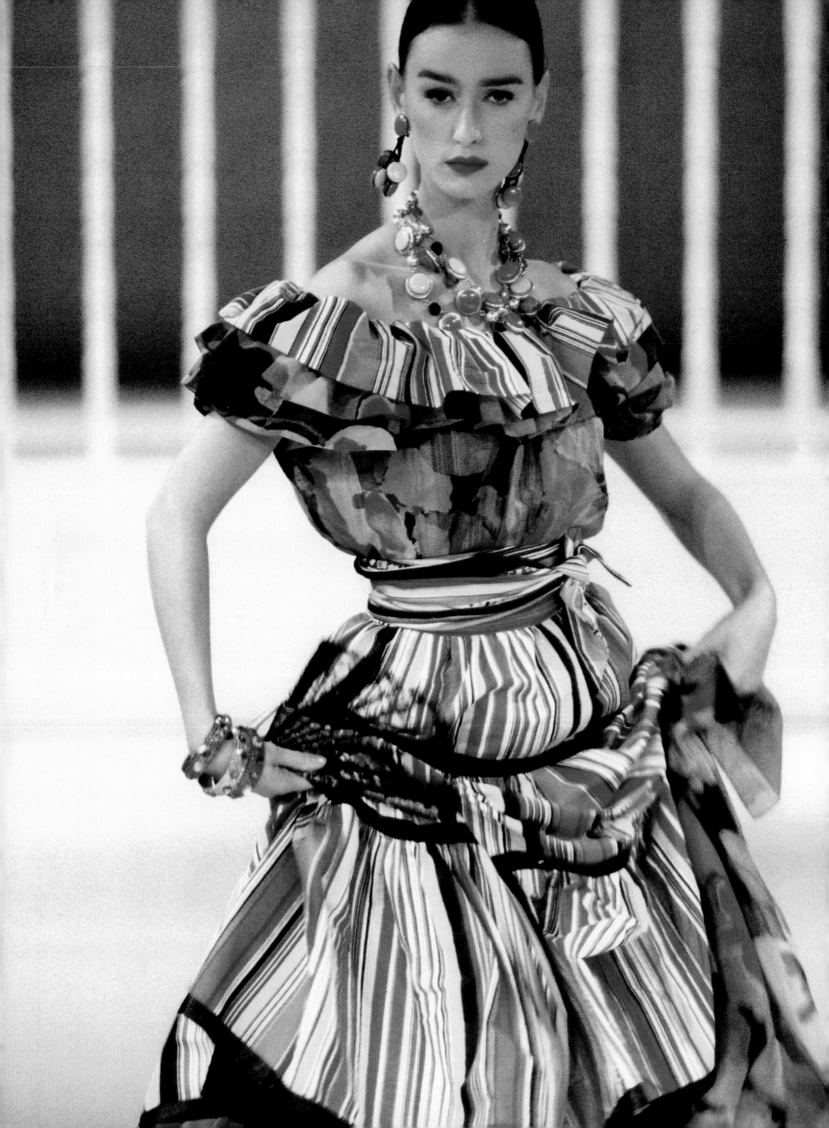

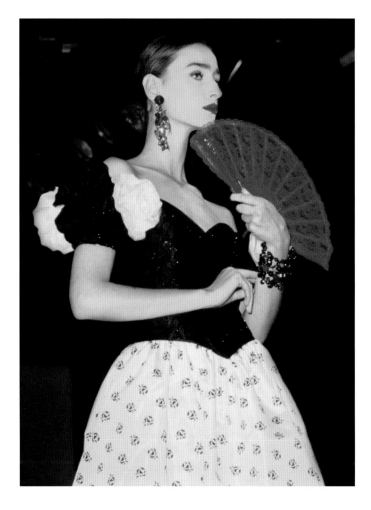

The eighties are famous for wide shoulders and Joan Collins's smouldering in TV classic *Dallas.* Our collections during this decade had gently gathered material at the shoulder to create width and we added a mix of longer pleated skirts and short, leather, tight, pencil skirts. There were elegant long slim dresses for charity evenings or private dances and touches of new romantic ruffled shirts. During various seasons we were inspired by gaucho culottes and then again Mexico and South of France and English gardens.

OPPOSITE PAGE:
Cotton stripes and bright florals on the catwalk, 1989, *Catwalking*

ABOVE:
A Spanish mood on the catwalk, 1989, *Catwalking*

RIGHT:
Photographer *Brian Aris* took this photo of Joan Collins in a Caroline Charles black lace blouse and red silk skirt, 1989

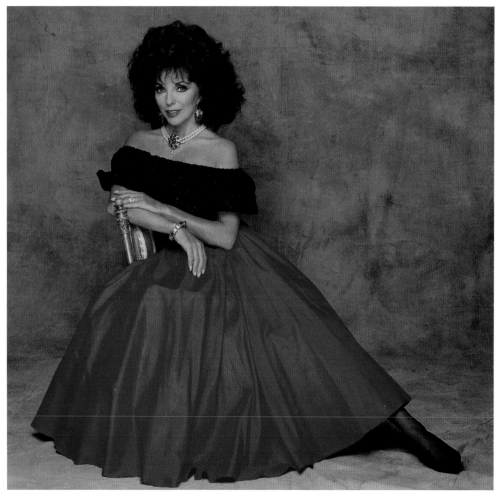

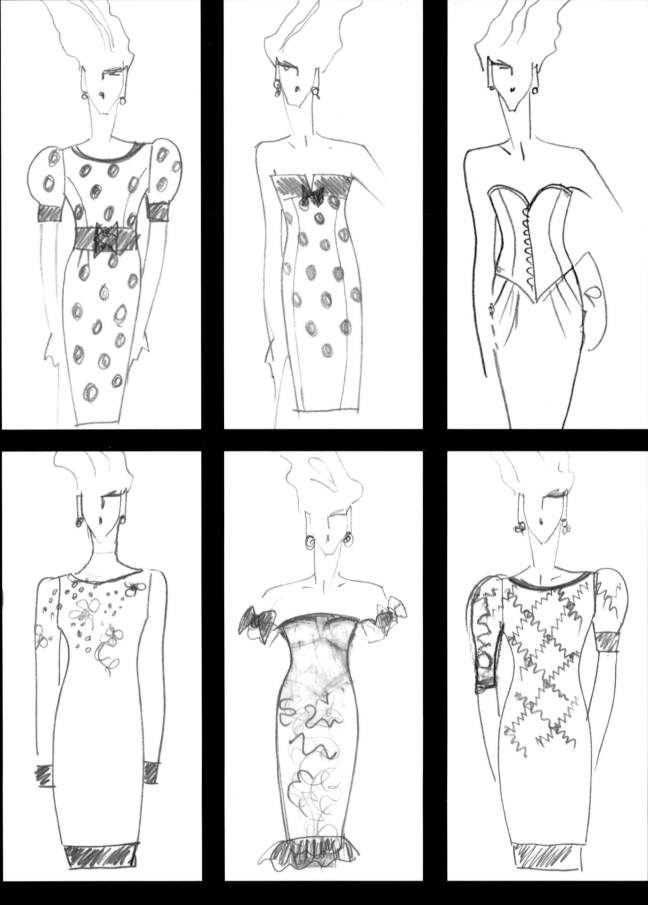

Sketches of glamorous black cocktail dresses, 1989

Black cocktail jacket and dress, catwalk show 1989, *Catwalking*

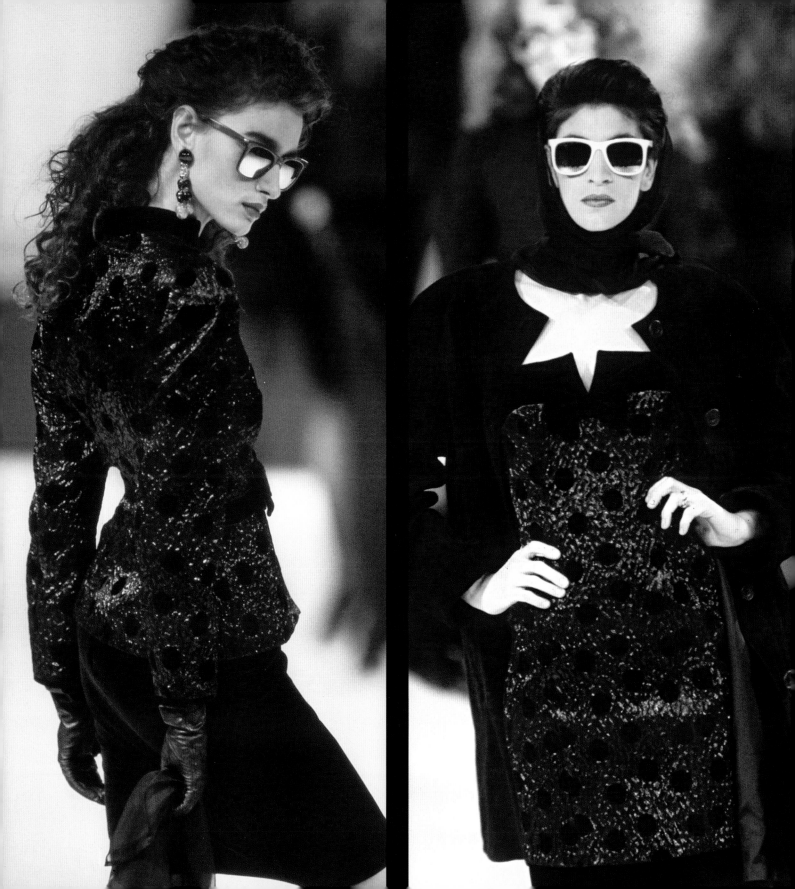

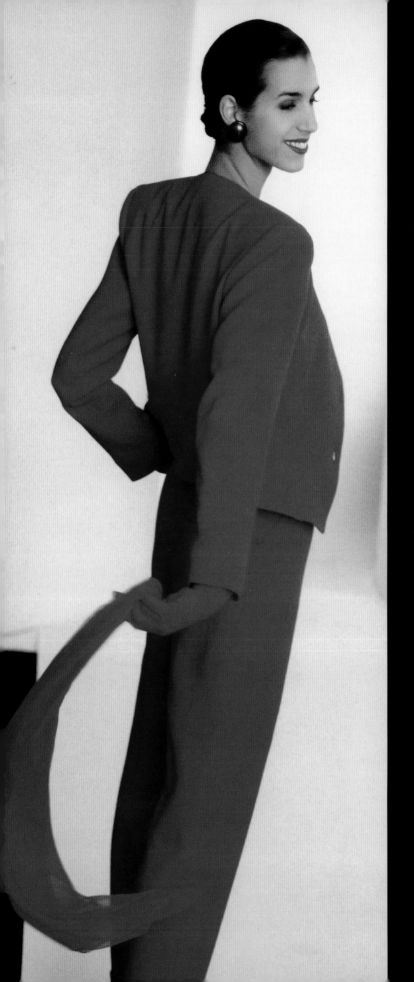

Caroline Charles studio sketches of wool
suits, 1989

LEFT:
Red wool suit and scarf, 1989, *Catwalking*

OPPOSITE PAGE:
Black-and-white check wool jackets and
dresses, London Fashion Week, 1989,
Catwalking

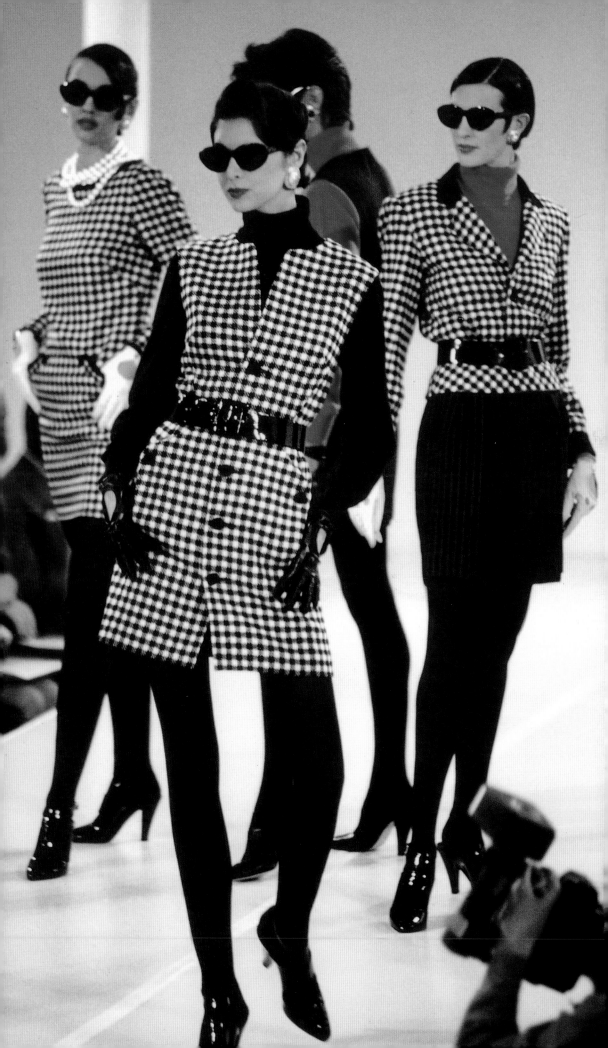

Caroline Charles worked with Ella Singh on beading designs – Ella was very talented and flamboyant and her team were always producing fabulous pieces and bringing swatches to London

THIS PAGE:
Beaded jacket and black narrow trousers, 1989

OPPOSITE PAGE:
Beaded jacket from the same shoot, 1989

WHO LOVES YA, BABY?

This page and detail opposite: hand beaded matador jacket, £815, by Caroline Charles. Black stretch-velvet pants, £105, by Norma Kamali. Fuschia and brown satin sling-backs, £225, by Manolo Blahnik. Sunglasses, £195, by Moschino. Gilt cuffs, from £205 each, by Deanna Hamro. Gilt cuff, from £205, by Dominique Aurientis. Earrings, from £51, by L'Or Noir. Earrings, opposite, from £75, by Eric Beamon

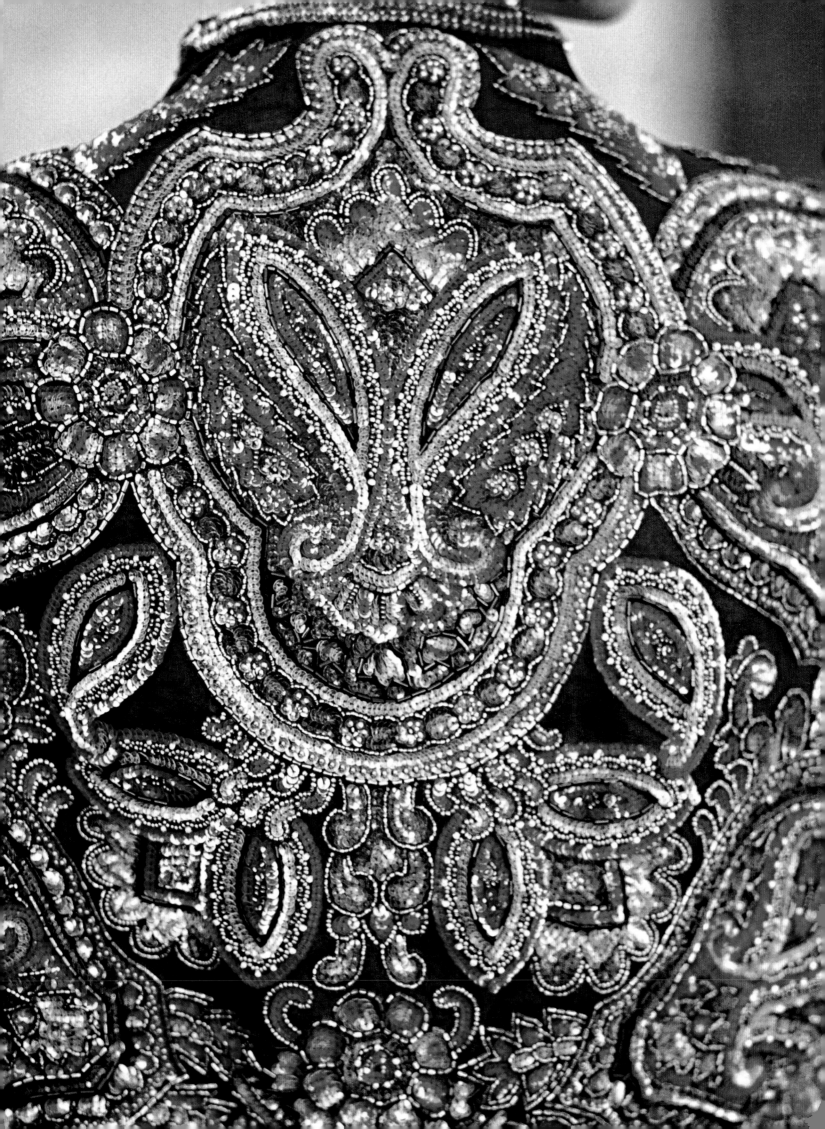

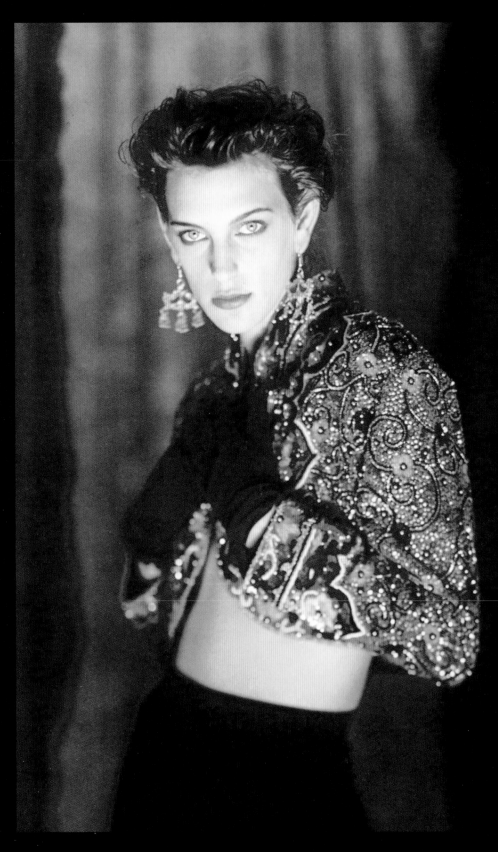

Beaded collectible bolero jacket made for Caroline Charles by Ella Singh,
September 1989, *Claus Wickrath*

OPPOSITE PAGE:
Sequinned Caroline Charles sweater and trousers. January 1982, *Woman's Journal*

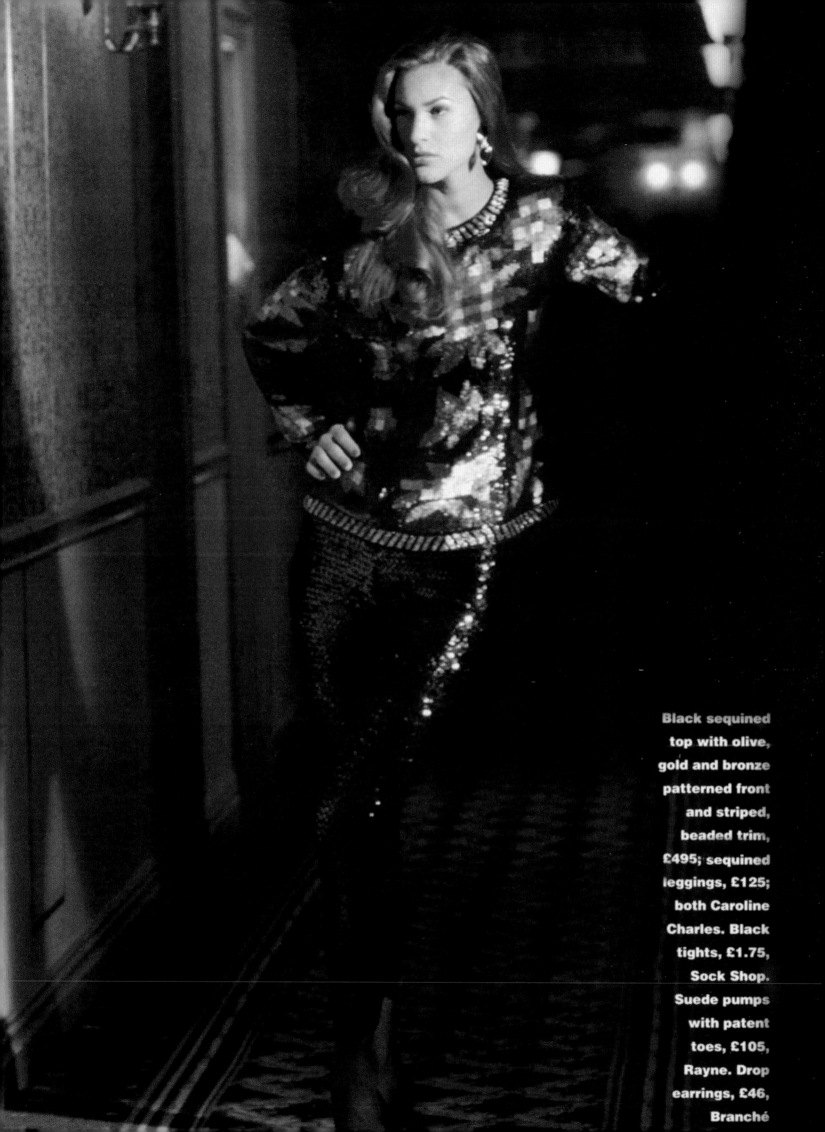

Black sequined
top with olive,
gold and bronze
patterned front
and striped,
beaded trim,
£495; sequined
leggings, £125;
both Caroline
Charles. Black
tights, £1.75,
Sock Shop.
Suede pumps
with patent
toes, £105,
Rayne. Drop
earrings, £46,
Branché

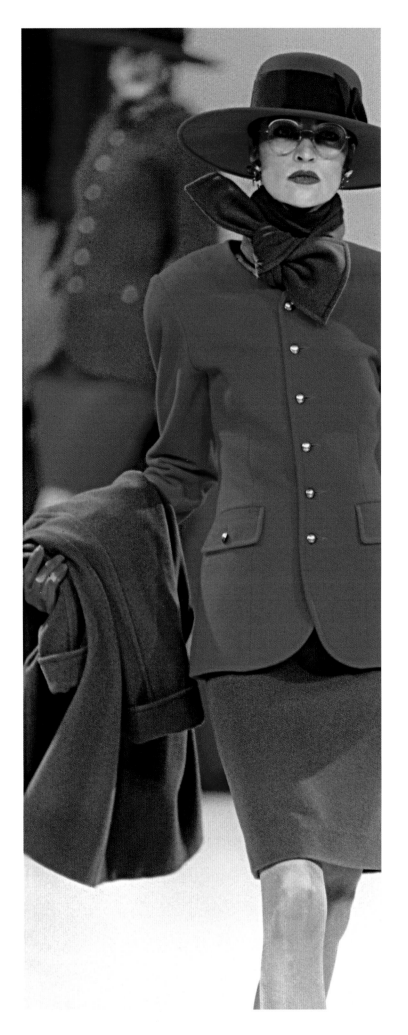

THIS PAGE:

Cashmere jackets with gilt buttons and rounded shoulders. Seen on the London Fashion Week catwalk, 1989, *Catwalking*

OPPOSITE PAGE:

C.C. sketches for checked wool and suede ensembles, 1989

BELOW AND RIGHT:

Autumn/Winter catwalk show, 1989, *Catwalking*

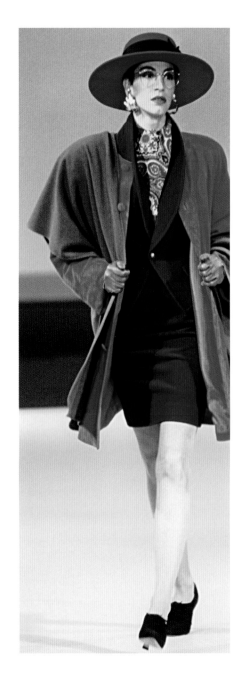

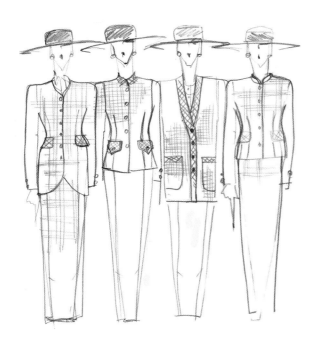

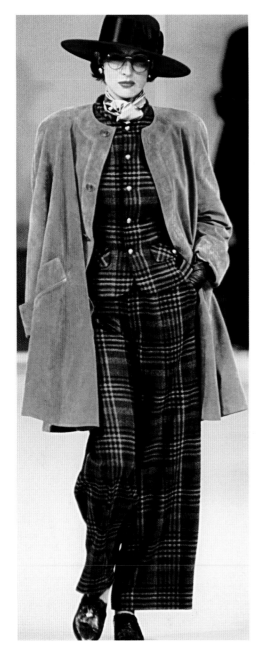

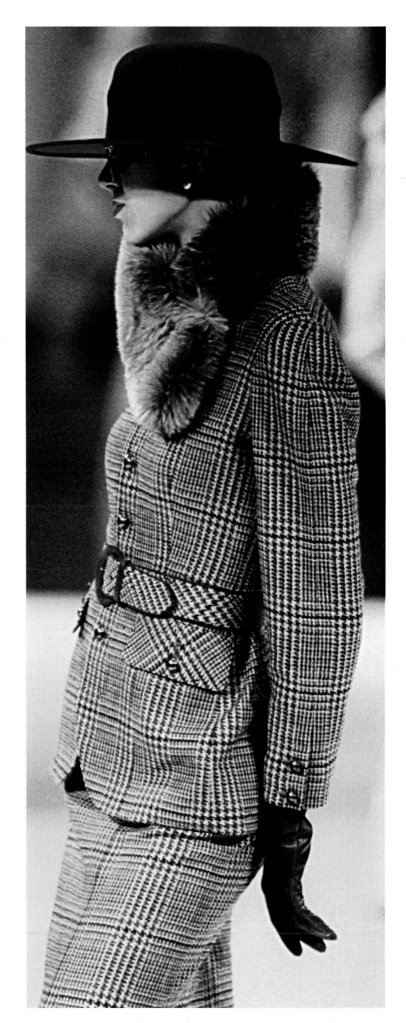

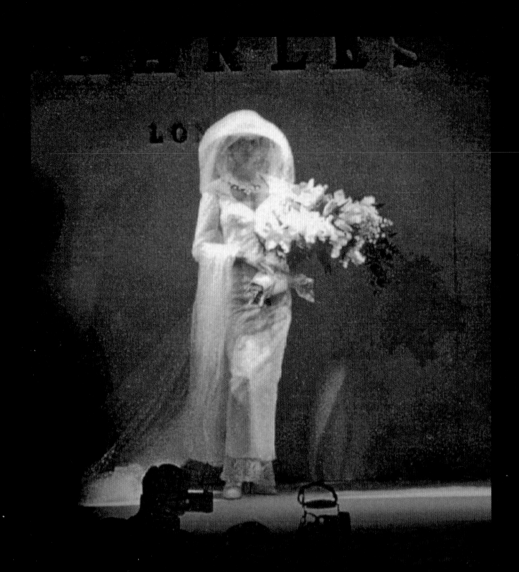

ABOVE AND OPPOSITE PAGE:
Beautiful Caroline Charles catwalk brides wrapped in spot net,
1989, *Catwalking*
The musical accompaniment of Maria Callas made for a very
emotional moment

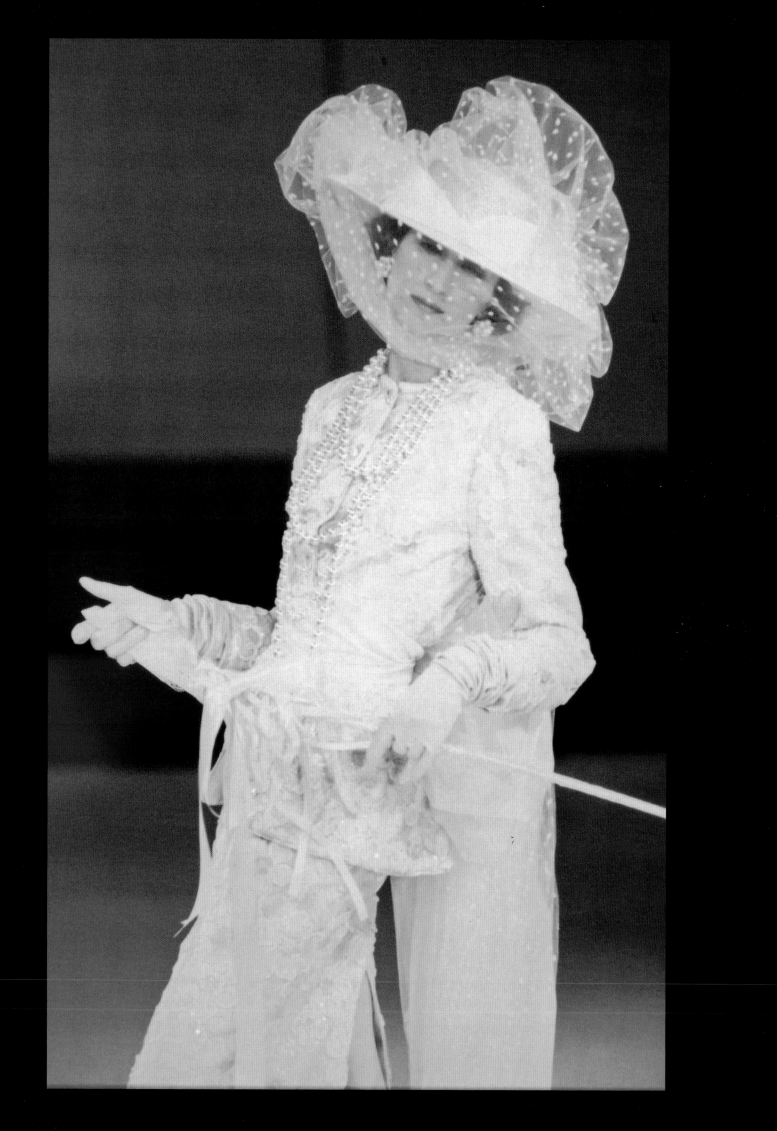

CAROLINE
CHARLES
LONDON

BOND STREET • BEAUCHAMP PLACE • ST JOHN'S WOOD • HARVEY NICHOLS
0171 493 4733 0171 589 5850 0171 483 0080 0171 235 5000
TOKYO

CAROLINE
CHARLES
LONDON

1990s

BOND STREET • BEAUCHAMP PLACE • ST JOHN'S WOOD • HARVEY NICHOLS
0171 493 4733 0171 589 5850 0171 483 0080 0171 235 5000
TOKYO

Caroline Charles linen separates in an editorial feature in a Japanese fashion magazine

1990: This was an exciting year and ended with the Tokyo/Osaka/Kyoto journey and another good party given by *Vogue* at the Café Royal for Liz Tilberis. In March 1990 the Mansion House hosted a fabulous show of London designers' clothes made in Yorkshire's best woven fabrics. John Packer, our hero, organised this on a grand scale, as only he could, and we were one of the designers. Our own spring show was put on in the new building in Beauchamp Place and though there was one show at 12 and another at 3pm the audience was seriously over-squashed – TV cameras take up too much space!

Our next journey to Japan in May was full of celebrations for Fujii Keori's 101 years in business. Although there had been many references to "the bubble" bursting, work seemed to be going on well. A party for 2,000 people was given in the Royal Hotel Osaka and there were long tables of food each representing different eras, with dancers performing traditional formations.

We visited Kobe with Jo Imura (our special friend and company minder) and, after meeting and greeting customers in a shopping mall, we went for a walk in the old town and saw the late 19th-century European villas: the Yokohama prints of top-hatted and tail-coated men from that period really came to life. Later there was another dinner, this time for the foreign visitors, who included Tasmanians, Koreans, Taiwanese, and Malcolm and I. There was an alarming moment at the end of dinner, when each nationality was asked to stand and sing a song. Thankfully Malcolm sang *Auld Lang Syne* for us and everybody clapped!

Ralph Halpern was the new chairman of the British Fashion Council and in July he gave a designers' dinner at Jo's Café. Joseph Ettedgui and Jasper Conran, John Galliano, Vivienne Westwood, Bruce Oldfield, Edina Ronay, Arabella Pollen and I were among the guests at one long table. This was quite a rare event, even if some of us had been friends for a while, as the designer meetings had stopped happening by then.

Before starting on the new Caroline Charles collection, a bit of inspiration and research was sought in Istanbul. There were wonderful fabrics and carpets and breathtaking famous buildings; the Blue Mosque and the Topkapi Palace with its collection of china, jewellery and clothes, plus the hareem and the walled garden with trees and fountains were all memorable. We had started work with new beading workrooms in India and their embroideries were easily influenced in our collection by this journey.

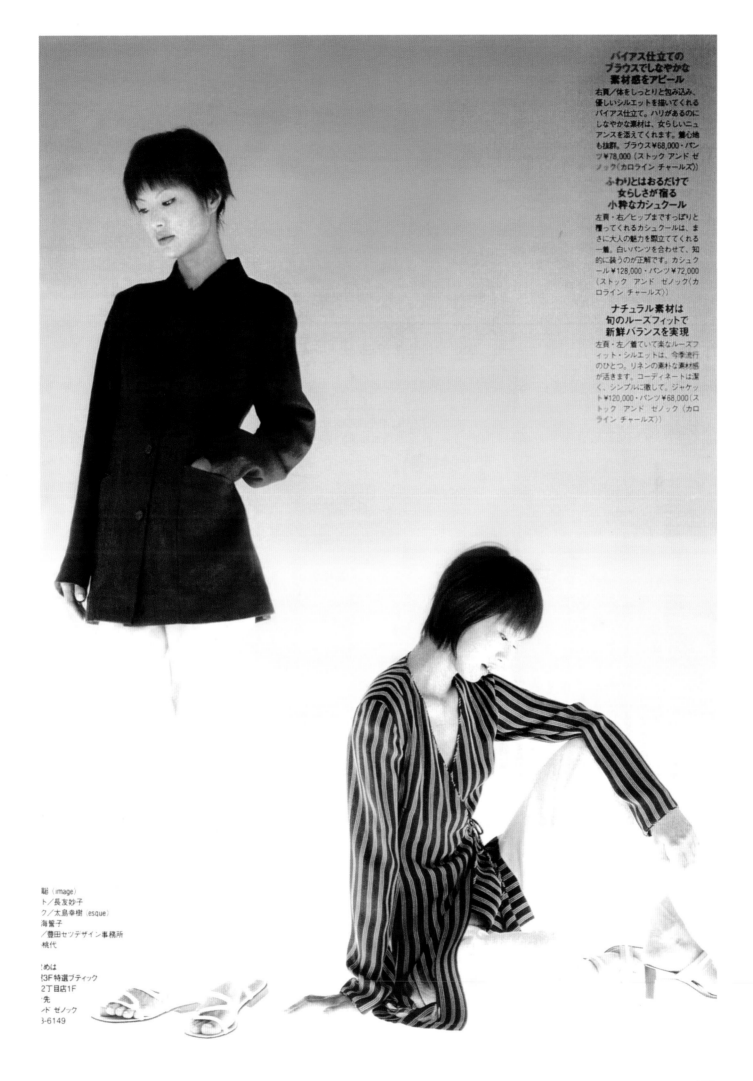

聡（image）
ト／長友妙子
ク／太島幸樹（esque）
海鷺子
／豊田セツデザイン事務所
梳代

!めは
!3F特選ブティック
2丁目店1F
・先
ド ゼノック
3-6149

バイアス仕立ての ブラウスでしなやかな 素材感をアピール

右頁／体をしっとりと包み込み、優しいシルエットを描いてくれるバイアス仕立て。ハリがあるのにしなやかな素材は、女らしいニュアンスを添えてくれます。着心地も抜群。ブラウス¥68,000・パンツ¥78,000（ストック アンド ゼノック〈カロライン チャールズ〉）

ふわりとはおるだけで 女らしさが宿る 小粋なカシュクール

左頁・右／ヒップまですっぽりと覆ってくれるカシュクールは、まさに大人の魅力を際立ててくれる一着。白いパンツを合わせて、知的に装うのが正解です。カシュクール¥128,000・パンツ¥72,000（ストック アンド ゼノック〈カロライン チャールズ〉）

ナチュラル素材は 旬のルーズフィットで 新鮮バランスを実現

左頁・左／着ていて楽なルーズフィット・シルエットは、今季流行のひとつ。リネンの素朴な素材感が活きます。コーディネートは潔く、シンプルに徹して。ジャケット¥120,000・パンツ¥68,000（ストック アンド ゼノック〈カロライン チャールズ〉）

1991: We flew to Milan from Luton airport to do some design work with our new bedlinen licence. Philip Flower was to be a good business friend and he ran a very successful company with Ralph Lauren, Liberty, and Caroline Charles, producing top-quality cotton, print and embroidery. This journey was especially good fun as six of us flew in a private jet – a Cessna Citation II – to Malpenza, Milan. The air hostess produced smoked salmon and a *Hello* magazine, and the two pilots did the *Telegraph* crossword. As we approached Milan there was, inevitably, fog and I heard the senior pilot saying we'd have to go into Geneva, which they'd rather not, as it was tricky. It already seemed to me that this plane was powered by two lawn mower engines, so I was very glad to finally land in Milan. The company we had gone to see was the most stylish family business imaginable. We were met by drivers in two old Jaguars with leather seats and wooden dashboards and taken to a family restaurant in the hills above Lake Maggiore. We ate the sort of Italian food only they can produce: all local, in season, cooked by mama and everyone talking to each other about food and wine. Then we stayed in an Edwardian Hotel of great charm on the lake and the next day was spent in the very modern print works of Mascioni. There we each had our own studio space, technicians and computers to mix colours for our own sample trials. This series of large buildings were the most architecturally perfect '90s functional and ecological workspaces used for wide-bed multi-colour printing. Water from the plant flowed in a stream around the edges in which swam perfectly healthy trout, so we knew nothing here was polluting the local water supply.

In September, Ennio Marchetto, the brilliant Italian mime artist, was performing at the Hackney Empire. His speciality was impersonating the great women stars and singing their best-known songs, each in her own costume. This quick-change act was done on stage behind a screen with the help of one assistant. It made the audience gasp and made any designer realise how quick a quick change can be!

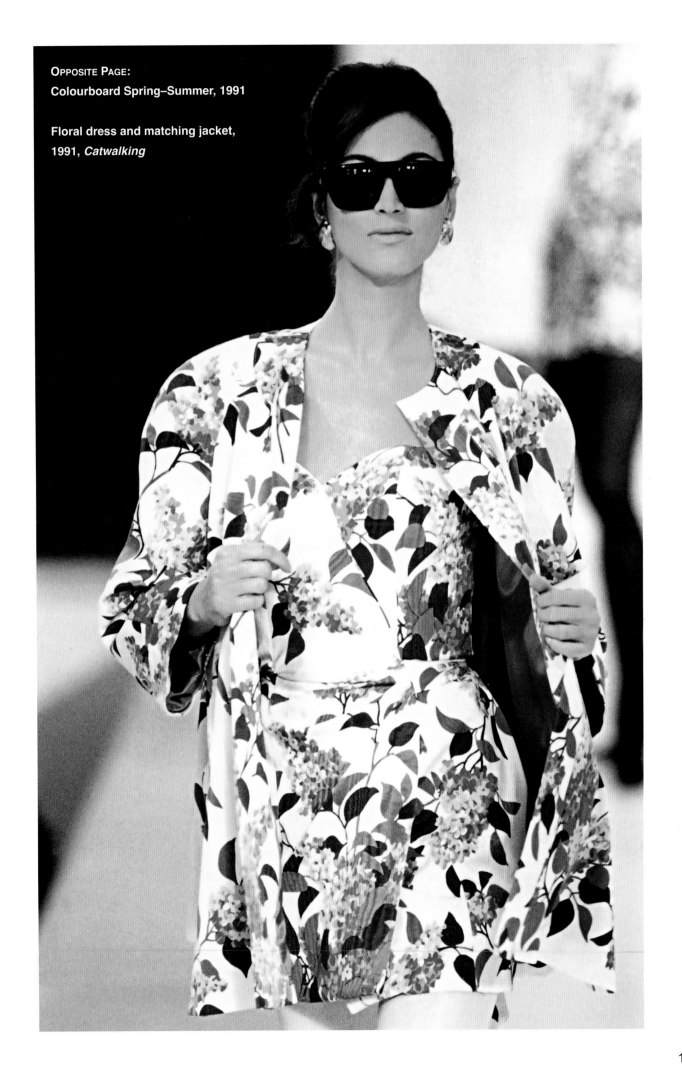

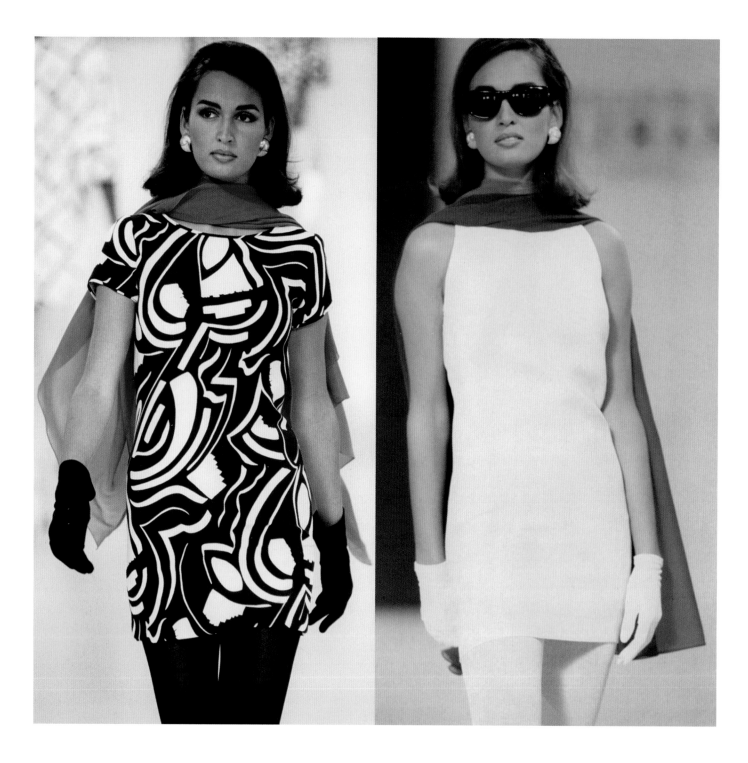

There was a raw space at Brompton Cross that had yet to be developed and we held our October show in this new environment (then known as "the collection") and the following season as well.

Also in November we made the usual breath-taking, but tiring Tokyo-to-Osaka-to-Tokyo-to-London journey; and then in December it was judging the BAFTA best costume dramas shown on TV that year. The debate with five other judges took place at the BAFTA building in Piccadilly and as they were costume designers and knew all the secrets of their trade, there was a lot of gossip and differing opinions.

1992: It so happened that the Caroline Charles show at the British Fashion Council tent fell on Friday 13th February this year! Happily, we survived any ill luck and went to Paris to the Première Vision textile show the next day. Designers are accustomed to the two main seasons interlocking to the extent of putting one season, say spring on the catwalk, while buying the following autumn fabrics.

June is student fashion show time and we supported the Nottingham Fashion College by introducing their good collection in the Business Design Centre, Islington. There was a different type of performance needed when I did *Gardeners' Question Time* on BBC Radio 4. Arriving at the studio in Lower Regent Street, a queue of knowledgeable gardening enthusiasts were waiting. This was going out live, and was completely terrifying: no notes, no crib sheet and anything I had ever known about gardening promptly abandoned my brain.

The October Caroline Charles show was in the British Fashion Council tent and sponsored by Jaguar. Beautiful sleek navy blue Jaguars were parked at the entrance and later, after the show, we gave a lunch for the dealers. *Harpers & Queen* gave a lunch at the Groucho Club and I sat next to Andrew Morton, the man, famous then, for his book about Diana, Princess of Wales. Also that month we added another licensee to our growing business in home products. Hunkydory made us excellent filing boxes and paper products for the desk and they had our ticking stripe and toile design in grey on white. Both are very pretty and are used to this day in our offices.

We made another trip to Italy to check designs going into print with Mascioni our bedlinen printers, and enjoyed the last of the mushroom season. This company was particularly fun to work with, having a well-developed sense of the good life. The Christmas supper given by *Vogue* was in San Lorenzo, our local restaurant, which was packed with designers and friends. BBC TV's *The Clothes Show Live* was the last Caroline Charles performance of the year and, as always, it had a very large audience and was appreciated all across the clothing industry for the breadth of coverage. Jeff Banks must take a bow.

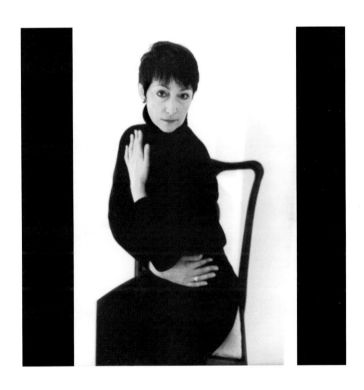

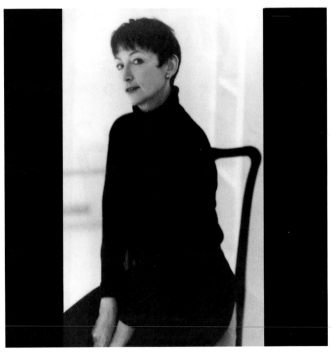

Unpublished portraits of C.C. in Beauchamp Place, 1991, *Michel Arnaud*

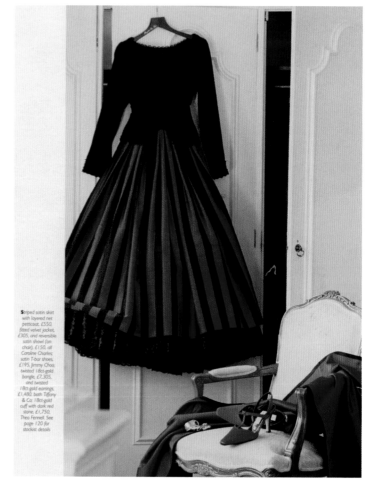

LEFT, TOP AND BELOW:
Heavy silk skirts with velvet jackets to suit a Spanish mood on the catwalk, 1992, *Catwalking*

ABOVE AND OPPOSITE PAGE:
Red & black striped skirt and black jacket and top, December 1992, *Charles Lamb/Harpers & Queen © Hearst Magazines*

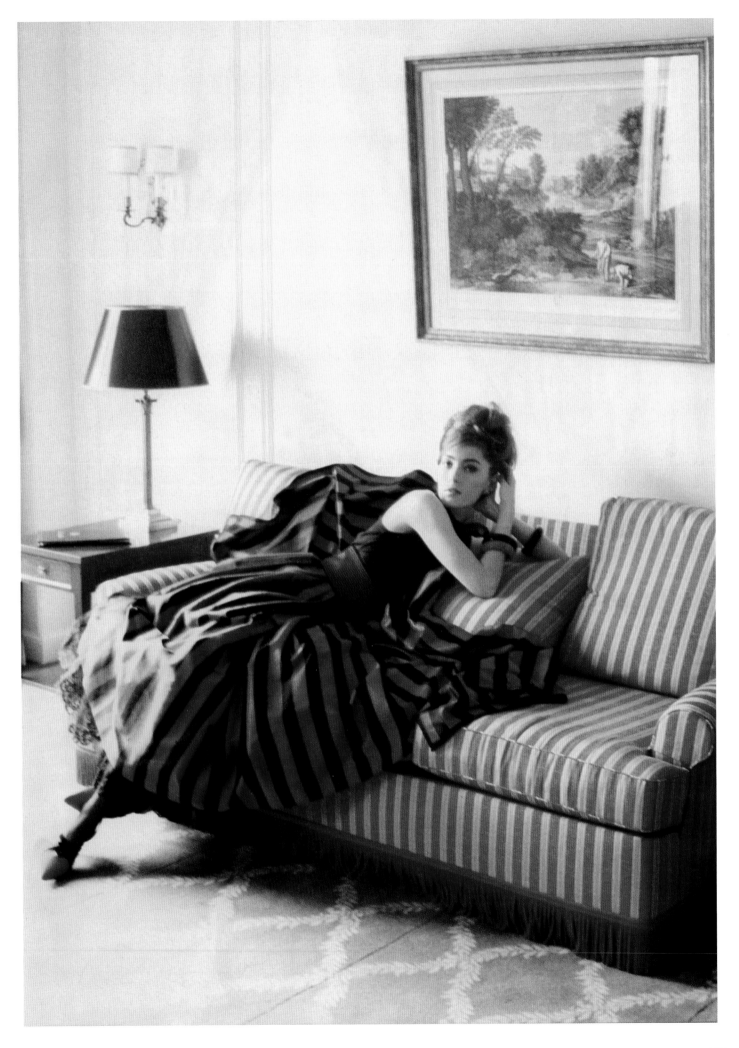

C.C. designed this silk scarf to commemorate the fortieth anniversary of the accession of HM The Queen, 1992

Her Majesty The Queen wearing the Caroline Charles scarf on Remembrance Sunday, 1992

The next interesting meeting that October was held in Stable Yard House, St. James' Palace. Our men's ties and our scarves had come to the notice of the team who looked after product for the shops at the Tower of London, and other Royal Palaces. Would we design for them? Definitely! So a marvellous day was spent in Buckingham Palace, looking at all the treasures, and rooms and doorways, stairways, ceilings etc. In the end we designed a scarf in black and white with drawings of the Coronation coach and general insignia. HM The Queen sent a thank you letter and wore the scarf at the Cenotaph in November on Remembrance Sunday.

Our new celebrity customer was Emma Thompson, who had won the Oscar for best actress that year for her part in the E.M. Forster film *Howards End*. We really enjoyed her company and her mother Phyllida Law, who was also an actress and writer, would come with her. For the Oscars ceremony in Hollywood we made Emma a green sequinned mermaid bodice with wide pyjama trousers in matching chiffon. She also won a BAFTA for the same film and had a black beaded version of her Oscars outfit made specially. The Oscars ceremony gets a worldwide splash of publicity and we enjoyed all that.

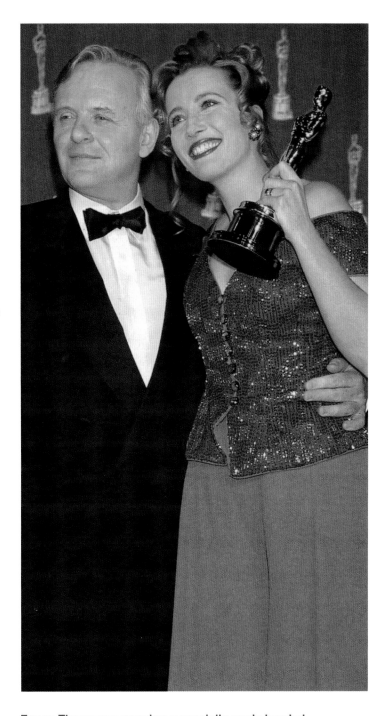

Emma Thompson, wearing a specially made beaded Caroline Charles bodice and wide trousers, accompanied by actor Anthony Hopkins and happily clutching the Oscar that she won for her part in *Howards End*, 1993

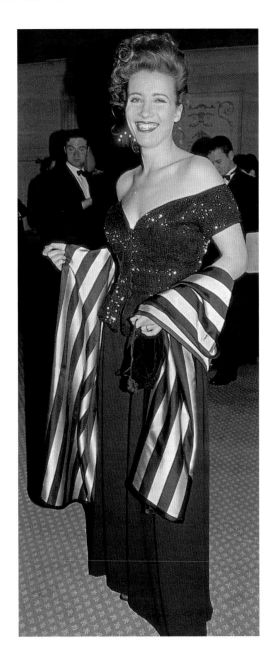

LEFT:
Emma Thompson at the BAFTAs in her custom-made Caroline Charles sequinned bodice, wide trousers – this time in black – with striped silk shawl, 1993

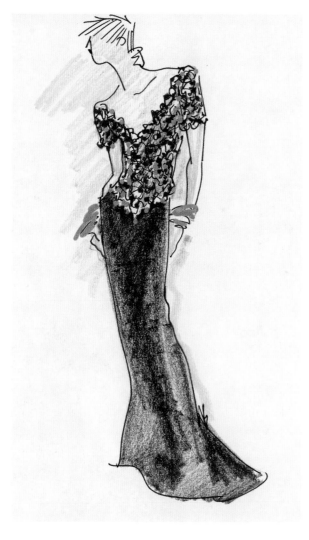

The V&A had invited me to give the designer lecture on Wednesday 21 April and, finally, this terrifying moment had to be faced. The theatre in the museum had a stage and tiered seats and there was a full house. The lectern was set slightly to the side and there was a central screen behind the speaker, and a hidden technician who changed the images as you pressed the button on the lectern. After a very shaky start, the four topics neatly separating the lecture and the pictures fit together and all was well.

Woman's Hour was the next, though far less alarming event, with Jenni Murray discussing the current fashions, followed by the *Sainsbury's magazine* launch with Delia Smith and Michael Wynn-Jones at Les Ambassadeurs. Memories of dancing and gambling there in the '60s were at odds with this wholesome new venture.

In August the business page of *The Times* ran a picture of me in Beauchamp Place and the story of the M&S tie-up. This was followed by other papers and the combination of this story and the *Telegraph* colour supplement spread gave the company extra sales for the Autumn Collection. In October London Fashion Week was at the Natural History Museum and the mood was positive with orders from Neiman Marcus and many others. Robert Kilroy-Silk's morning live TV show invited me to discuss the anti/pro fur debate and, by contrast, the John Lewis store group had a "London first" meeting in the chairman's rooms, which I attended.

Caroline Charles studio sketch of a hand-beaded sequin bodice with long crepe fishtail skirt, 1993

C.C. photographed in a favourite straw hat, October 1994, *Howard Sooley/Harpers & Queen © Hearst Magazines*

Opposite page:
Carla Bruni models double silk waterfall blouse, September 1993, *Neil Kirk/Vogue © The Condé Nast Publications Ltd*

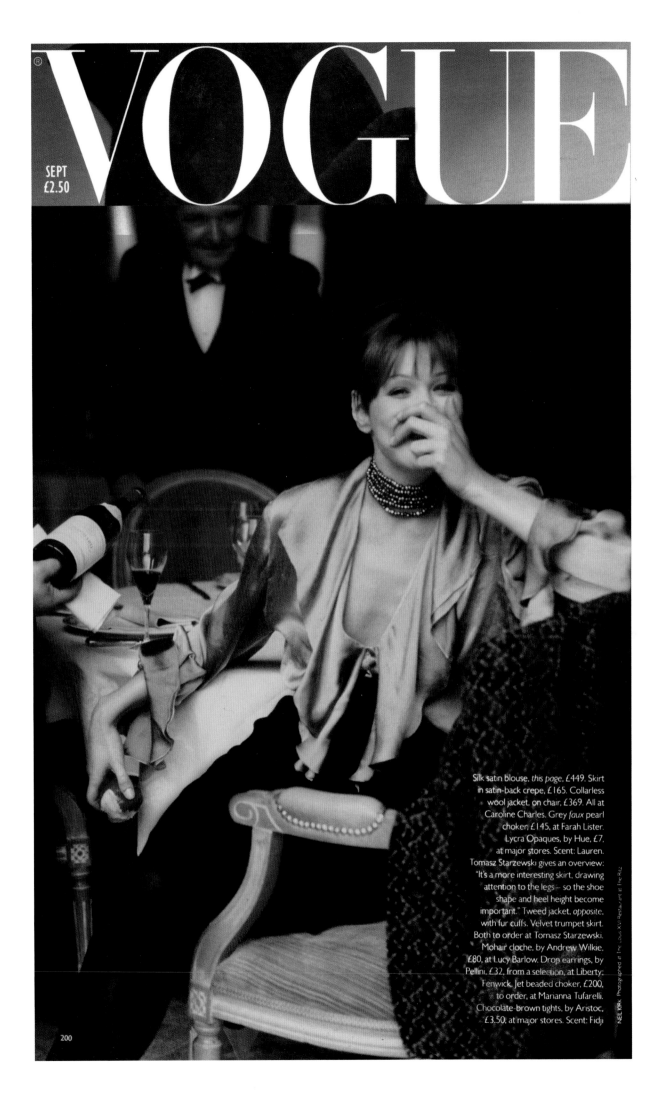

VOGUE

SEPT
£2.50

Silk satin blouse, *this page*, £449. Skirt in satin-back crepe, £165. Collarless wool jacket, on chair, £369. All at Caroline Charles. Grey *faux* pearl choker, £145, at Farah Lister. Lycra Opaques, by Hue, £7, at major stores. Scent: Lauren. Tomasz Starzewski gives an overview: "It's a more interesting skirt, drawing attention to the legs – so the shoe shape and heel height become important." Tweed jacket, *opposite*, with fur cuffs. Velvet trumpet skirt. Both to order at Tomasz Starzewski. Mohair cloche, by Andrew Wilkie, £80, at Lucy Barlow. Drop earrings, by Pellini, £32, from a selection, at Liberty; Fenwick. Jet beaded choker, £200, to order, at Marianna Tufarelli. Chocolate-brown tights, by Aristoc, £3.50, at major stores. Scent: Fidji

NEIL KIRK. Photographed at The Louis XVI Restaurant at The Ritz

200

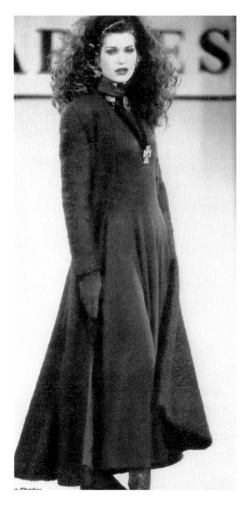
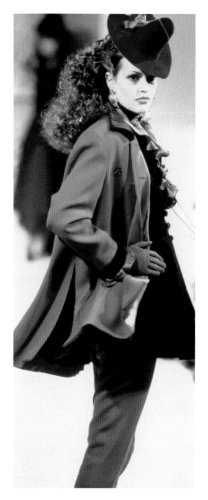
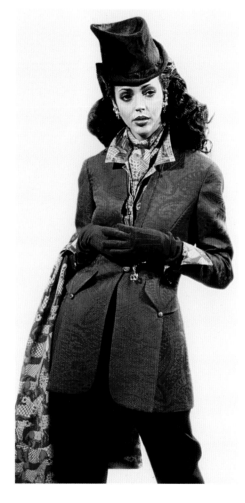
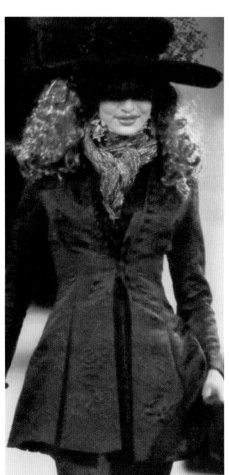
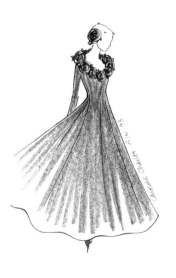
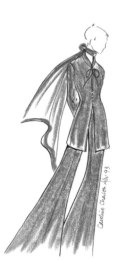
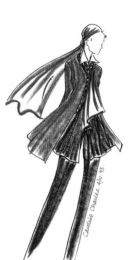

Caroline Charles studio sketches for the A-W 1993 Collection

TOP AND LEFT:
London Fashion Week, Autumn/Winter 1993, *Catwalking*
Hats by Stephen Jones.
The show was a huge success and images from the show were published by various newspapers and magazines

1993: The run up to London Fashion Week was particularly frantic as there was no one venue for the shows. We eventually settled on an empty bank building in St James, which was very spooky and had backstage live wires fizzing quietly or popping loudly. The collection had a very gothic-meets-dandy mood, and suited this abandoned site perfectly, so that we had a really good success and the press pictures were plentiful.

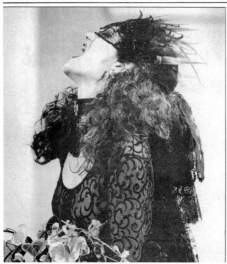

Romantic vision for London fashion

By Roger Tredre
Fashion Correspondent

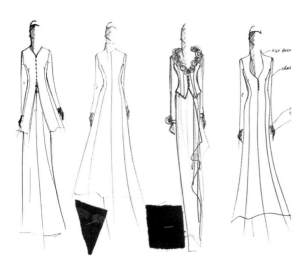

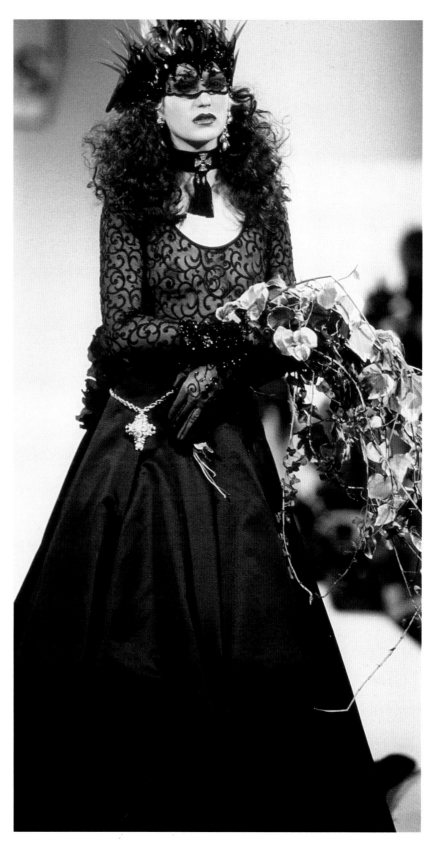

TOP:
Gothic bride from the catwalk show, 5 March 1993,
Independent, Herbie Knott © Getty Images

ABOVE:
Caroline Charles studio sketches for the
Autumn/Winter catwalk, 1993

The show ended with a Dracula bride who wore black and bayed at the moon. A dramatic finale to a gothic-meets-dandy catwalk show, 1993, *Catwalking*

THE DISCREET CHARM OF CAROLINE CHARLES

Autumn-Winter Collection, shot on location by the *Telegraph* magazine, August 1993, *Mike Owen*

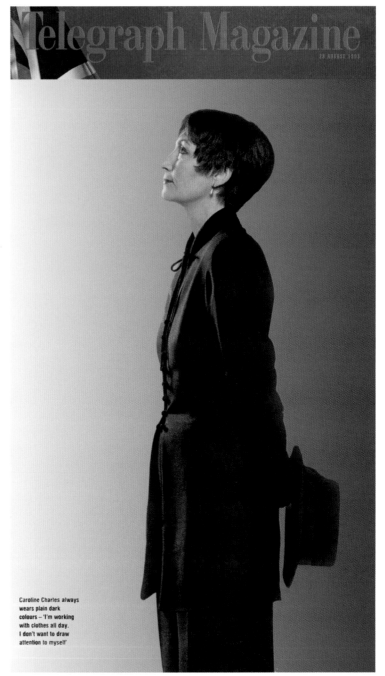

Telegraph Magazine

Caroline Charles always wears plain dark colours – 'I'm working with clothes all day. I don't want to draw attention to myself'

Lord Snowdon took this portrait of C.C., 1993, © *Snowdon, Camera Press, London*

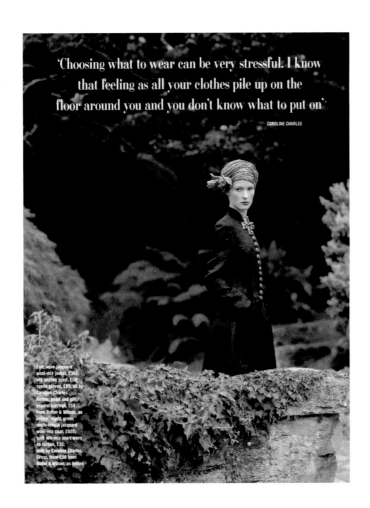

'Choosing what to wear can be very stressful. I know that feeling as all your clothes pile up on the floor around you and you don't know what to put on'.

CAROLINE CHARLES

The *Telegraph* colour supplement ran several pages on the collection and about the company, and Lord Snowdon took the portrait of me. The article was written by Maureen Cleave, a friend from the early 1960s when we had met on the set of *Juke Box Jury*.

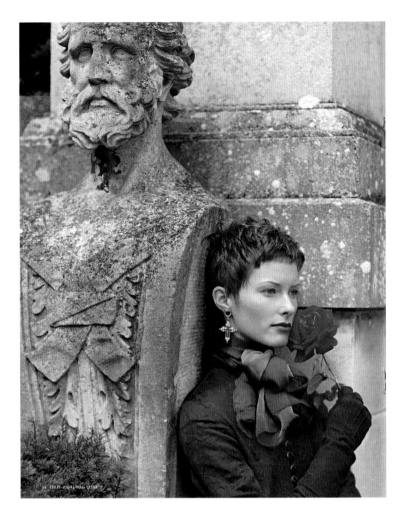

Hair by Ayo at Nicky Clarke. Make-up by Carol Brown using Estée Lauder's 'Beyond the Blue' Autumn 1993 collection: Lucidity light diffusing make-up, ivory beige; Re-Nutriv lipstick, muse; Signature automatic pencil for eyes, hyacinth sky; Signature eyeshadow duo, mystique; two-in-one eyeliner/brow-colour, light brown/blue. Photographed at Luton Hoo, Bedfordshire, ring 0582 22955 for information. Fashion assistant, Alison Pye

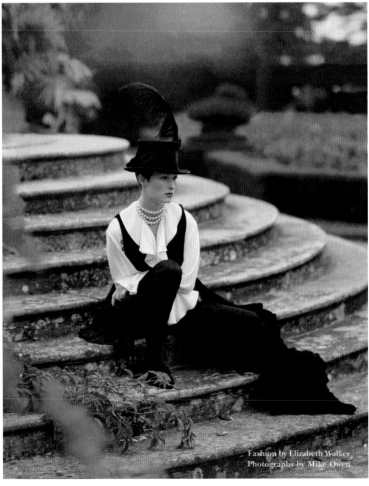

Fashion by Elizabeth Walker
Photographs by Mike Owen

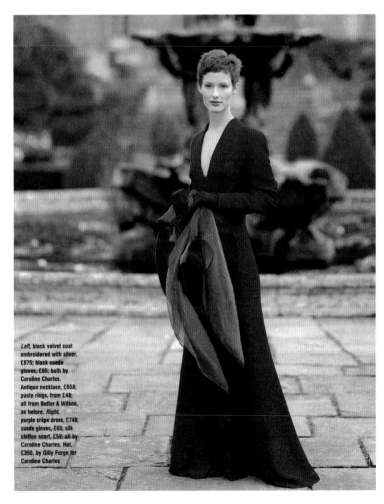

Left, black velvet coat embroidered with silver, £875; black suede gloves, £65; both by Caroline Charles. Antique necklace, £658; paste rings, from £48; all from Butler & Wilson, as before. *Right*, purple crêpe dress, £740; suede gloves, £65; silk chiffon scarf, £59; all by Caroline Charles. Hat, £350, by Gilly Forge for Caroline Charles

1994: The year started in Frankfurt with a business dinner in a *Schloss* with the leaders of the bedlinen business. Then on to Paris for fashion accessories and a stay at L'Hotel in St Germain, Oscar Wilde's favourite. In February, after the Caroline Charles press show, I flew to Vietnam with our daughter Kate. We visited Hannoi, Hue, Hoi An, and Hoi Chi Ming and really loved the country and the very friendly people. On leaving to catch the Saigon-Bangkok connection to London a young guard arrested me! My crime? I had bought a pretty little blue and white saucer at a market stall. Apparently it was an antique and taking it out of the country was illegal. I happily donated it to the museum in exchange for a speedy exit! The *Mail on Sunday You* magazine ran my six-page diary story of the journey with pictures and sketches.

In May the Royal Society of Portrait Painters held a photocall at the Mall Galleries, and I went to stand by the portrait of me by Anne McKenzie. I was in good company: other subjects included the then speaker of the House of Commons, Betty Boothroyd, and a Bishop.

We had taken a large house and shop in Bond Street and had had the whole building renovated. This was to be our West End flagship, and we were finally ready to open the doors in early June. The party was from 6pm and we had an all-girl group of musicians on the pavement playing their classical repertoire and wearing black lace bodies. Inside was an all-male jazz group and a very large

Interior of the Bond Street Caroline Charles store, 1994

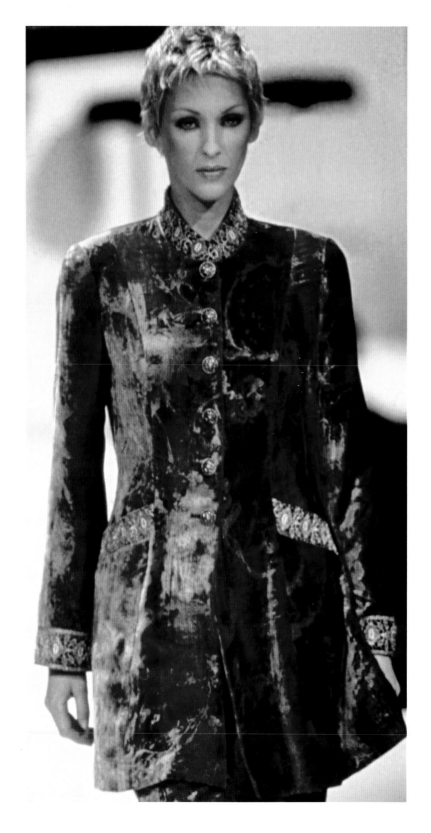

number of guests. The ballerina Darcey Bussell and Mrs Ivana Trump were among the throng of well wishers.

Being a governor of the London Institute (now University of the Arts London) entailed many meetings and reading of papers, often marked secret. This organisation runs excellent art schools in London – Central Saint Martins and the London College of Fashion, amongst others.

Later in June the Smirnoff International Fashion Awards flew Kate and me to Nairobi to judge the Kenyan entries. This was held at the Norfolk Hotel and the winner was a young local girl. She lived in a shack on the side of the street, in a shanty town, with her mother and had a hand sewing machine. I gave the prizes and visited the girl the next day. The following week included a tour of the Masai Mara, the Aberdair Country Club, the Mount Kenya Safari club and a night in the Ark. It was all in majestic countryside, with awe-inspiring skies and beautiful animals. We were thrilled by the opportunity.

By October it was market week in New York for the household linens, and we were also on the look out for a New York shop on this quick visit. Earlier in the month the London Fashion Week shows had been at the Natural History Museum and the big party was at Lancaster House again, with the Princess of Wales as the guest of honour.

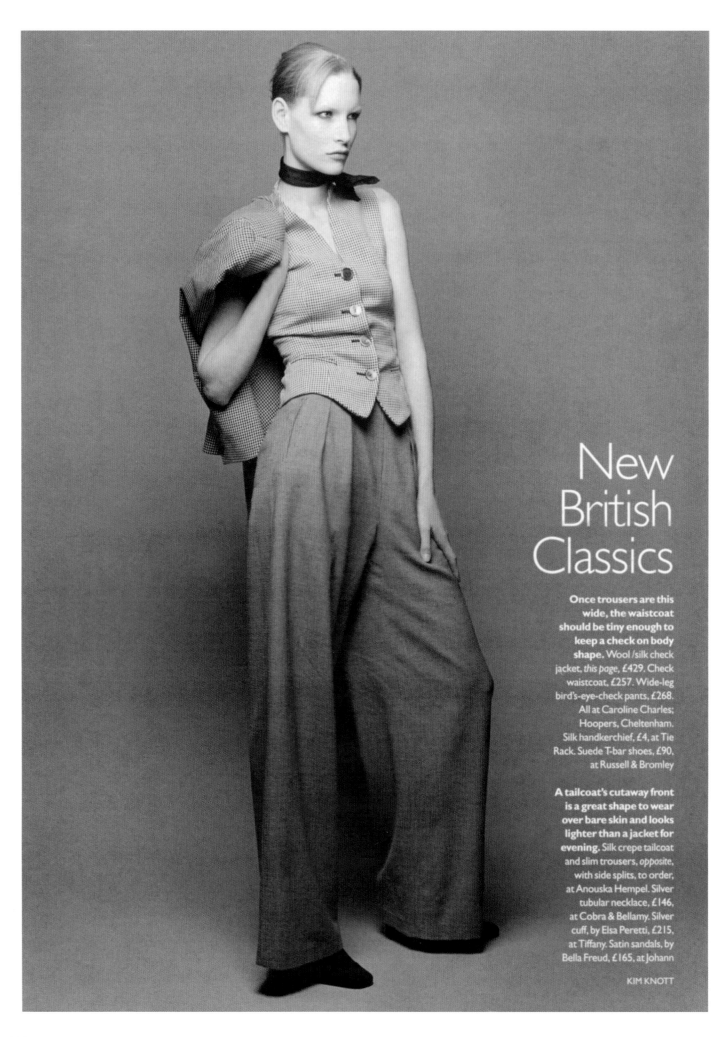

New British Classics

Once trousers are this wide, the waistcoat should be tiny enough to keep a check on body shape. Wool /silk check jacket, *this page*, £429. Check waistcoat, £257. Wide-leg bird's-eye-check pants, £268. All at Caroline Charles; Hoopers, Cheltenham. Silk handkerchief, £4, at Tie Rack. Suede T-bar shoes, £90, at Russell & Bromley

A tailcoat's cutaway front is a great shape to wear over bare skin and looks lighter than a jacket for evening. Silk crepe tailcoat and slim trousers, *opposite*, with side splits, to order, at Anouska Hempel. Silver tubular necklace, £146, at Cobra & Bellamy. Silver cuff, by Elsa Peretti, £215, at Tiffany. Satin sandals, by Bella Freud, £165, at Johann

KIM KNOTT

The work with accessories needed constant attention and so another journey to Florence and Milan was made. The knitwear and leathers were particularly the pieces we were developing for our Japanese and UK shops.

January **1995** brought more judging, this time of the Jasmine Awards. Many boxes and bottles of fragrance arrived in my office and we all took turns in choosing the winners in each section – strange how such large quantities of these normally precious liquids soon dispelled the mystic. At last, we gave the prizes in Mossimans at a party given for the press and trade of the beauty business.

The Millennium plans for London were being hatched in small groups, and I went to a discussion lunch hosted by Simon Jenkins. The idea was to show a thousand years of fashion continuously, in the central arena of the Millennium Dome. Certainly the agencies would have been delighted to be offered that much work for their models. The other people at the table were a poet, Michael Heseltine and Henry Wong from the Barbican, who at least had the experience of the big Montreal Expo and knew how to do large-scale events.

Kristin Scott Thomas in a navy spot chiffon dress, early '90s

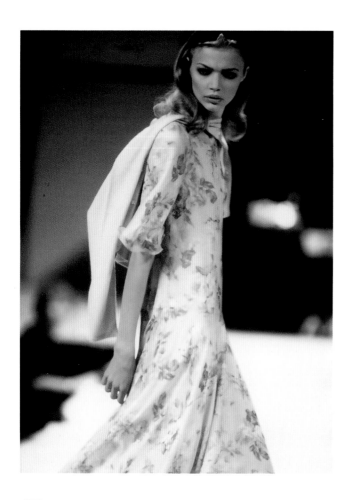

February was fashion show time and Elsa Klench was in town with her team, filming for CNN. We looked forward to seeing her each season and describing the collection on camera. Being the consummate pro that she was, she asked the best questions and the resulting coverage of London Fashion went out worldwide. After the show my son Alex and I went to Marrakech for a few days and stayed in a new Hotel designed by Billy Willis. It was very Moroccan in style, but very Western in comfort.

David Mlinaric was also visiting with his son, and together we met interesting locals who lived in the Medina and the Palmerie. Of course David being among the top interior designers knew all the best dealers of braids and textiles and shared them with us. The St Laurent house and Majorelle garden and many other houses built round courtyards were inspiring and fascinating. After another textile fair in Paris and working on the *Clothes Show*, in February there was an invitation from the Government to give a talk as a part of a training and motivation programme. This event took place on HMS *Belfast* moored in Southwark on the Thames, and was attended by the ever-dwindling group of London outworkers. They made good tailoring in North and East London and were important to many designers at the time. 'Off shore' production had yet to sweep away the last UK manufacturing skills, which were mainly operated by Greek and Turkish Cypriot small units. In May we opened a new space in Tunbridge Wells for the Caroline Charles collections and increased our home licences by working with Early's of Witney on luxurious blankets. By now our offerings included bedlinens, towels, blankets, sleepwear and stationery. We devoted the first floor of the Beauchamp Place building to 'At Home' and added furniture, pictures, lamps and mirrors. This was well received by customers and the press, and expressed our taste in a contained space, as well as parts being sold widely in John Lewis and abroad.

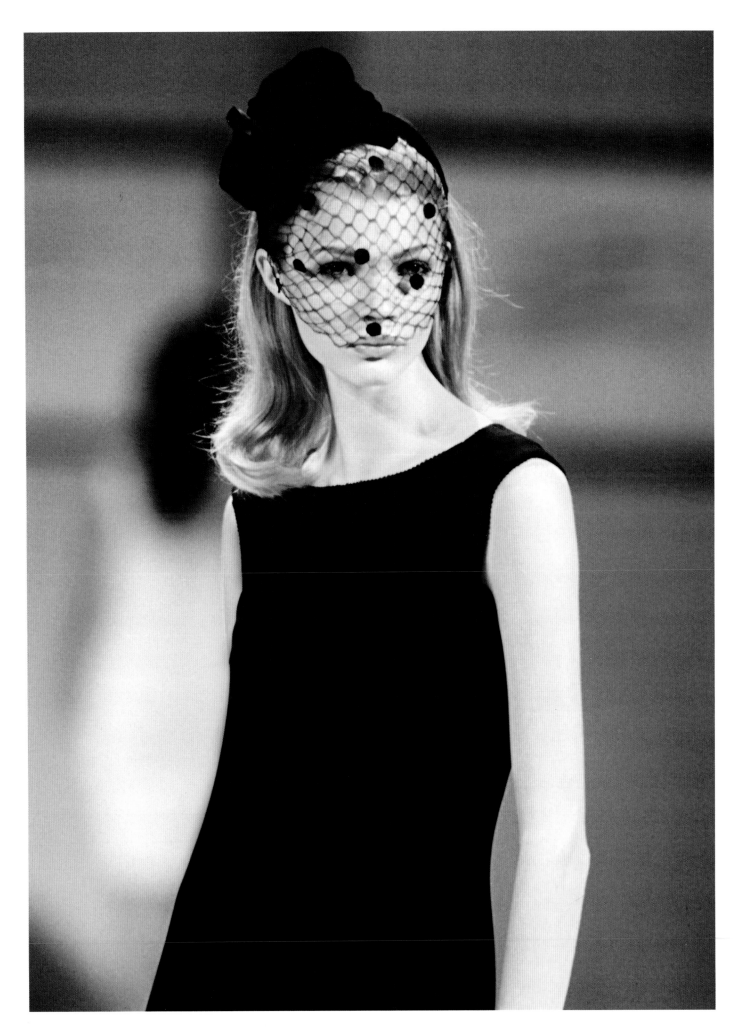

Baby, you can wear my car

Photograph from the Caroline Charles catwalk show, which was held in association with Tigra cars, 1996, *Catwalking*

1995: By September another fashion week loomed and we did our show in our Bond Street building. The catwalk was a very steep staircase that English Heritage had insisted we keep in our renovations even though they were definitely not part of the original period of the house.

There were two memorial services that autumn, both for women who will be sorely missed and remembered always. Jean Muir had led the way as the London designer with the surest touch. Making jersey and tweed and leather work for her own inimitable style, and running an international business had been her forte, which we all applauded. Maggie Keswick Jencks had a design flair that, like Jean's, was entirely personal. I was in her class at school and had admired her drawing style even then, but in later life Maggie's designs with Janet Lyle at Annacat really caught the *zeitgeist* of fashion. Later, her work was with gardens alongside her architect husband Charlie Jencks, and she has left a lasting memorial to help cancer sufferers in the form of her Maggie's Centres.

After the October show in London Fashion Week we opened our third shop, this time in St John's Wood in North London. By now we had our style worked through and had an excellent designer and building team. The latter was run by Jim who had started with our Bond Street building, where all six floors had needed work.

1996: The Caroline Charles show on 29 February was held in the London Fashion Week tent and was sponsored by Vauxhall. They had a super smart new Japanese-designed sportscar called a *Tigra*. This was centre stage at the back of the catwalk and we used the designs and drawings on the flats that made up the set. We even sold one of the cars on the day of the show! John Major gave the season's fashion party at No.10 Downing Street and made an amusing speech. In July we started work with a new Japanese partner – Rocky Matsuoka headed the team from Tokyo, and plans were laid for corners in stores and a Caroline Charles stand-alone shop on the Ginza. This site on the main prestige shopping street in the capital was agreed and we visited and sent designs for the space. We chose to move away from English antique furniture and started to make glass and old gold-painted metal pieces to furnish the shops.

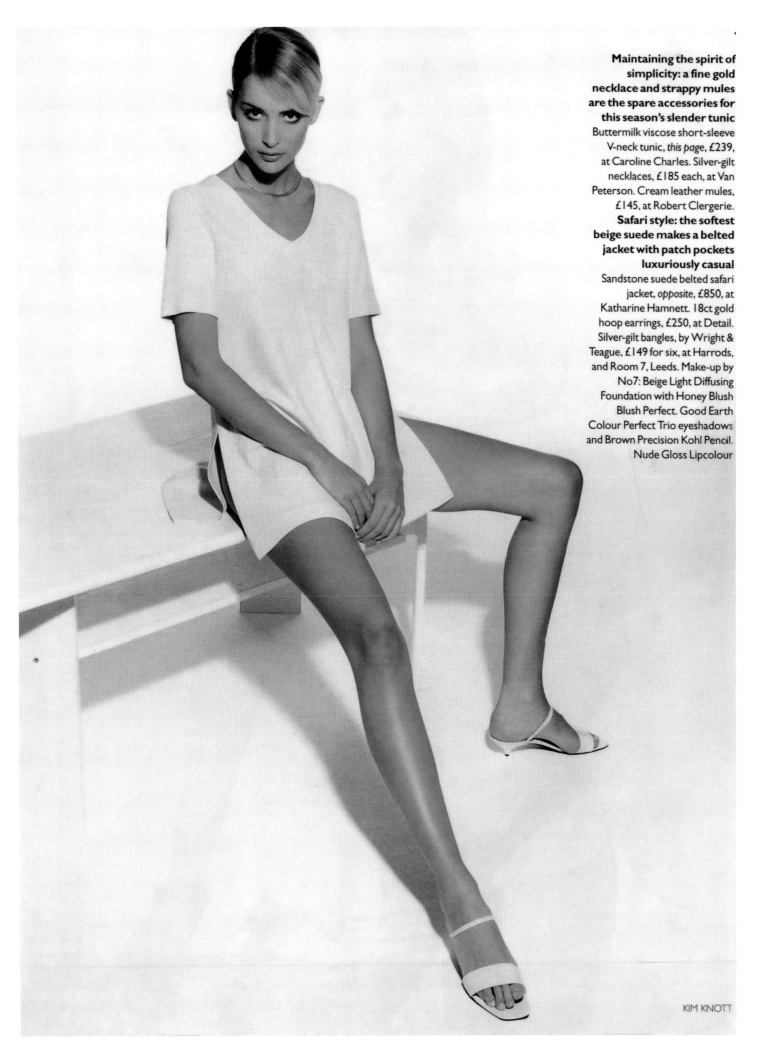

Maintaining the spirit of simplicity: a fine gold necklace and strappy mules are the spare accessories for this season's slender tunic Buttermilk viscose short-sleeve V-neck tunic, *this page*, £239, at Caroline Charles. Silver-gilt necklaces, £185 each, at Van Peterson. Cream leather mules, £145, at Robert Clergerie. **Safari style: the softest beige suede makes a belted jacket with patch pockets luxuriously casual** Sandstone suede belted safari jacket, *opposite*, £850, at Katharine Hamnett. 18ct gold hoop earrings, £250, at Detail. Silver-gilt bangles, by Wright & Teague, £149 for six, at Harrods, and Room 7, Leeds. Make-up by No7: Beige Light Diffusing Foundation with Honey Blush Blush Perfect. Good Earth Colour Perfect Trio eyeshadows and Brown Precision Kohl Pencil. Nude Gloss Lipcolour

KIM KNOTT

174

The new shop in Tokyo was ready for the builders to start work. We went to look at it and to put on a show in the British Embassy, which we shared with the Dunhill men's collection. The Embassy gave us a very good tea party and the guests and press were welcoming. In Japan there is always a very serious and respectful approach to top fashion. After a quick working trip to Florence we gave a Christmas party in our Bond Street building, *Vogue* gave a party at the Cobden Club in W10, and the fashion awards were celebrated with a dinner at the Albert Hall.

We started designing a new working woman collection to add to our existing ones. This was a good project and to this day I still wear some of the original pieces. Linen blends and fine stretch worsteds in navy with white t-shirts – perfect. *Vogue* happily thought so as well and Mary Portas, our PR, and Alexandra Shulman, the Editor, arranged a good page of editorial for this collection.

1997: After the Caroline Charles show in February the collection went to New York with appointments to show to a new breed of buyer – the personal shopper. These people buy for private clients and are a considerable force, so much so, that large stores now employ their own. To a lesser extent it replaces the attention and service offered by couture, but with ready-to-wear clothes and prices to match.

London seemed to deserve a fashion museum, and there was a perfect site about to be free to house this venture. The Museum of Mankind in Burlington Gardens was a great building and perfectly situated between Bond Street and Savile Row. What could be better? The work needed to raise the funds and make it happen was extensive and though many leading people were supportive, it became obvious that this was a full-time job and not one for a working designer.

MAIN IMAGE:
Colourboard, Spring-Summer 1997

Caroline Charles studio sketches for the Spring-Summer 1997 collection

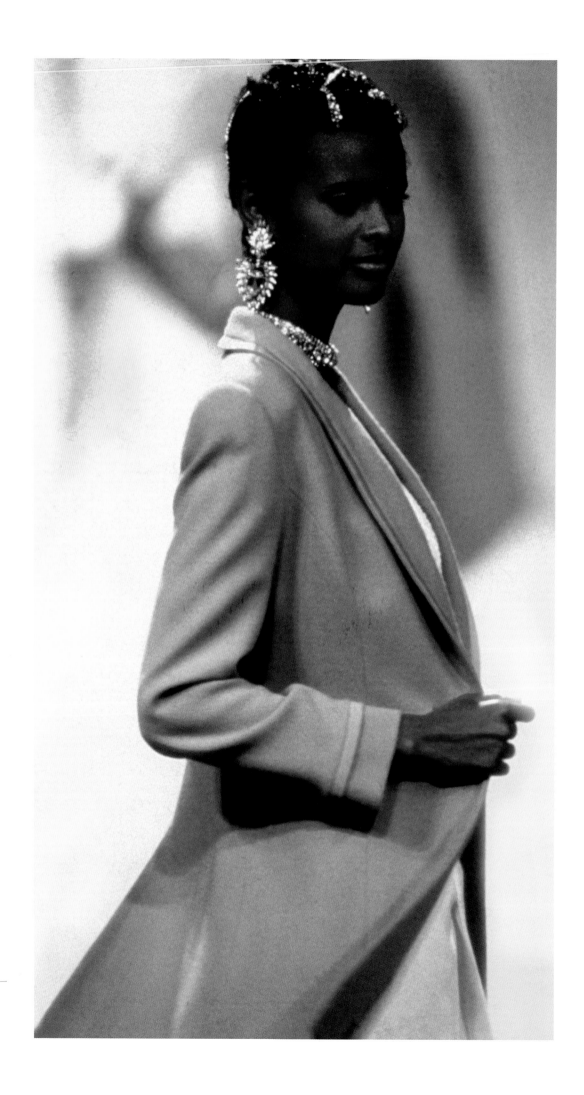

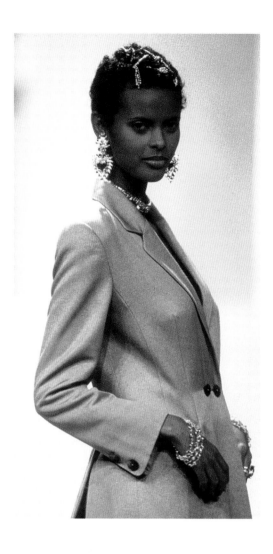

The new Tokyo shop opened in March and we went to celebrate and to put on another show in the British Embassy. David and Sally Wright were the most hospitable and entertaining Ambassadorial couple; they did so much for us and so often. The Milan and Florence journey was squeezed in on our return, before the May wedding of our daughter Kate at the BAFTA building in Piccadilly. With our Bond Street business up and running our focus had turned to Mayfair and the West End, so the Caprice and the Ritz Hotel were all places we celebrated in. Kate looked perfect in a pale blue long coat over a white dress covered in twinkle beads and Jason, her husband, wore a dandy Rhaja coat in Brocade.

On 30 July the new Prime Minister, Tony Blair, gave a party at No.10 for some fashion designers, pop singers and others. There was even a Bishop amongst this group and the party had a completely

different mood to previous years. Cherie Blair became a regular Caroline Charles customer and would wear tunics and trousers that suited her. She appeared one year on the Christmas card dressed by us, and she and Tony visited a Caroline Charles shop in Tokyo and were photographed holding up the carrier bags – so no complaints there.

That same month it was the Tokyo-Osaka flight and back to Tokyo by bullet train. We had a really fabulous new company to work with called Kuwabe and they had the Caroline Charles licence for scarves and handkerchiefs. They made the most luxurious scarves in finest cashmere and developed all sorts of print techniques and finishes. We were in good company with International top names and the quality of their work was the best. In the Japanese market handkerchiefs were a very important part of the ground-floor store business as the main item in the gift area. These handkerchiefs were not for blowing your nose, as you never do that in public in Japan, but for mopping your brow or drying your hands, but mostly for giving as presents.

Soft crepe long jackets in pale Spring colours, London Fashion Week, 1997, *Catwalking*

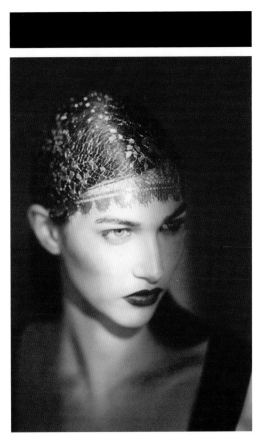
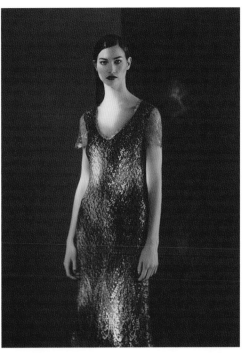
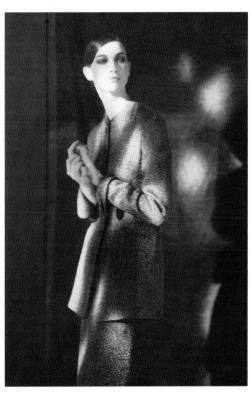
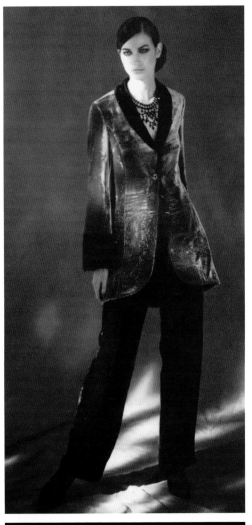
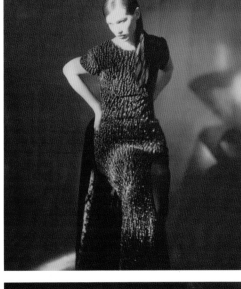
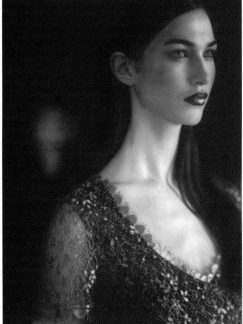
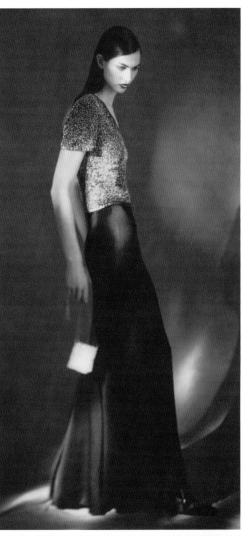

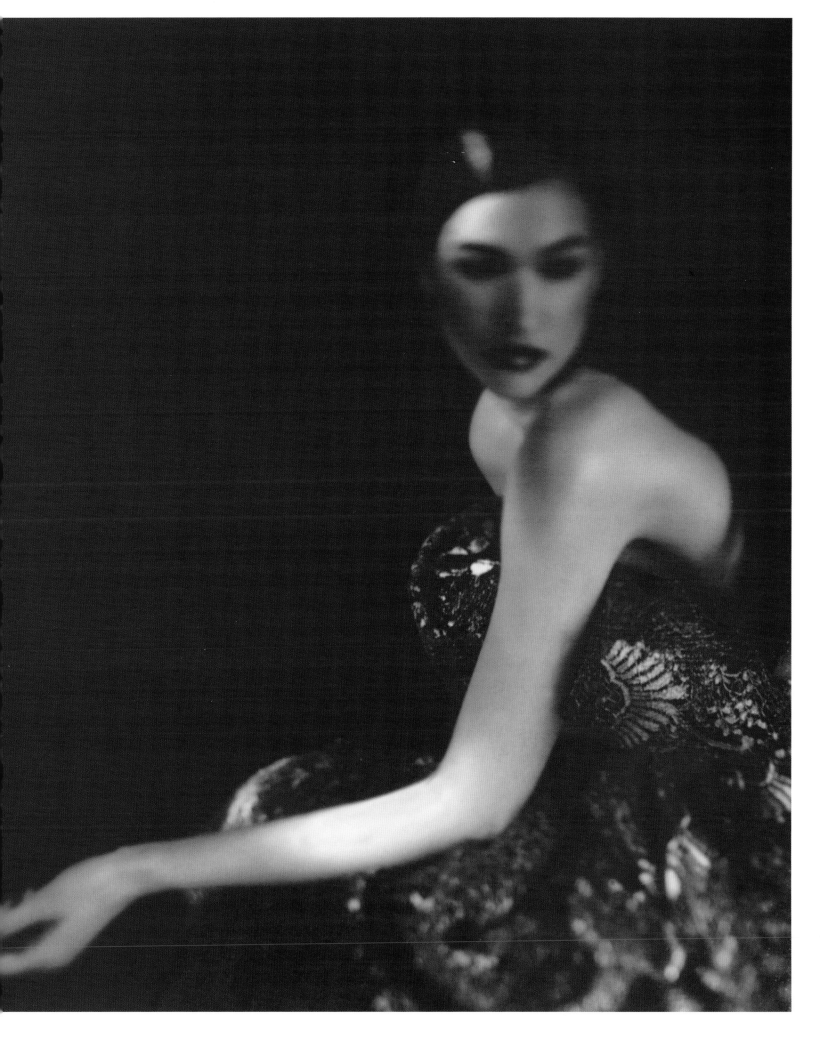

In October the Australian artist Claire Lloyd made a film about Caroline Charles and shot the brochure pictures. She has a special talent and the work looks as fresh today as it did then. We showed the film at the start of the Caroline Chares show that season.

The Embassy in Vienna hosted a show and press conference for six British fashion designers in November. We contributed very glamorous beaded evening clothes, but sadly discovered that really Austria was not in the market for such fripperies.

1998: The Caroline Charles show day in February had a 6:00am start for a 10:00am show on the first day of London Fashion Week. We felt the mood was good early in this twice-yearly event and so chose the first day to show. There was the usual BBC and ITV press work, plus pre-show pieces for GMTV and SKY, the cable channels, Kiss FM, commercial Radio, and associated press who syndicated news.

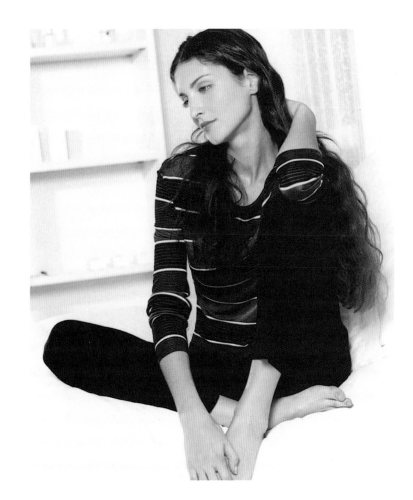

To get in the mood for spring I went on a spree to Monte Carlo, Nice and Menton and looked at old haunts, long since vacated by my grandmother in the 1950s. The French Riviera remains itself, despite the new wave of people and styles, and has wonderful galleries of both Matisse and Chagall works. We were back at the Embassy in Tokyo again in April with the Wrights who hosted another show with their usual wit and warmth. How lucky we were at Caroline Charles to have enjoyed such a long run of business in a marvellous country and to have been supported by so many interesting people.

Another good trip that spring was to Seville in May. The Mesquita in Cordoba is an outstanding wonder of Spanish architecture and the Islamic and Christian culture. It is definitely my favourite building.

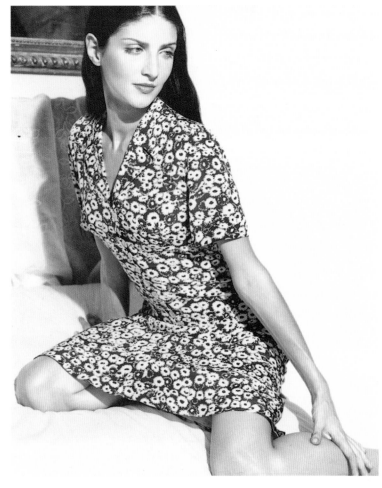

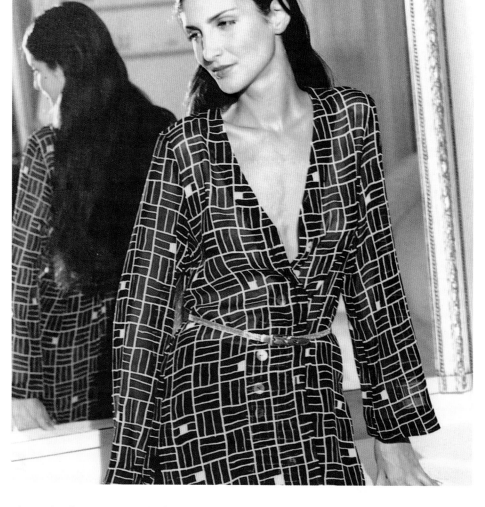

By contrast, I went to Stoke on Trent later in the month to discuss designs with Wedgwood. The plan that they outlined and called 'a critical path' seemed at least two years long and we wondered if things didn't change faster and could be made quicker? The Caroline Charles home business was making good progress and we did a shoot in Beauchamp Place for a Christmas Day table and decorations in August. *Good Housekeeping* organised this to meet their print schedule. *House & Garden* also did a good spread for Caroline Charles using two pages to show the new bed linens.

Then one November evening, rather dramatically, three buildings collapsed in Beauchamp Place. Developers were trying to keep the 1830s façades and modernise the houses. The result of an over-zealous team of workers brought down not only the buildings, but a lamp post. It fell across the street and into the first floor of our house, and not surprisingly set off the burglar alarm. Many months went by until Beauchamp Place regained its good looks.

1999: Optec Japan was a new company to sign Caroline Charles. They made spectacle frames in the lightest and most modern designs and we were to be under contract to them for the following seven years.

This year was the first where we visited Hong Kong to work with three new agents and many suppliers. It was the beginning of our real expansion into off-shore production. The Caroline Charles design studios did knitwear and shirting and embroideries plus jeans and scarves, skirts and dresses. The feeling of relief after years of struggling to get production was immense, and very inspiring and exciting.

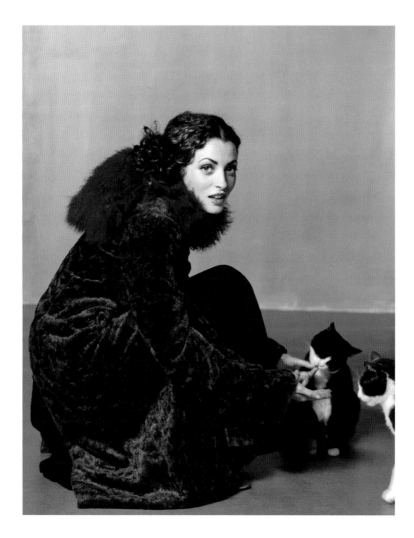

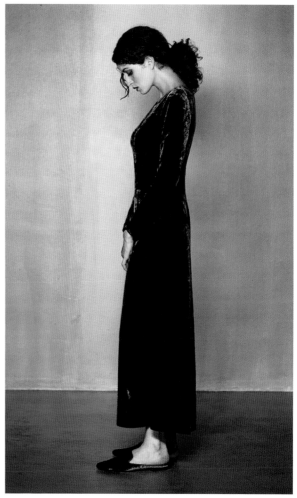

ABOVE AND OPPOSITE PAGE:

Velvets with a rich colour palette and Pre-Raphaelite mood, Autumn-Winter
1999, *Stephanie Rushton*

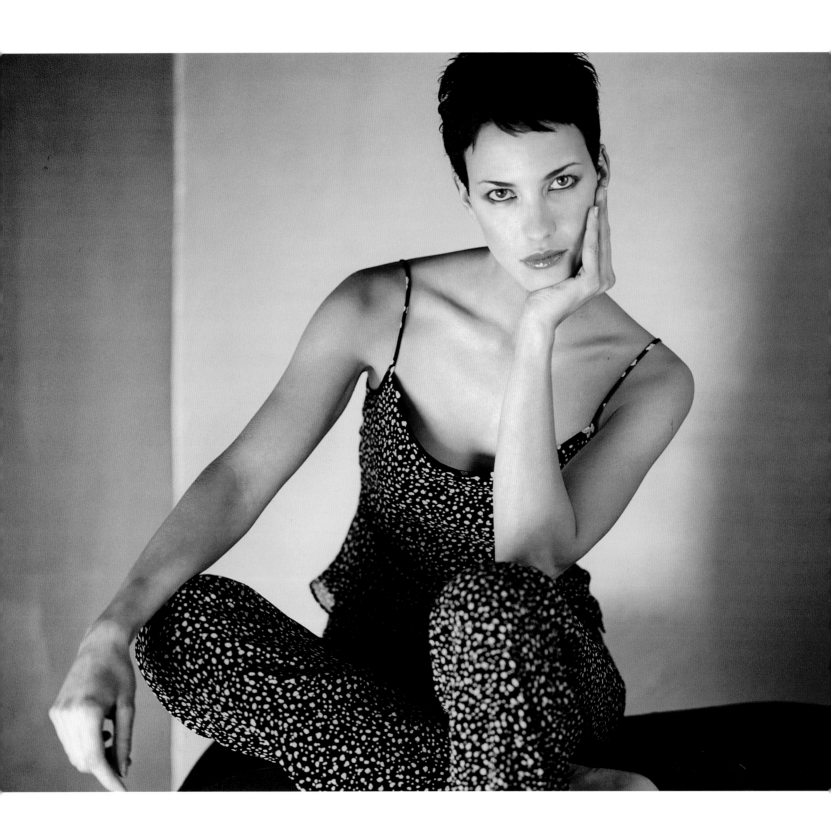

ABOVE AND OPPOSITE PAGE:

'Working woman' separates in navy & white linens and cottons,
Spring/Summer, 1999, *Stephanie Rushton*

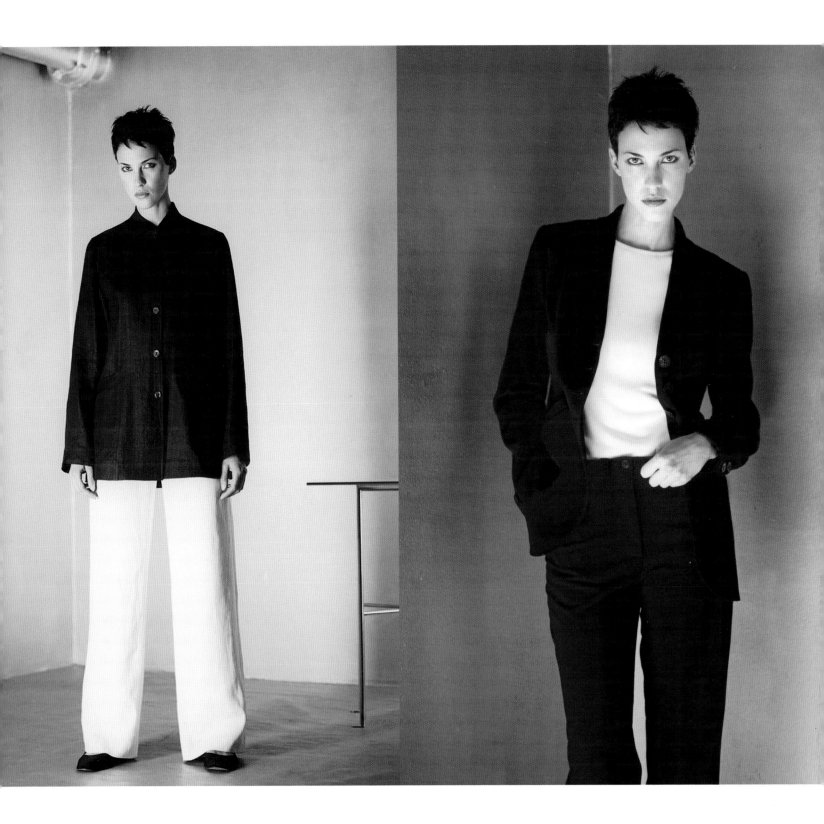

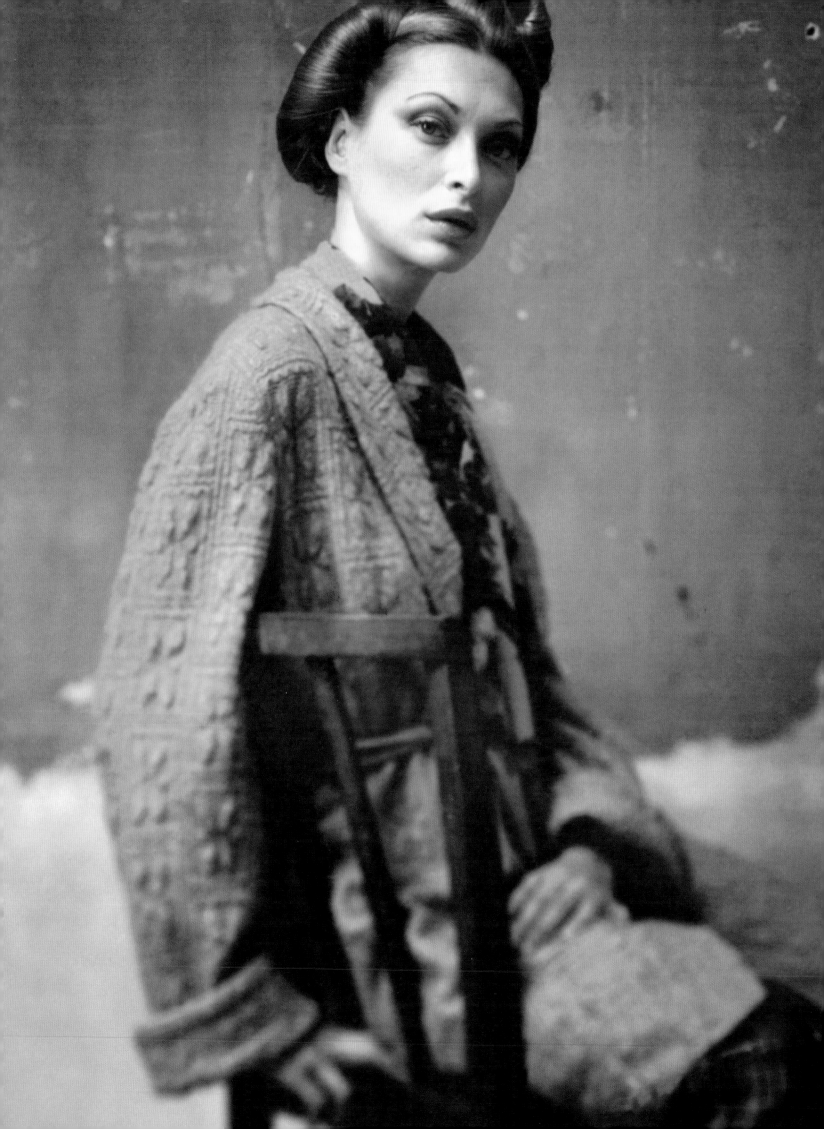

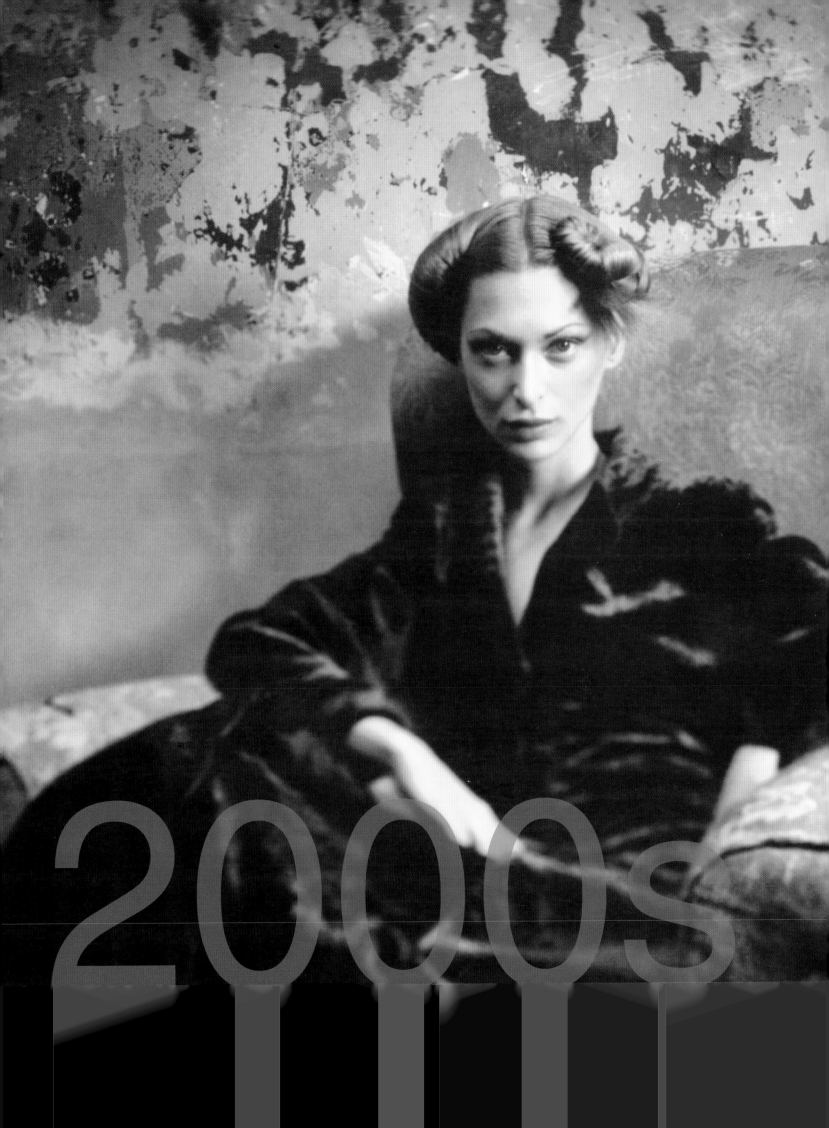

2000s

2000: The sense of excitement of this new century was everywhere. We decided that a spring cruise or holiday collection was called for. We set off for Mauritius in February to study the needs of women in a glamorous resort, only to find this was cyclone season, and there were strong winds and constant downpours and floods for a week. The *Guardian* newspaper had commissioned a travel piece so that was written and ran as a double page spread headed, 'Fashion Victim'.

The next lot of trips that spring were to our fashion shows across the country. Caroline Charles customers are always really good to meet as they express lots of opinions about the collections and their favourite pieces. We have dressed many people for important events in their lives and it is fun to hear the stories.

Emboldened by a good year, we decided to have a celebration dinner at San Lorenzo in Beauchamp Place. Mara, the hostess of our neighbourhood's favourite restaurant, organised the party with a special menu, and wonderful velvet red roses. All the staff had a great evening – it was such a good idea.

The new century had started with good will and confidence and the New Labour Government had given the country a prosperous feeling. Rightly or wrongly, but buoyed by this mood, we decided to start looking at towns in the UK where we could open shops of our own.

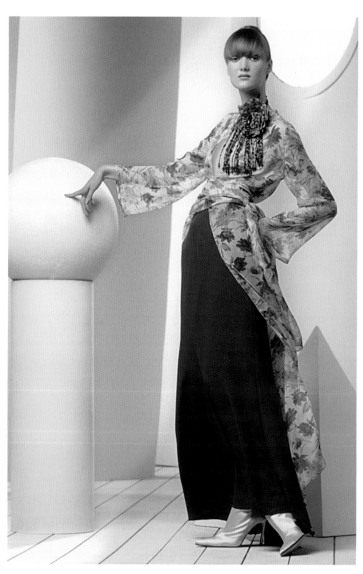

Spring-Summer, 2002 © *Clive Arrowsmith*

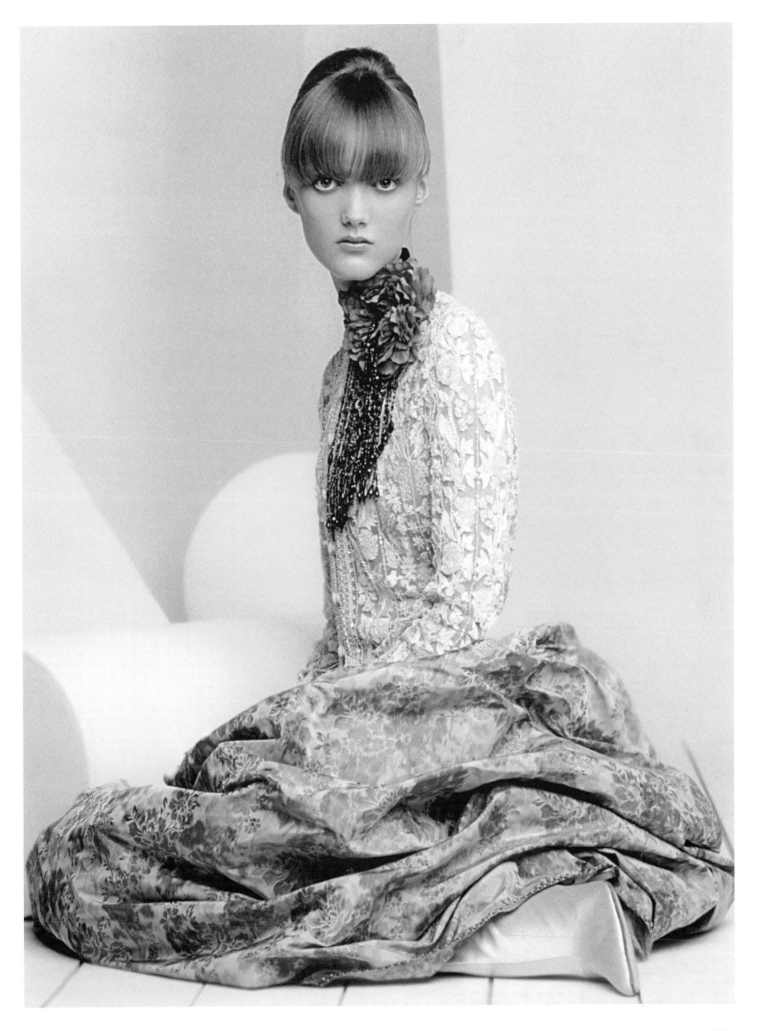

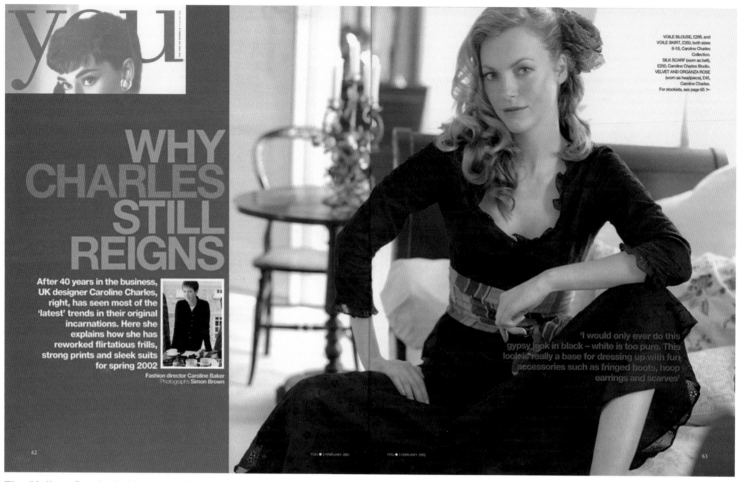

The *Mail on Sunday*'s *You* magazine printed a lengthy feature on Caroline Charles's 40th anniversary, with brilliant images and an interview with Caroline Charles

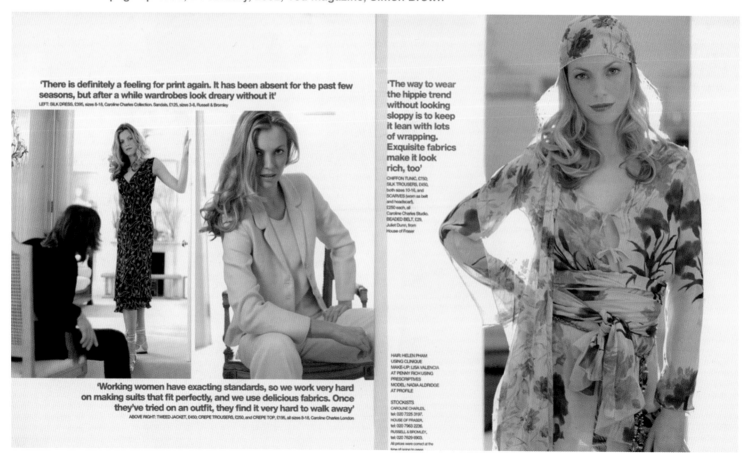

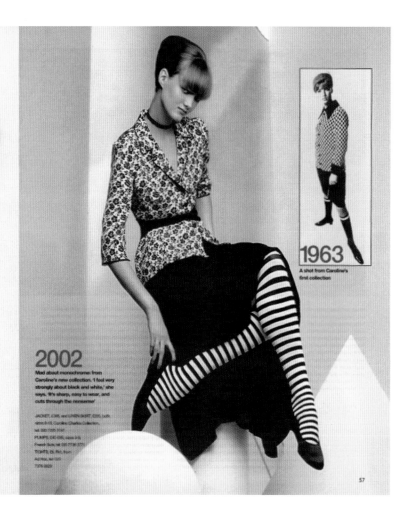

Double-page spreads, 2 February 2002, *You* magazine, various photographers; *Simon Brown, Clive Arrowsmith*

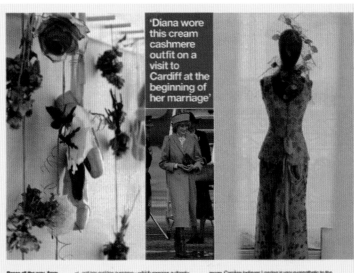
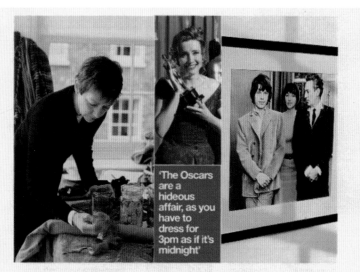

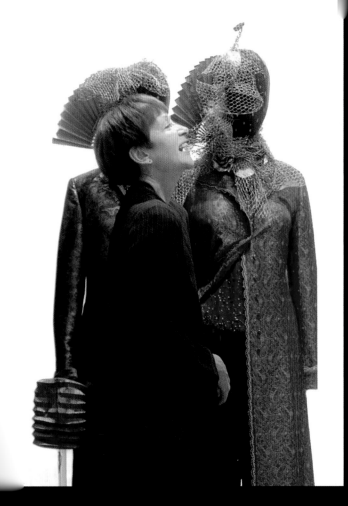

C.C. amazed and thrilled to get a medal, picture taken for *The Times*, 15th June 2002

OPPOSITE PAGE:
Autumn-Winter, 2002 © *Clive Arrowsmith*

The financial feel good factor of this millennium year inspired us to make an extra collection using vintage-looking fabrics and embroideries mixed with modern pieces. We called this 'Caroline Charles Studio', and hoped it would do well, despite the cost. The trade shows that we did in Paris in March had buyers from the US putting down many orders. So far so good, and photographer Clive Arrowsmith took beautiful pictures for us.

In June 2002, I was delighted to find that I was included in the Queen's birthday honours list to receive an OBE; the *Daily Telegraph* and *The Times* each ran a picture. The celebrations for this honour and the company's upcoming 45th anniversary took place in the V&A. We gave a party in the central hall with music, cocktails and a small show, plus a generous speech given by Nicholas Coleridge, Managing Director of Condé Nast Britain (and now President of Condé Nast International). And to top it all, I was given an award by the British Fashion Council.

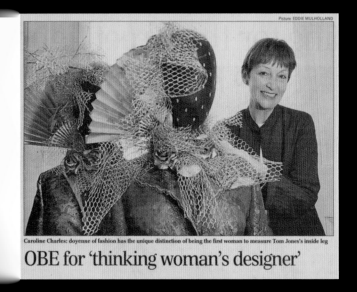

Picture EDDIE MULHOLLAND

Caroline Charles: doyenne of fashion has the unique distinction of being the first woman to measure Tom Jones's inside leg

OBE for 'thinking woman's designer'

C.C. photographed in the Beauchamp Place showroom for *The Daily Telegraph*, 15th June, 2002

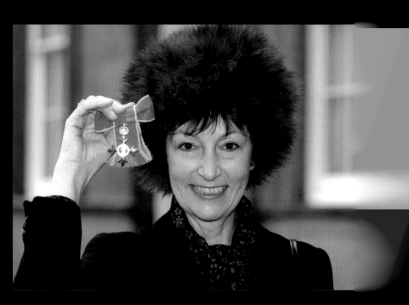

C.C. in the courtyard of Buckingham Palace, after collecting her O.B.E., 12 November 2002 © *Rex Features*

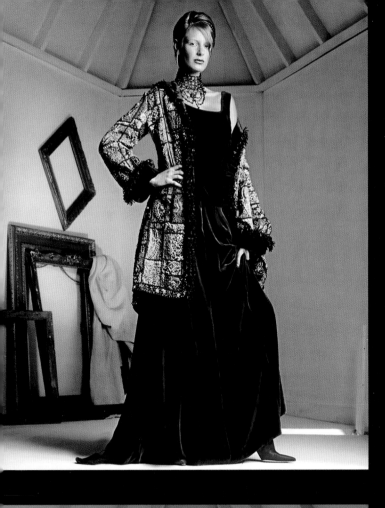
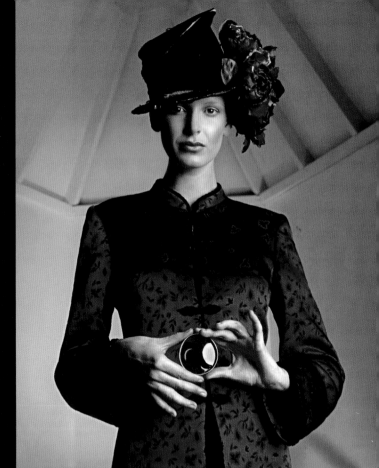
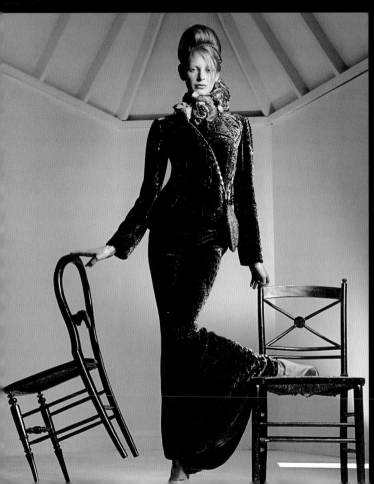
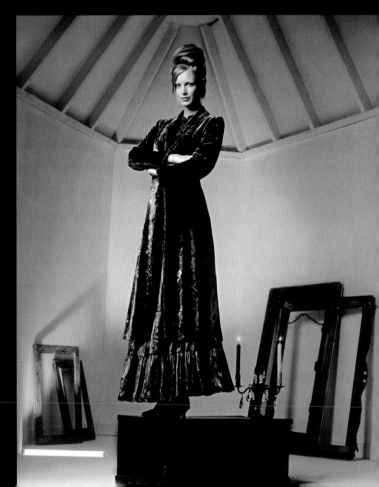

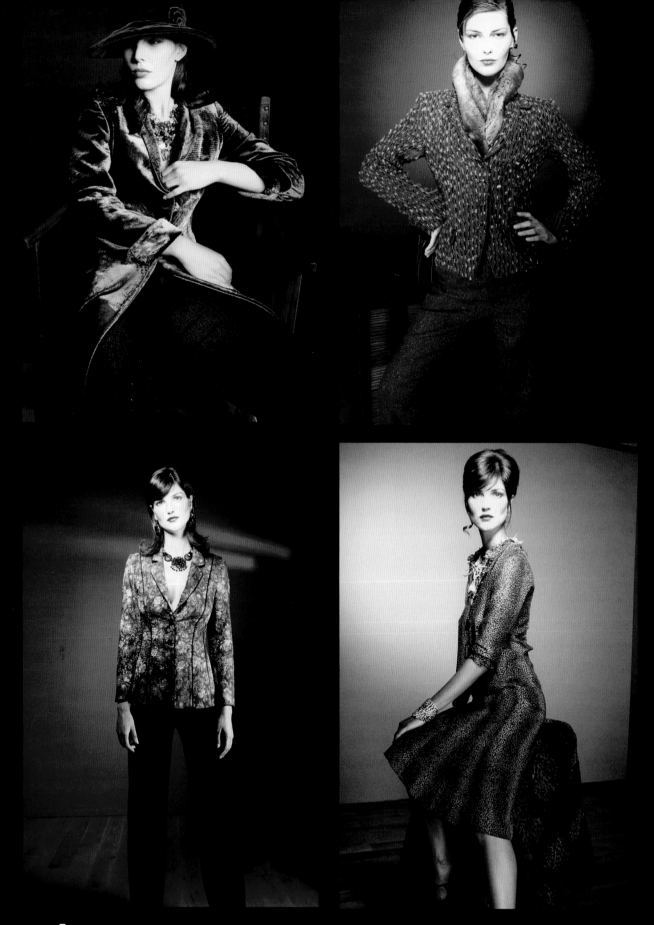

Autumn-Winter Collection. Tweed, brocade, velvet and leopard print georgette. All C.C. favourite
fabrics, 2003, *Paul Westlake*

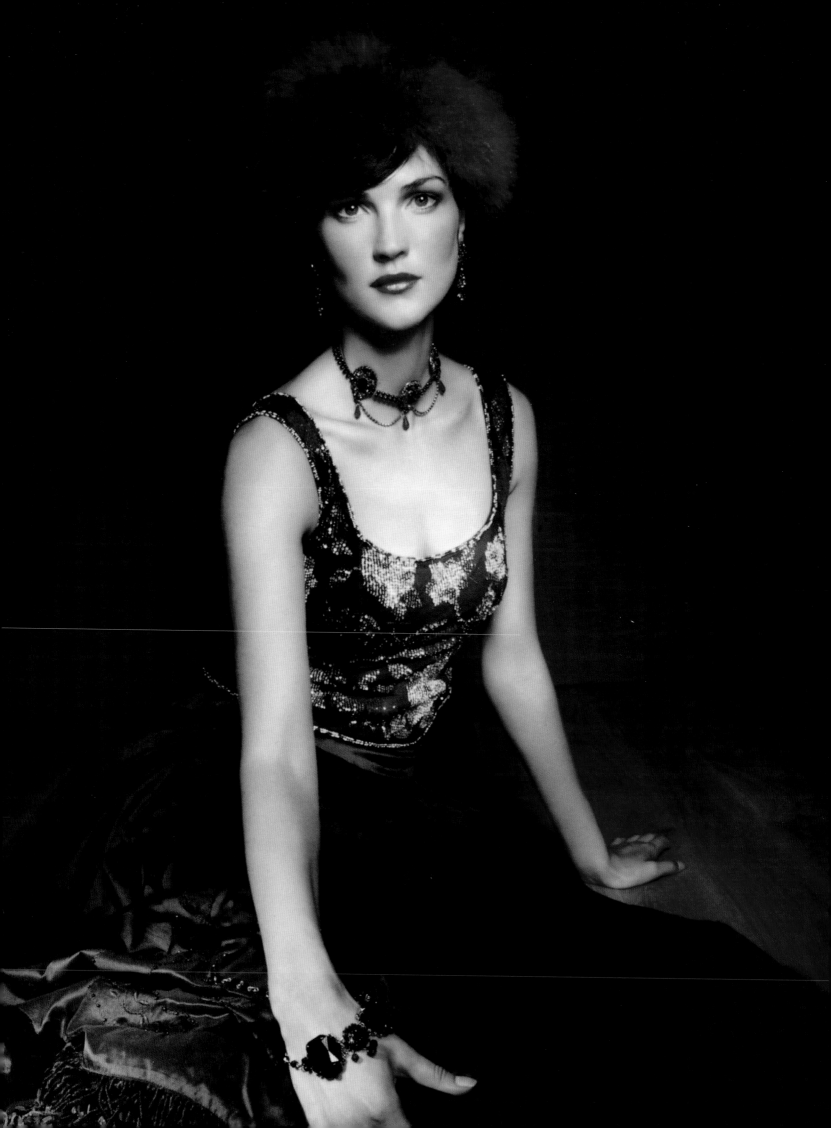

Emperor coat in organza brocade, embroidered and beaded. Plissé skirt in antique gold from the Autumn-Winter Collection, 2003, *Paul Westlake*

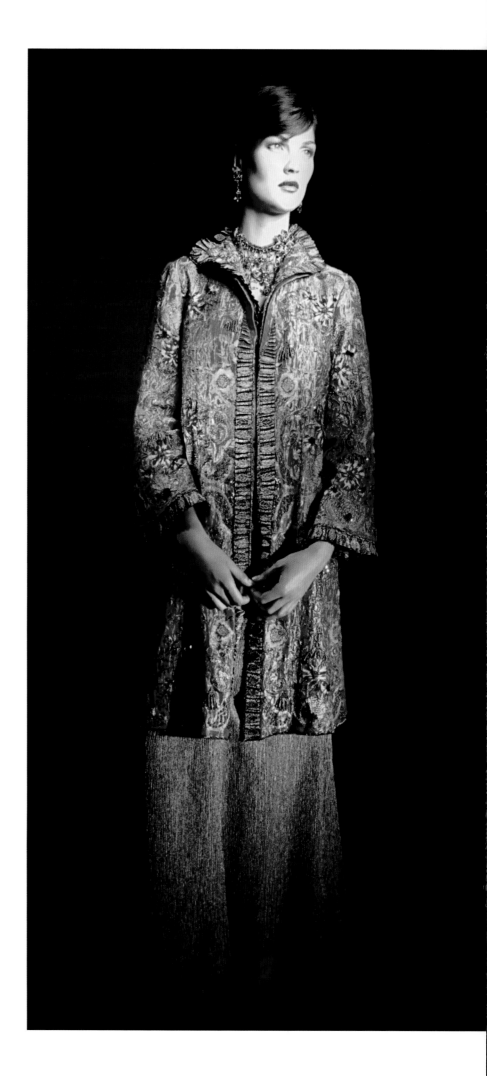

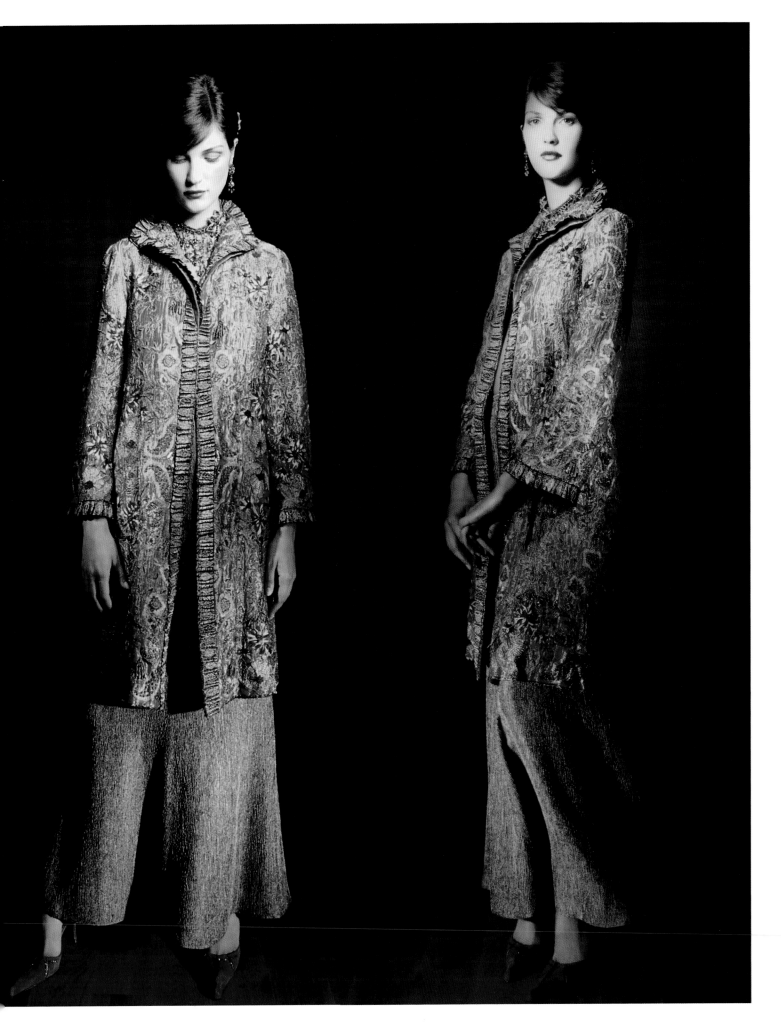

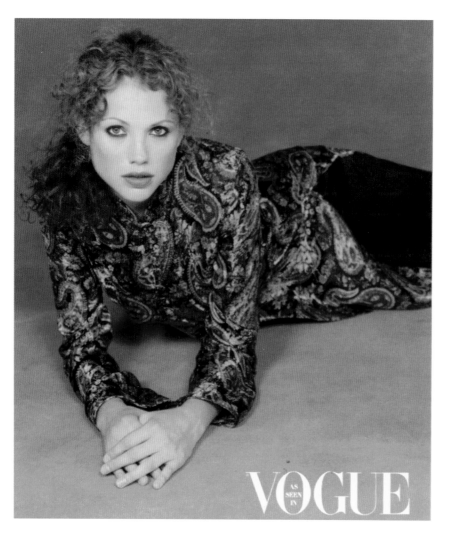

THIS PAGE:
Images from the Caroline Charles
Autumn-Winter Collection, 1997, *Willy
Camden*

ABOVE LEFT:
Silk and lamé woven paisley tunic

BELOW LEFT:
Argyll pattern cardigan knitted to
match the colours in the silk
georgette skirt

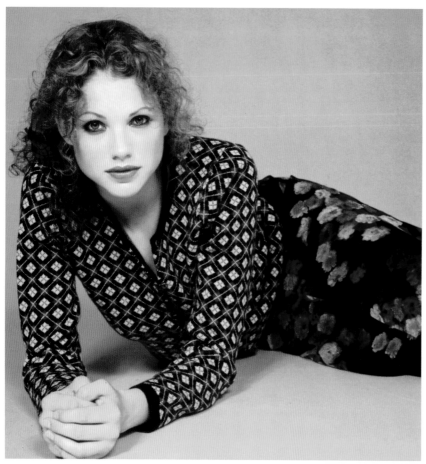

OPPOSITE PAGE:
Brocade Oriental coat, 2003,
Paul Westlake

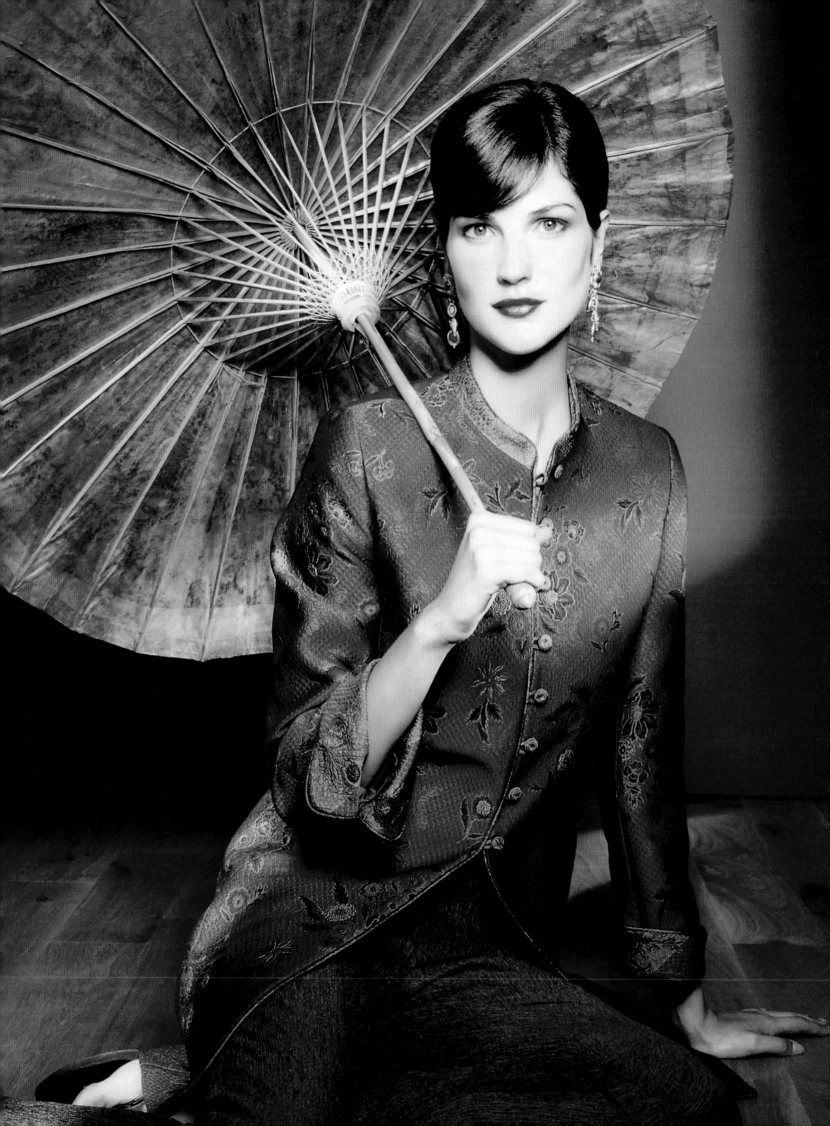

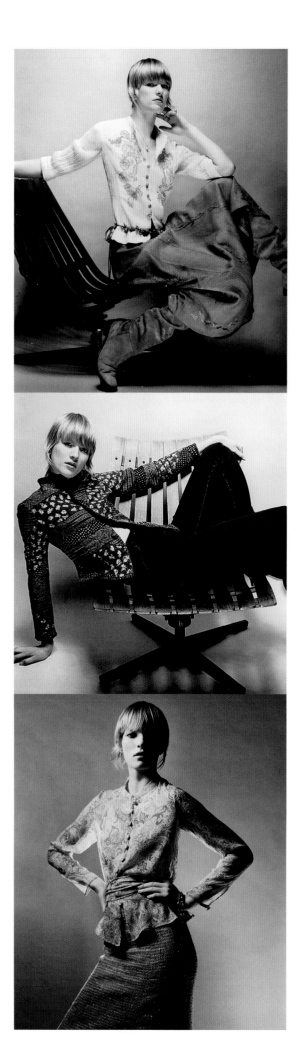

Spring-Summer 2003,
Jason Hetherington

OPPOSITE PAGE:
Hand-embroidered cardigan, 2003

THIS PAGE:
TOP:
Cotton blouse with wooden beads and toffee linen
skirt with matching embroidery, 2003

MIDDLE:
Embroidered denim jacket and jeans, 2003

BELOW:
Paisley silk printed blouse with a tweed skirt.
A classic Caroline Charles combination, 2003

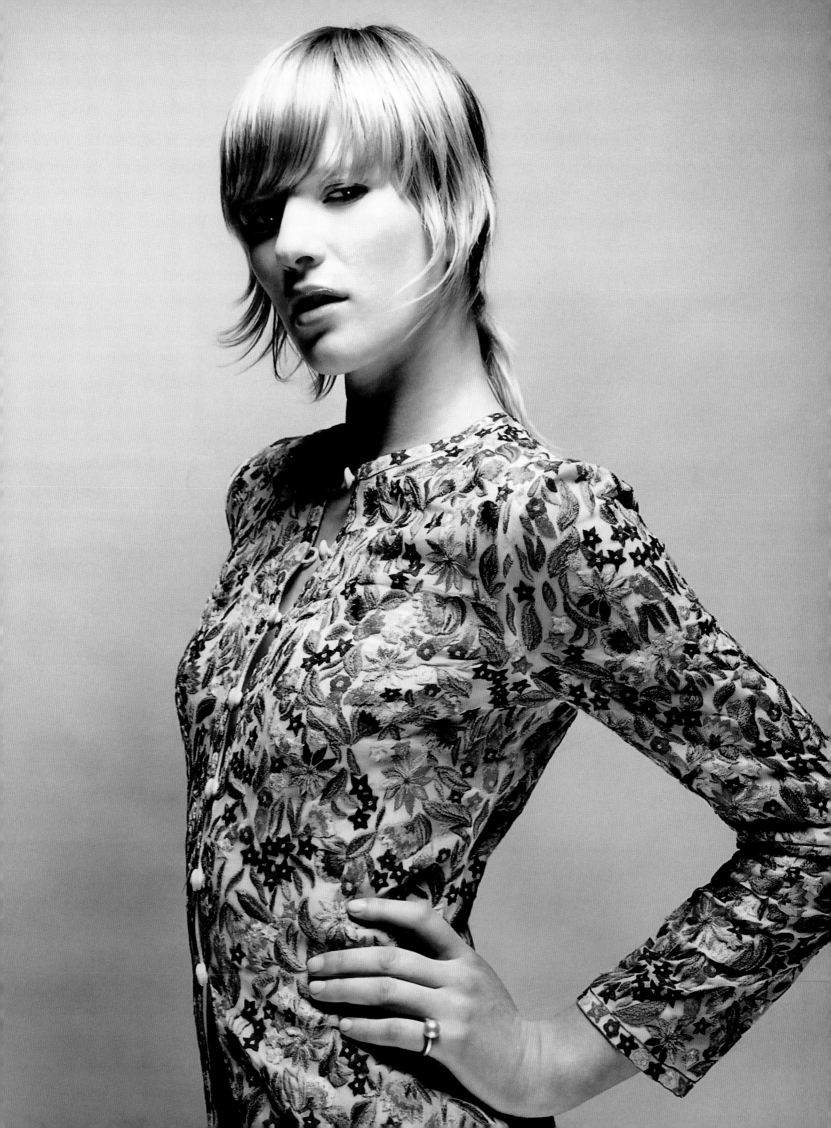

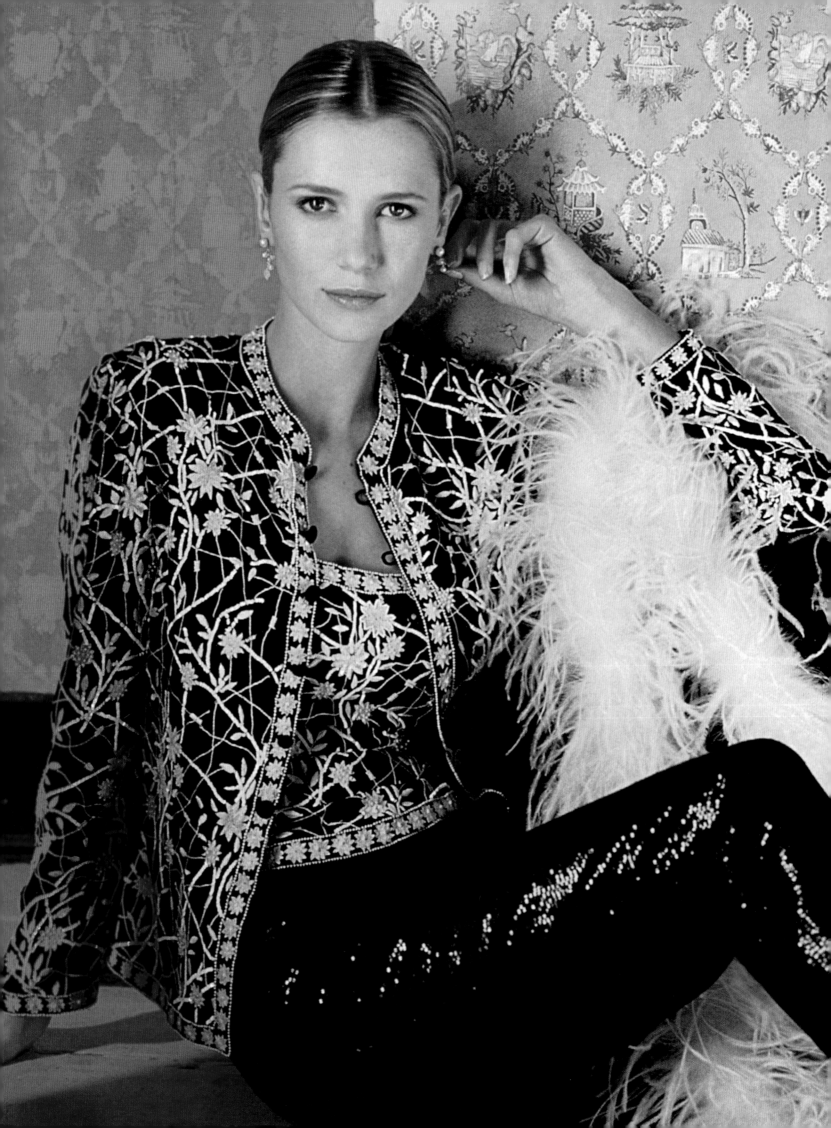

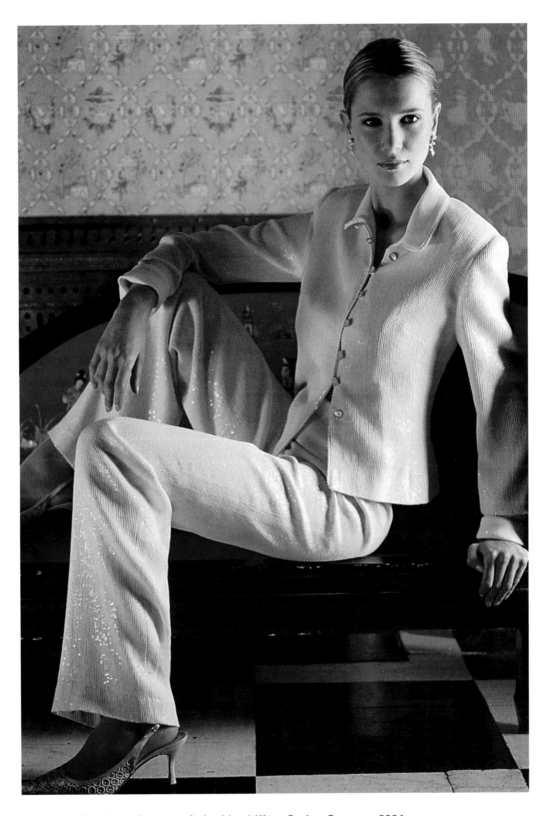

White pearlised sequins on soft double chiffon, Spring-Summer, 2004,
Pascal Chevalier

OPPOSITE PAGE:
Black chiffon twin-set embroidered in pearls and beads with black sequin trousers,
Spring-Summer 2004, *Pascal Chevalier*

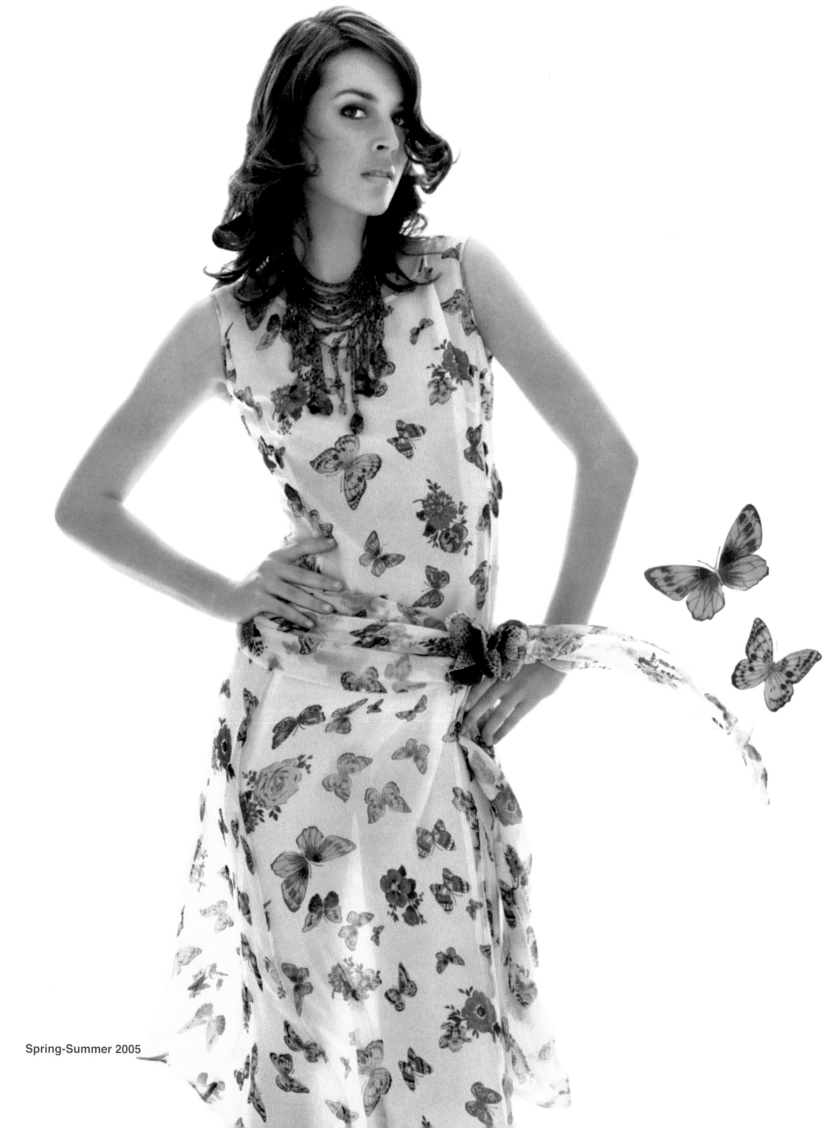

Spring-Summer 2005

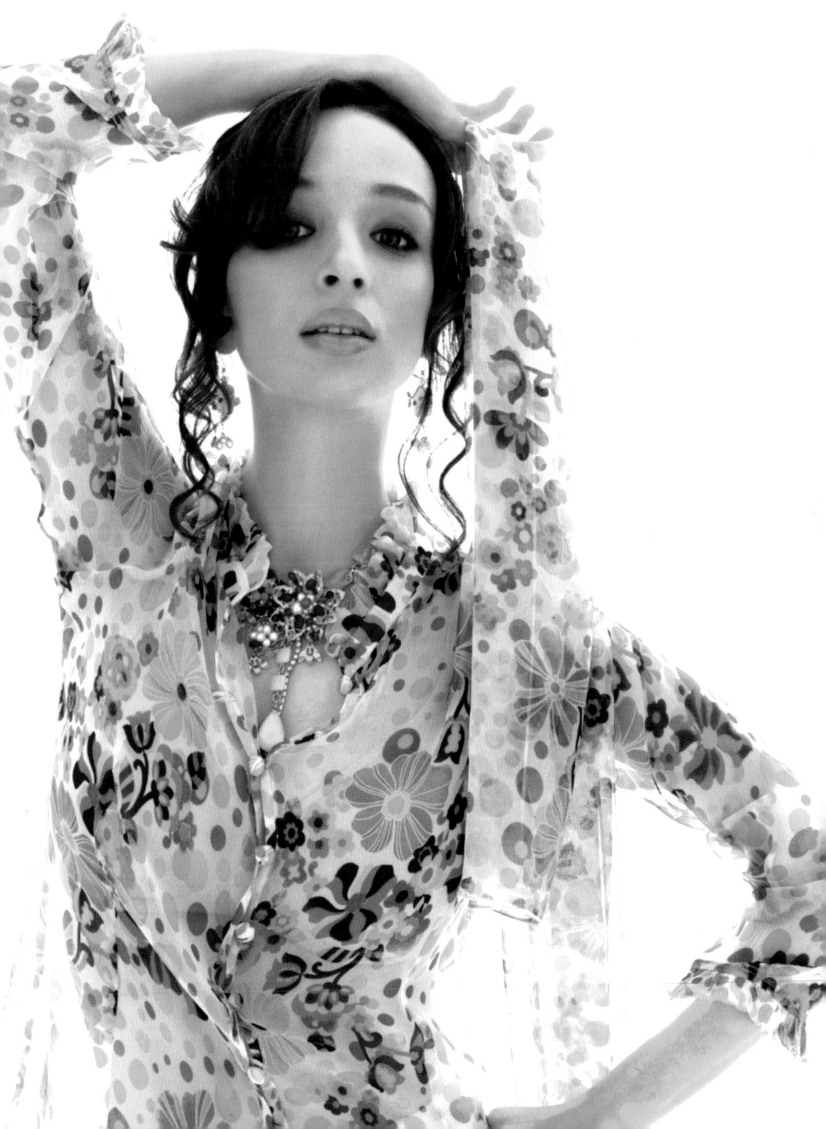

Caroline Charles
Q&A

Iain R. Webb

IRW: In the beginning you were part of the crazy Youthquake phenomenon, which must have been totally heady days, especially as you were so young at the time. How was that experience?

CC: You didn't really know what was going on and didn't worry about the bank balance or who you were going to sell it to. There were just a lot of people who were interested in what you were doing. Because I'd had a very good apprenticeship at least I knew how to put clothes together properly and I had a natural love of textiles. It was so heady because it seemed to be a break from London couture, which had been very elegant and grand and the High Street, which was good, classic, quality clothing. There wasn't much of a youth movement other than Mary Quant and Kiki Byrne, who were excellent. There were about eight new designers who were managing to get going and people just swept us up and took us to America and to Paris and put us in films and on the radio and TV. I don't think we thought we were lucky, I think we just thought this was life. I don't know about the others but that's how I felt.

IRW: It was a momentous time for society. Did it feel like that personally?

CC: Everything seemed possible. We wanted to make a break from our parents' generation without offending them, of course. In a way that has been achieved, there's no such thing as 'You will wear royal blue this year' or 'You will not put your anorak on to go to an interview or wear your sneakers'. It's very free now. Of course, from the point of view of style it's comfortable and everybody chooses what they want to wear.

IRW: You share initials with another great pragmatist, Coco Chanel. Do you share her ethos; is there something about being a female designer that has played a part in your successful career?

CC: Coco Chanel is one of the designers I most admire. She really knew her customer and she made pretty tweed easy suits for lunch time, little black dresses for evening and jersey pieces for weekends. She understood that pearls and straw hats were the ultimate accessories and her scent is unforgettable. I have always felt that being a female designer for women's clothes gives me an advantage. The people who like our collections and buy our clothes find that we offer pieces that suit their lives.

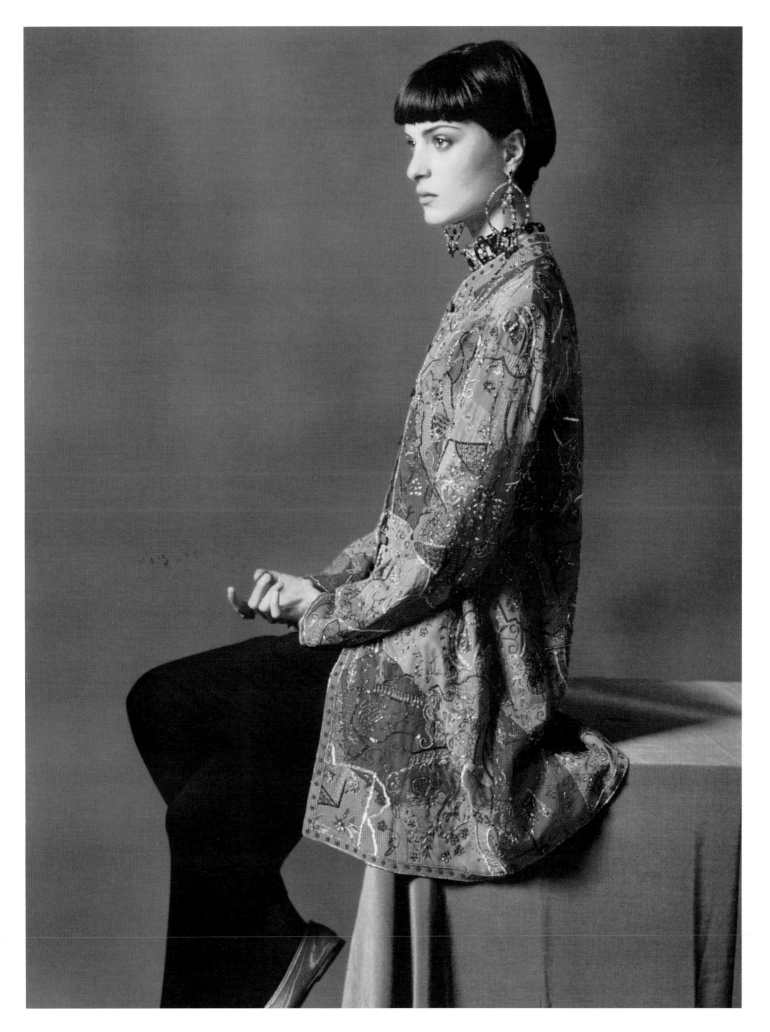

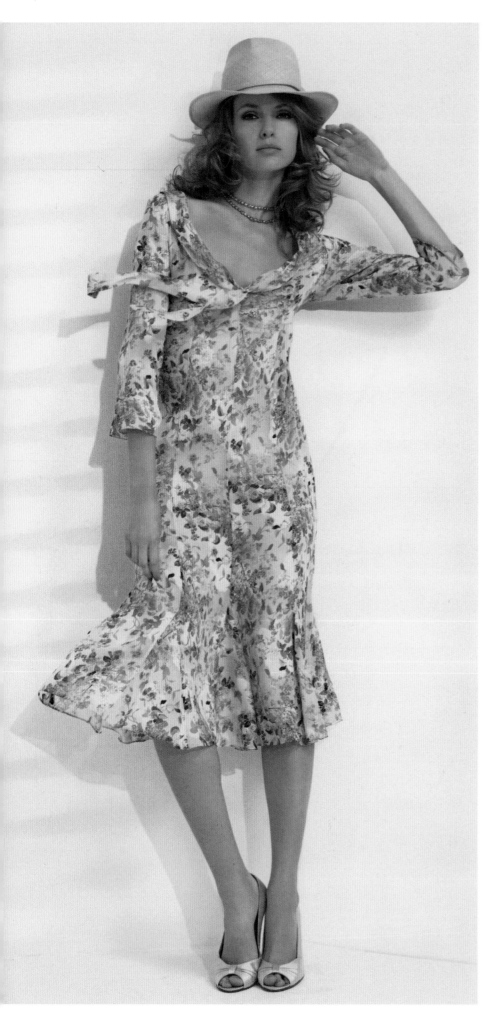

IRW: When you sit down to design a dress, what are you thinking?

CC: About the mood of the season, the economy, the social events and the climate generally. The fabrics play a vital part in how the collection builds and we spend months looking for them.

IRW: And is there a specific woman who you think about? Is there an ideal?

CC: Well, of course, she's a perfect five foot nine, size 10, blond, sometimes dark or red... No! I really think she's more an animated woman with a busy life, who wants to feel confident and look as if she's having a good time. She's quite serious in her work, she's probably interested in the arts.

IRW: And would she be interested in fashion rather than obsessed by fashion?

CC: Oh, definitely. She would be interested in fabric, shape and quality; but as a girl I was obsessed with fashion. At boarding school I found myself holding up *Queen* magazine, open at the fashion pages in the dark, fast asleep.

IRW: How does your working year take shape?

CC: Well, it's two six-month seasons that interlock. At this time of year there are three elements – you get retail winter, spring already on the catwalk and in production and you get next winter, half way through making the samples.

Spring-Summer 2006, *Elisabeth Hoff*

Chintz-print silk georgette dress. Perfect for a 'Princess Margaret' look

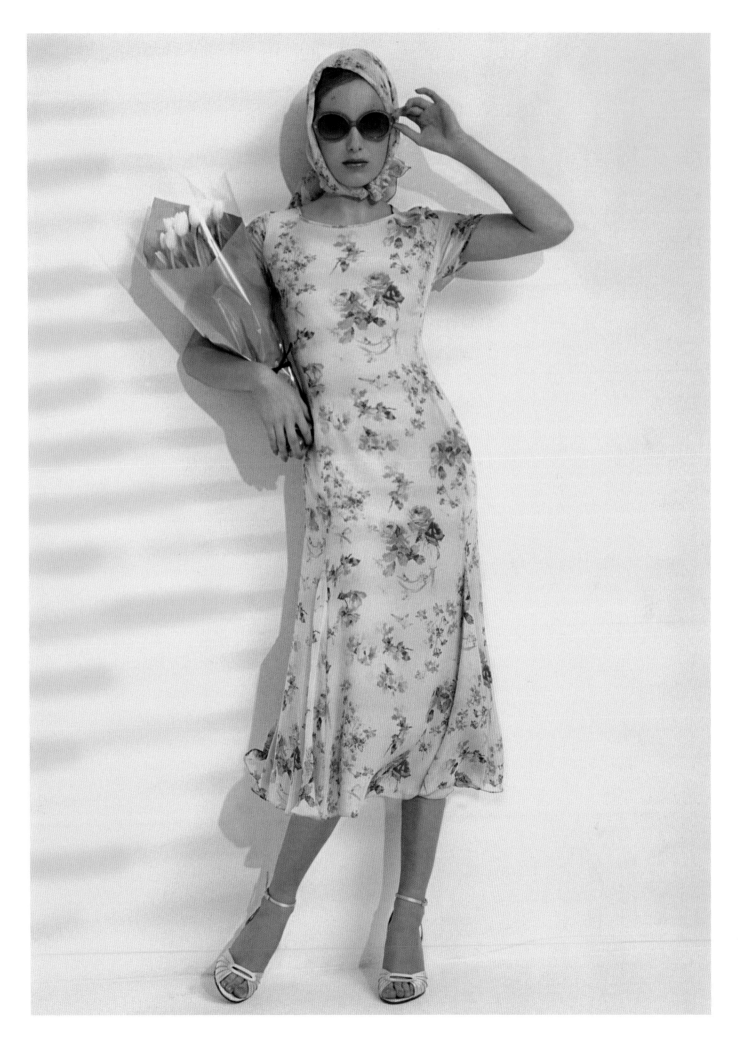

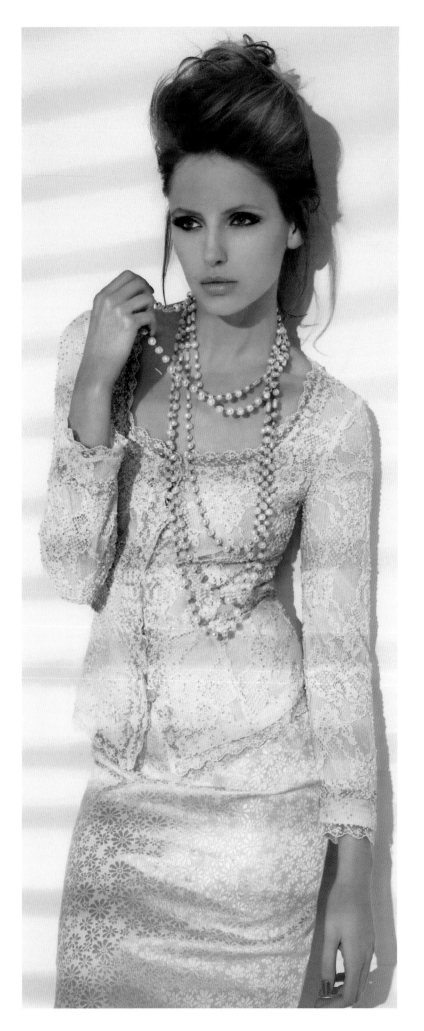

IRW: As a designer, are you attuned to picking up on things that are then worked into a design?

CC: Yes. I think we are all researchers, you can be in travel mode or a bookish mode or a theatrical mode, but we are all picking up things because that's the way we work. We have to have a point of view.

IRW: When other people style your clothes, does it sometimes change your perception of things or how you might put things together?

CC: It does. Rather depending on whom the stylist is, but you have to let go. Of course that's true of everything in life really, but particularly with the clothes. It used to make me cry, particularly when I designed pieces for Marks and Spencer. They would change things and mess it up, or mess it down, actually. Or if we had to do communal shows you'd see your clothes with other people's bags or jewellery on them. Of course you should be grown up enough to understand, but really you want to express the collection as you and your team conceived it.

Spring-Summer 2006, *Elisabeth Hoff*

LEFT:
Lace jacket with beads and brocade skirt

OPPOSITE PAGE:
Beaded bodice in antique golds and pearls. Ella Singh beading at its most beautiful

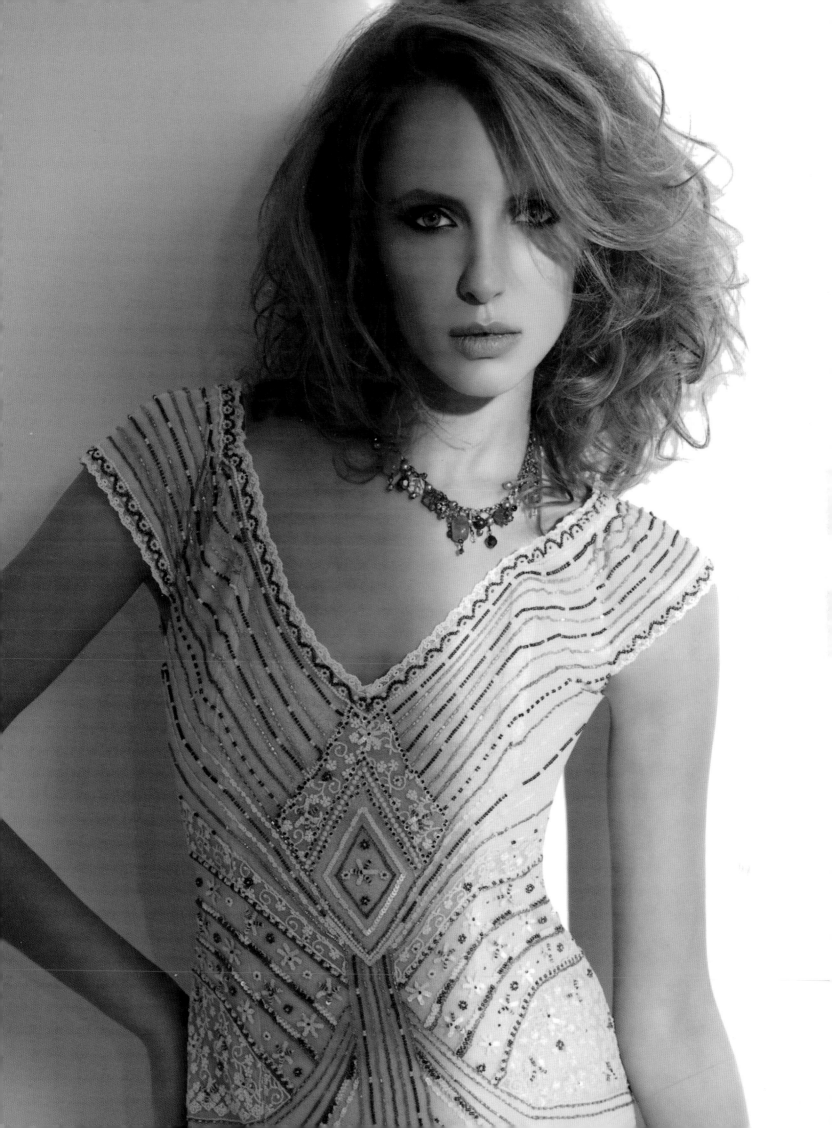

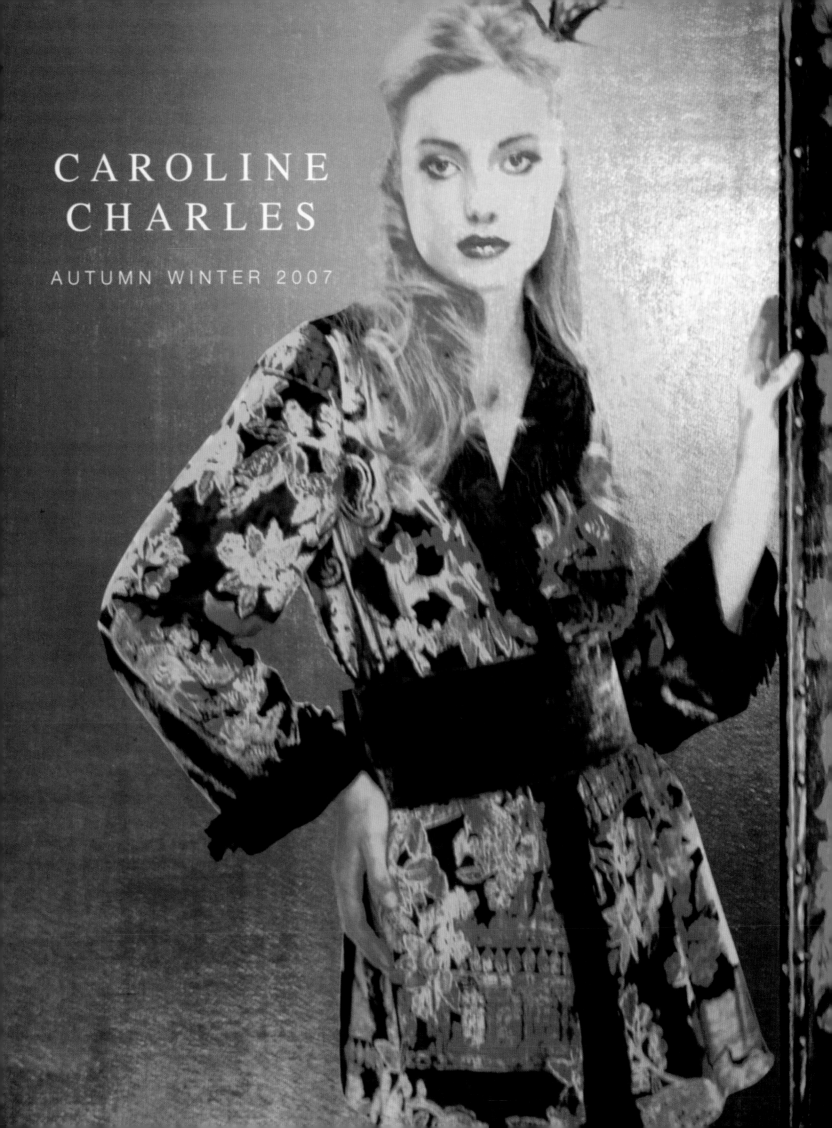

CAROLINE CHARLES

AUTUMN WINTER 2007

IRW: Tell me about the Studio collection that seems to have a narrative arc from your beginning in couture focusing on antique textiles and a special piece.

CC. Yes, that was a lovely phase; it was just before the luxury word was becoming over-used. We found antique fabrics and lined them all with silk and did not consider the cost. We took this small collection to Paris and showed it there and they just loved it. I had always suppressed this way of working because I had tried to sell more clothes to please factories, and we had just begun to work in China with our blouses, jeans and knitwear; and yet, this collection was completely back to making small runs. It was wonderful. But as the time has gone on, as always happens in this company, whenever we make a new collection it slowly infiltrates its way into the main collection. So that luxury pieces – you'll find lots of silk linings and fabrics you don't want to ask me the price of – just get merged in.

We started with these big coats and wonderful Chenille weaves. Gorgeous!

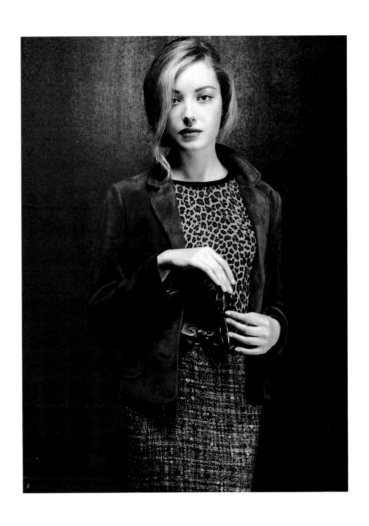

Autumn-Winter 2007, *Matthew Shave*

OPPOSITE PAGE:
Beautiful printed velvet kimono

THIS PAGE:
ABOVE:
Suede blazer with leopard knit and tweed skirt
BELOW:
Black silk twinset with intricate hand beading in gold

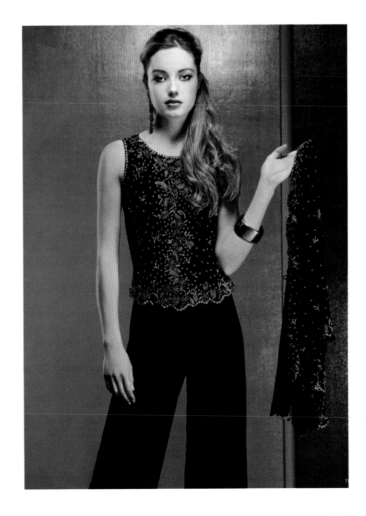

IRW: Do you think that your apprenticeship in couture where you learned how to make clothes has been the backbone of your design process?

CC: Definitely. I was never trained to be a pattern cutter but when I did my couture apprenticeship we worked with detailed sewing techniques. I love the making process, so the couture system that I joined was fabulous. I learnt exactly how you make a hat, how you trim it, how you put the petersham in. I learnt all about tailoring. I learnt all about ball dresses. I love the craft of sewing, I think you need these skills; it makes you a better designer. Being close to a team of skilled people is important to me, they are part of the creative process. After the apprenticeship, I went to Mary Quant where I was paid eight pounds a week, so I was rich! Mary had a terrific amount of skill. She really knew what she was doing. It's not enough to design, you have to make and sell. Marketing is the new skill.

IRW: At that time girls did make clothes that they wanted, because there weren't things available to buy.

CC: People could sew and there were lots of lovely fabrics to be bought.

IRW: You also assisted a fashion photographer, Tony Rawlinson. Do you think that gave you an insight into how clothes are worn or put together?

CC: Yes. It certainly gave me a clear understanding of how clothes are photographed, which is entirely different from how they are worn. The lighting, dark room, printing and retouching are all very interesting. In those days most studios had a darkroom. Fashion becomes a completely different thing in the hands of a journalist or photographer.

You think these people love your clothes, but actually they love the images.

IRW: And you mention the difference between the image and how clothes are worn. Oddly a lot of designers, I think, forget that clothes are to be worn and it's not just about making an image, whether it's on a catwalk or a picture in a magazine.

CC: What they know is that they've got to establish their name and the picture in the media will keep them in their job. But they also have to remember that a woman does have arms and they have to be able to do this or that and they don't want to pull it over their heads because they've just brushed their hair and things like that.

IRW: Talking about the fashion side and the longevity of your career – the fashion industry can be cruel. A young designer is told "You're amazing!" but we know that next year someone else will be hailed as 'amazing'.

CC: We've taken our customer base with us. I've been lucky enough to have a good team and have the pleasure of choosing fabrics and the pleasure of making clothes. Fashion is about so many things. The displays of social rank and wealth, sexual attraction of course, comfort against the elements. Sport. Everybody is in sports gear. Religion. Uniform. Country. Folk. Eastern exotic. All those things are very interesting.

Printed silk velvet, cut as a kimono with an obi belt. An heirloom Caroline Charles piece to hand on down the generations. Autumn-Winter, 2007, *Matthew Shave*

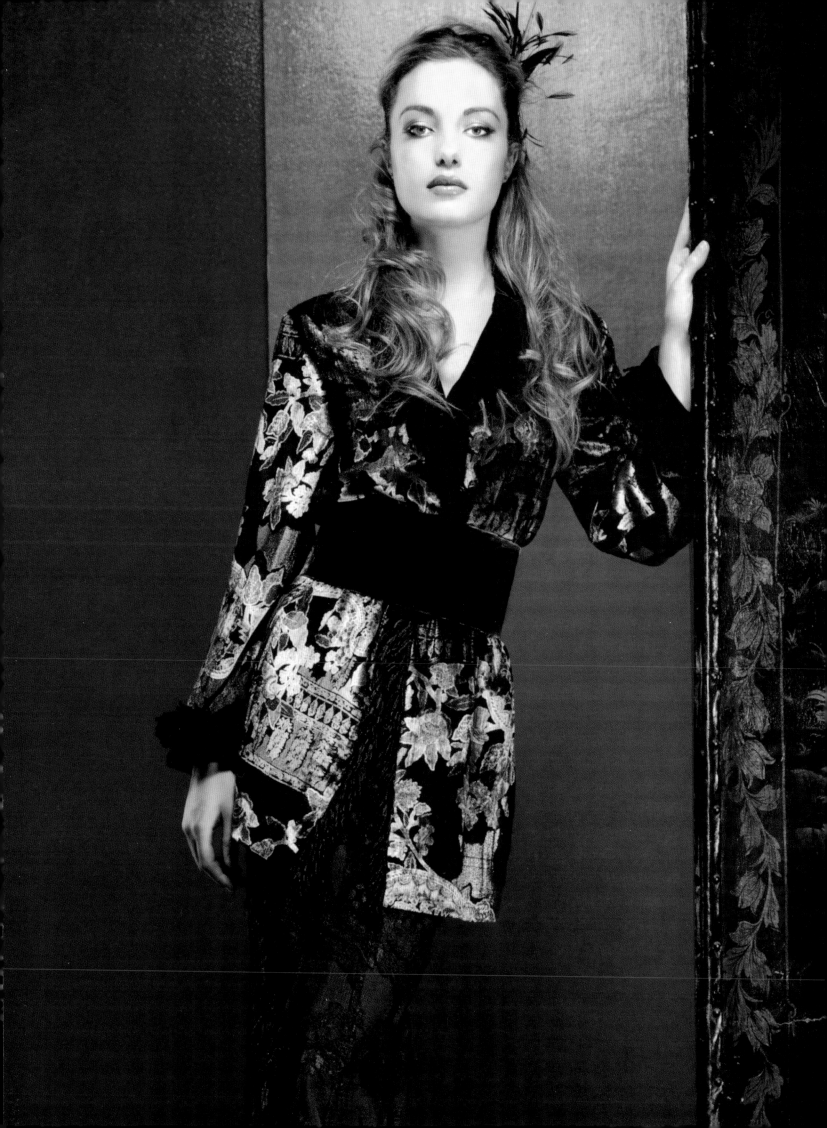

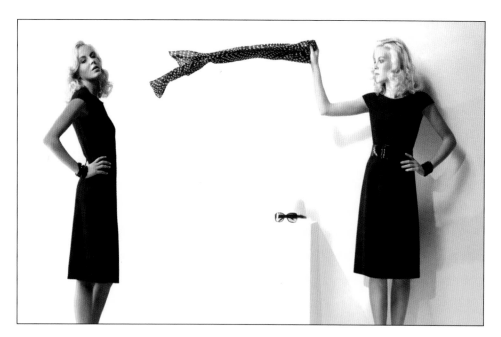

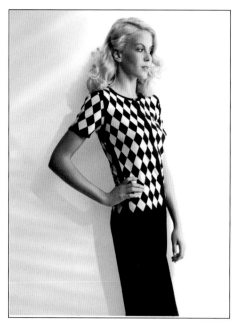

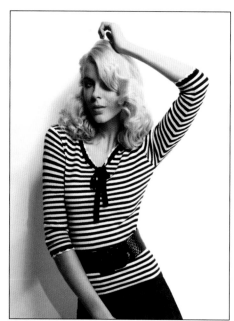

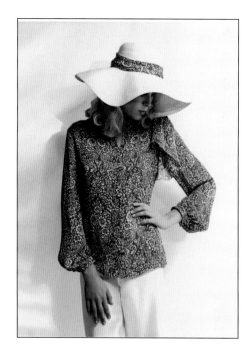

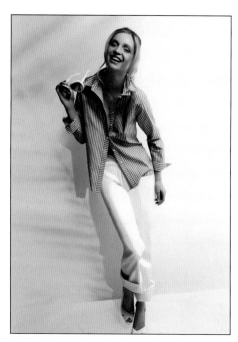

Spring-Summer 2008, *Matthew Shave*

This season was all about cool colours and Grace Kelly glamour

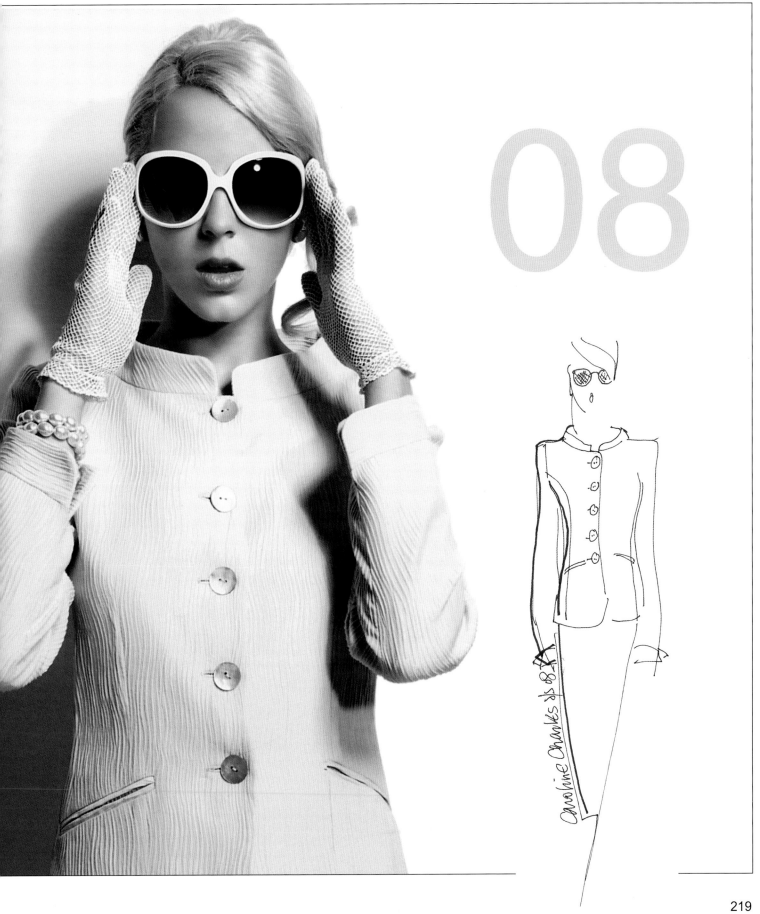

08

Caroline Charles ss 08

IRW: Having done London Fashion Week many times, the actual staging stays pretty much the same each season. Does that make it easier or more difficult? How do you approach your presentation each season?

CC: I go to the theatre a lot. I love lighting and sound effects and the actors. So here you are with twenty girls who don't speak English who are five foot eleven at least, a static lighting rig and the soundtrack that somebody hasn't blended properly, whether it's Mozart or Motown. When the show is over and you're talking backstage to foreign journalists who ask what the meaning of this or that was and you think, 'I wonder, I'm not sure' [laughs] or because you've got a bustle skirt you start talking about Suffragettes and they think, 'How do you spell Suffragettes?' The sadness for me is that it isn't a rehearsed proper presentation and I wish it were, but the show schedule and the timing don't allow for that.

IRW: And it is six months work over in ten or fifteens minutes?

CC: Yes, but those are very long minutes. And the wrong things all happen at once and the wrong hats go on and there are hairdressers in the way… but it's all quite amusing when it's over.

Backstage images from London Fashion Week, Autumn-Winter 2009, *Catwalking*

How lucky to have such a good actress in a Caroline
Charles jacket

IRW: As a designer you are constantly looking
and seeing things and noticing what's going
on. I noticed in your boutique you have a
jacket in Prince of Wales velvet that has lace
on the edge but it almost looks like it's
unraveling. It looks like a raw edge but it's
cleverly lace, which is that touch for your lady.
Would that be right?

CC: I like surprising small elements and
working with different textures and fabrics, in
particular those laces, which are either French
or Japanese now, the variety and colours have
certainly expanded over the years. When we
have decided what the colour board is going to
be and I'm searching for purple, let's say, I
become obsessed with it so everything, the
side of the bus, the corner of the puddle on the
street, everything has got purple in it. That's
the way my eye works.

IRW: And it's those kinds of details that are the
finishing touches.

CC: The details. Yes. I like a bound button-hole
and I like properly piped edges, things that
make the clothes special and make them last.

Colourboard, Spring-Summer, 2009

OPPOSITE PAGE:
Backstage images from Spring-Summer catwalk, 2009, *Catwalking*

Autumn-Winter 2010, *Elizabeth Gibson*

Tweed and flannel, silk collars and Grecian-inspired
beading

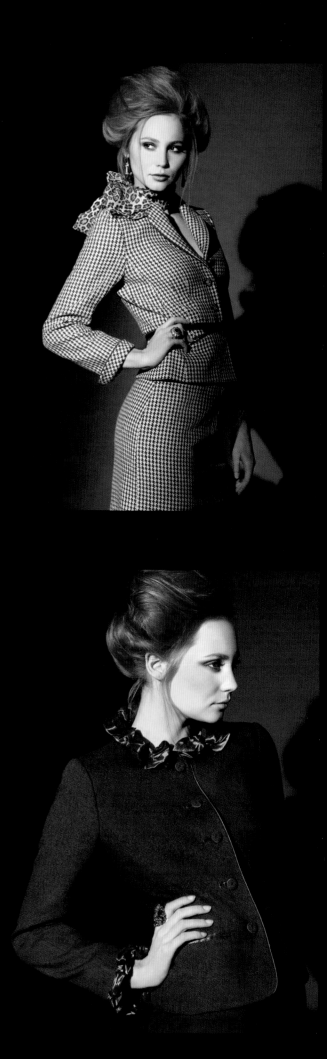

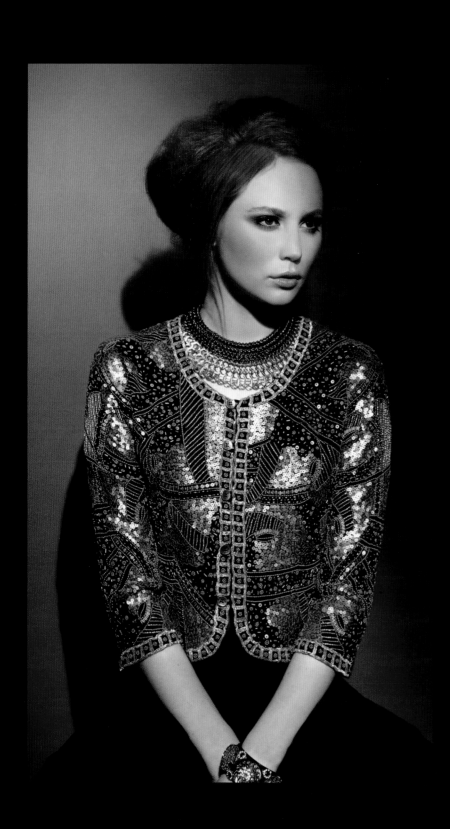

IRW: You were part of the emerging phenomenon of designer as celebrity, in that you had your own weekly slot on BBC Radio *Teen Scene* and appeared as a guest on *Juke Box Jury*. Was it odd that you were designing dresses but then put on TV and the radio as yourself?

CC: Because it happened straight away I didn't think it was odd. But sometimes, now you mention it, it probably was. I was put together in the papers with Cilla or Lulu or Millie or Sandie Shaw. I didn't actually make stage clothes, but they loved what we made so they would come and choose with their stylists and agents and we had PRs and the whole thing went together as a movement. People were interested in young designers. It was very lucky for us.

IRW: Did you enjoy that fame?

CC: I enjoyed America in the Sixties because America hadn't had this youth wave and they absolutely loved it. In London, we were dancing The Twist and The Madison and we did that every night in the Ad Lib or other clubs, often several in a night. So when we went to America on tour we would have the models dance on stage. The audience was mostly made up of students, and would get up and dance with them. They knew the music because the Beatles had already made it to America. There would be Go-Go girls in cages wearing fishnet tights and a live band and somebody on a microphone talking about the clothes and it made

a party. That's really what I miss about London Fashion Week – it's not a party anymore. It's a professional presentation targetted at the industry. Back then we were part of the pop music scene and it was a very good combination. I was reminded of it when I was in Japan, where there'd be 150 girls waiting in the hotel corridor for me because I had touched the Princess of Wales!

IRW: Following on from that, you have had your own famous clientele with Streisand and Jagger. Do you think celebrity culture has co-opted fashion now or do you think that has always been there as part of the story?

CC: I think that it was always thus with the Duchess of Windsor or Marlene or Marilyn... It used to be Edith Head running the show but she was doing it mostly for films. Now it's taken a different turn. The public know everything is borrowed to promote a designer or a star actress.

Caroline Charles hand-beading

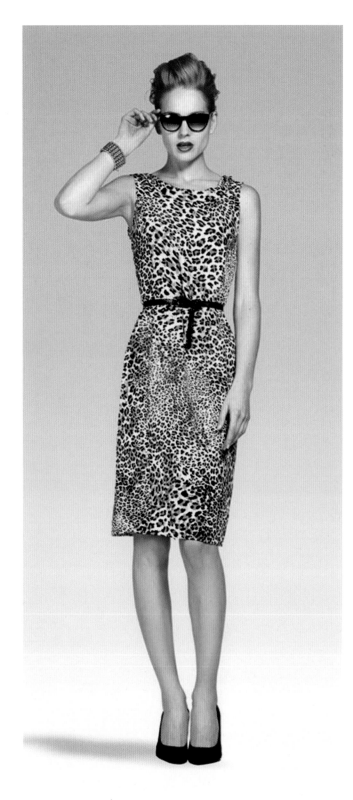

IRW: You dressed Emma Thompson at the Oscars. You couldn't pay for that kind of publicity. How was that for you?

CC: You're right; she was one of the people in my career who you couldn't replace. She was easy to dress. We did the Baftas and Oscars. She showed me a letter from the Valentino Studio that Valentino had written to her saying, 'How had she managed to settle for this?' There was a sort of superiority about the big houses doing the Oscar dressing.

IRW: I suppose the red carpet has become another catwalk. The coverage must be...

CC: The coverage of the Oscars is phenomenal, but you have to be selling that full-blown or skinny ballgown and I'm not that taken with them.

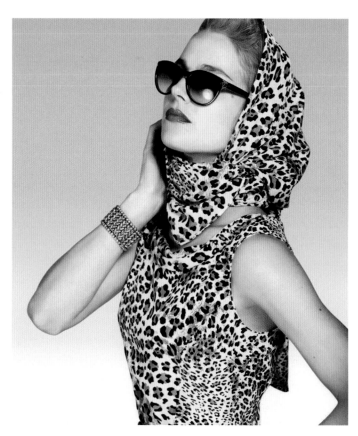

Spring-Summer 2011, *Nick Kelly*

THIS PAGE:
Silk leopard safari dress

OPPOSITE PAGE:
Cotton jacquard jacket and wide-brim straw hat – a very 1950s inspiration

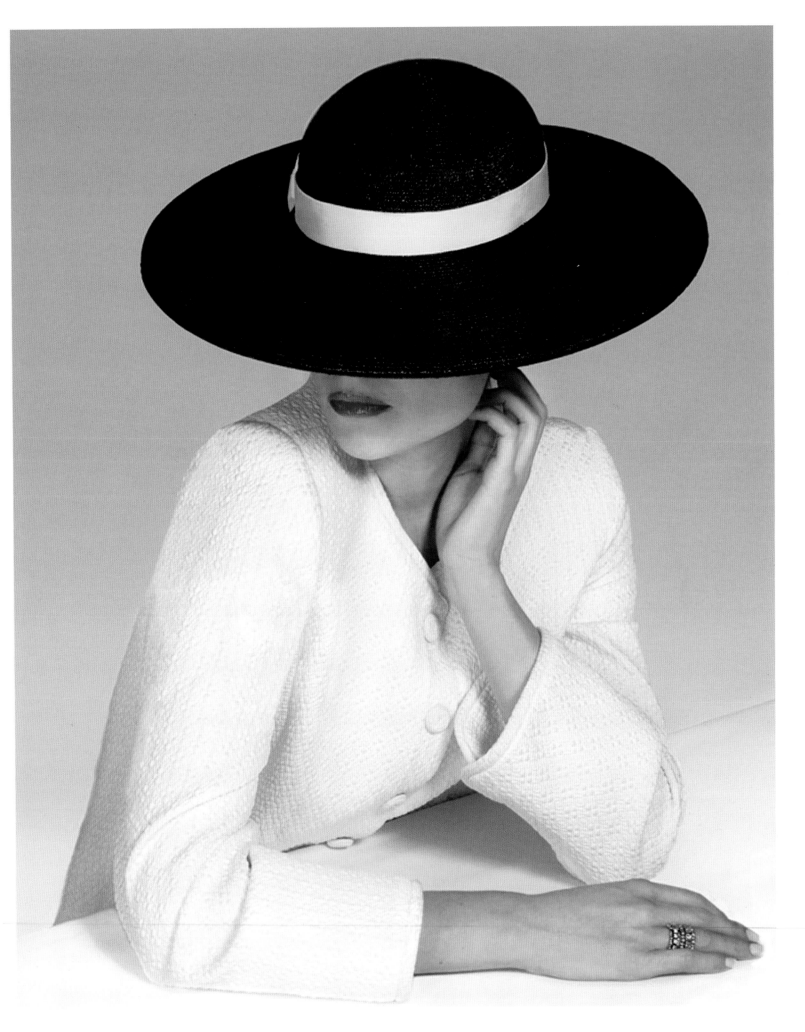

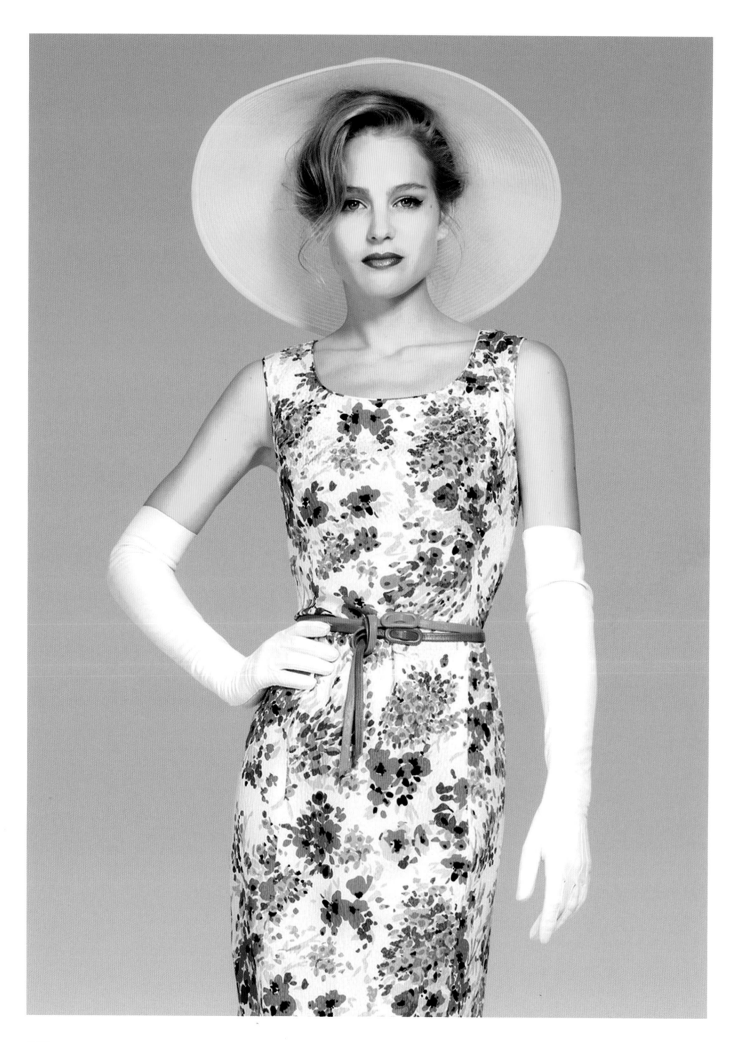

IRW: You mention ballgowns, but you've also designed workwear for Boots, Habitat, Jaguar, Estée Lauder. That again is taking the pragmatic approach and designing for purpose. Would you say that is a cornerstone of your ethos?

CC: Yes, totally! I love those projects. It's a question of how many pockets this person is allowed and what they put in that pocket? Does it move? Can we have stretch fabric? Will it launder? All those things are good. When the Eurostar was starting that was a project we were offered and the Bunny Club girls.

IRW: And does that inform your fashion pieces? Going back to what people want and the lives they lead?

CC: I've become used to looking at what people are wearing at social events and private parties and when travelling.

Appealing to the customer requires the design team and sales people to understand the needs of an international woman: the social life, the work and travel, the economic climate and the weather in different time zones.

The fabrics, the colours, the cutting and sewing and, of course, the fashion and style of tomorrow and today are paramount. We have always made clothes to last and believe that they are useful and can be handed on to different generations. So the challenges are many, but they are all stimulating and I am very pleased to have landed the job.

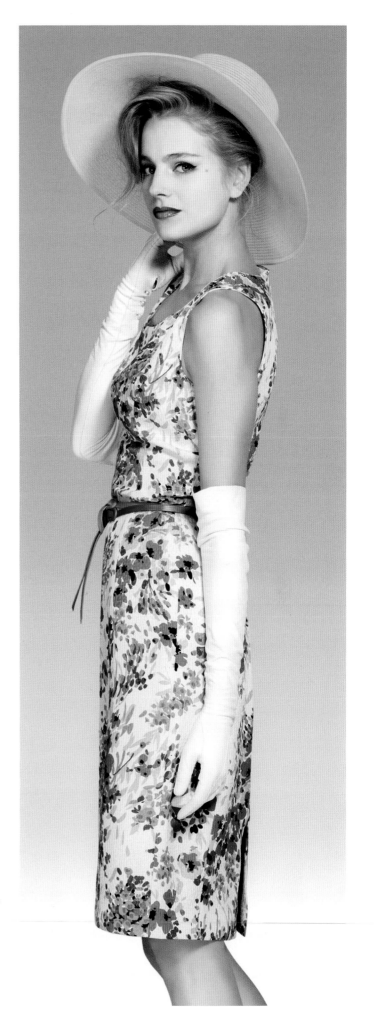

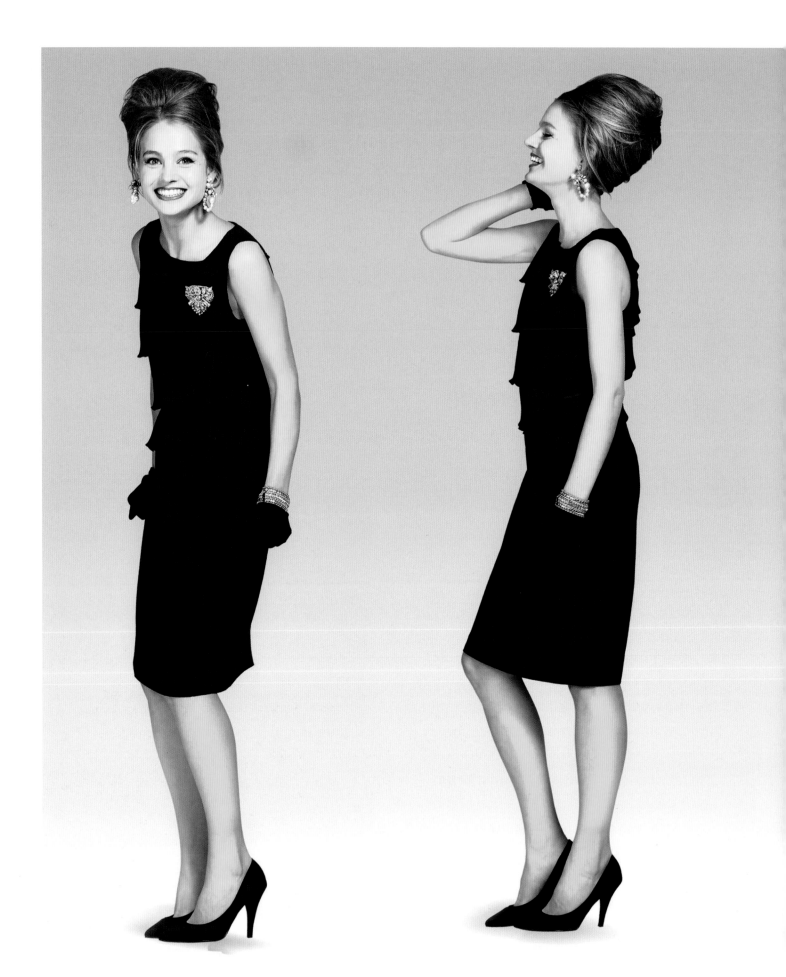

PREVIOUS SPREAD:

Spring-Summer 2011, *Nick Kelly*

'Bella' dress in Italian Como print on figured silk

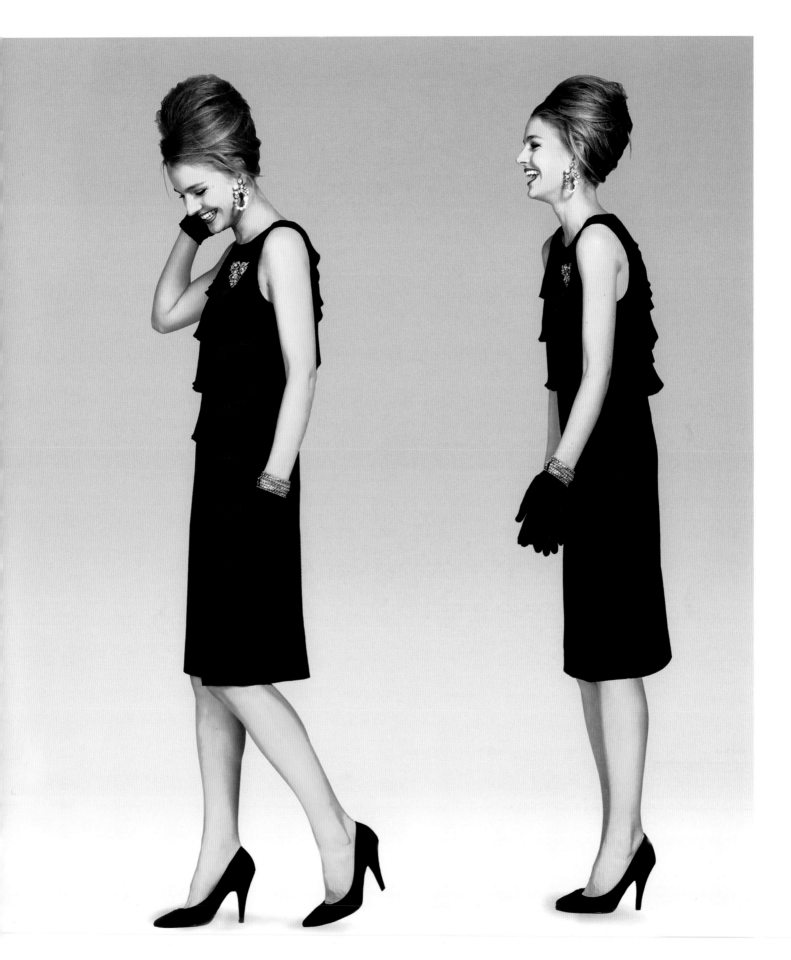

Spring-Summer 2011, *Nick Kelly*

Tiered crinkle silk cocktail frock – very Audrey Hepburn

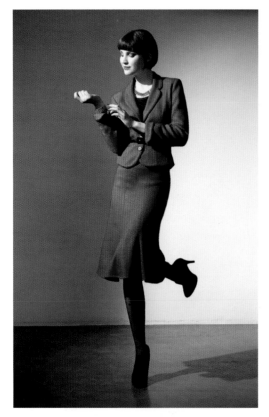

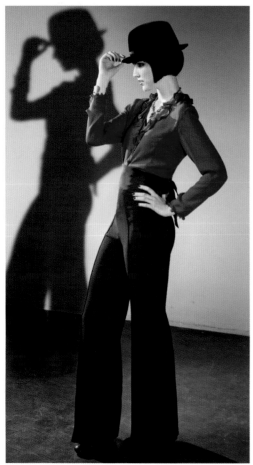

Autumn-Winter 2011/12,
David Goldman

Inspired by Berlin cabaret-meets-London
bowler hat

IRW: You mentioned how you have taken a clientele with you – from the working woman to Diana, Princess of Wales. Is that something you are proud of?
CC: With the Princess of Wales it was a working uniform that she needed. She was very professional and I loved that about her. I think the whole way through we have taken women with us, women and their daughters and their granddaughters because the clothes fill a need. They are the treat of course.

IRW: And you have continued to expand, working with Harrods and your own stores, as your career has gone on. That's quite a feat in itself.
CC: I find the business side interesting. It's just as creative, of course, in a different way. There is the joy of doing it. That's very valuable to us.

IRW: A very British thing is the combination of the practicality and pragmatism – what am I wearing this for? And the theatricality and flamboyance of our eccentrics. That collision.
CC: Yes. That collision is the London spark. The French are glamorous and the Italians are very good at what they do. But no country has as many art schools as we do and the fashion graduates work in international brands.

IRW: Do you think your story could have happened anywhere else but London?
CC: No, I definitely feel that this is my town and if you read about the history of London it's all about embracing difference. It's the melting pot that London is. I love all the elements of London – even when it's raining.

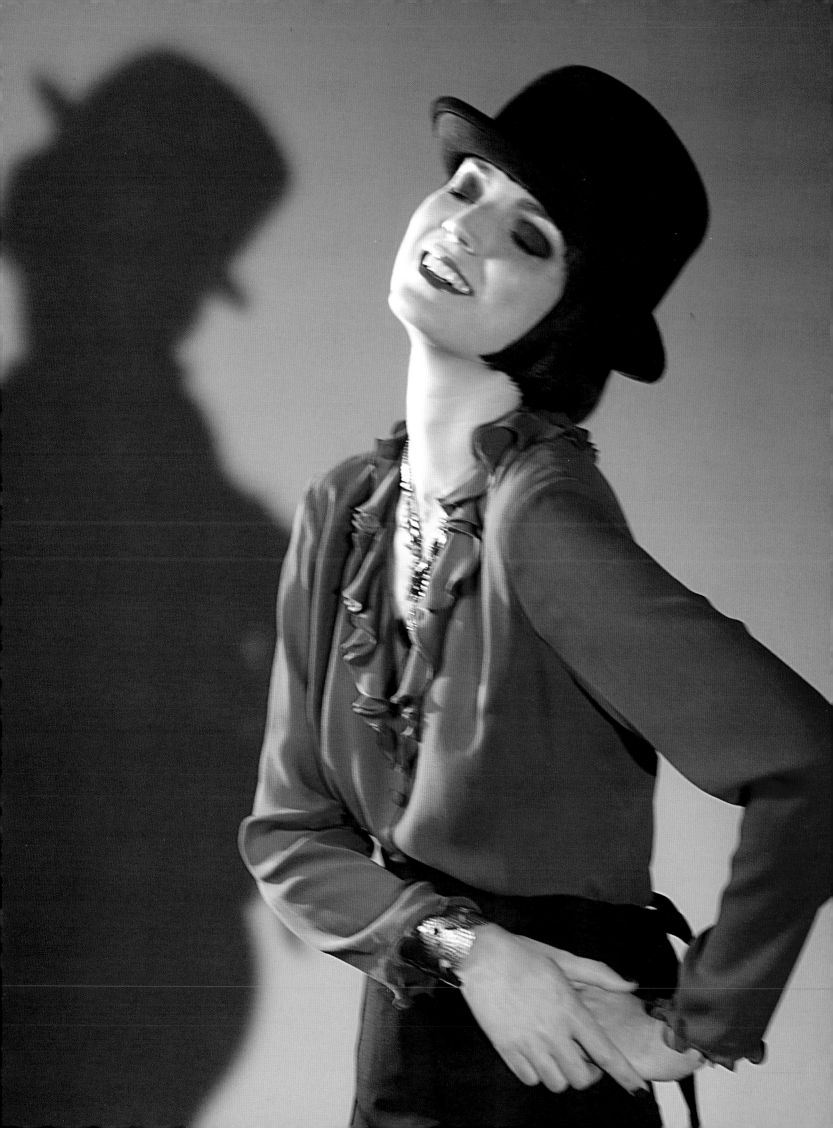

French tweed jacket, 2012, *David Goldman*

Italian cotton print summer dress, 2012, *David Goldman*

P.S. ...going forward

Spring-Summer 2012
The Royal Jubilee celebrations were splendid all over the country and our collections were seen at many receptions and parties. As ever, the French tweeds and the Italian printed cottons and silks continued to be a great source of inspiration and were much admired.

Silk georgette print dress, 2012, *David Goldman*

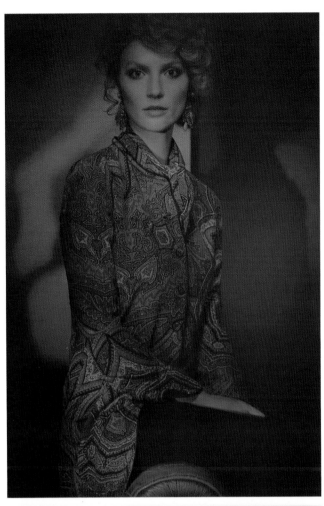

Autumn-Winter 2012

We have just returned from a working trip to Beijing, where this Autumn collection was particularly popular. The heritage of our company and the choice of fabrics and individual design and details are very suited to the current trend in China. Meanwhile, designing the Spring-Summer 2013 collection is complete and London Fashion Week show plans are underway...

Autumn-Winter 2012, *Euan Danks*

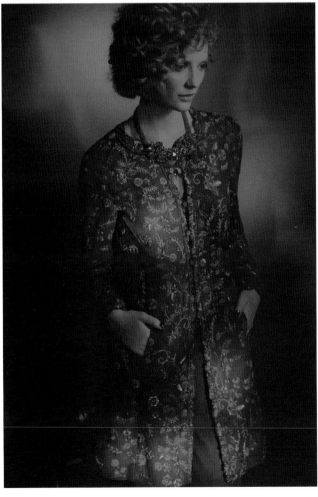

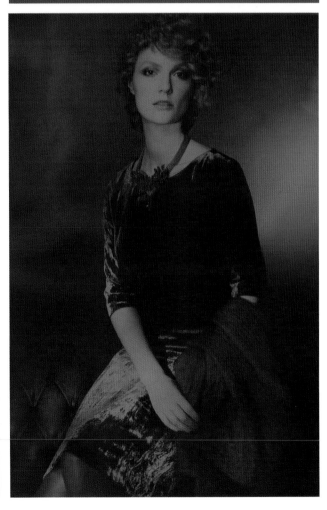

PICTURE ACKNOWLEDGEMENTS

Photographers

Michel Arnaud
Clive Arrowsmith
Allan Ballard
Chris Barham © Rex Features
John Beale
Robyn Beeche
Tom Blau
John Bishop
Eric Boman
Jane Bown
Martin Brading
Simon Brown
Willy Camden
Catwalking
Pascal Chevalier
John Cowan
Euan Danks
James Darell
Henri Dauman
Demarchelier
Donovan
Nicky Emmerson
Ronald Falloon
John French
Elizabeth Gibson
David Goldman
Tim Graham © Getty Images
Jason Hetherington
Elisabeth Hoff
Anwar Hussein © Getty Images
Philip Jackson © Rex Features
Nicky Johnston
Nick Kelly
Neil Kirk
Herbie Knott © Rex Features
Kim Knott
Charles Lamb
Bruce Laurance
David Levenson © Getty Images
Lidbrooke

Claire Lloyd
Sandra Lousada
Helen Lyon
Eamonn J. McCabe
Liz McAulay
Don McCullin
Joseph Montezinos
Larry Morris
Mike Owen
Marco Palumbo
Norman Parkinson
Jonathan Postal
Anthony Rawlinson
Mike Reinhardt
Roy Round
Stephanie Rushton
Joseph Santoro
David Seidner
Matthew Shave
Silano
Snowdon
Howard Sooley
John Swannell
Mario Testino
Albert Watson
Paul Westlake
Claus Wickrath
Angela Williams
David Woolley

1960s PAGES 9 – 43

Allan Ballard: 10, 11,
John Beale: 22, 30, 31 (top)
Jane Bown: 28, 29
John Cowan, 21
Henrie Dauman, 40 (top left)
Ronald Falloon, 13 (middle right)
John French: 20, 38 (top left)
Philip Jackson/Associated
Newspapers, © Rex Features, 41
J.B. Associates: 9, 13 (top left), 26
Lidbrooke, 42
Don McCullin © Contact Press
Images, 14 & 15
Larry Morris, 36

Michael Ochs Archive © Getty Images, 35
Tony Rawlinson: 10, 11, 13 (top right)
Roy Round, 27 (below right)
Joseph Santoro, 32
Snowdon © Camera Press London, 12
Angela Williams, 18 (below left & top right)

Every reasonable effort has been made to contact the copyright holders of material reproduced in this book. But if there are any errors or omissions, we will be pleased to insert the appropriate acknowledgements in any subsequent printing of this publication.

The author and publisher would like to thank everyone who generously contributed to this book, in particular the many individuals and companies who have kindly given permission to reproduce imagery from their archives.

Robin Christian, GNM Archive
Nicholas Coleridge, The Condé Nast Publications Ltd
Diana Donovan, Terence Donovan Archive
Tess Hines, Mary Evans Picture Library
Efi Mandrides, IPC Media syndication department
Terry Mansfield CBE, Hearst Corporation
Chris Moore, Catwalking
Julie Reynolds, Light and Soul Studio
Donna Roberts, syndication, Hearst magazine UK
Seventeen magazine USA
Elizabeth Smith, Norman Parkinson Archive
V&A Images Archive
Connie Woodhouse, Harper's Bazaar

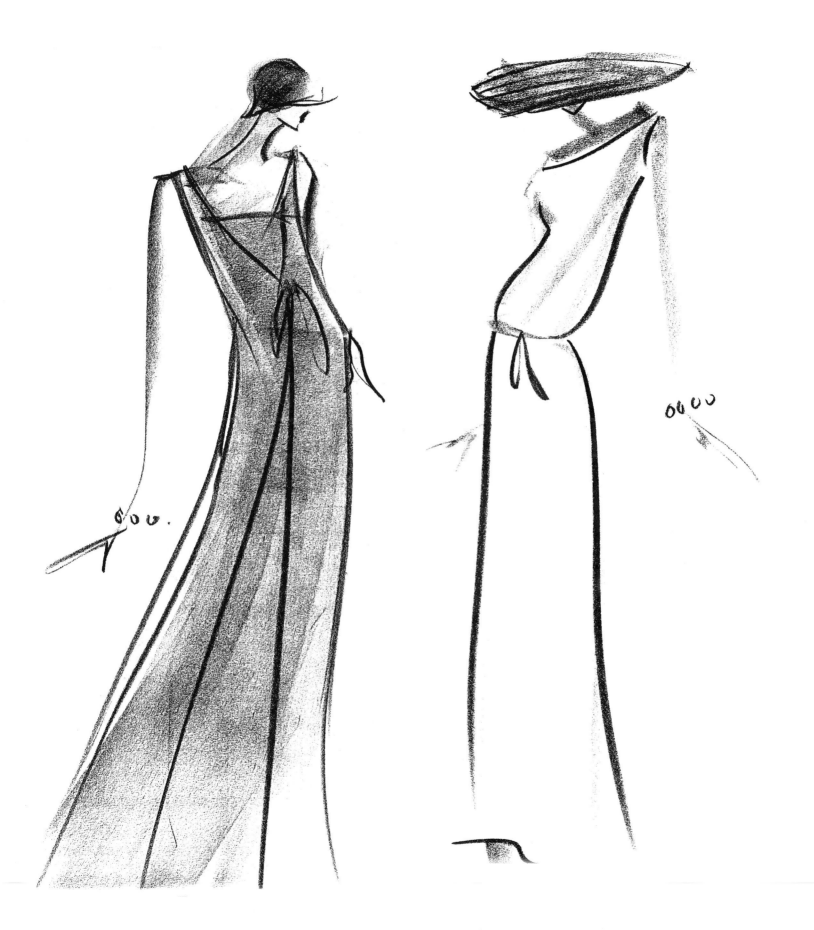

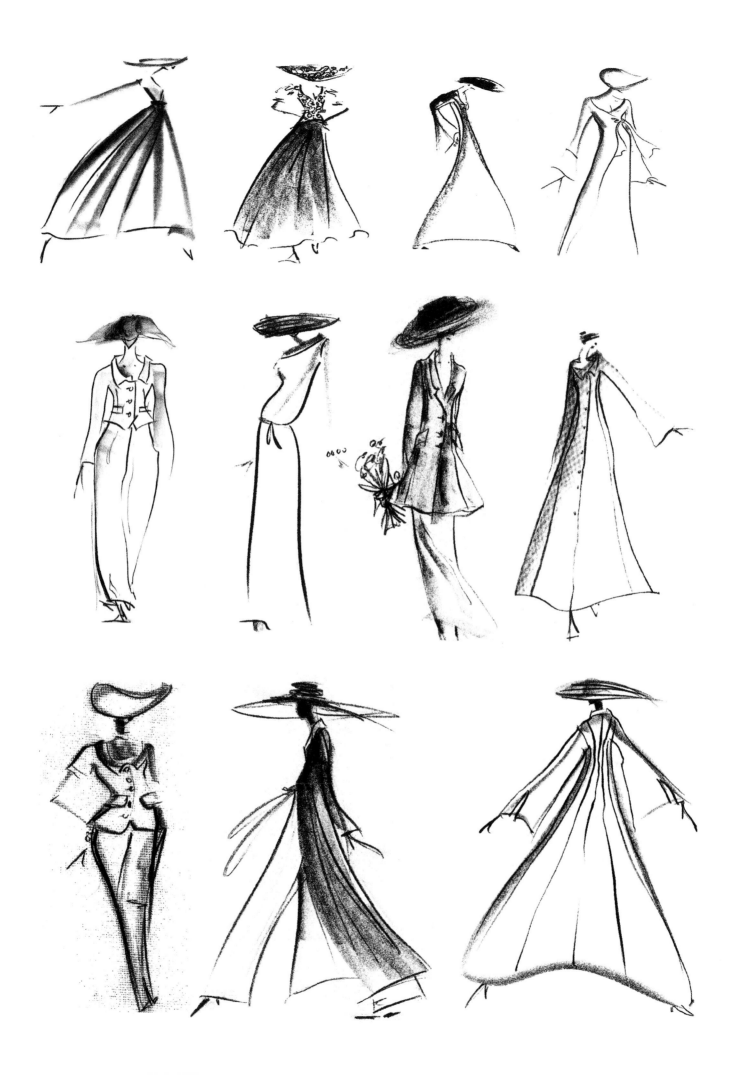

INDEX

Page numbers in **bold** refer to images and/or captions

Frontispiece (p.2): 1980s, *Jonathan Postal*

pp.4, 241-242, 247: Caroline Charles studio sketches, 1990s

ISBN 978 1 85149 716 4

British Library Cataloguing-in-Publication Data
A catalogue record for this book is available from the British Library

The text paper used within this publication is FSC certified and from
sustainable resources.

Printed in Slovenia
Published in England by ACC Editions a division of
the Antique Collectors' Club Ltd., Woodbridge, Suffolk

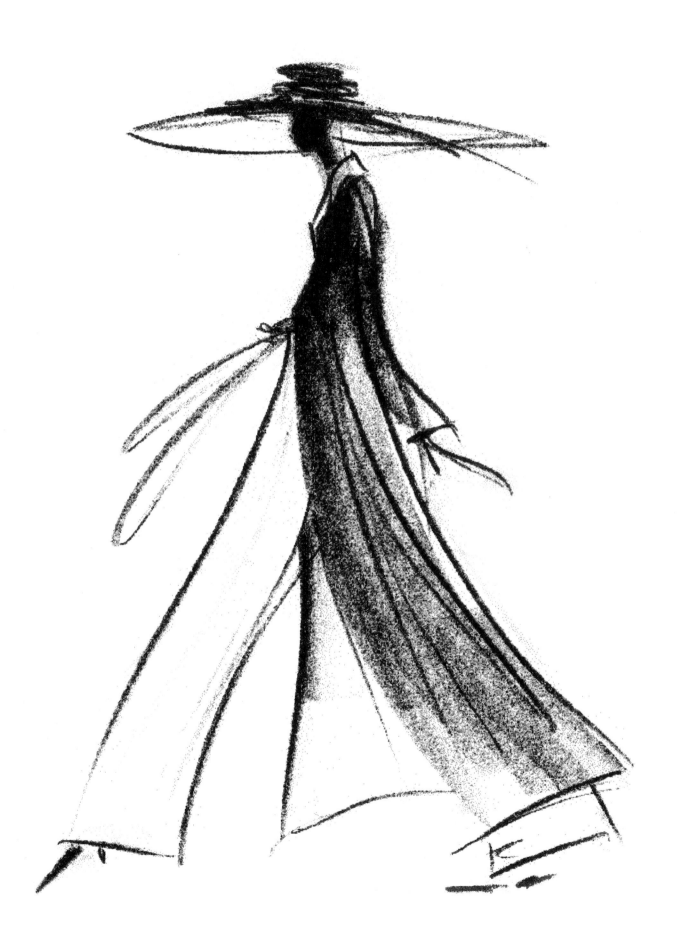

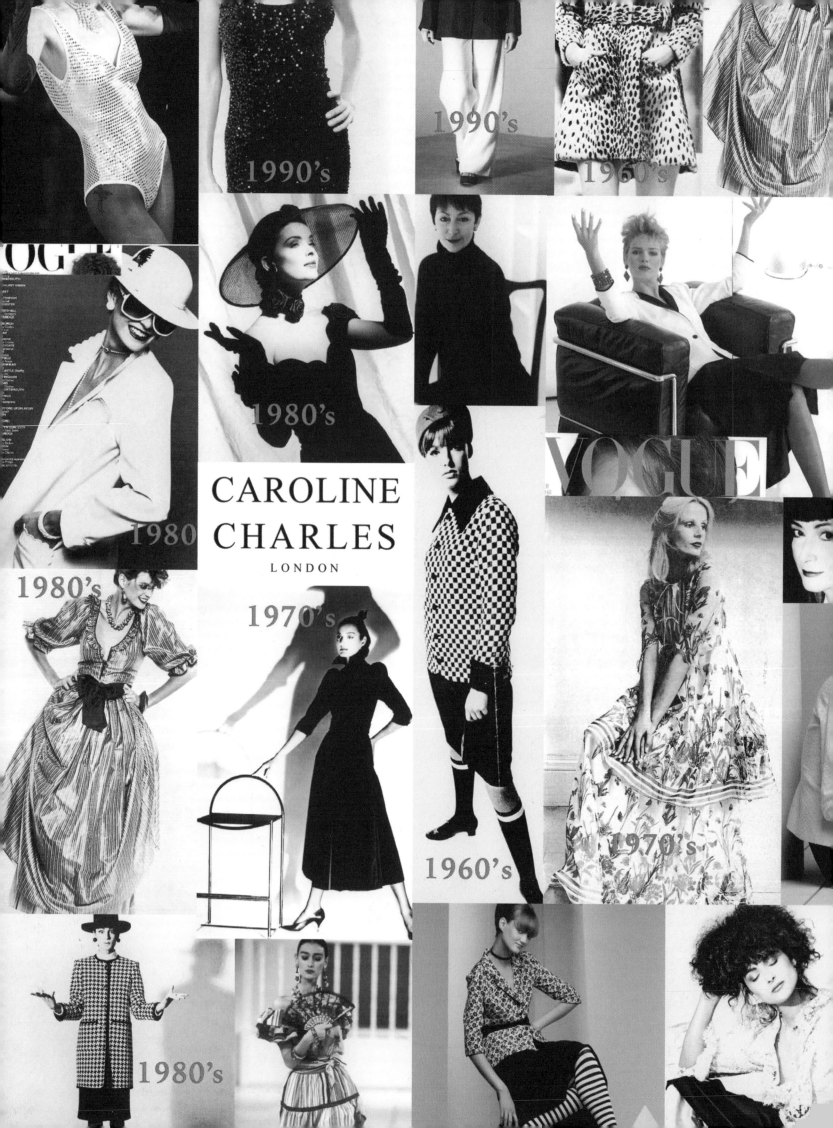

CAROLINE
CHARLES
LONDON